benton **buckley books**

a publishing house

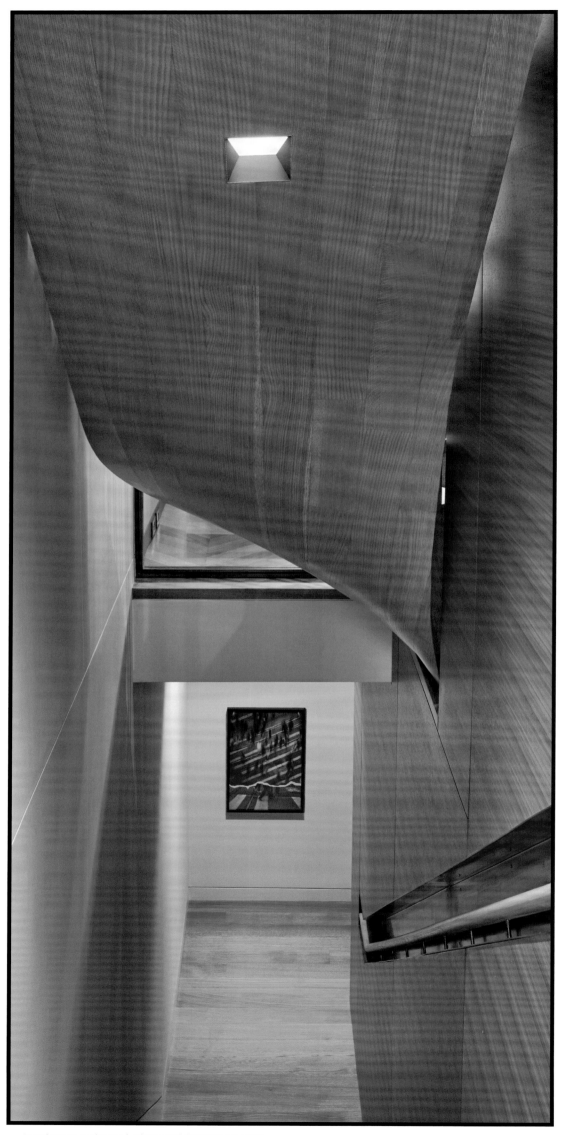

# NV
# NEW VIEW

A Curated Visual Gallery

Twenty Magnificent Homes
by Northeast Architects

Beth Buckley

Foreword by Anne Decker
Introduction by Brian Mac

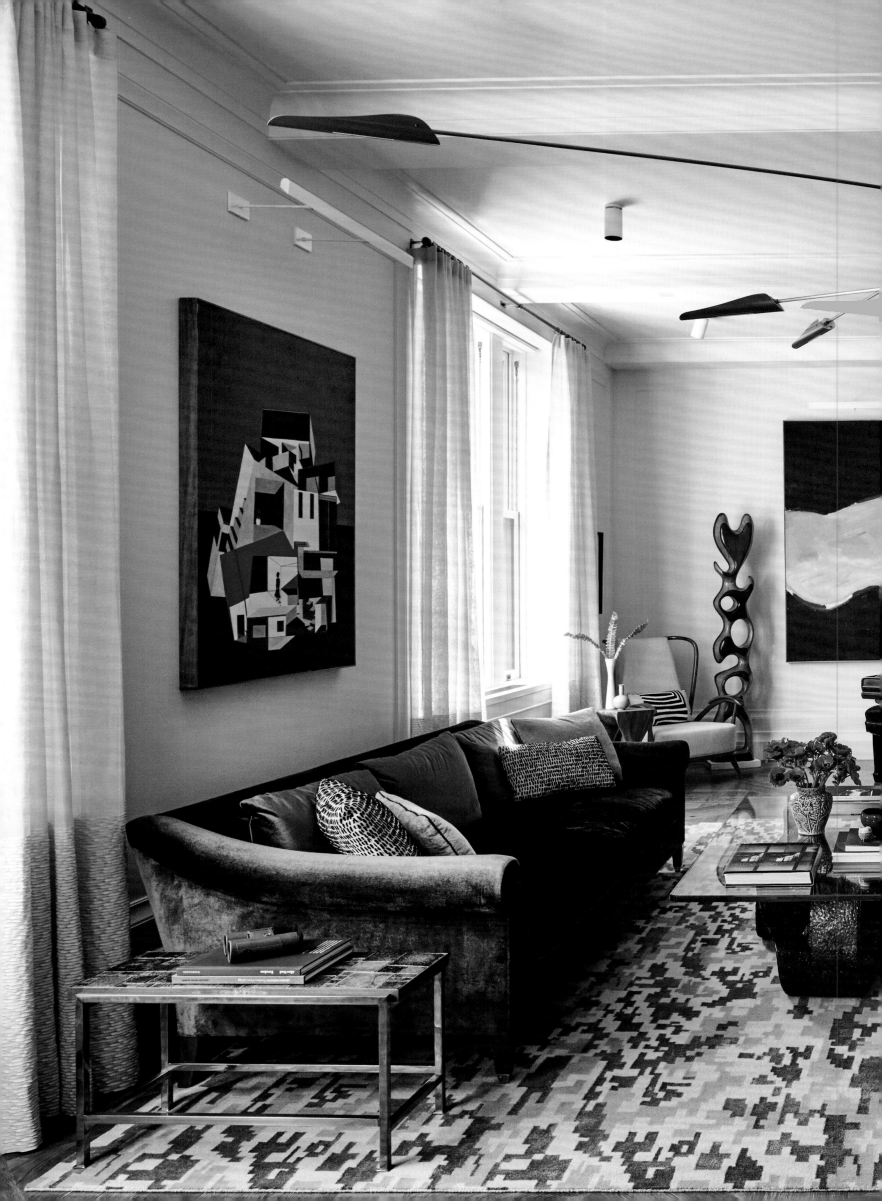

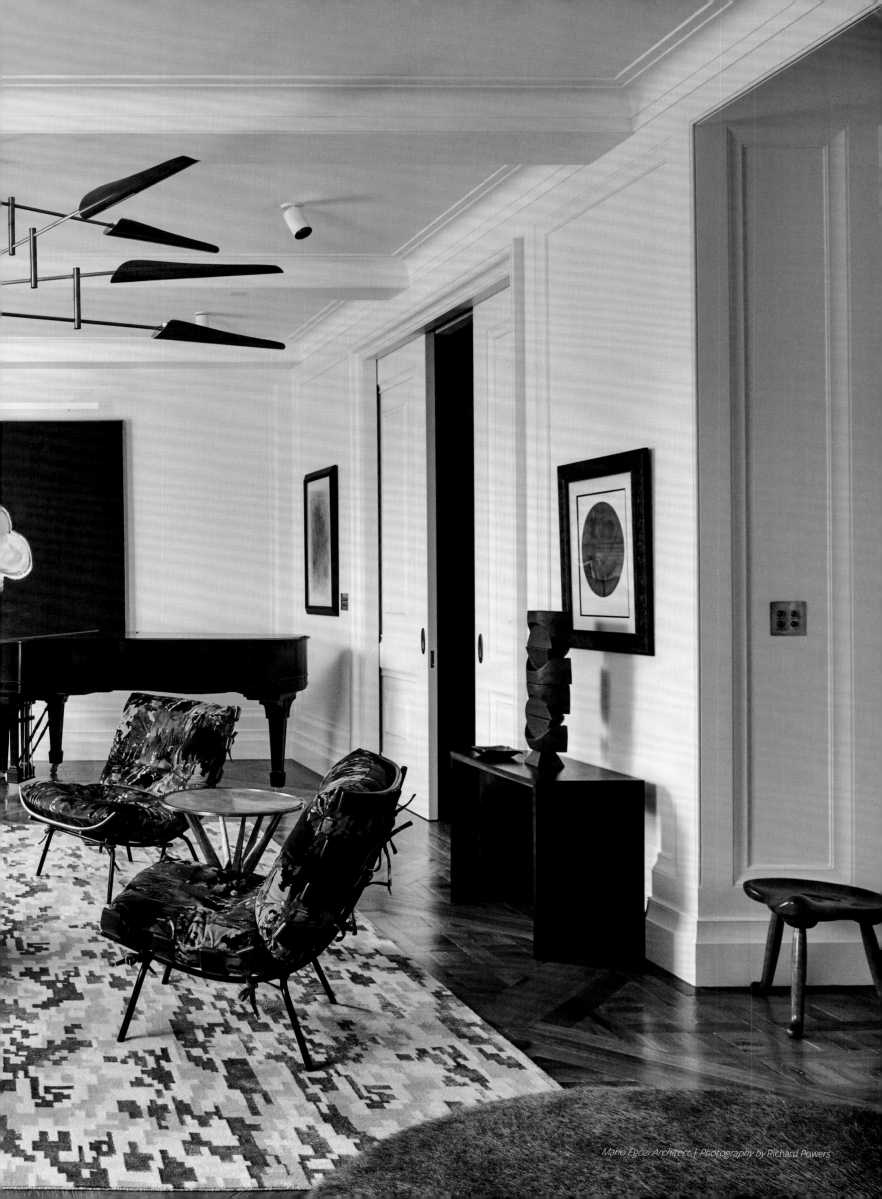

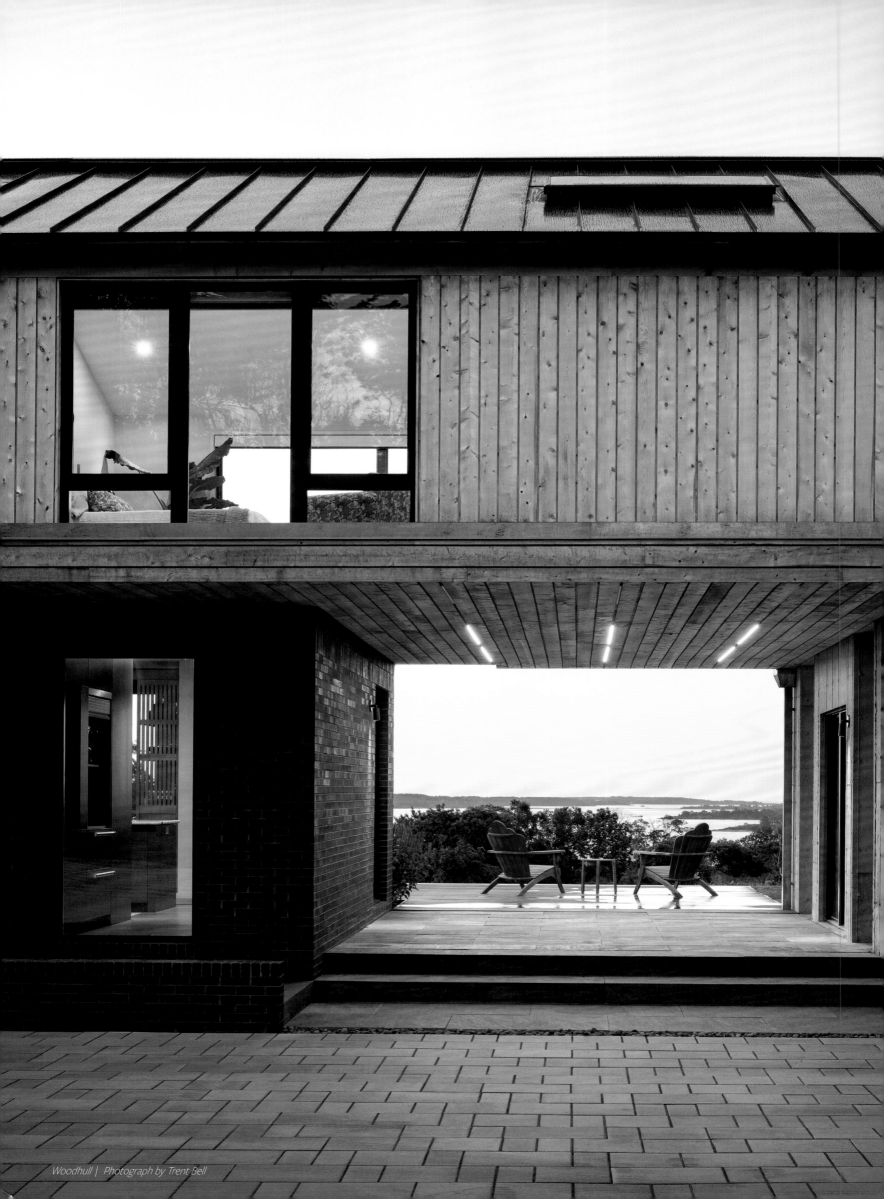

*Woodhull | Photograph by Trent Bell*

# FOREWORD

By Anne Decker
Anne Decker Architects

I had the good fortune of growing up in the South Pacific, a lush, tropical landscape dotted with simple, honest, authentic structures. It's interesting the way our memories are connected with a sense of place formed by the natural and built landscapes around us. Many of my childhood memories are rooted in experiences of simple structures: concrete block houses, Quonset huts, chicken coops. Even today I'm moved by their simplicity, the raw beauty of a concrete block structure designed to withstand typhoon-force winds, the curved ribbing of a Quonset hut, the linear extrusion of a chicken coop. Beautiful in form, like a Richard Serra or Donald Judd sculpture, these structures are the most basic expressions of shelter.

Buildings have a way of touching us. One of my earliest recollections of home is running around, paintbrush in hand, helping my parents breathe life into a handsome, but neglected, older home with panoramic views of the breathtaking Mānoa Valley, overlooking Honolulu. A modest structure, its clean lines consisted of three connected boxes that gracefully stepped to mirror the hillside. Our house encompassed a striking mix of Japanese and modern elements, with broad eave overhangs and oversized floor-to-ceiling glass that blurred the line between inside and outside, pulling in the surrounding greenery. At night, the twinkling city lights of Waikiki glimmered in the far distance. The telescope my dad placed at our dining room window became a permanent fixture that delighted us, revealing details of the stars and night sky.

These memories have stayed with me over the years, and I have often wondered what made this house feel "right." Was it the seamless connection to nature? The gentle flow of the fresh breeze through glass louvers, or the play of sunlight across the polished concrete floors? Or maybe the way the music reverberated in the living room with its high ceilings, while my sisters and I danced with abandon to Trini Lopez's "If I Had a Hammer!" Looking back, it's difficult to pin down the main reason, or even a handful of reasons, why I loved this house. I suppose the magic was how well everything worked together, and the memories it held.

As architects, we strive to create meaningful spaces that bring emotional and physical value, creating a sense of belonging that speaks to us on a personal level. Ultimately, every good design begins with the human experience. Home is not just about shelter and protection; it's also about emotion and memory. Homes are made to be experienced and touched. And it's these personal experiences that bring meaning and significance to our work.

This beautiful collection of homes is a tribute to successful collaboration among architects, clients, contractors, and master craftsmen who – shaped and informed by the unique context of each place and the unique needs and desires of those who will enjoy it – have created a wealth of stylistically diverse structures. Whether a pied-à-terre in New York City or a whimsical cottage in Maine, each home was thoughtfully planned and masterfully created as a haven where daily life is to be celebrated. May the homes that grace these pages guide and inspire you in your personal search for what it means to be "home."

Anne Decker

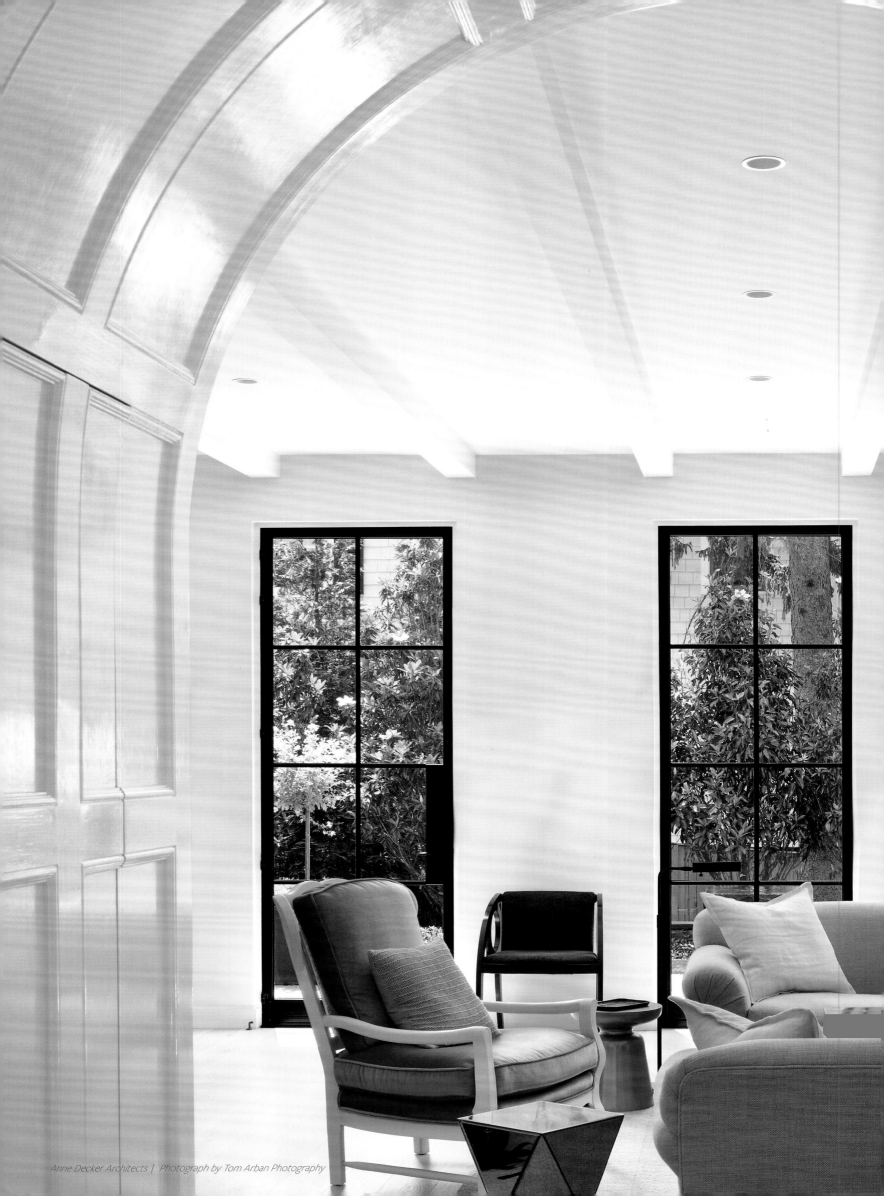

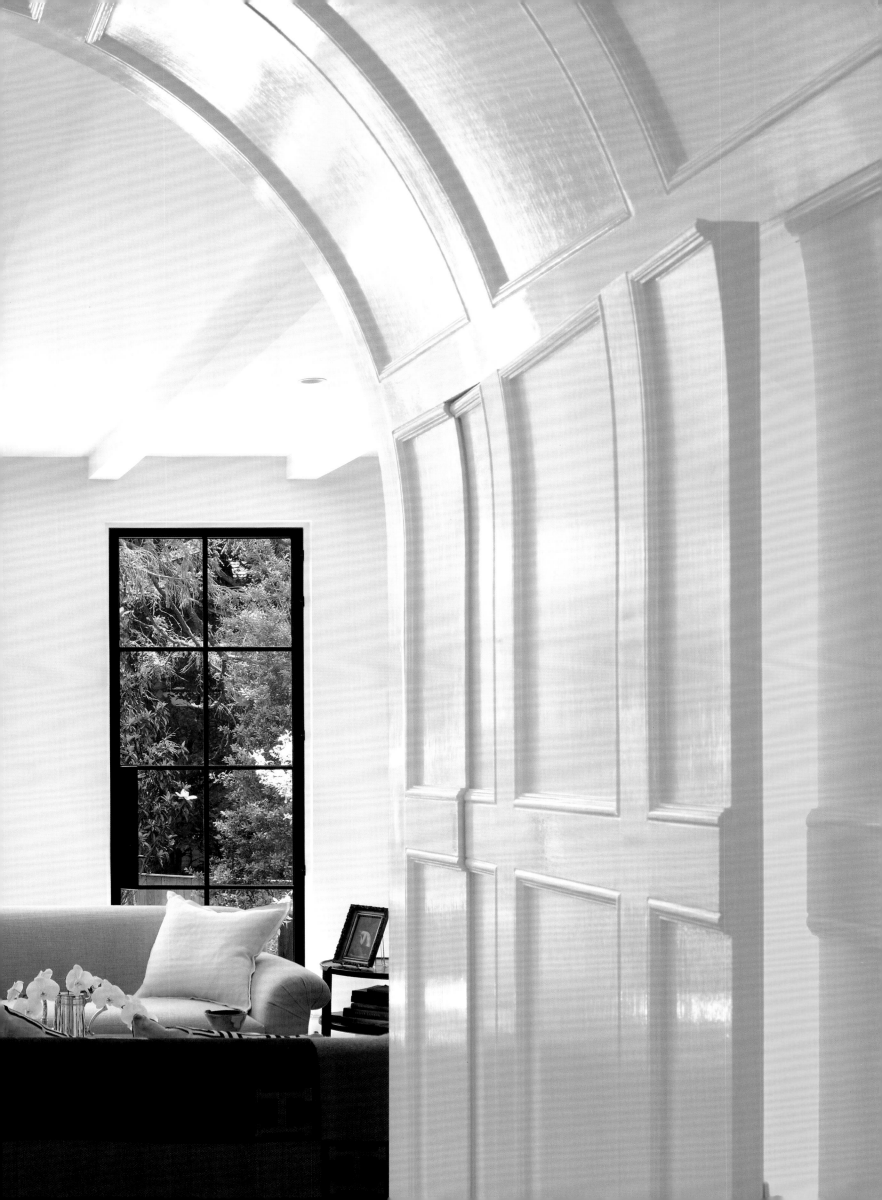

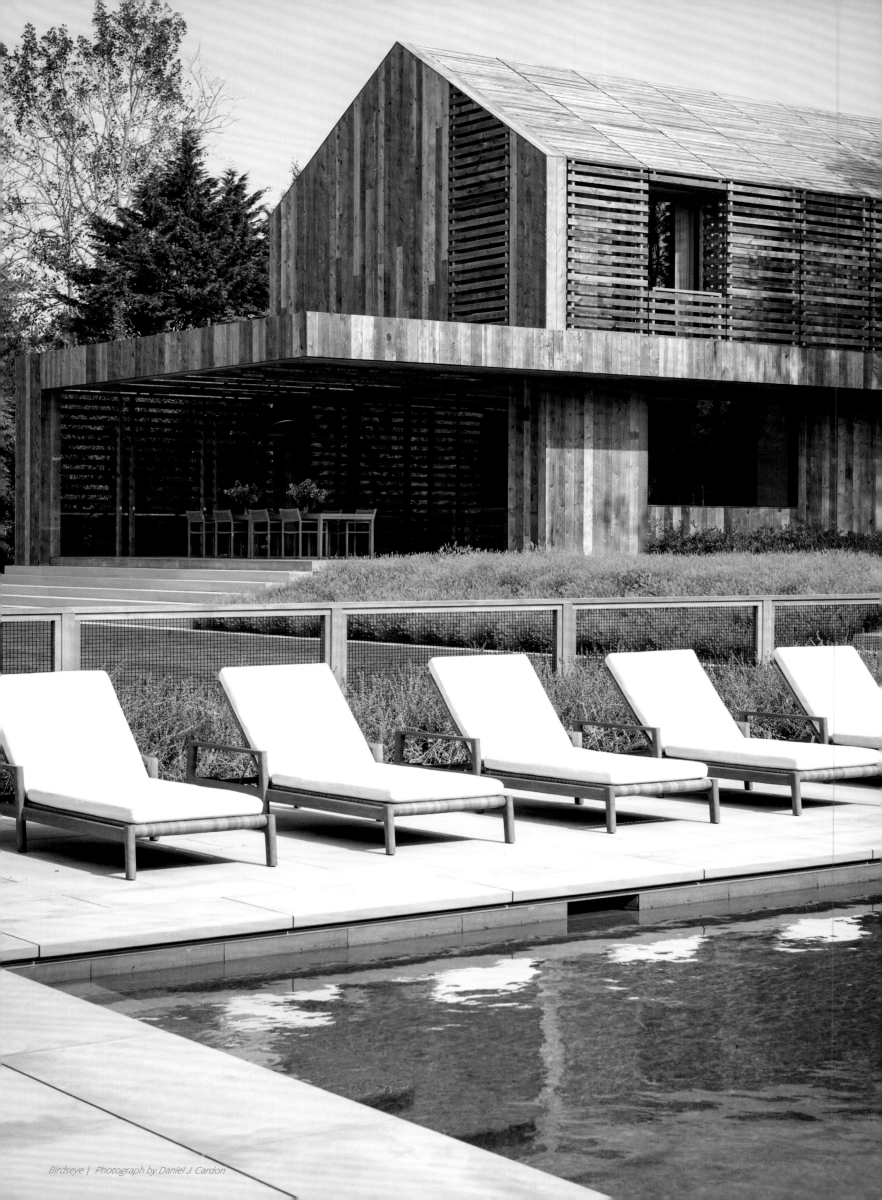

*Birdseye | Photograph by Daniel J. Cardon*

# INTRODUCTION

A publisher once told me that an architect's job is to design buildings, not write about them. His stoicism left me wondering if this advice was in critique of the stereotypical architect rambling on about obscure, conceptual ideas or in advocating a design writer's fresh interpretation of the work. I'm still not sure of the intent, but for me, I felt a sense of relief not having to conjure up a handful of words to describe two years' worth of intense work. Wrapping words on top of art often feels redundant, awkward, and void of the complete experience. I have always been an advocate of letting the building speak for itself and allowing others to interpret the experience. Each line drawn should reinforce the story. Throughout the design process we edit the concept to clarify and enrich the story. Once completed, the building becomes the storyteller. The unique voice of the architecture should breathe from the project.

The honor of authoring this introduction allows me to write about the process of passing the storytelling baton to the building. Throughout the book, there is a shared path reflected in all of the various firms' work. The expression "everything at once" is the architecture of thoroughness that most resonates with my definition of "capital A" Architecture and sits firmly within all of the projects among these pages. Conceptually, this is the language we must speak as artists. One that exudes the essence of authenticity through design and reflects a holistic embodiment of responsibility to art, craft, environment, and community. Creating diligent residential architecture proves to be a process of collaboration among like-minded, passionate individuals. It's the commitment to designing a home that will inspire generations to come. *New View* beautifully presents homes that thoroughly engage "capital A" Architecture. Every aspect of each detail reinforces a central vision for each home. Covering the spectrum from classical to contemporary, the homes in this collection speak for themselves and tell the story of "everything at once."

Brian Mac

"The first gesture of an architect is to draw a perimeter; in other words, to separate the microclimate from the macro space outside. This in itself is a sacred act. Architecture in itself conveys this idea of limiting space. It's a limit between the finite and the infinite. From this point of view,

all architecture is sacred."

— Mario Botta,
architect

A Curated Visual Gallery

"Many of our buildings are rooted in an understanding of context and history, but our work is not historic. It is influenced by technology as well as tradition, and there is an underlying modernist sensibility to everything we do."

— Morris Adjmi

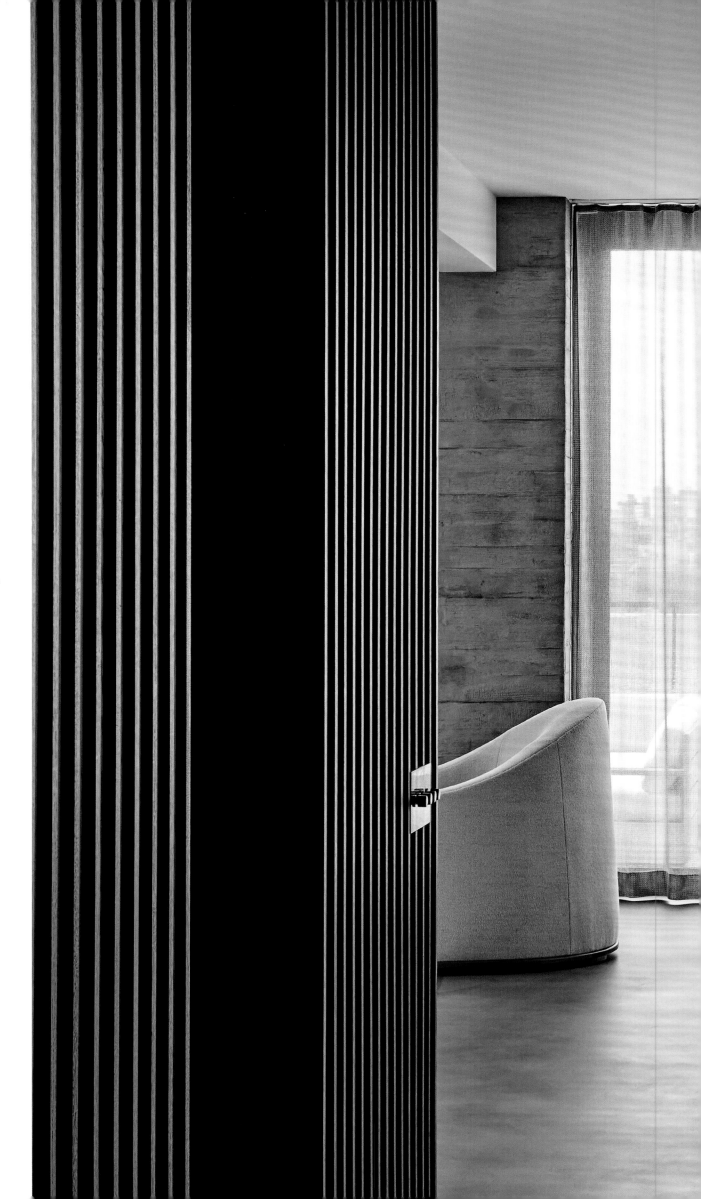

# Morris Adjmi

## MA | Morris Adjmi Architects

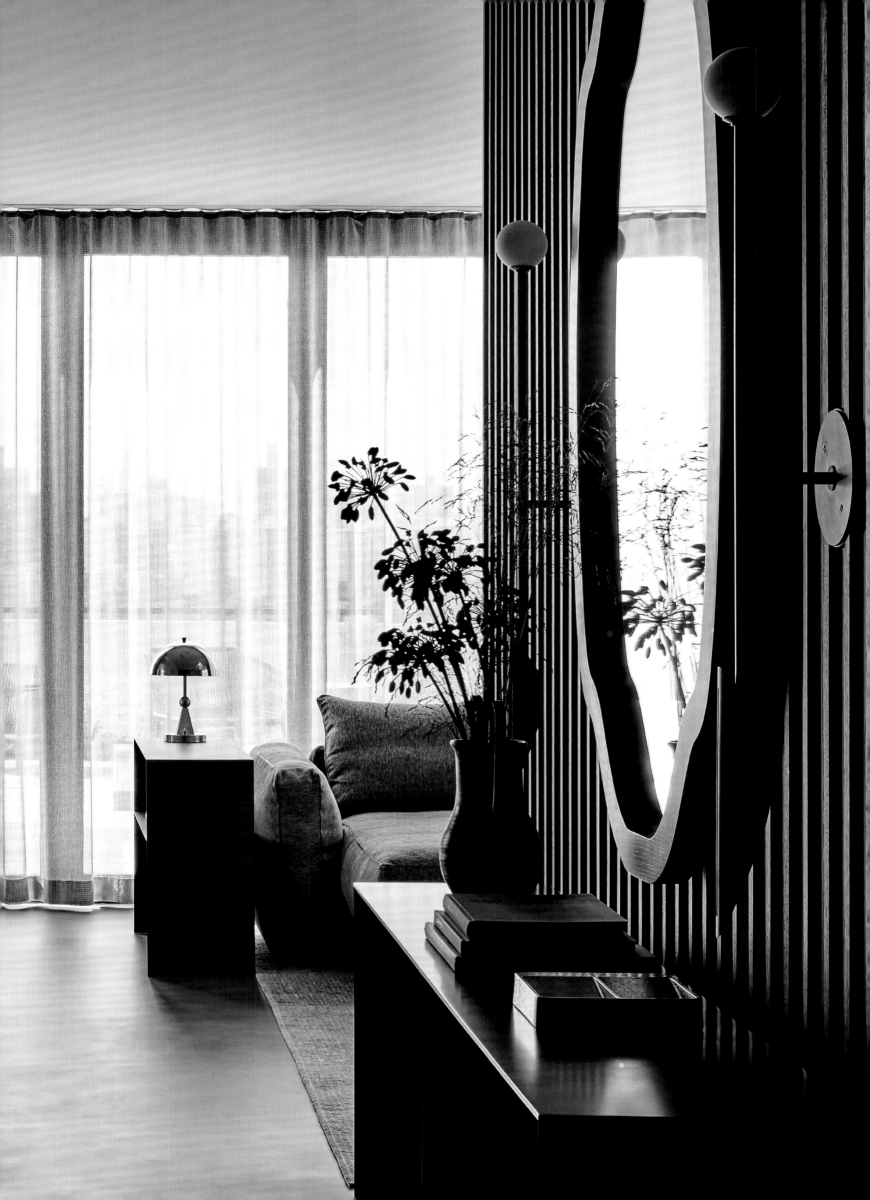

With its French, Creole, and Spanish influences, there are few places in the country that can rival the distinctive architectural style of New Orleans, especially in the city's French Quarter. Morris Adjmi grew up in this dynamic environment and would spend hours drawing the balconies, ornate ironwork, tall windows, and transoms found throughout.

"New Orleans, my beautiful hometown, made me want to be an architect," he said.

Yet by the time Adjmi entered Tulane University in the late 1970s, he said that as much as he loved the city's unique buildings, he realized they belonged to a specific moment in time and history.

"That realization was pivotal for me in terms of how I developed my own design approach and philosophy. I didn't want to imitate the buildings that I loved, but it felt essential to learn from them."

Adjmi's desire to find a deeper understanding of New Orleans' architecture beyond its historicism and style led him to Pritzker Architecture Prize-winning architect Aldo Rossi, noted for the famous Teatro del Mondo in Venice, Italy.

Adjmi enrolled in the Institute for Architecture and Urban Studies in New York to take an advanced design workshop with Rossi. The pair ended up working together on a project in Milan and eventually launched a 13-year professional partnership.

Adjmi established MA | Morris Adjmi Architects in 1997 following his collaboration with Rossi. Today, the firm has a combined staff of nearly 100 in New York City and New Orleans.

"We strive to create iconic buildings that stand out by fitting in — contemporary architecture and environments inspired by art, history, and context using sustainable technologies and innovative materials," Adjmi said.

The firm is on an exciting path, honoring Aldo Rossi's legacy as it cements its own. "At MA, we are guided by a shared mission to create buildings that contribute meaningfully to the built environment. Buildings we hope are worth preserving in 100+ years. Rossi's mentorship set me on this path and my hope is that MA serves as a nurturing environment to help cultivate the development of future leaders who will continue to design buildings that bridge the past, present, and future."

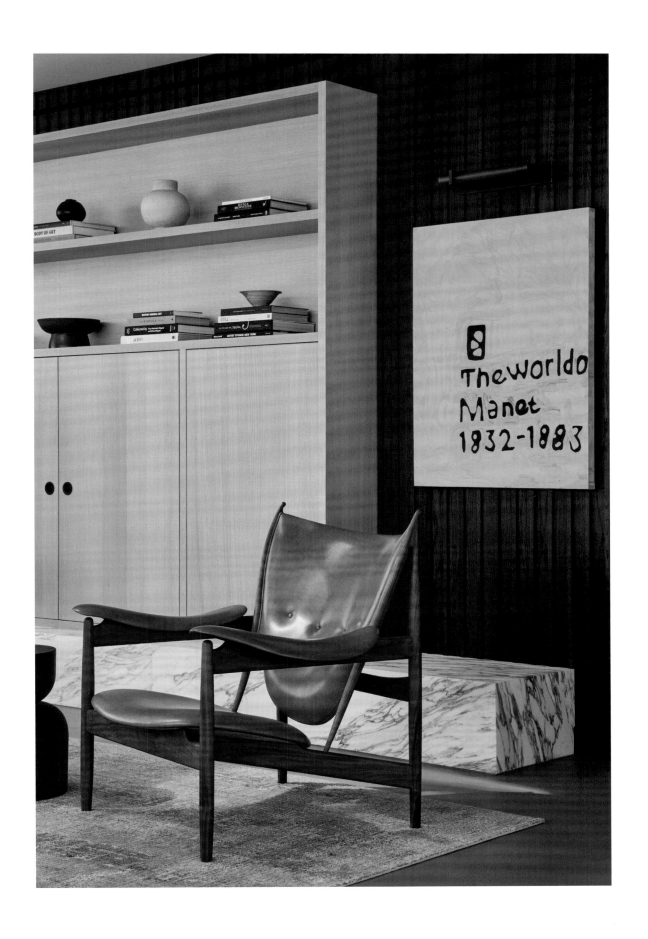

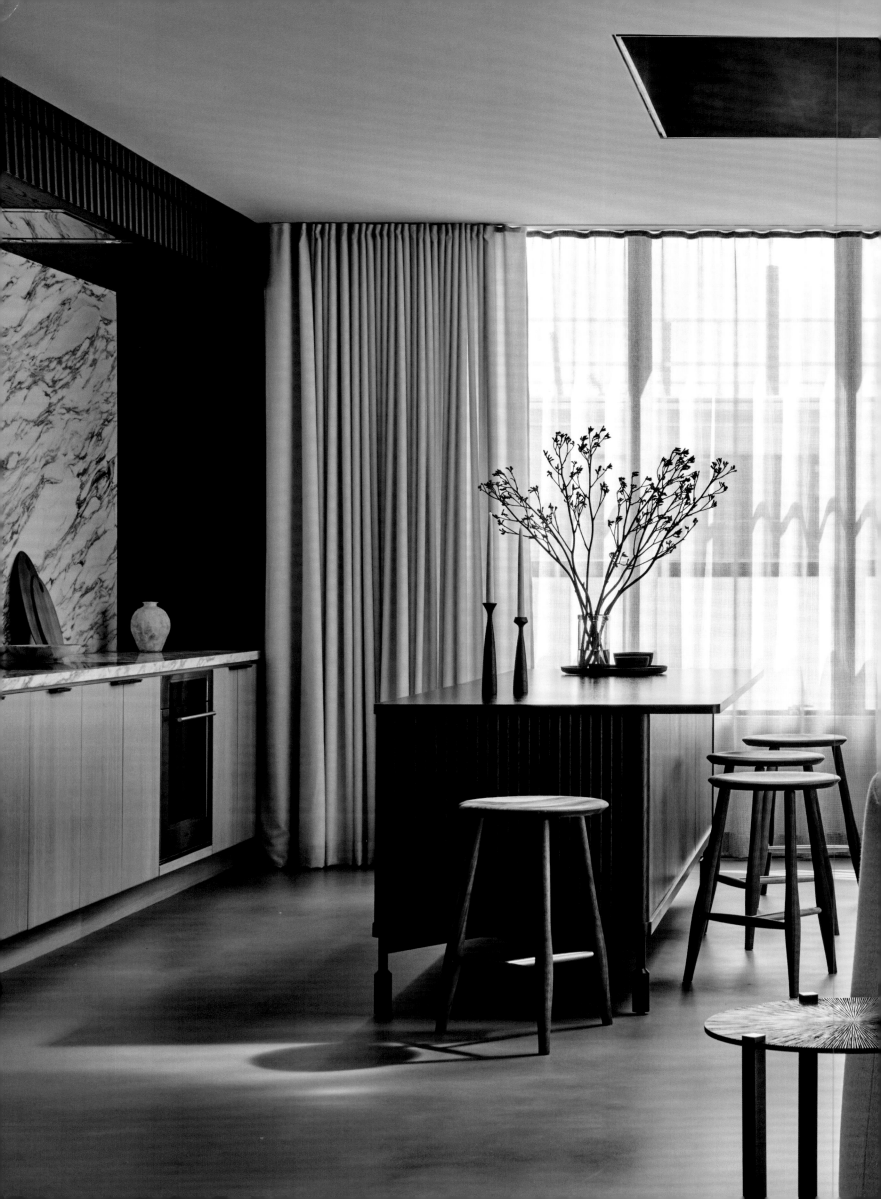

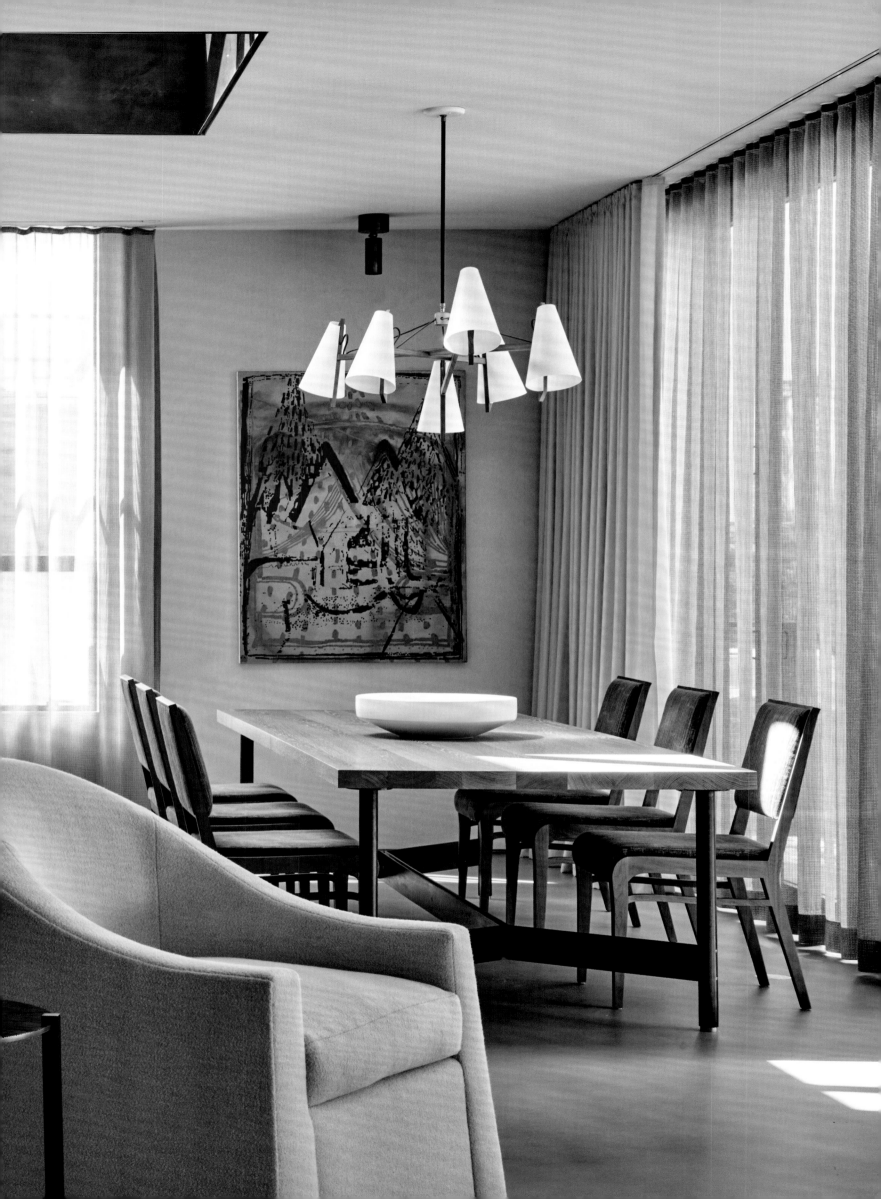

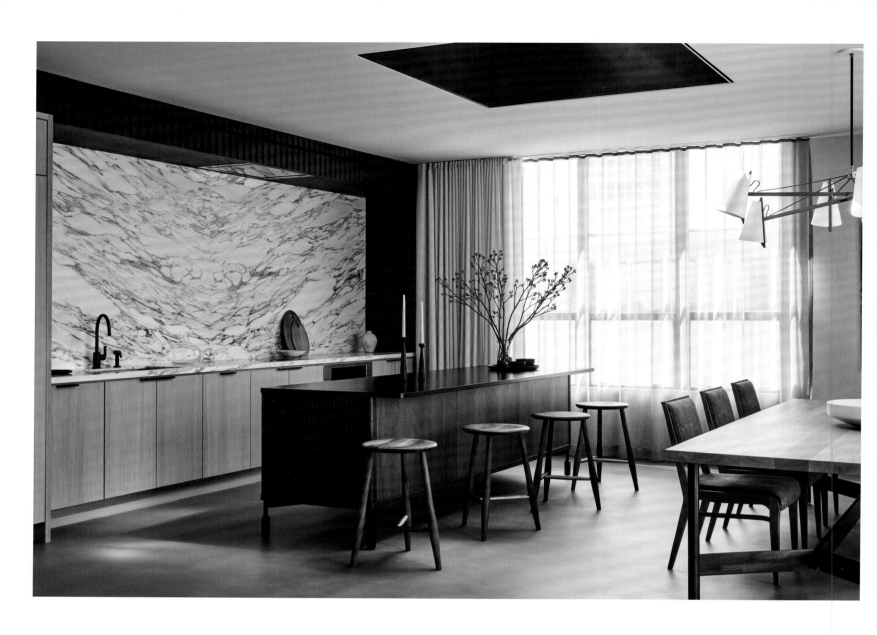

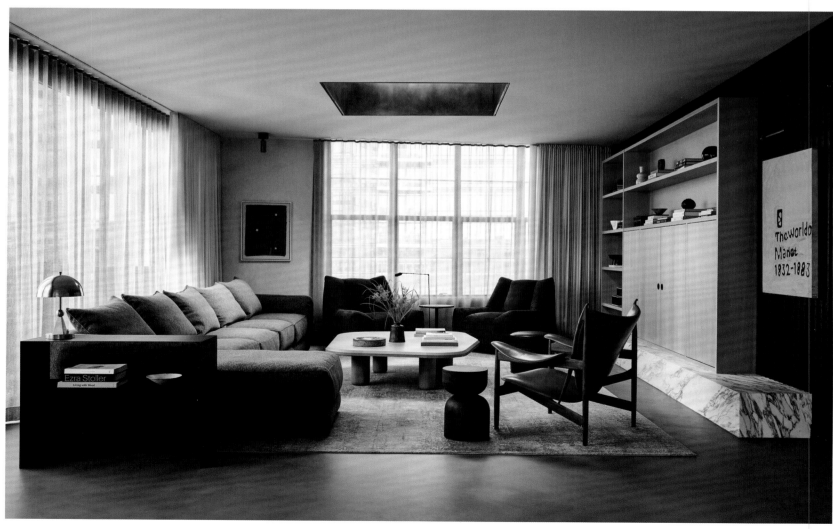

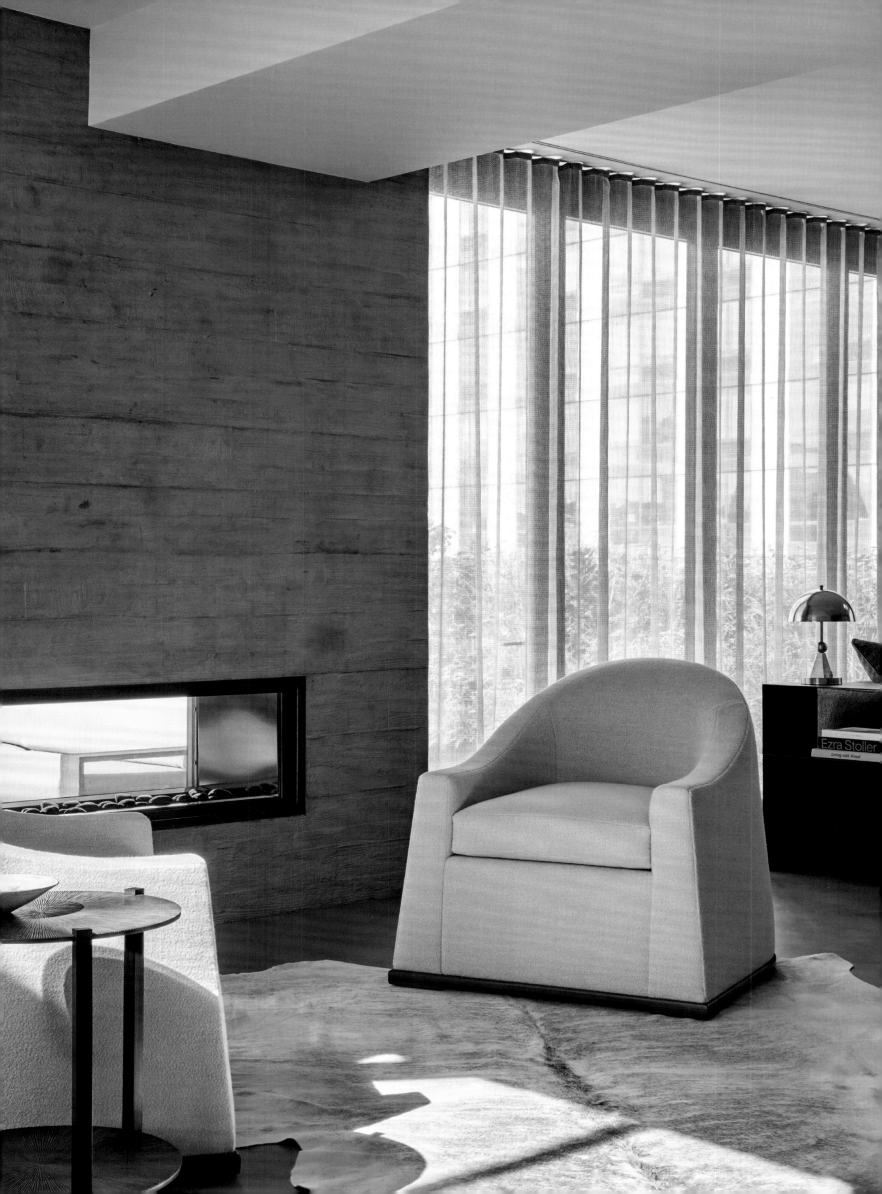

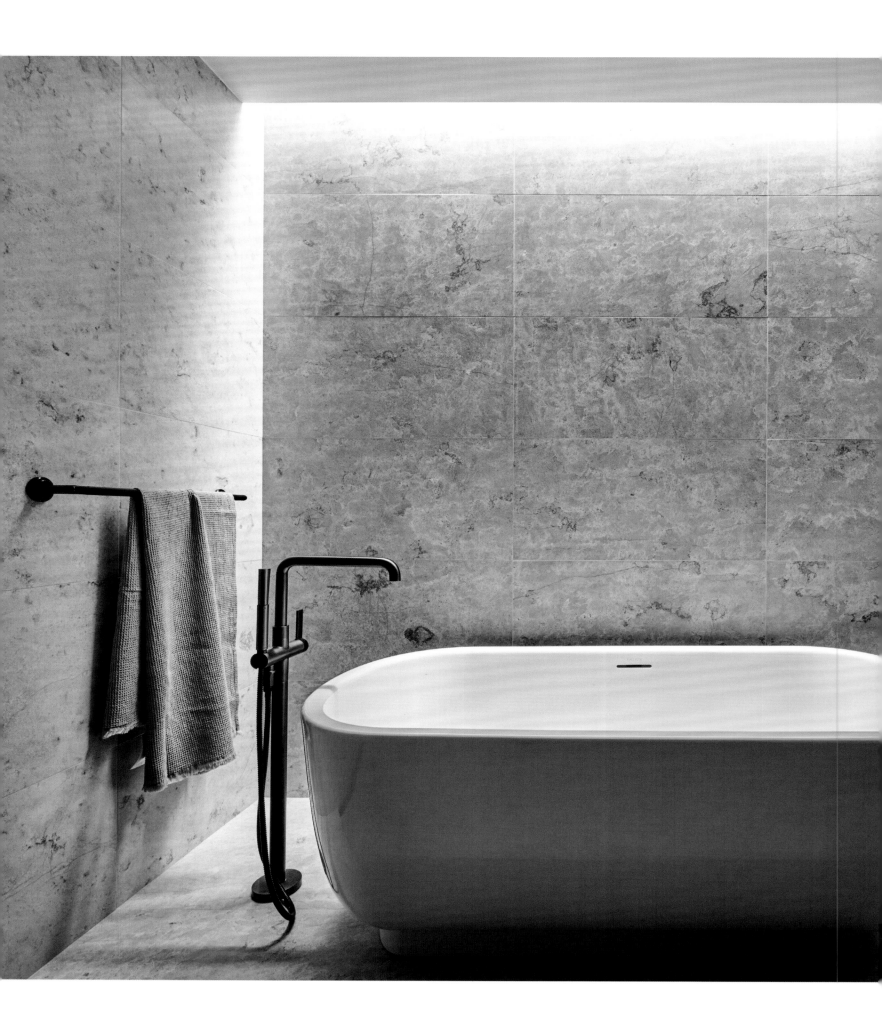

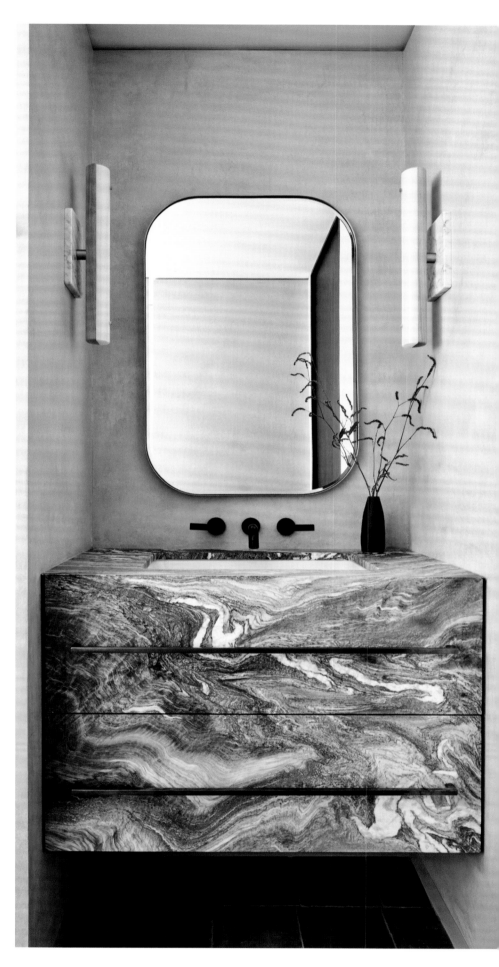

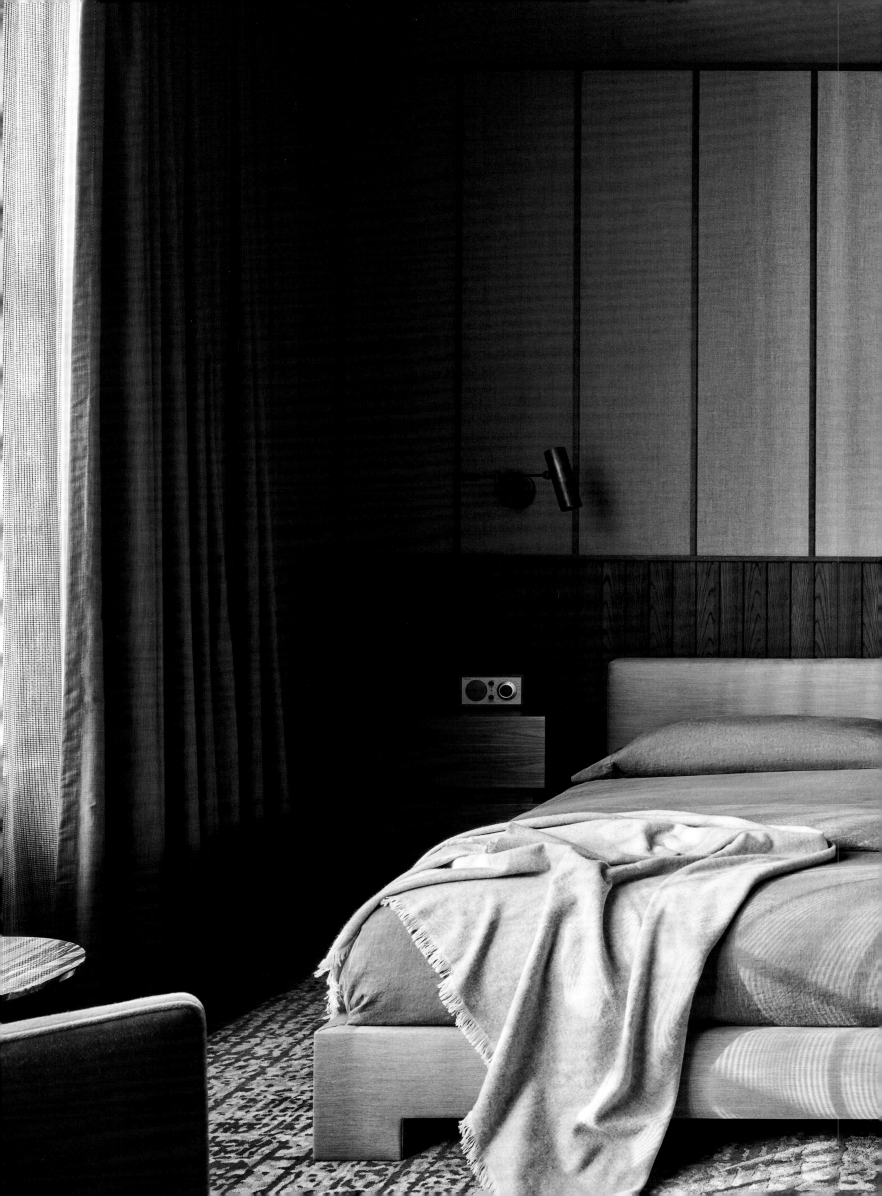

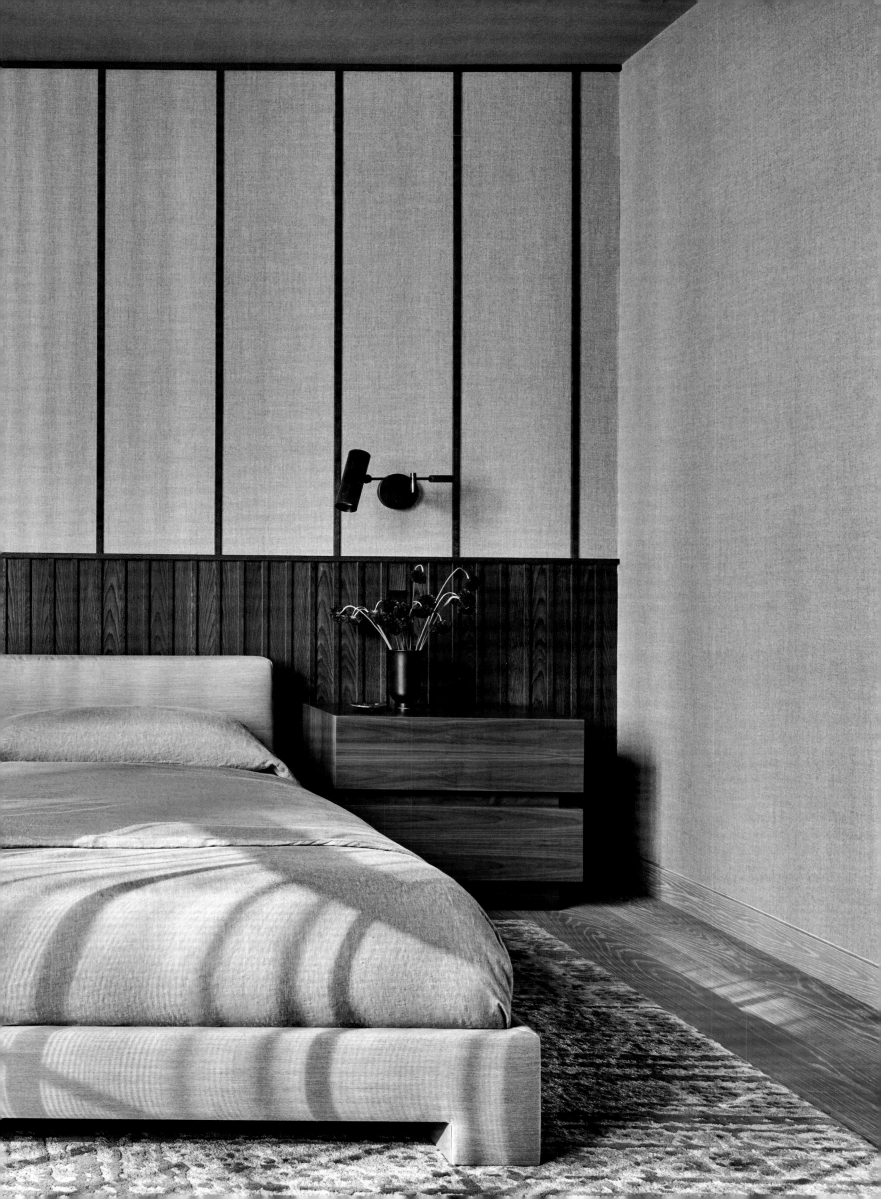

"I believe in creating comfortable and welcoming spaces informed by the user's personality and style — whether that's one specific client in the case of a private residence, or the preferences of a broader population in the case of a multifamily building."

— Morris Adjmi

One of MA's most notable recent projects is the Austin Nichols Penthouse in Brooklyn, New York. In 2016, MA transformed the Austin Nichols House, a circa 1915 concrete warehouse, into a luxury multifamily building with unobstructed views of Manhattan across the East River. Several years later, Adjmi and his team were called upon to provide a full interior fit-out of one of its expansive penthouse units.

"The client's objective for the project was to create a family-friendly pied-à-terre — a chic, urban respite for family and friends to come together," Adjmi said.

MA transformed the three-bedroom, four-bathroom unit into a modern and masculine home. At 2,400 square feet, the dwelling boasts dark woods and natural stone that add depth and richness to the post-industrial building's inherent concrete, glass, and steel elements.

One of the penthouse's unique design features is a folding wall system installed across its entire western façade, which maximizes indoor-outdoor living during warmer months. Along this elevation, a double-sided fireplace can be enjoyed from the terrace and living room.

"We knew we had to find a way to take full advantage of the home's amazing unobstructed views of Manhattan," Adjmi said. "It's a rare and exciting experience to be able to enjoy the skyline so intimately."

*Interior Design: MA | Morris Adjmi Architects*
*Photographer: Nicole Franzen*

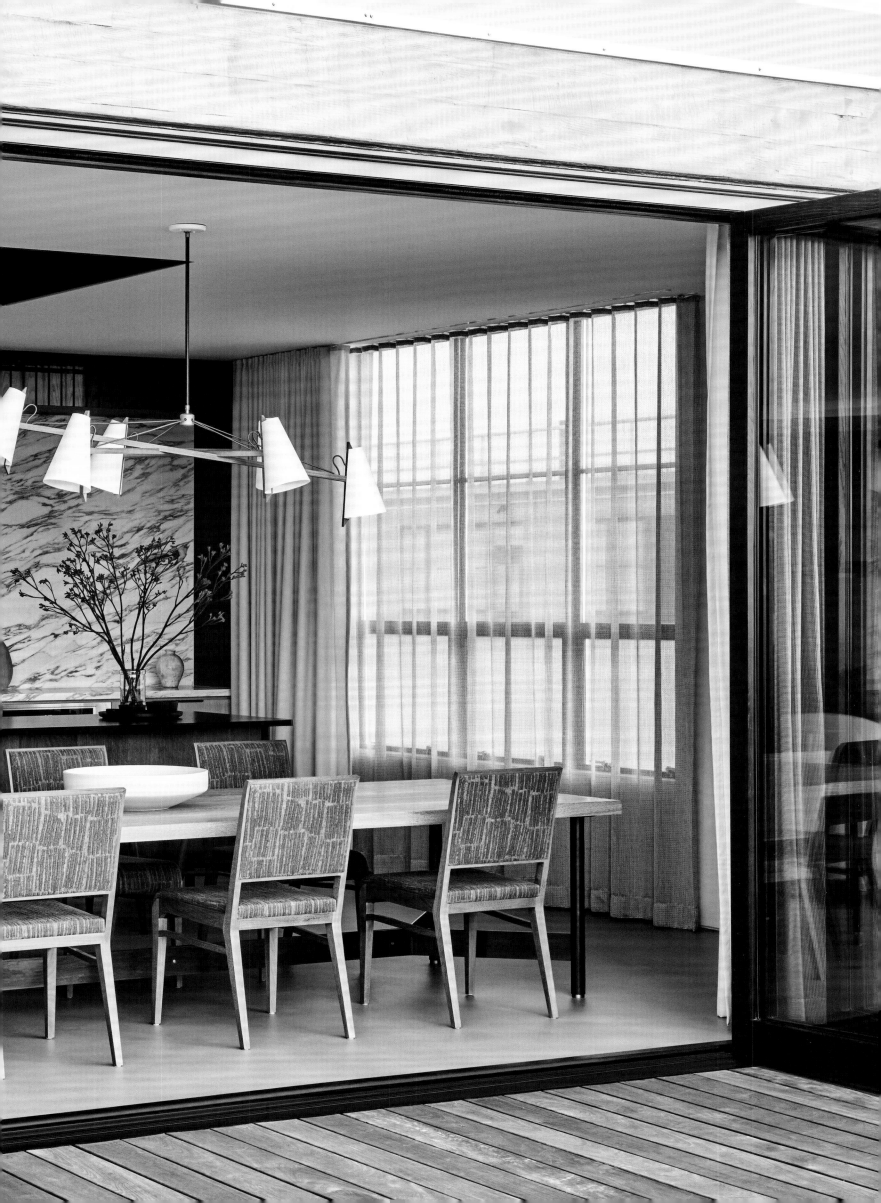

"Ultimately, I feel that the crafting of a home is about inspiring owners to become their best selves, rather than simply solving problems of perceived deficiencies."

— Ed Barnhart

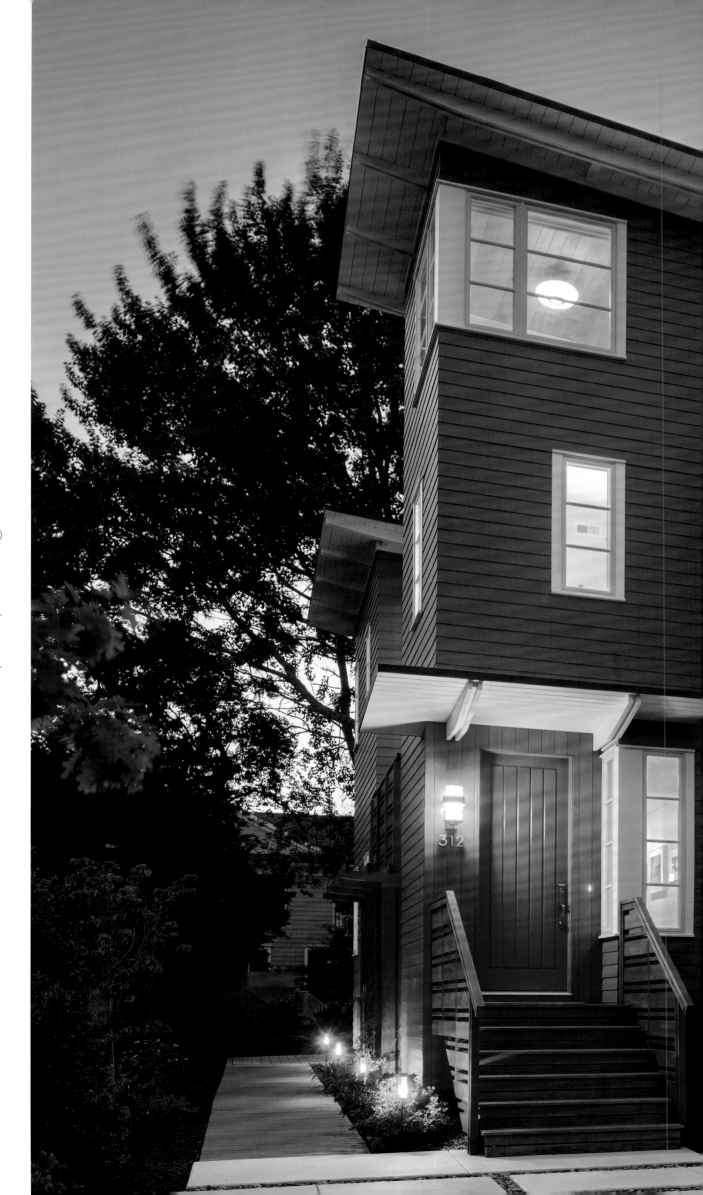

Ed Barnhart

Always by Design

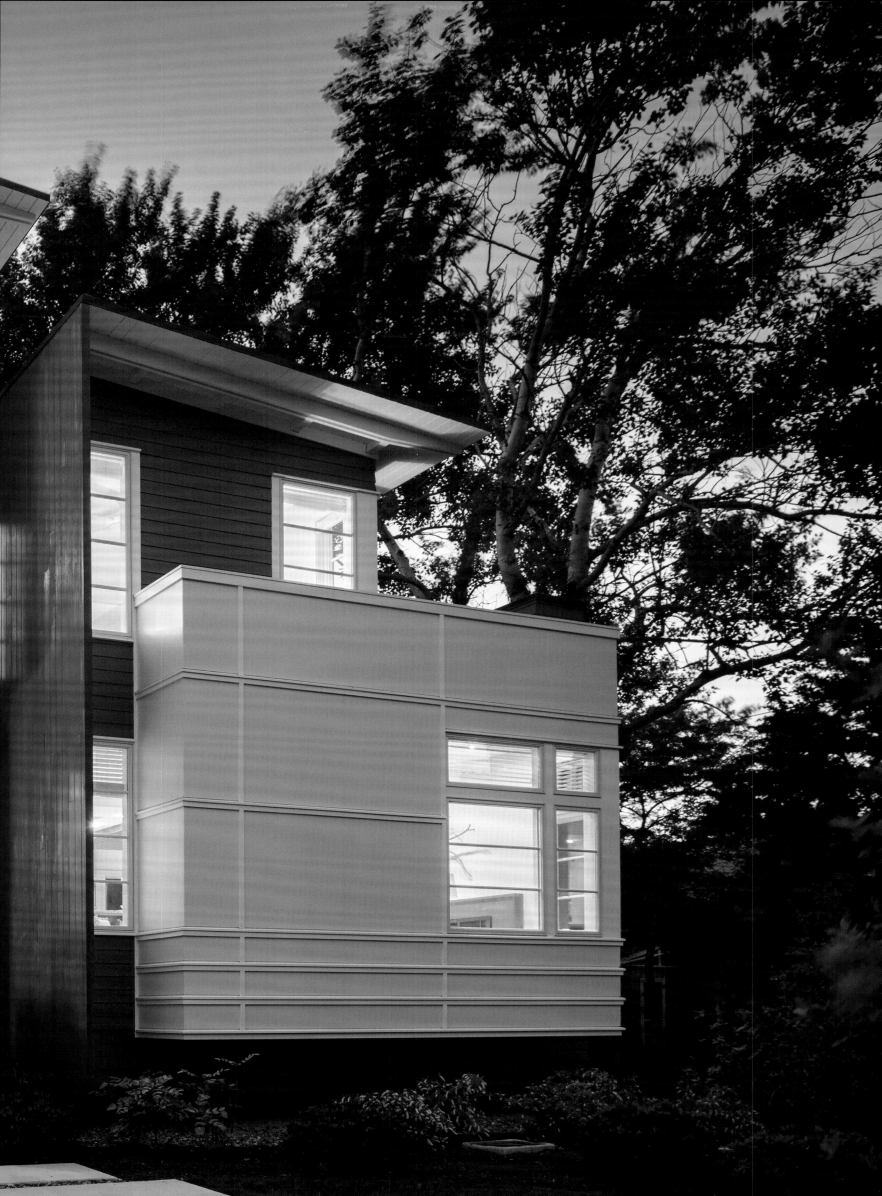

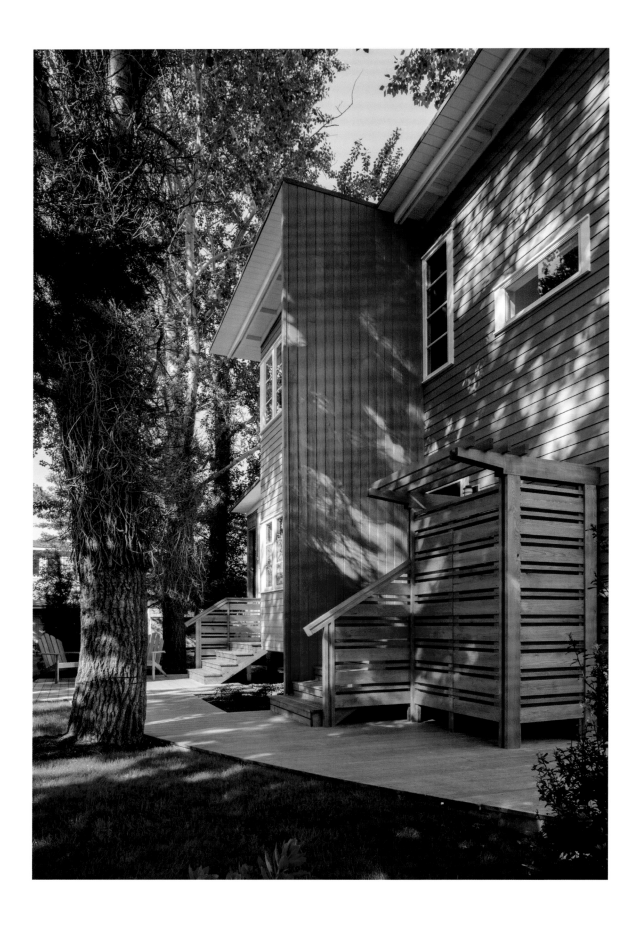

Visiting the Jersey Shore home that Ed Barnhart designed for Anne Downey, a client he subsequently married, attests to the fact that architectural practice, for him, is personal. Very personal.

"Designing a home should be about engaging all of one's senses. For instance, in designing a shore house, I've used wide solid white oak plank flooring knowing that the boards would cup slightly in a coastal environment. Walking barefoot on the finished flooring is a real joy, like getting a subtle foot massage."

Growing up near Saratoga, New York, Barnhart developed both a love of nature, while hiking the nearby Adirondack Mountains with his dad and, thanks to numerous family cross-country summer trips, an appreciation for diverse regional styles such as Queen Anne and West Coast Modernism, as well as for specific works like Yosemite National Park's Ahwahnee Hotel and Frank Lloyd Wright's Fallingwater. Taken together, they fostered his awareness of the importance of building with a sense of place.

After earning dual degrees in architecture and building sciences from Rensselaer Polytechnic Institute, Barnhart honed his design sensibilities at Pennsylvania firms Venturi, Scott Brown & Associates, and Bohlin Cywinski Jackson, working primarily for clients such as prominent cultural institutions and universities in the U.S. and abroad.

After 20 years of such work, Barnhart founded Philadelphia-based Always by Design in 2005, seeking, as he puts it, "greater wholeness and intimacy, both for myself and my clients." To that end, he now works exclusively on designing custom single-family homes for individual owners.

"When I was a freshly minted architecture school graduate, I thought that the ideal project was having a client who said, 'This is what I want. Here's a wad of cash that should more than cover it. I'm going on a year-long cruise and want it done when I get back.' Now, I seek to know clients as people first and foremost. What life experiences have shaped them? What are their values? How do they see their lives ideally playing out? Although it's an impossible task, my goal is to try and inhabit each owner's shoes as fully as possible and provide something that they will value more with each passing year."

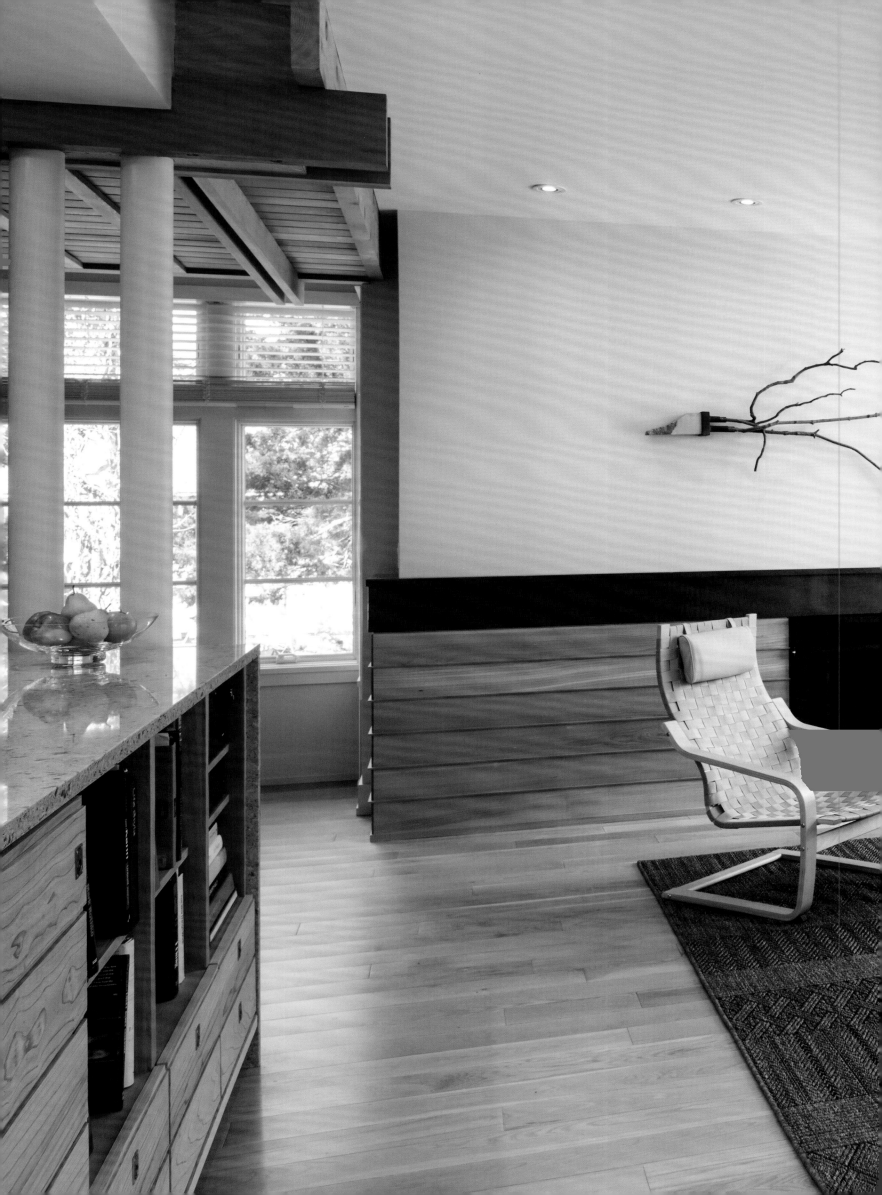

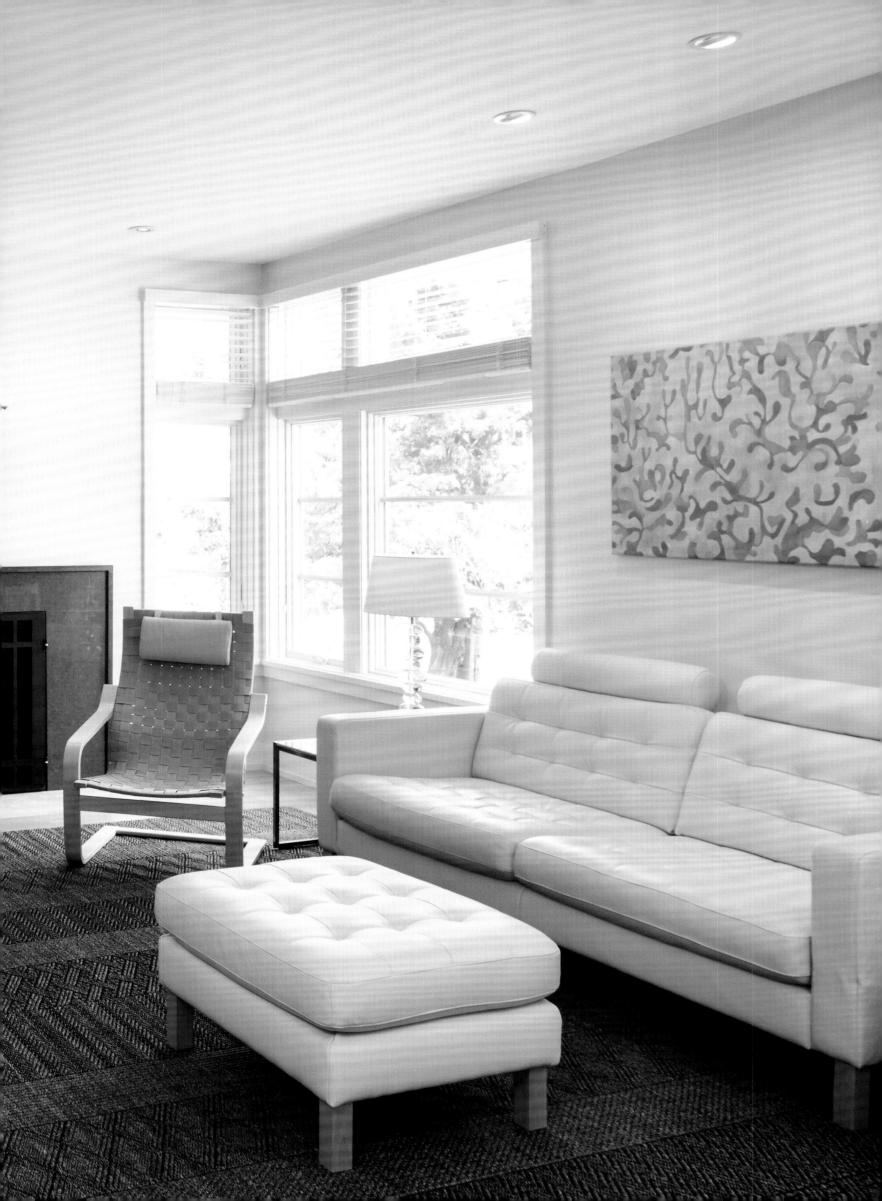

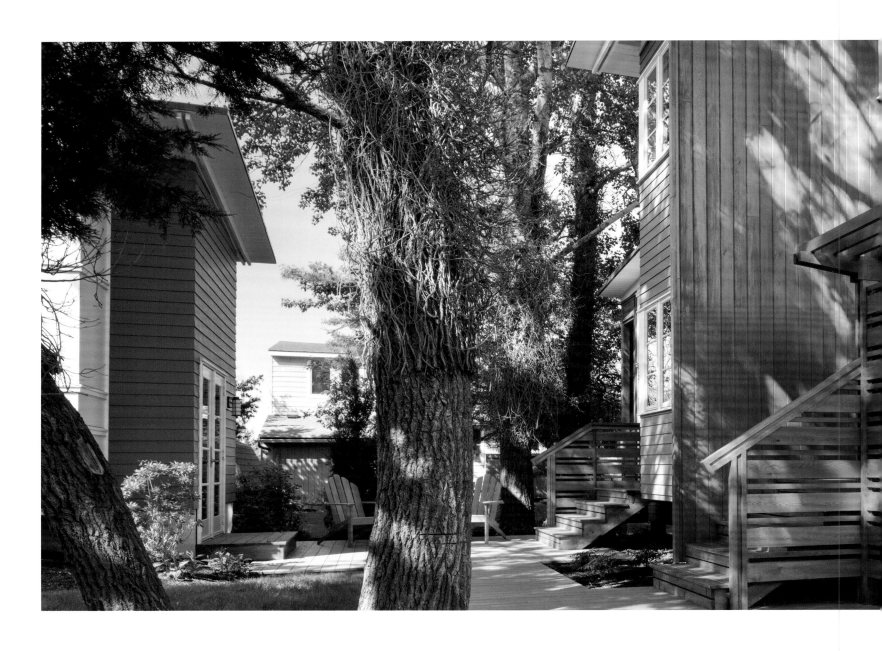

"Emerging from architecture school there was a belief that things had to be visually bold and/or structurally heroic in order to have impact. Over time, I've come to learn the power that 'small' decisions and details can exert on inhabitants. I've learned the power of nuance."

— Ed Barnhart

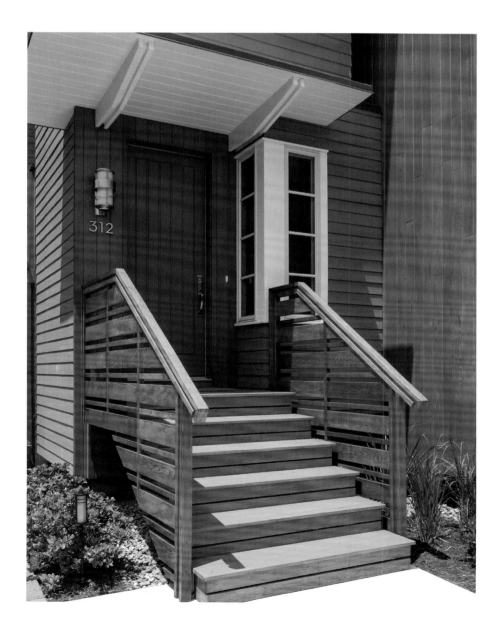

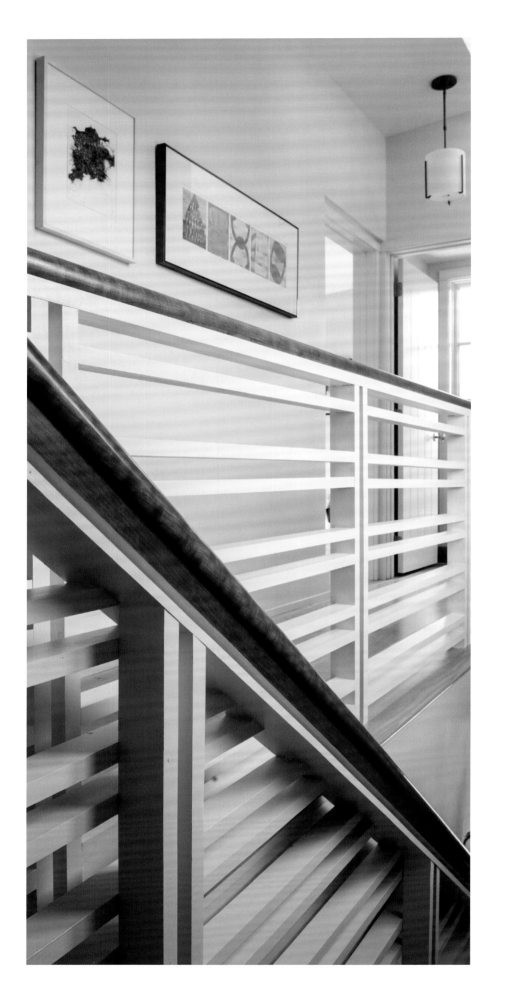
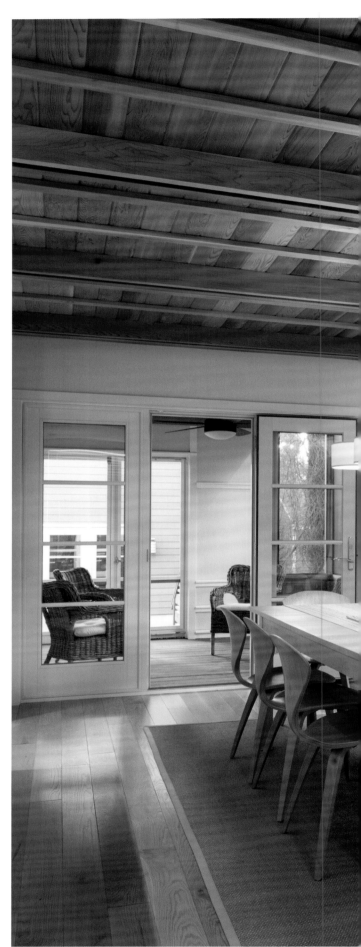

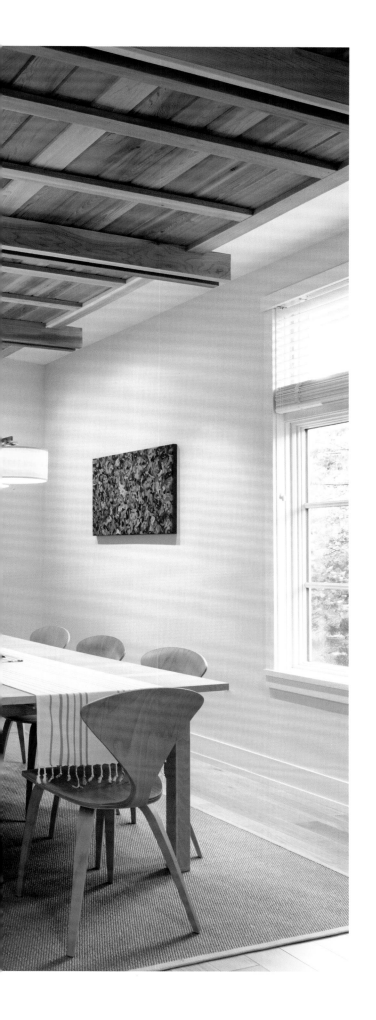
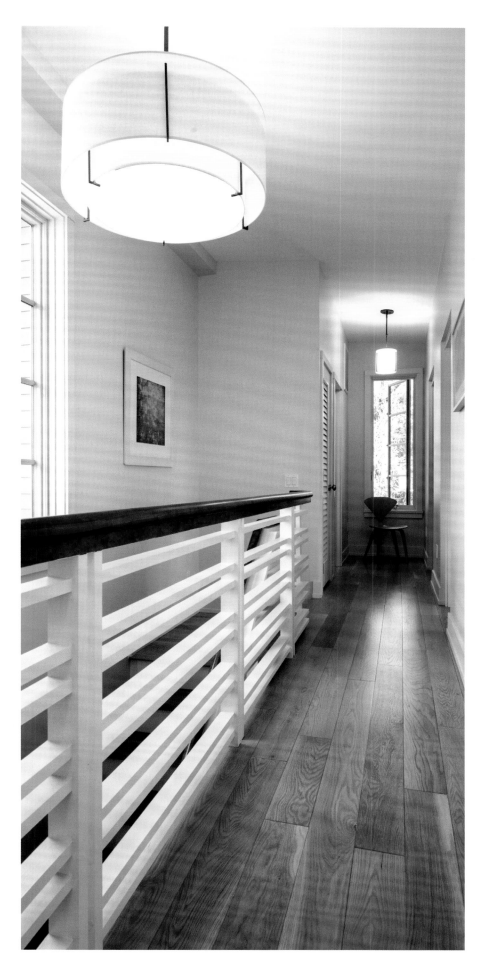

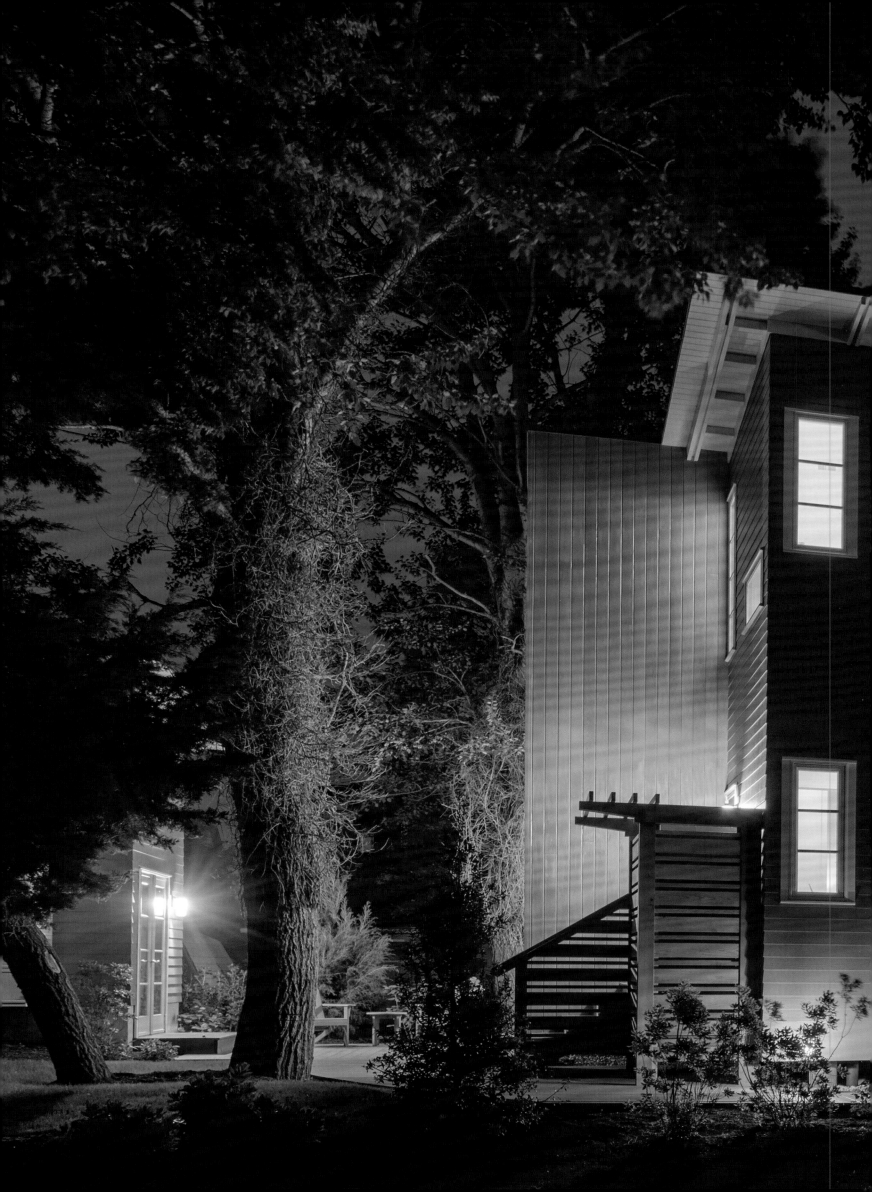

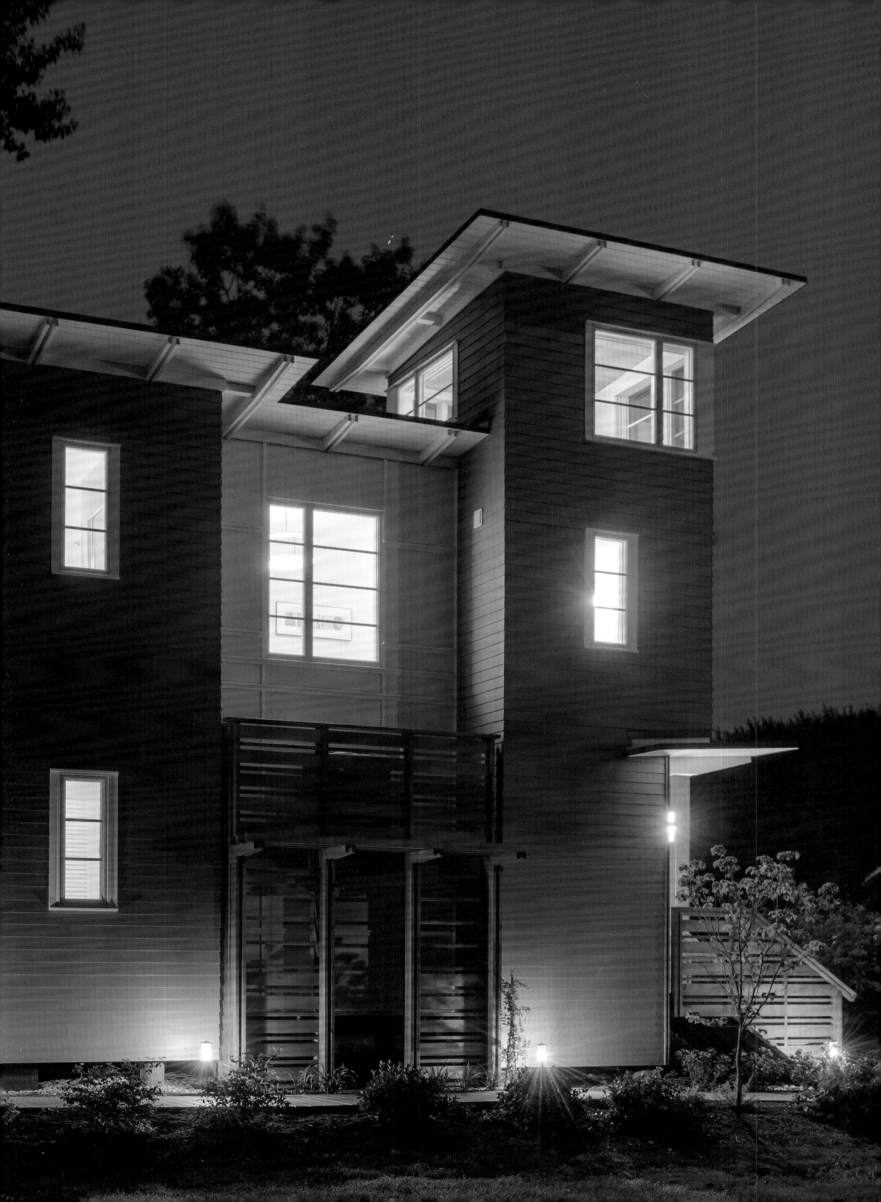

To that end, Barnhart insists on working directly with owners at every step of the design and construction process to ensure continuity of vision and completeness of details. Consequently, he is selective about the projects he undertakes, choosing to design only about one new house a year while supplementing that work with renovations and additions.

"The fact of the matter is, if you're designing something to be highly valued by the initial owners as well as subsequent generations, it takes time. It's one thing to design the basic structure of a home, but it's another to tune it so that it really resonates."

For Barnhart, this involves a desire to pare down to what's important while finding what he calls 'poetic openness.' Often the houses he designs are modest in size, usually under 3,000 square feet, but engage a larger sense of place by using abundant and varied natural light and positioning windows and skylights to sculpt views of the sky, a surrounding forest, or nearby lighthouse. Spaces are designed to invite flexibility, serving perhaps one use early in family life but later enabling inhabitants to age-in-place by living entirely on one floor.

"Rather than pursuing any singular metrics-based sustainability methodology for a given project, I will cherry-pick recommended practices from a variety of organizations invested in human wellness, ecological stewardship, and sustainable practices which resonate most strongly with the objectives of an owner and nature of the project. More than anything else, I seek for a project to maintain a long and potent multi-generational service life expectancy. That's always an easy sell."

*Builder/Contractor: M.A.W. Builders*
*Photographer: Bartholomew Studio*

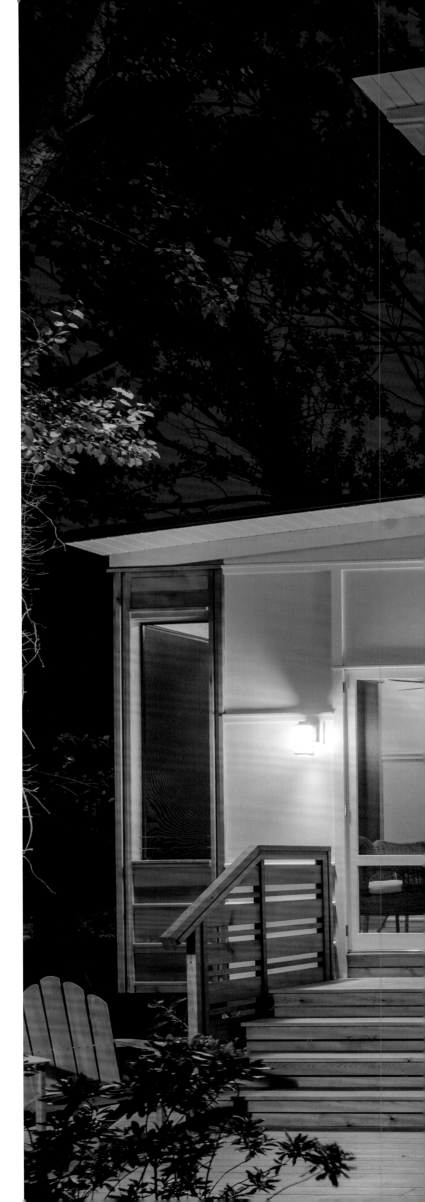

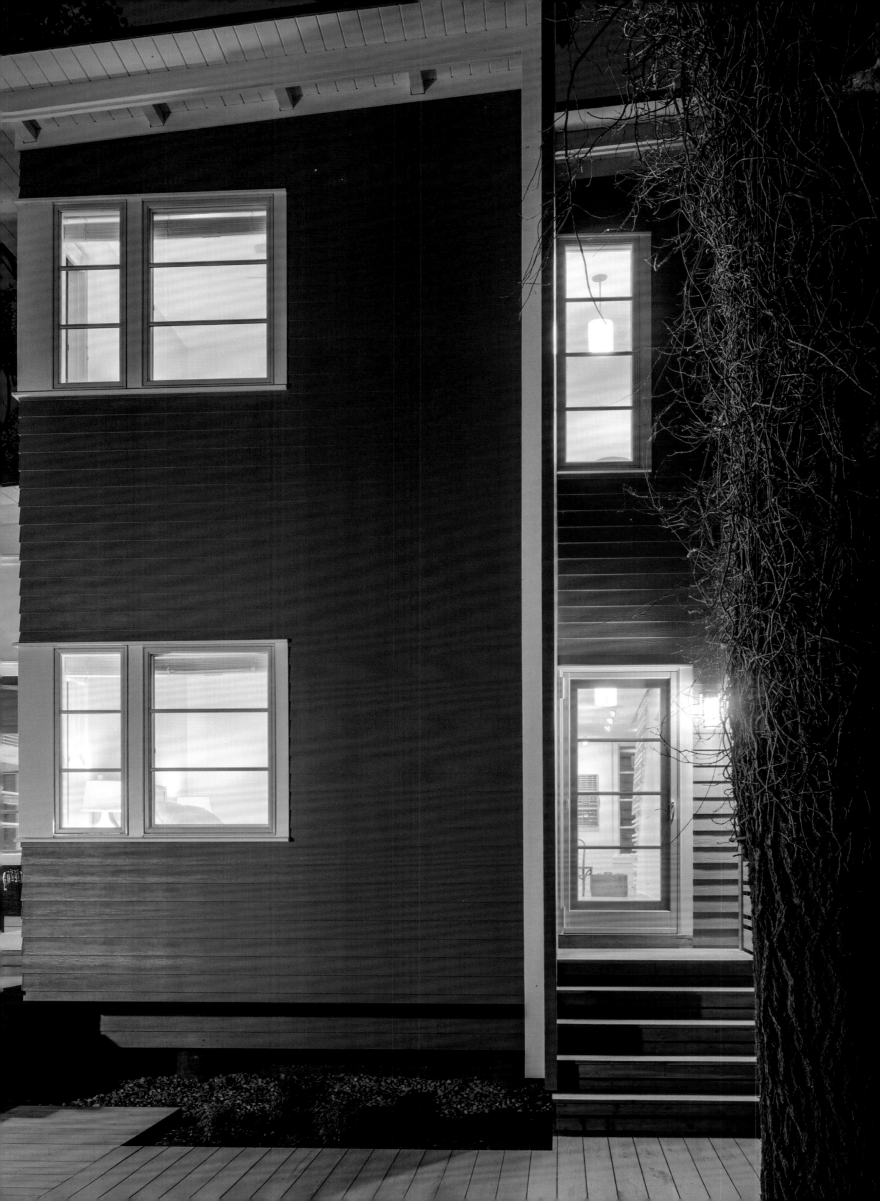

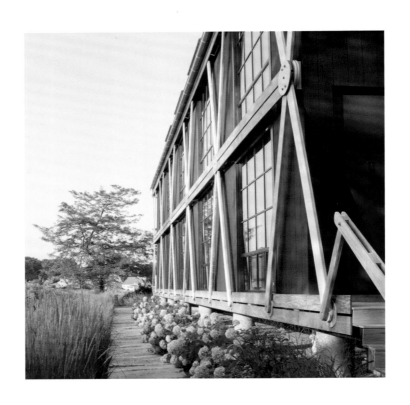

"Our work is inspired
by place, culture, and
history. We are dedicated
to solving architectural
problems innovatively with
environmentally sustainable
solutions that are expressive of
structure and program."

— Bruce Beinfield

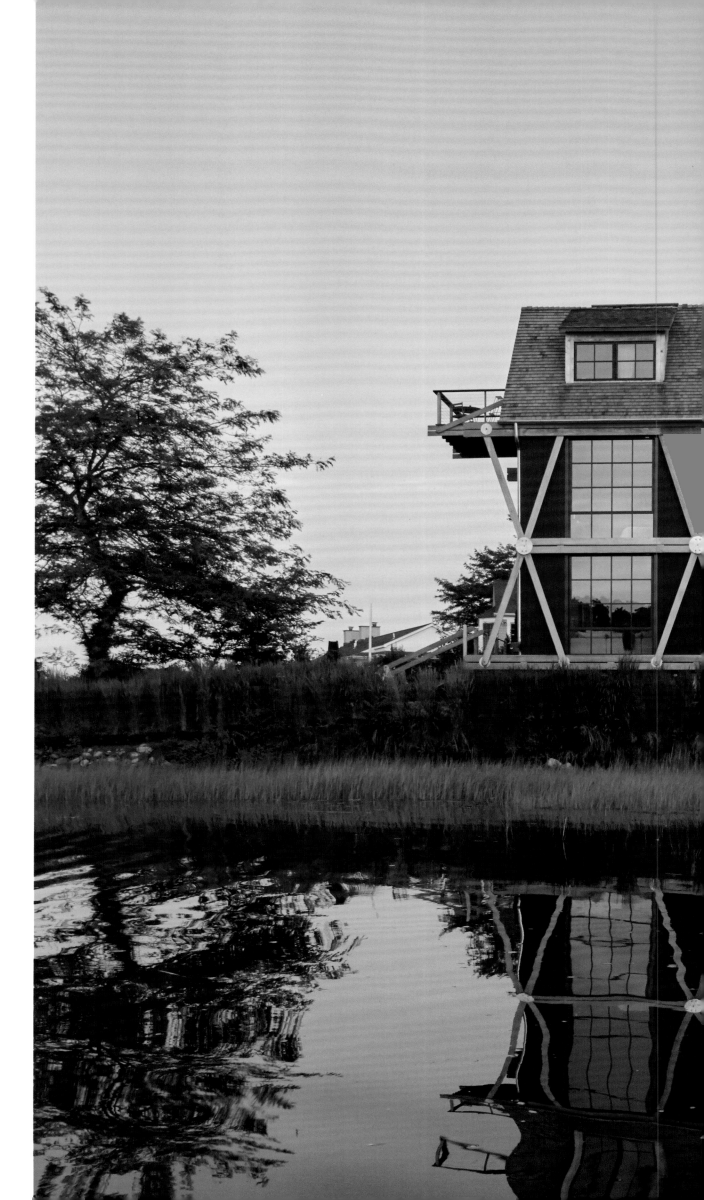

# Bruce Beinfield

## Beinfield Architecture

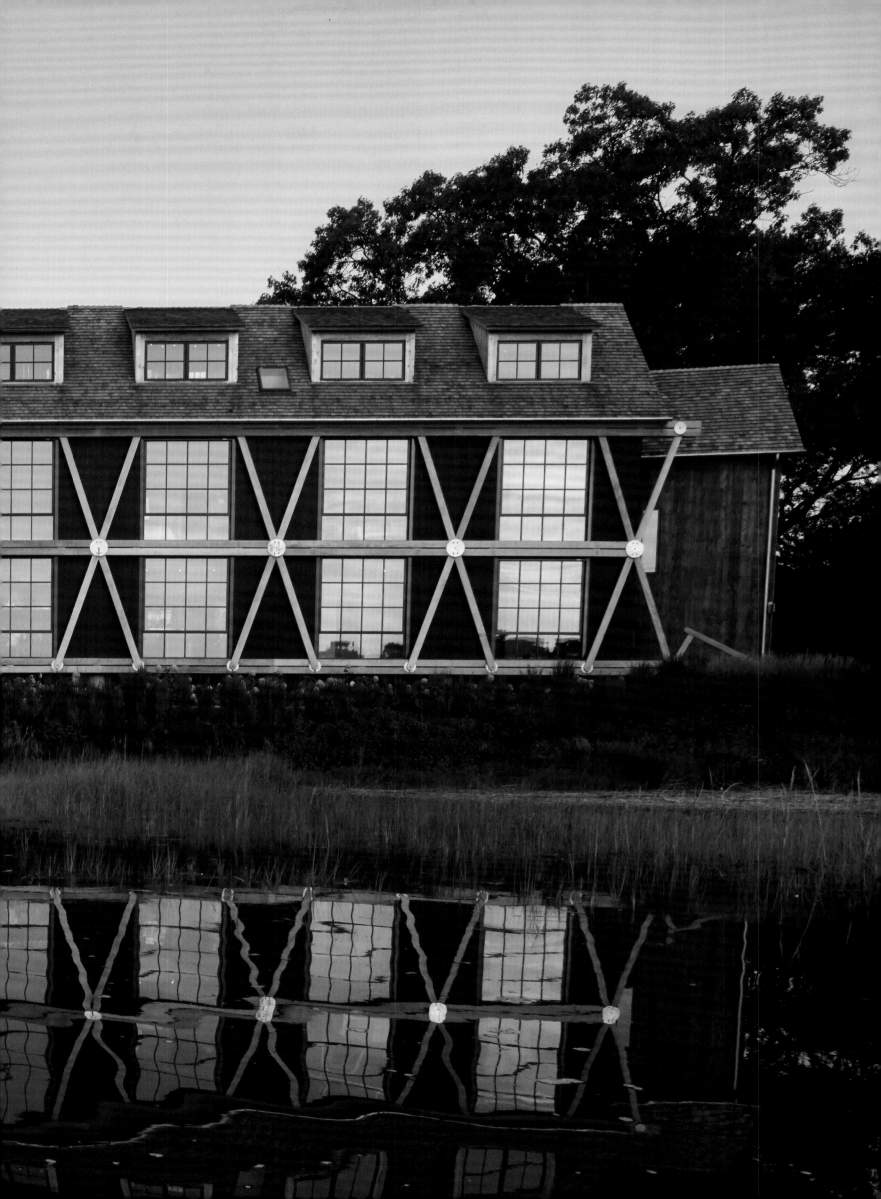

Bruce Beinfield's design is informed by vernacular traditions and the timeless and essential meanings found in the stark, simple, patterned forms of early New England architecture. His firm, started in 1985 in South Norwalk, Connecticut, takes an alchemical approach to architecture, striving to transform the ordinary into the exceptional and employing common materials toward uncommon ends. This objective is evident in Beinfield's diverse and award-winning commercial, retail, restaurant, and residential projects.

"We use historical vernacular forms in search of meaningful symbols, imagery, and experience, and ultimately judge our work based on the feelings it evokes, and its ability to resonate," said Beinfield.

The firm's residential design process is grounded in its ability to gain a full understanding of each client's needs, giving birth to architectural concepts that celebrate the idiosyncratic potential of each project.

"We encourage our clients to share their dreams with us and then carefully tailor the design of a home to their individual lifestyles, daily rituals, and site-specific possibilities," said Beinfield. This process has resulted in over 25 unique, award-winning homes which have been extensively published in leading design journals.

One of Beinfield's more notable homes, the Trolley House, is situated on a 500-foot-long-by-25-foot-wide spit of land extending into the Farm Creek tidal estuary, which was created by fill in 1894 to support trolley tracks to a major amusement park nearby on Long Island Sound. The hurricane of 1938 doomed the historic park with only remnants and faded photographs surviving. Those photos revealed a series of spirited barnlike structures, intertwined with a wooden roller coaster characterized by expressive diagonal bracing. The trolley trestle over the channel shared the same honest expression of 19th-century structural design and craftsmanship.

The house honors that heritage, speaks of resilience and sustainability, and fosters an intimate relationship with the wildlife that inhabits the estuary environment. Structural, mechanical, storage systems and fenestration patterns were used to define the rooms within.

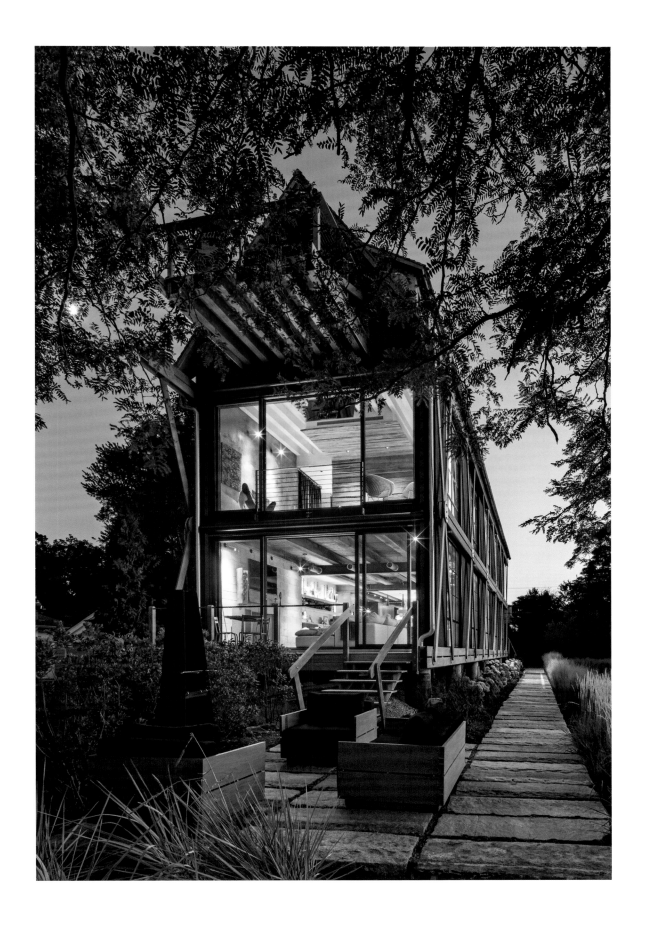

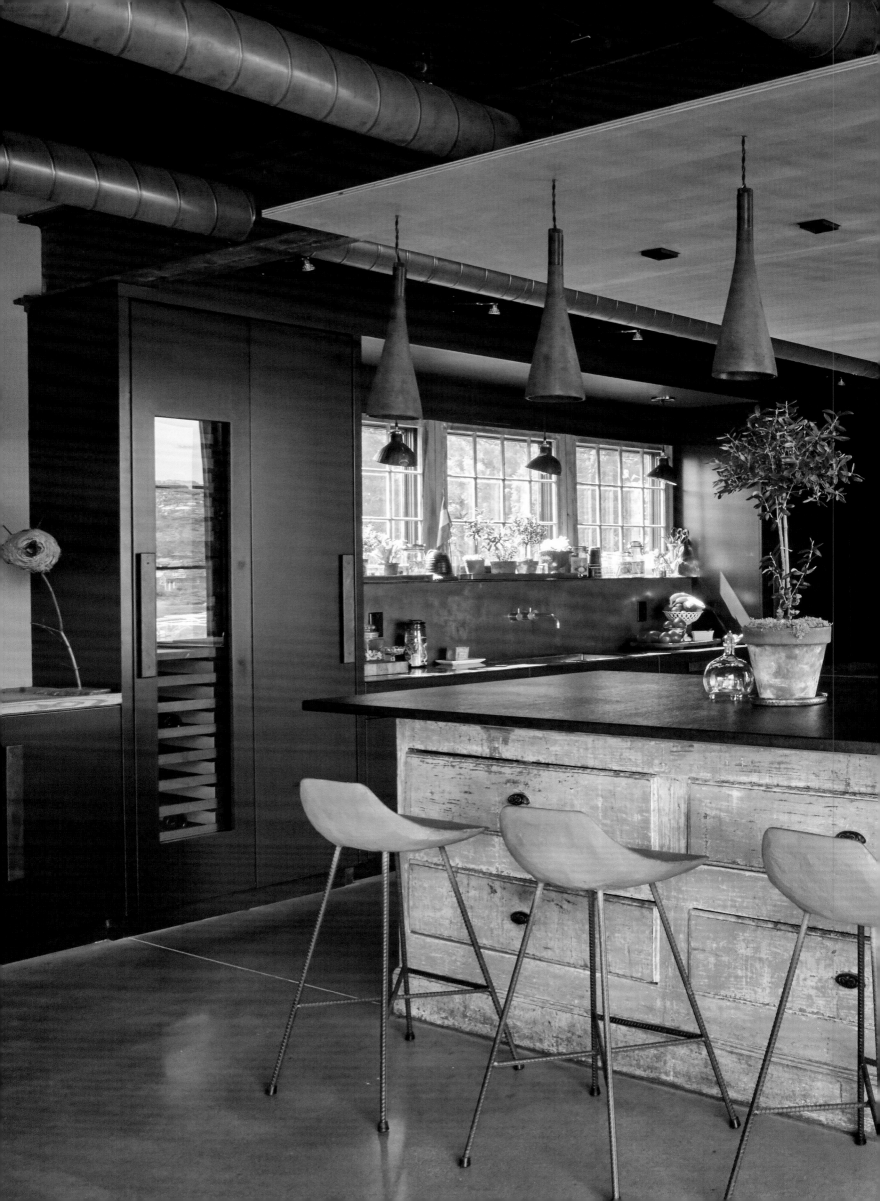

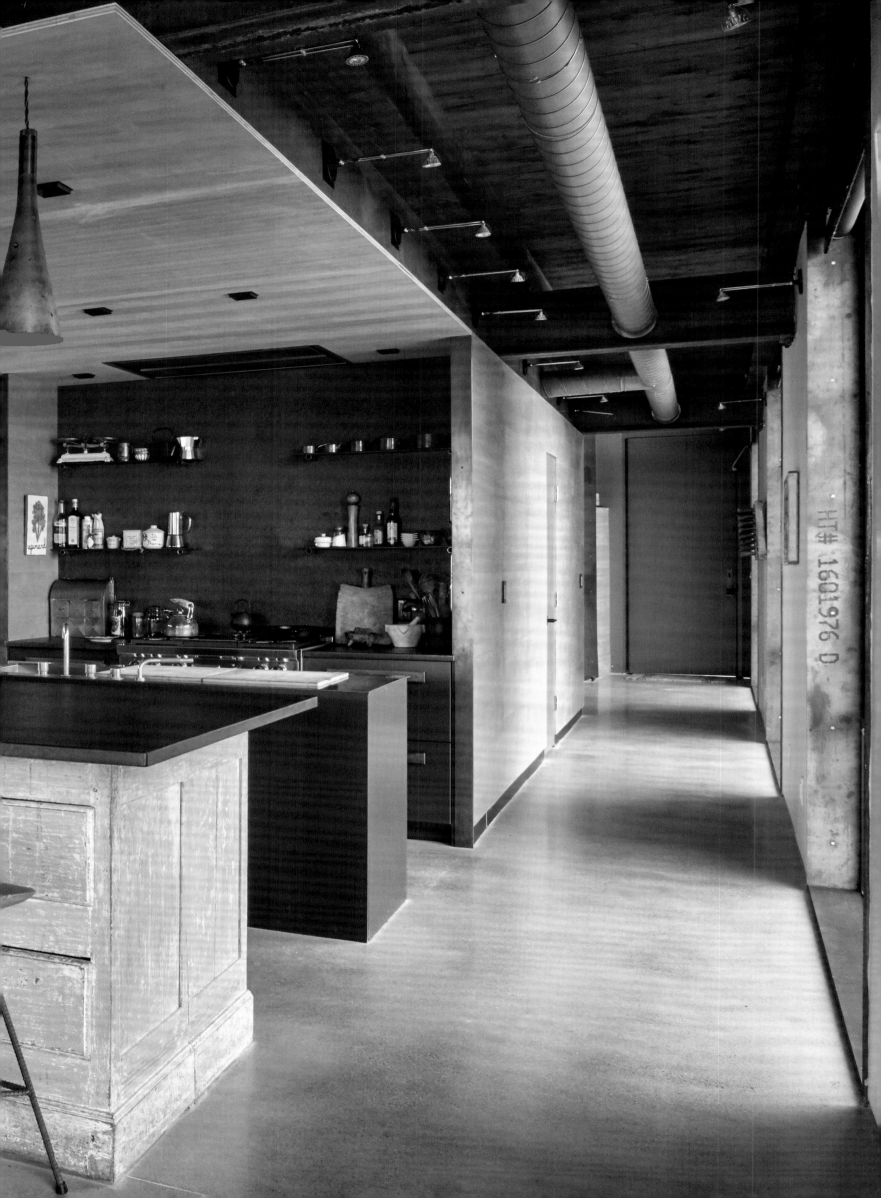

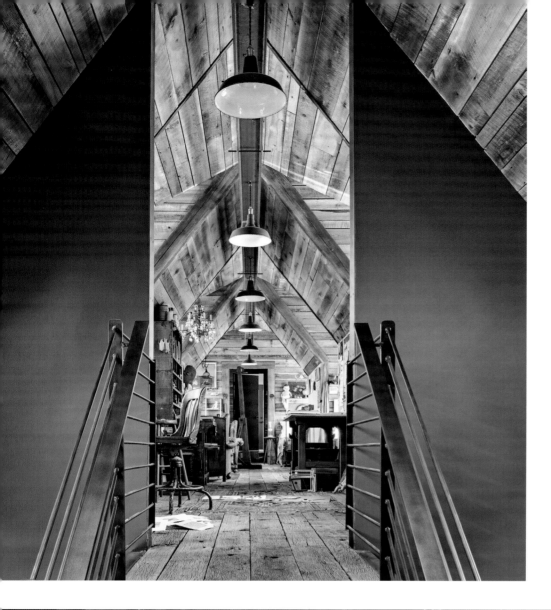

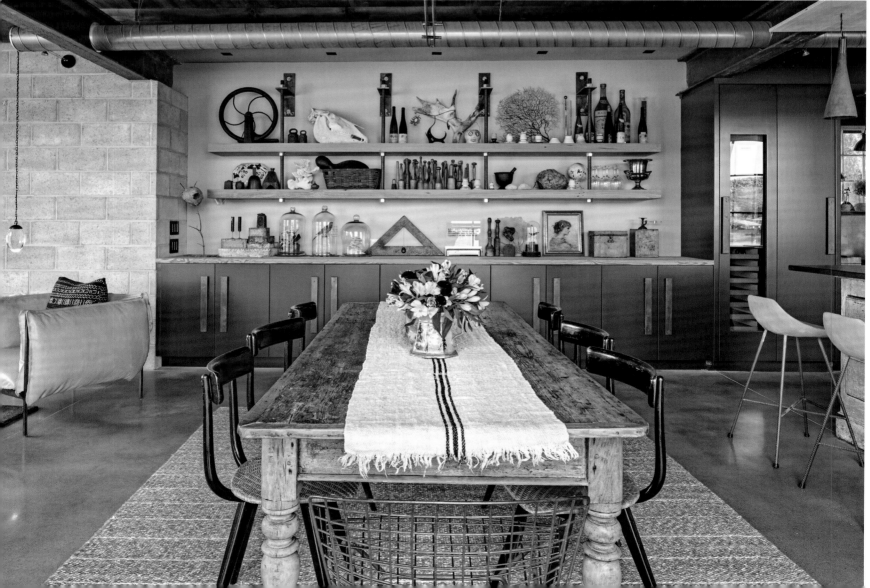

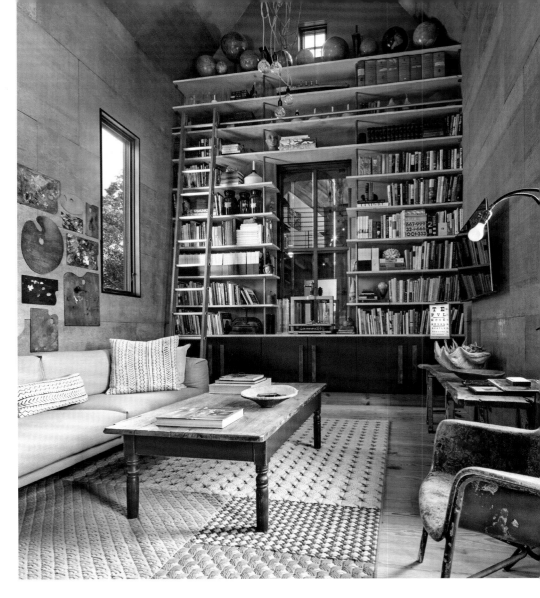
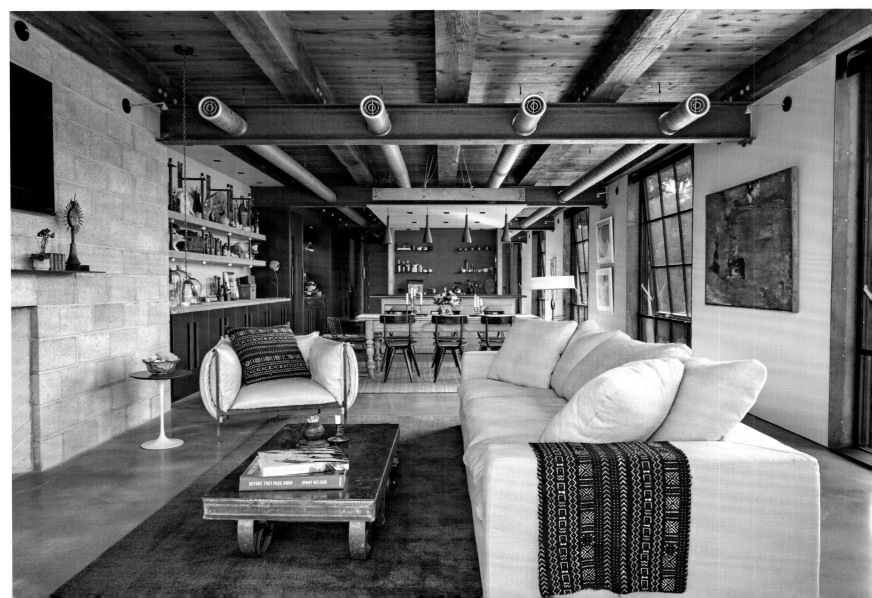

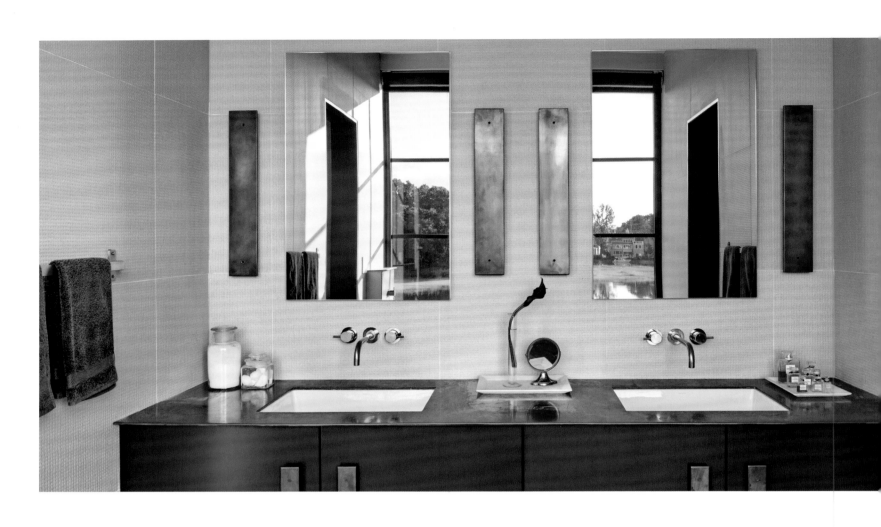

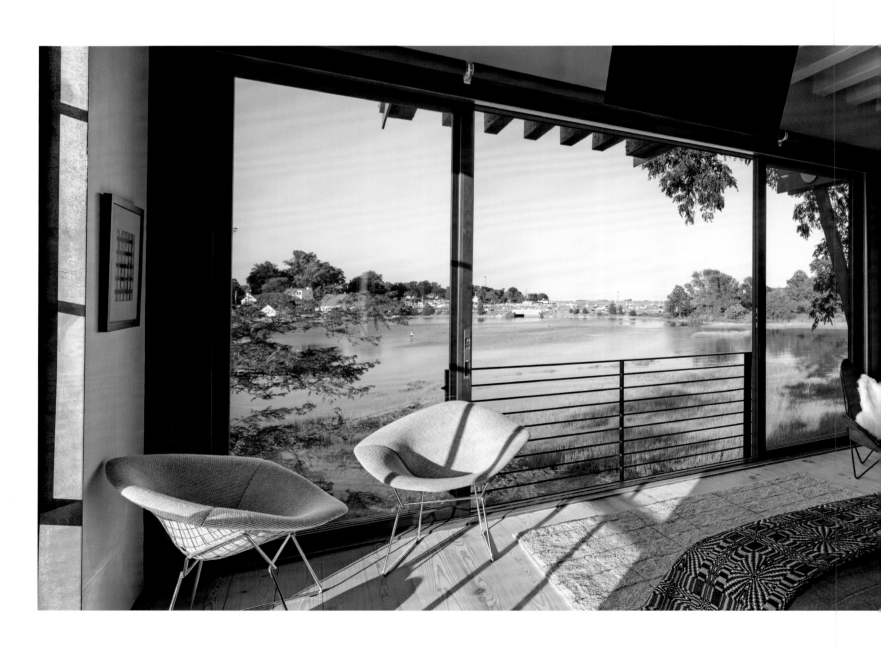

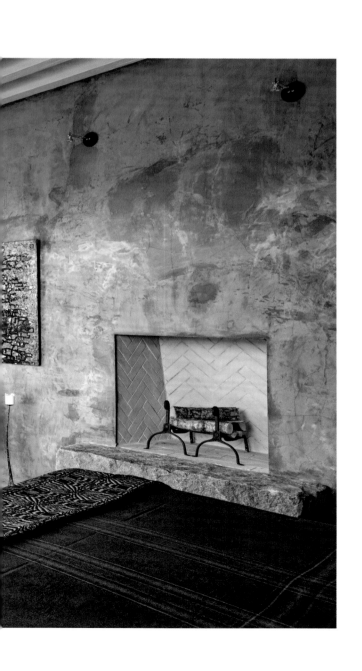

"Client dreams provide the raw material from which each building concept is forged."

— Bruce Beinfield

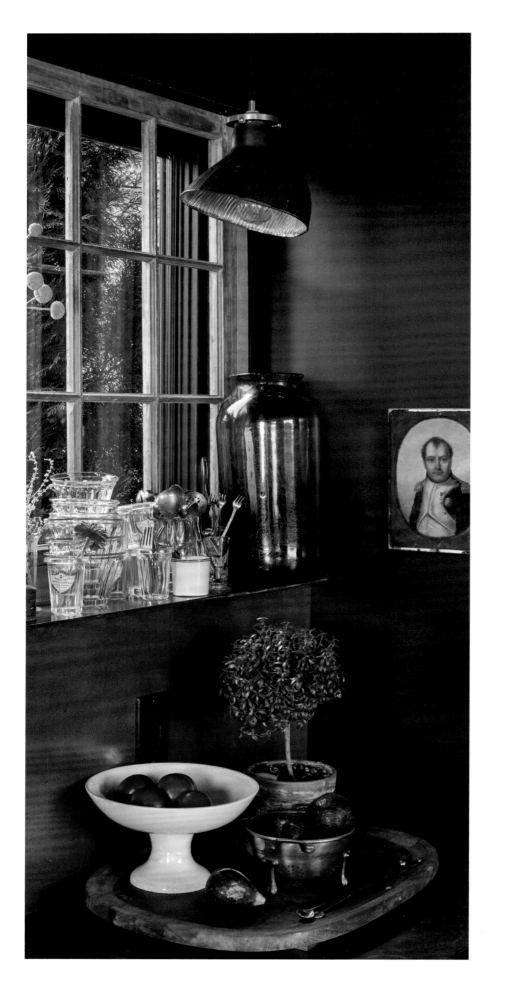
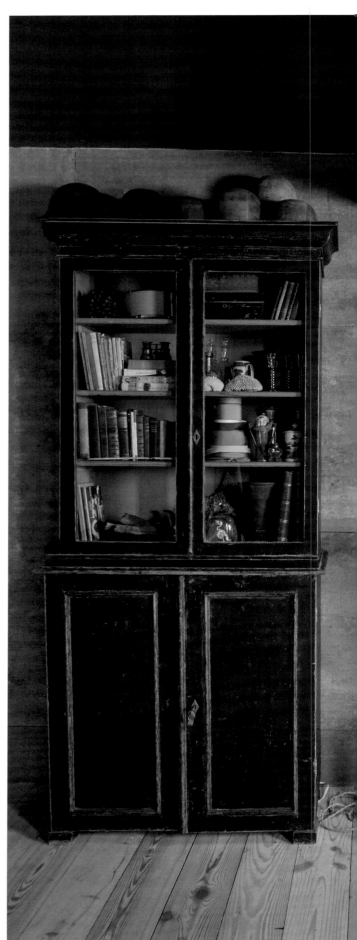

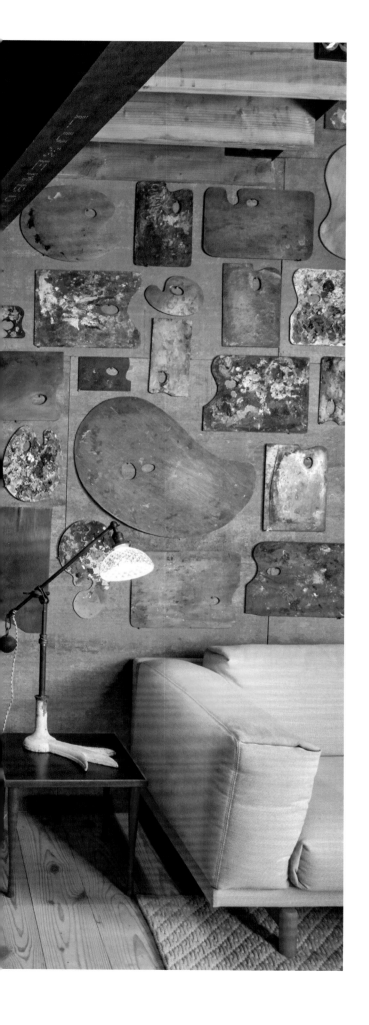
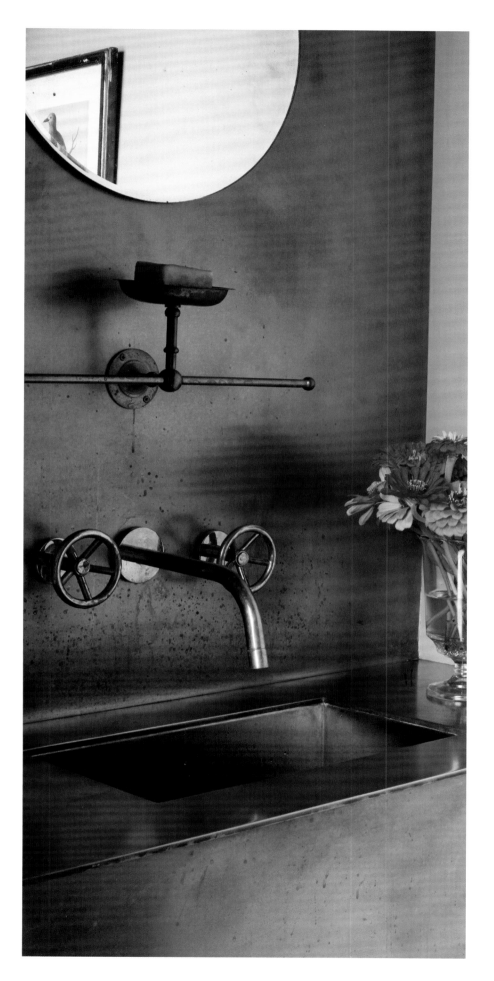

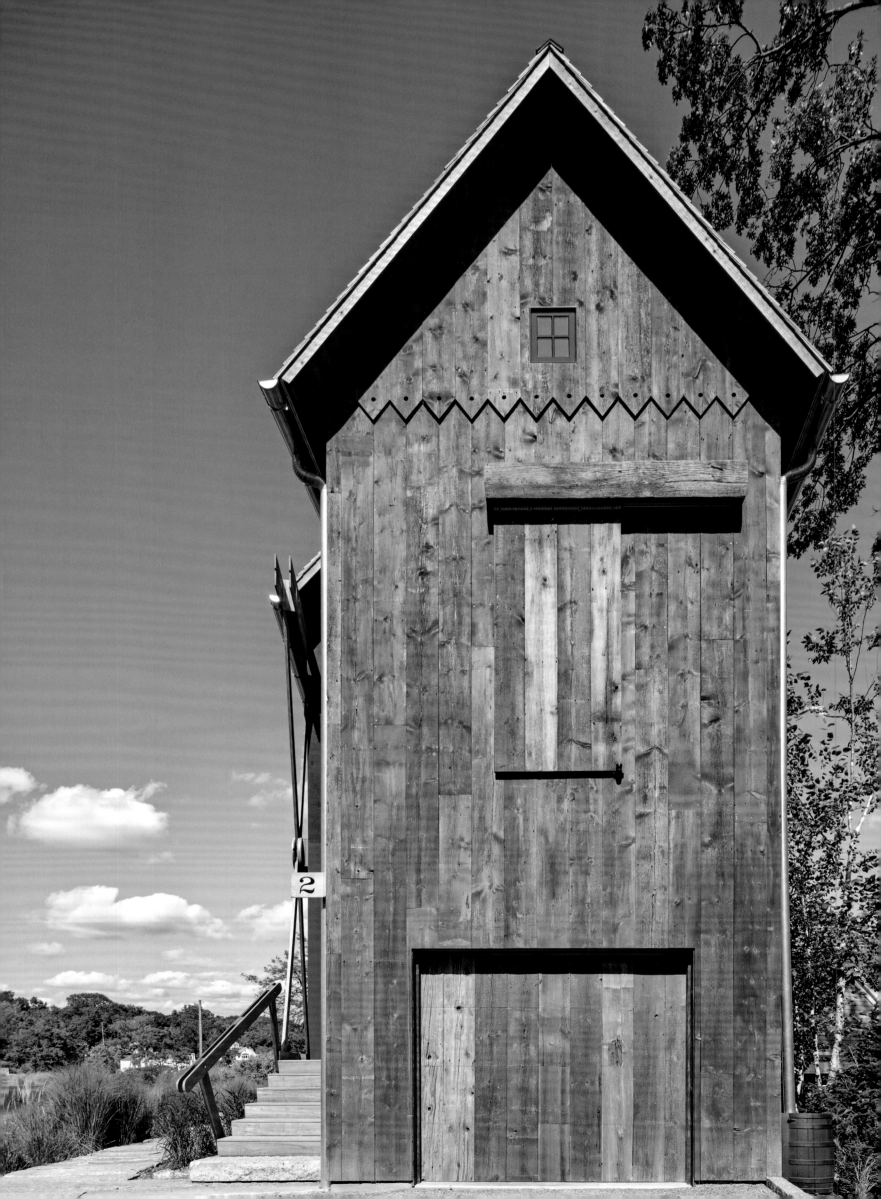

Setbacks yielded a 12.5-foot-wide street façade. The whimsical expression is that of a simple barn, with salvaged siding remembering a past life and intentionally masking the building's age.

The main portion of the house consists of a 16-foot-by-75-foot rectangle that floats above the earth on concrete piers to let flood waters flow beneath. Steel operable glass walls open up to the natural environment. The exoskeleton of lateral bracing shield storm shutters that protect the large operable glazed surfaces from storms and provide additional insulation on winter nights. A concrete floor with radiant piping provides a passive solar heat sink.

Structural bays marked by steel girders separate the interior spaces. Heavy timber beams, raw steel, concrete, and copper surfaces endow the place with industrial strength and organic warmth. Spiral ductwork that penetrates the steel ties the spaces together.

A dynamic tension reflects the sensibilities of both Beinfield and his wife, Carol. He, the architect, imposed a rigorous underlying order as an armature for her, the artist/collector, to layer on the chaos of life. That dialog animates the home.

---

*Interior Design: Carol Beinfield*
*Landscape Architecture: Bruce Benfield*
*Builder/Contractor: Ray & Art*
*Photographers: Robert Benson, Meg Matyia*

"We believe architecture has the ability and responsibility to enliven our collective experience. To bring joy to our lives. This is where we begin, listening acutely to clients, and to what brings them joy."

— Thomas Catalano

Thomas Catalano

Catalano Architects

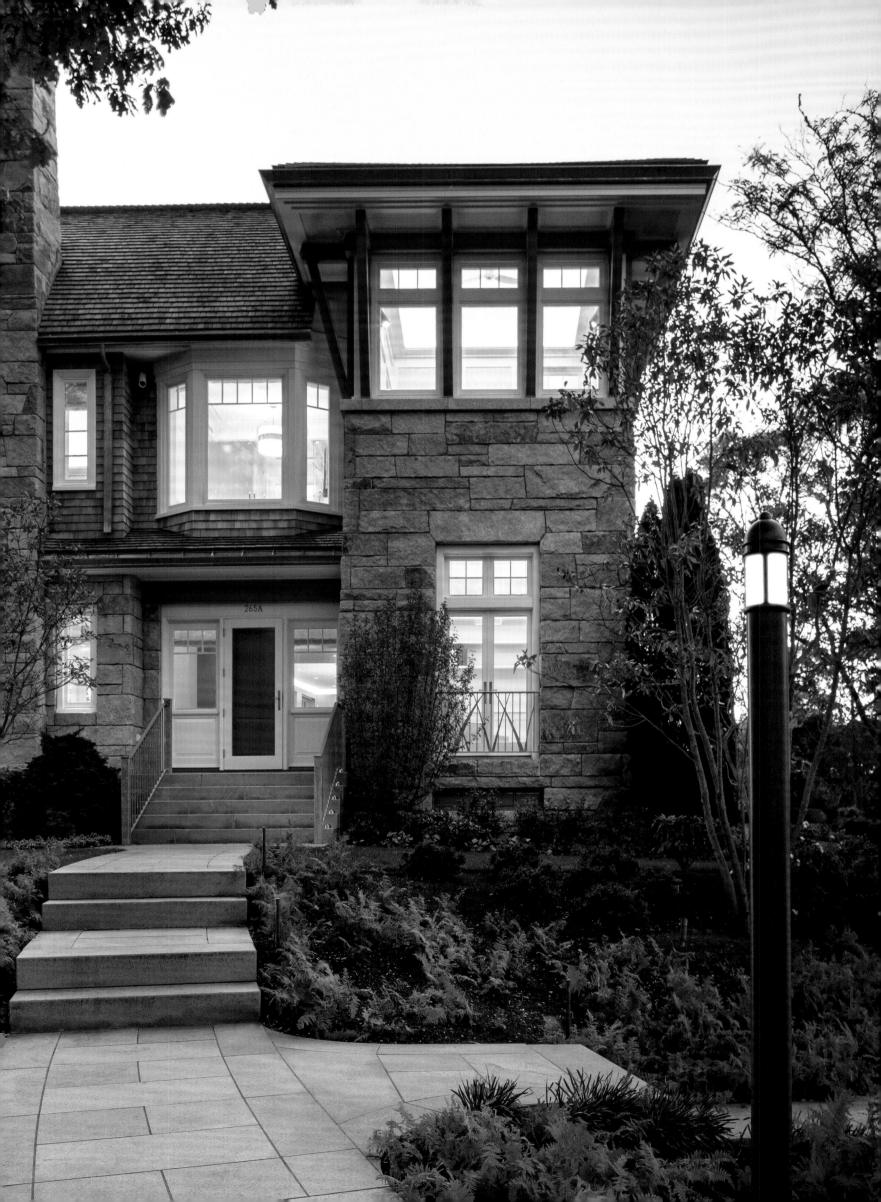

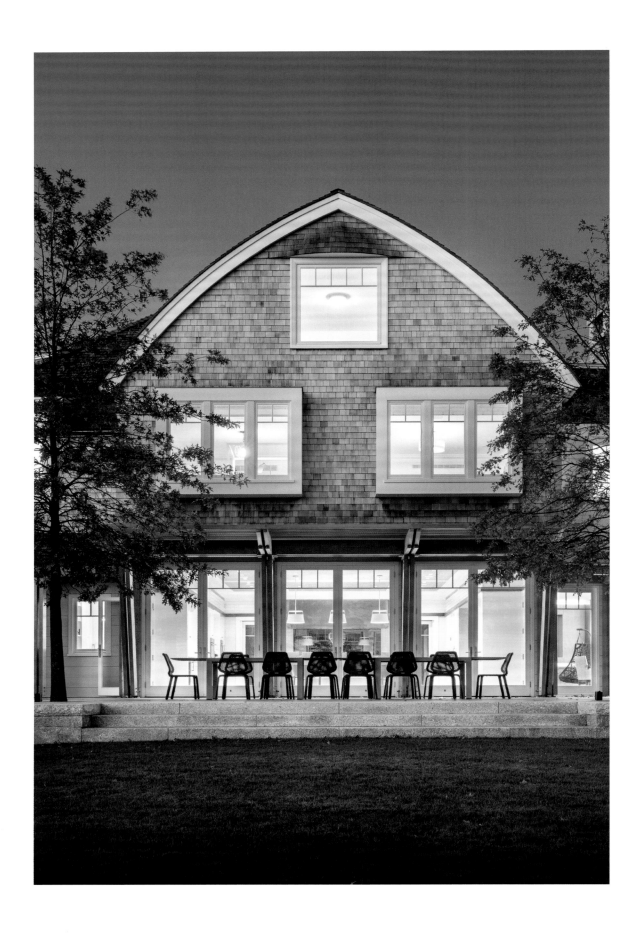

With its rich and storied history, New England has long been noted for its distinctive architecture, which has influenced domestic architectural styles across the country. Tom Catalano grew up in this inspiring environment, and he said the experience opened his eyes to the power of architecture and how it shapes culture and reinforces our social well-being. "Experiencing first-hand examples of great building design fostered my desire to become an architect," said Catalano, owner of the Boston, Massachusetts-based firm Catalano Architects, which he founded in 1987. "In New England in particular, styles run the gamut from early shingled buildings to the boom in modern domestic architecture that evolved after World War II. Our work is influenced by the Yankee shipbuilder as much as it is by Walter Gropius and his contemporaries."

This compelling mix of styles and influences can be seen in the company's expansive but also warm, inviting, and timeless designs. Catalano said that whenever starting a new project, the first thing he and his team do is develop a thorough understanding of the site, and how to best take advantage of the sun and the views while maintaining privacy for clients and abutters.

"We consider the building envelope and design of elements to maximize thermal performance and environmental quality while minimizing air infiltration through the use of controlled systems," Catalano said.

This process is bolstered by establishing a close relationship with the homeowners and listening to their dreams for the property and how they envision living in the space. "We believe in a collaborative process built on creativity and communication that leads to enduring design — perfectly suited for the way each client lives," said Catalano. "We listen intently to what makes each client's lifestyle unique to thoughtfully achieve their design aspirations."

Catalano's design process was put to the test recently when his firm designed a multi-building residence in Cape Cod. The homeowners are based in San Francisco and have family on the East Coast, so they wanted to create a gathering place where multiple generations could get together and enjoy quintessential Cape Cod summer activities, from playing in the water to enjoying meals outside. The owners also needed privacy and space, including areas to work from home.

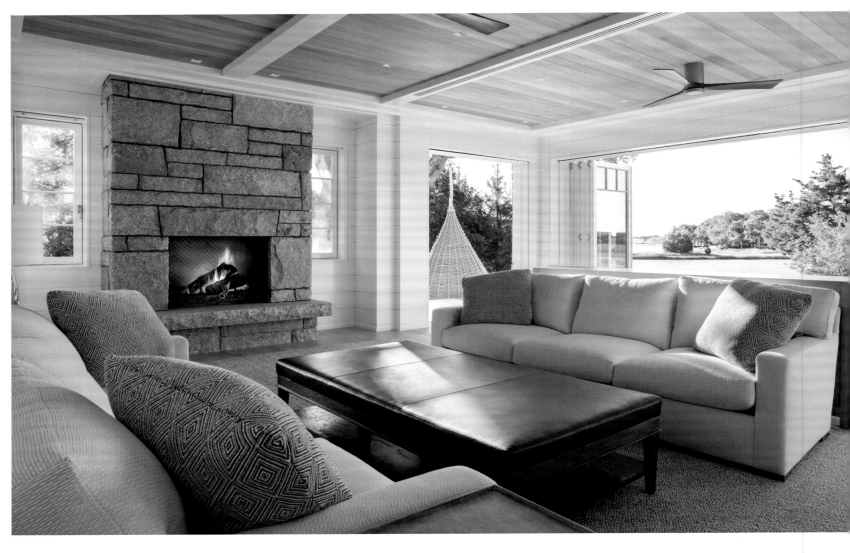

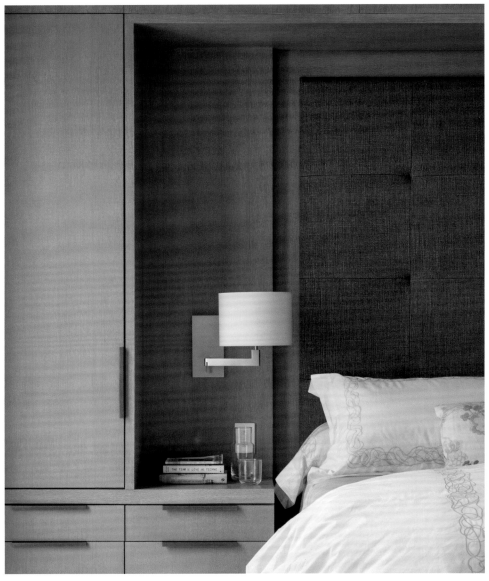

"We have persistently honed our craft. An understanding of historic architecture and domestic architectural precedents fuels and informs our design process — allowing us to discover and define the details that lead to timeless, remarkable design."

— Tom Catalano

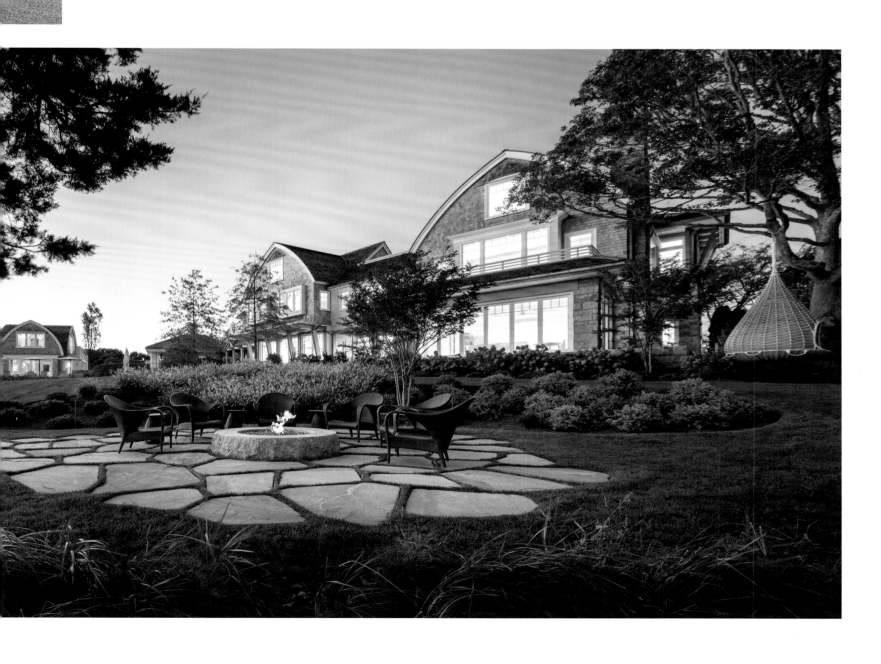

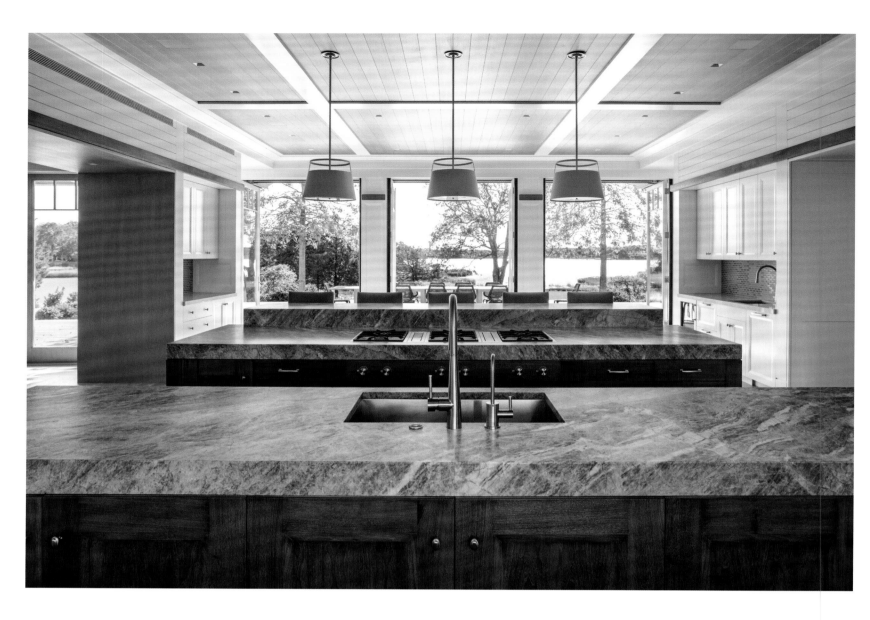

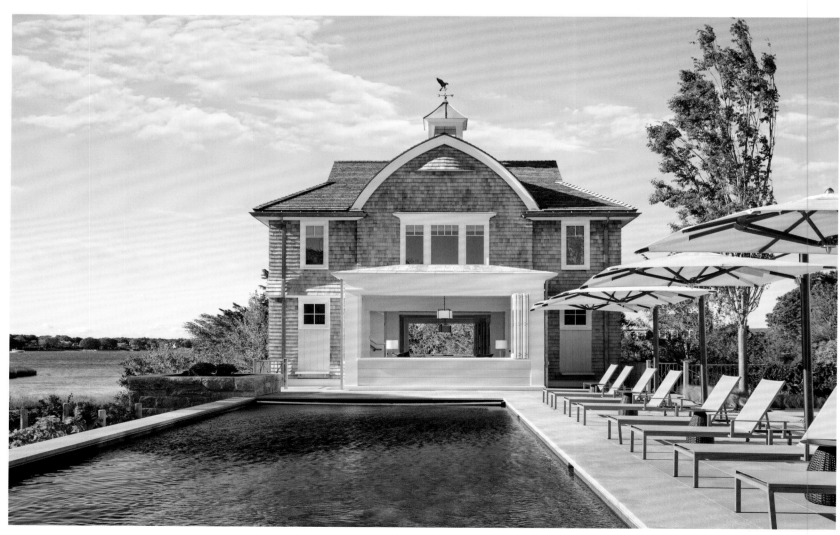

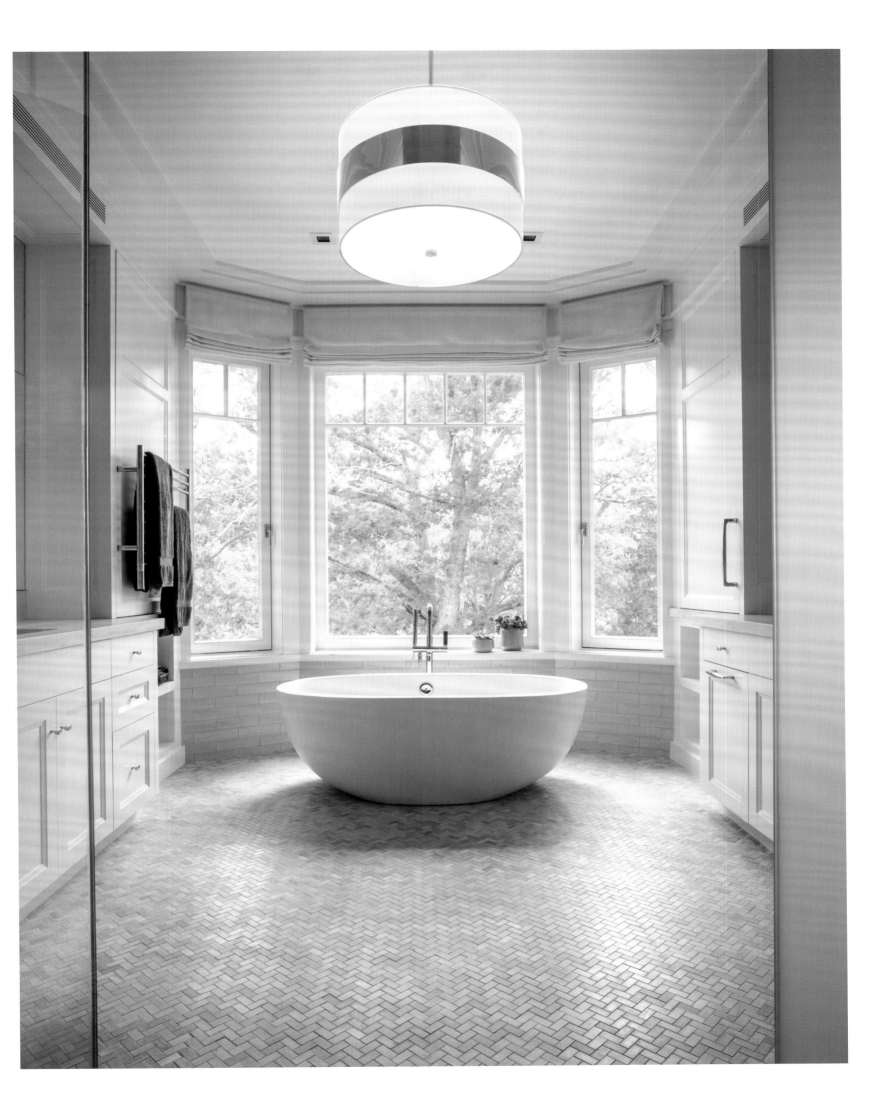

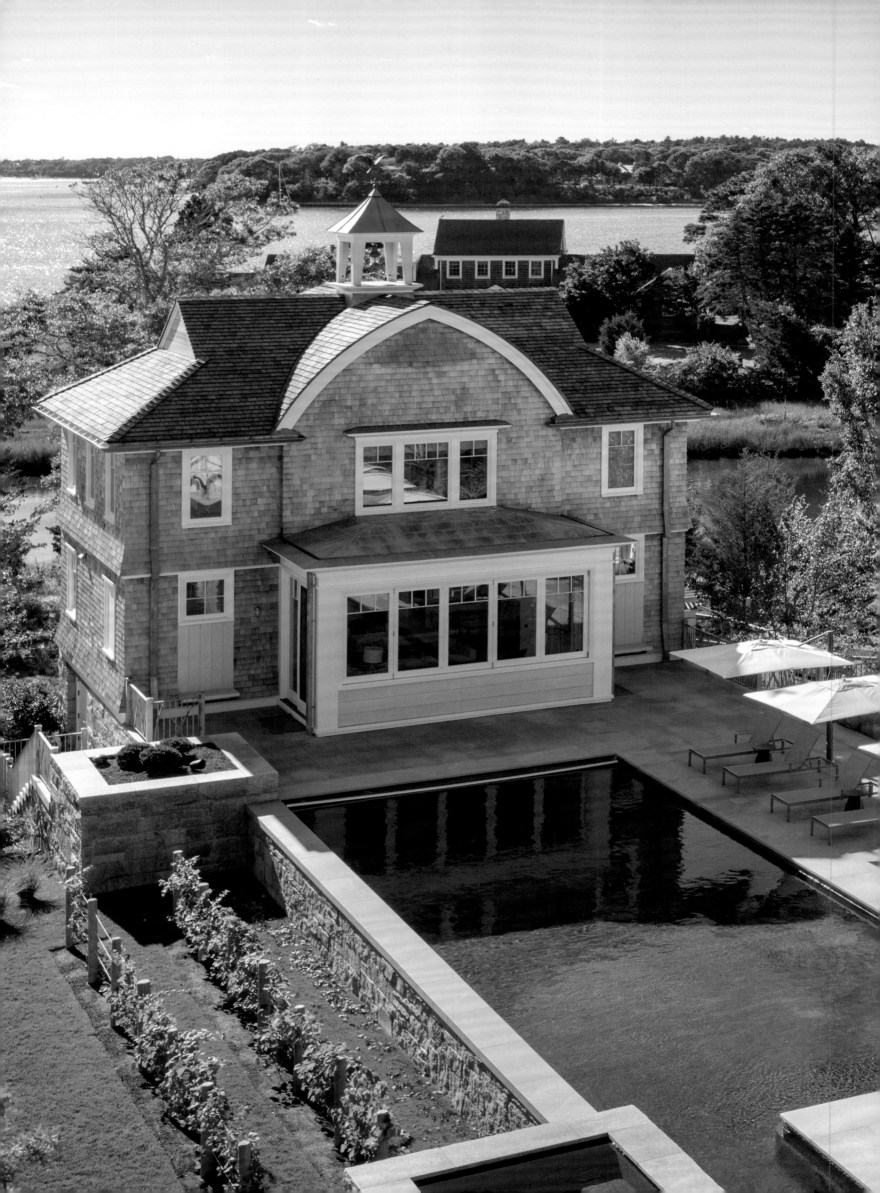

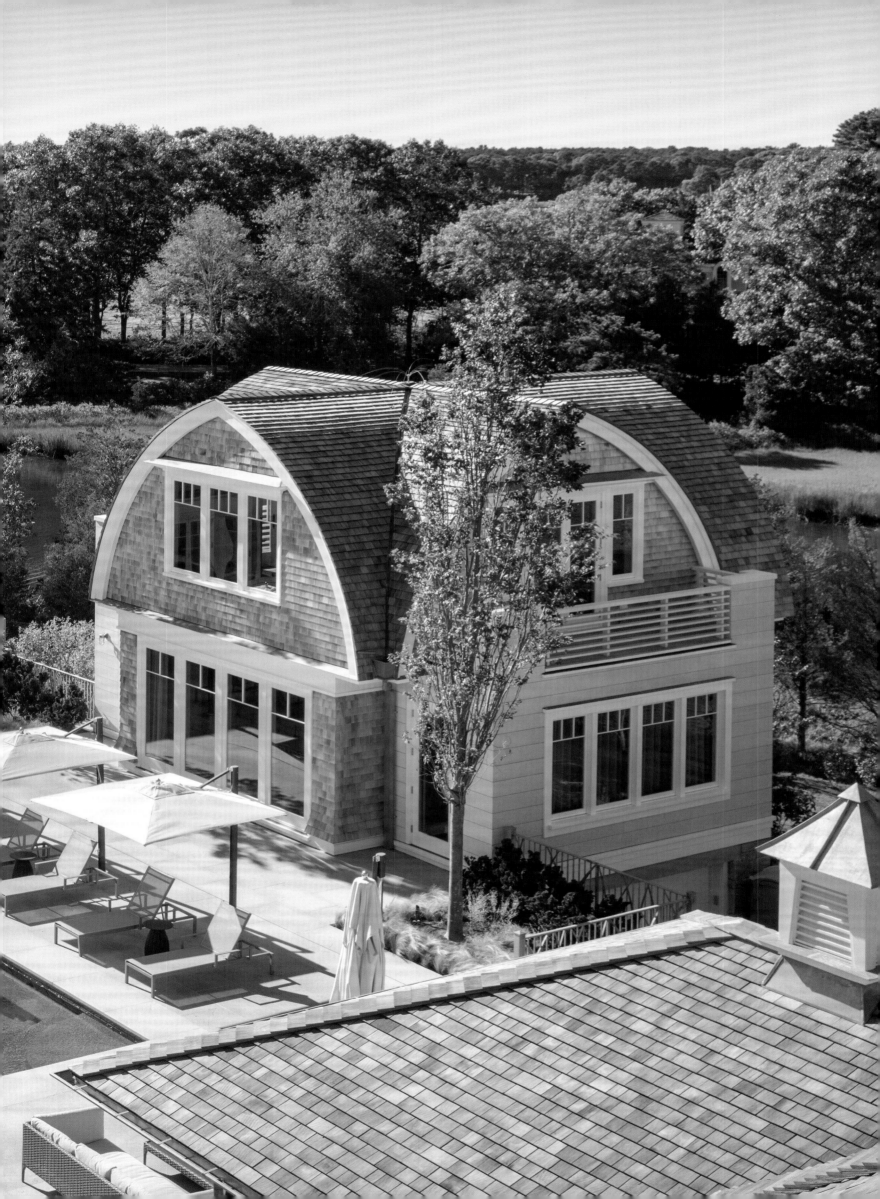

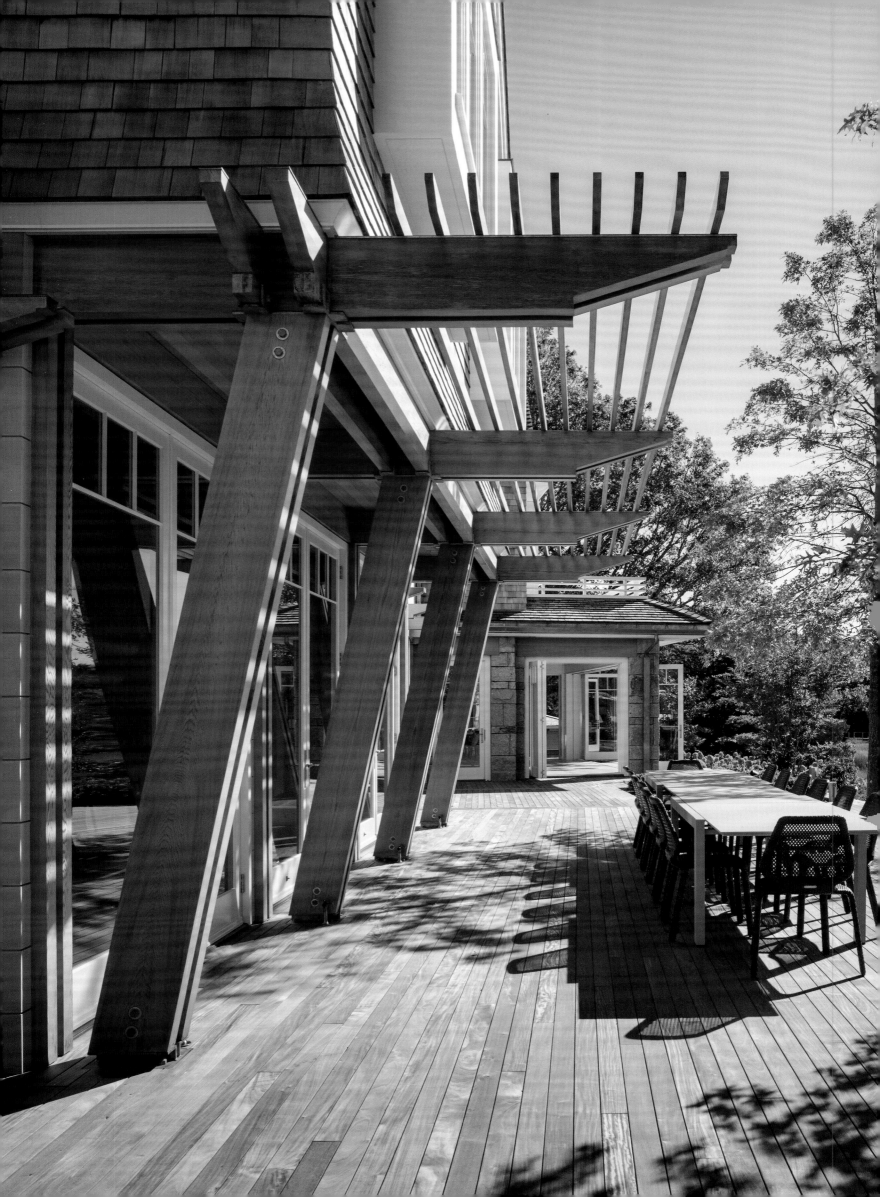

"The needs of their multi-generational family inspired the campus-like organization of the site and buildings," Catalano said.

But before construction could begin, substantial work was needed to prepare the site, which used to be a low-lying island that was partially filled in the mid-20th century from an existing structure. As sea levels continued to rise, the oceanfront property flooded frequently.

"The first challenge for the client was to build resiliency into the site, as he and his wife plan on passing the house down to their children," Catalano said.

To help protect and secure the property as well as raise it by several feet, Catalano Architects worked with a civil engineer and environmental consultant to develop a rock revetment wall along the shore of the property. The team also did mitigation planting with native plants that resist saltwater incursion and offer habitat to local fauna while also removing invasive species and augmenting an existing grove of wild cedar trees.

"It all helped to ensure the site was resilient to rising sea levels, flooding, and other environmental threats," Catalano said.

The project's primary residence was situated to take advantage of the site's breathtaking views. Other buildings were designed to respect their unique relationship to the primary dwelling, as well as the relationship of each of the buildings to the sun and the outdoor environment created between the buildings.

In the end, the clients got their Cape Cod dream home, and Catalano and his team completed another project that typifies the firm's dedication to craft, high standards, and remarkable design that brings joy to others.

"We are very fortunate to have great clients who share our passion for timeless, sustainable design and who wish to bring something to a family heirloom," Catalano said. "We pride ourselves on being careful listeners who strive for a thorough understanding of how our clients will live in the home that we are designing."

*Interior Design: Manuel De Santaren*
*Landscape Architecture: Hawk Associates*
*Builder/Contractor: KVC Builders*
*Photographer: Trent Bell*

"The design process can be very subjective. We find that the best way to get an idea across is through imagery. Images are a visual short-hand in zeroing in quickly on what resonates and excites our clients."

— Anne Decker

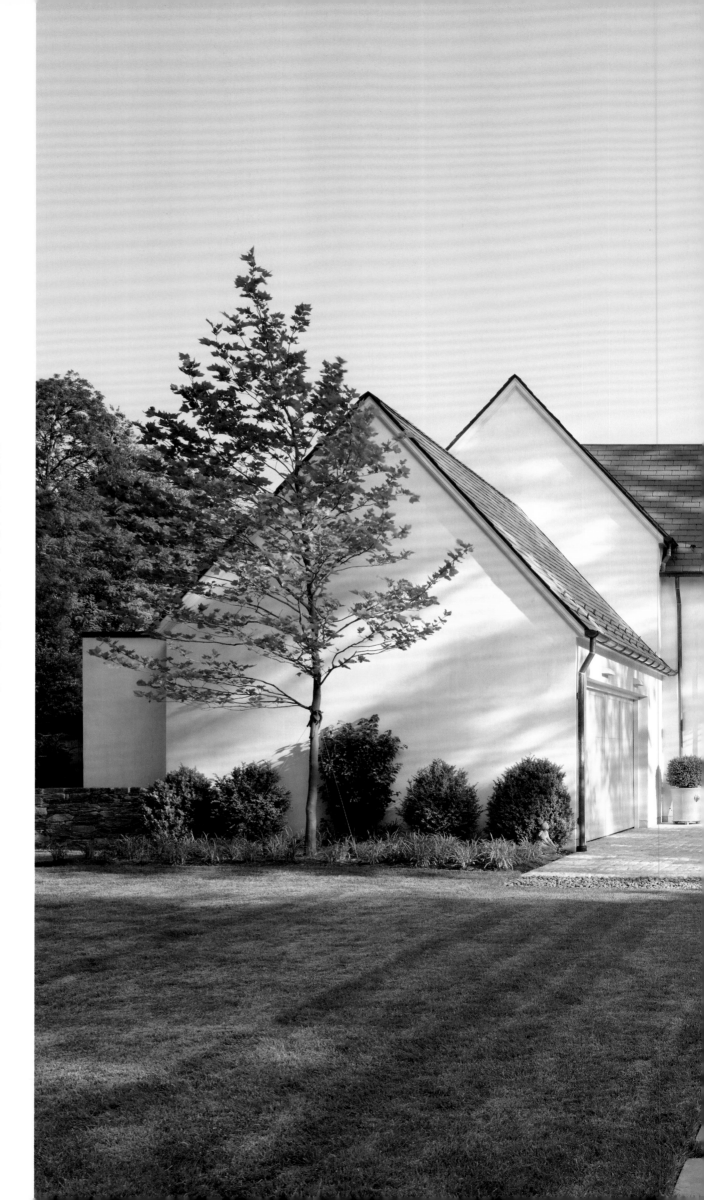

Anne Decker

Anne Decker Architects

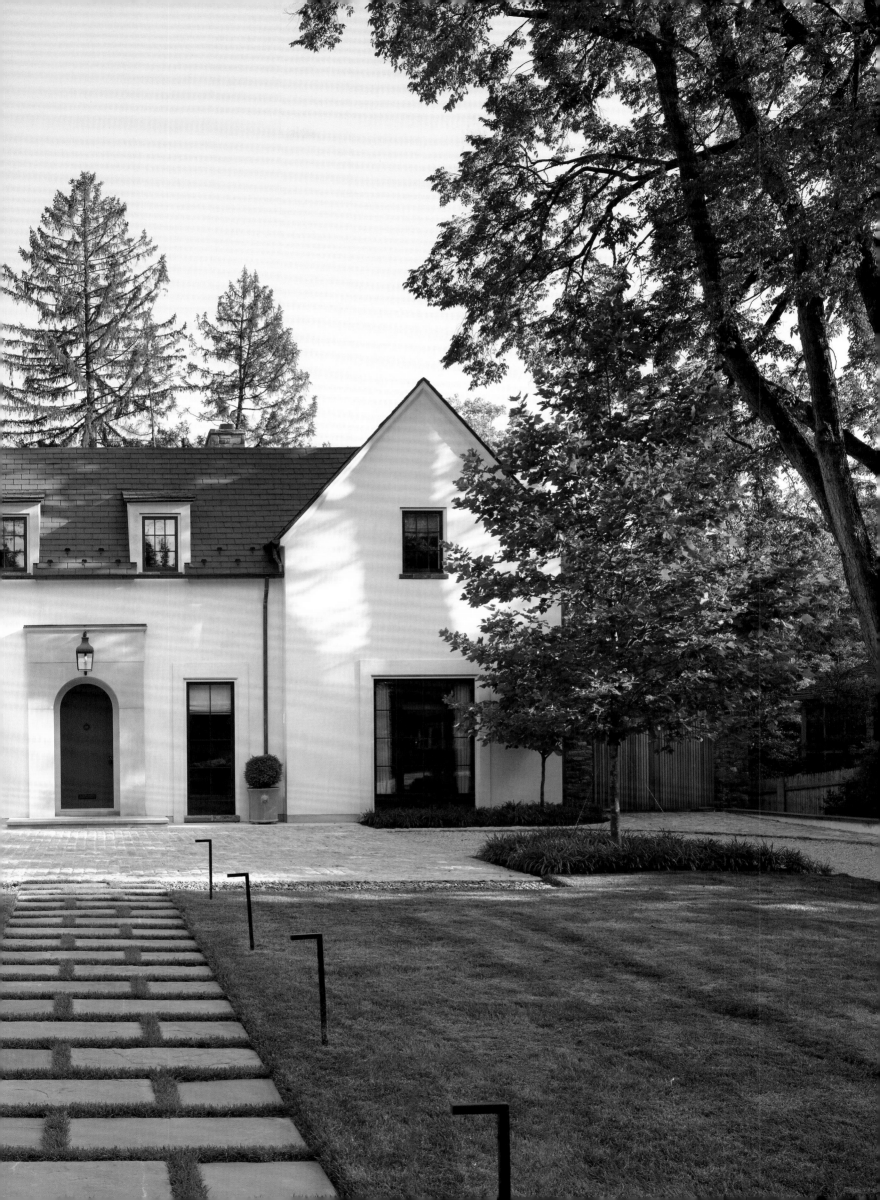

As a child, Anne Decker would spend hours drawing, oftentimes with her mother sitting beside her and encouraging her to take in every nuanced detail, from the shadow-play of a tree trunk to the feather patterns of a bird. Ultimately, these experiences inspired her to be an architect.

"I developed, from an early age, an appreciation for the physical world, its beauty, textural quality, and all its intricacies," she said. "I loved capturing the world around me and enjoyed working on our family homes and seeing the possibilities."

This ability to "see" and to distill environmental and aesthetic considerations into finely crafted, meaningful architecture has served her well at Anne Decker Architects, a Bethesda, Maryland-based firm she founded in 2009. With more than 25 years of experience, she serves as the firm's principal architect and owner.

Decker and her team have designed many award-winning homes, noted for their sensitivity to scale and attention to detail, all of which help enrich and inform a sense of place while also ensuring that each home represents the owner's unique vision.

"I believe in clarity and simplicity of form, the precision of details, and the beauty and tactile quality of materials," she said. "It's through light, color, composition, and rhythm that a house truly sings. And it's through the juxtaposition of opposites: big to little, solid to void, shiny to dull, balance and counterbalance, that you appreciate one for the other, creating a tension that feels right.

With a fine arts background, Decker describes her aesthetic as "distilled, understated, and tactile," and says that by removing what is unnecessary, a house becomes all about proportion, texture, and light.

Inspired by such noted architects as Louis Kahn, Tadao Ando, and Peter Zumthor, Decker is drawn to pure, simple, humble forms: architectural archetypes, basic geometric shapes, and the harmony and simplicity they convey.

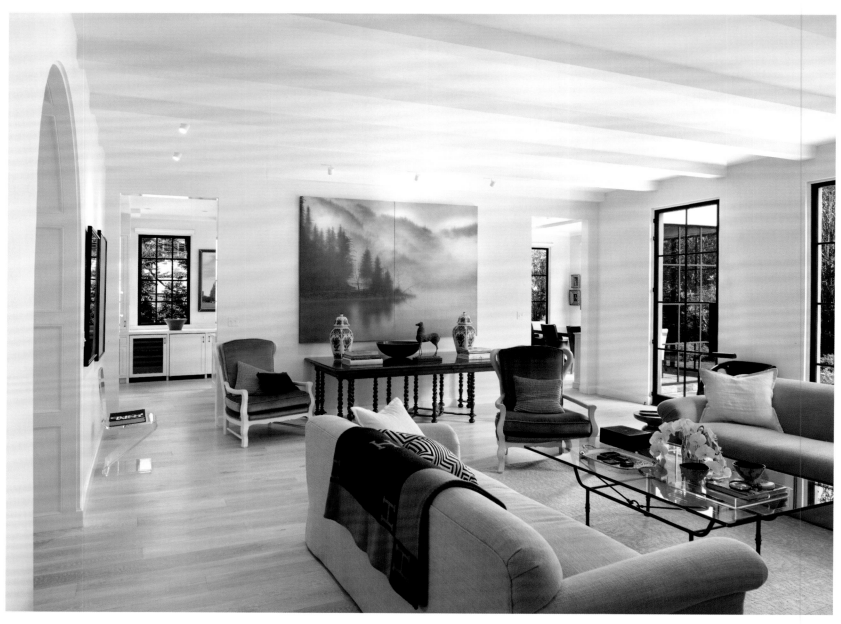

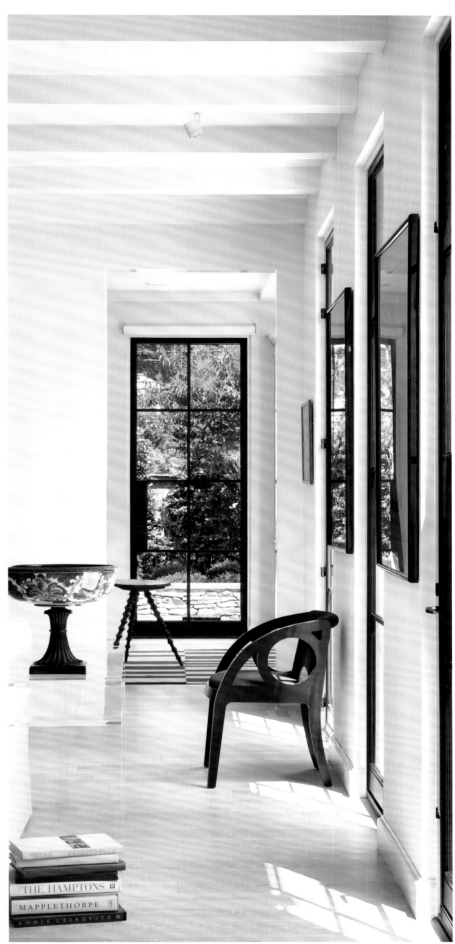

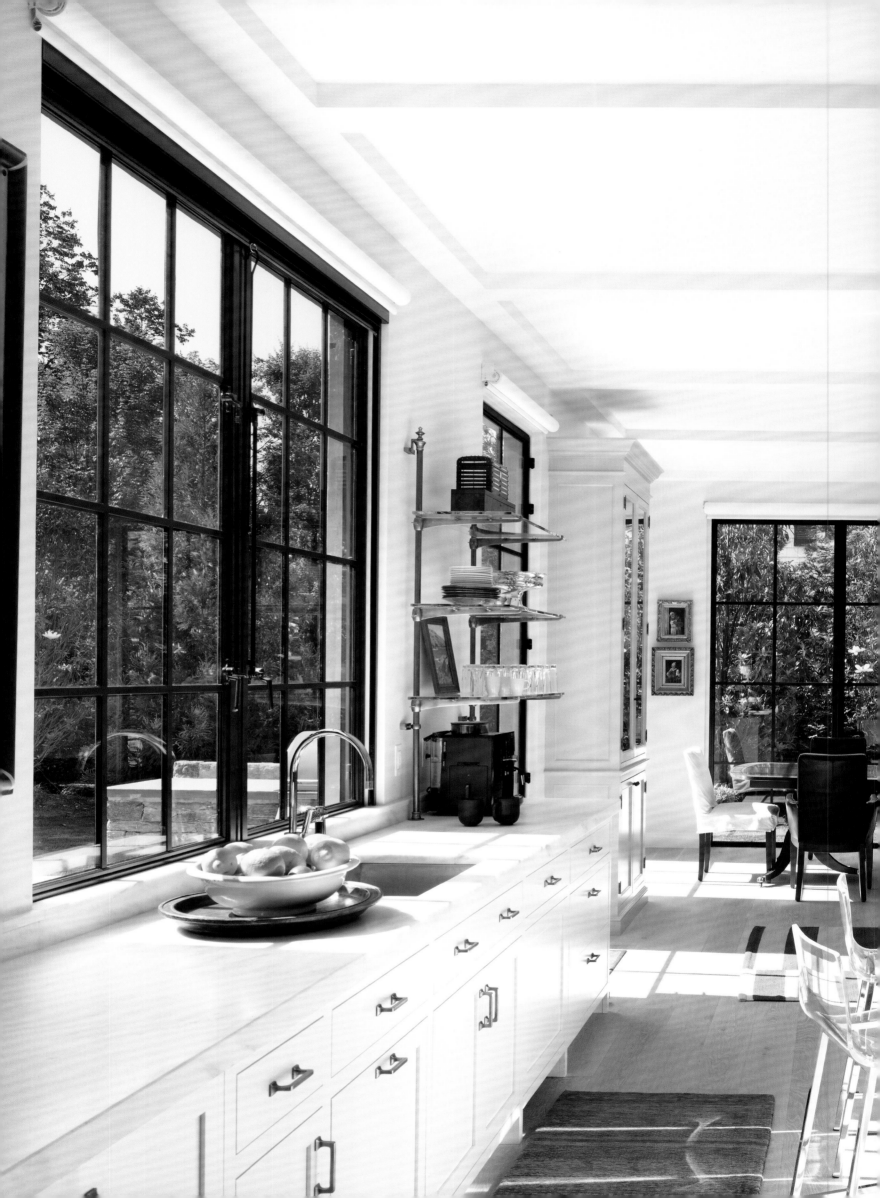

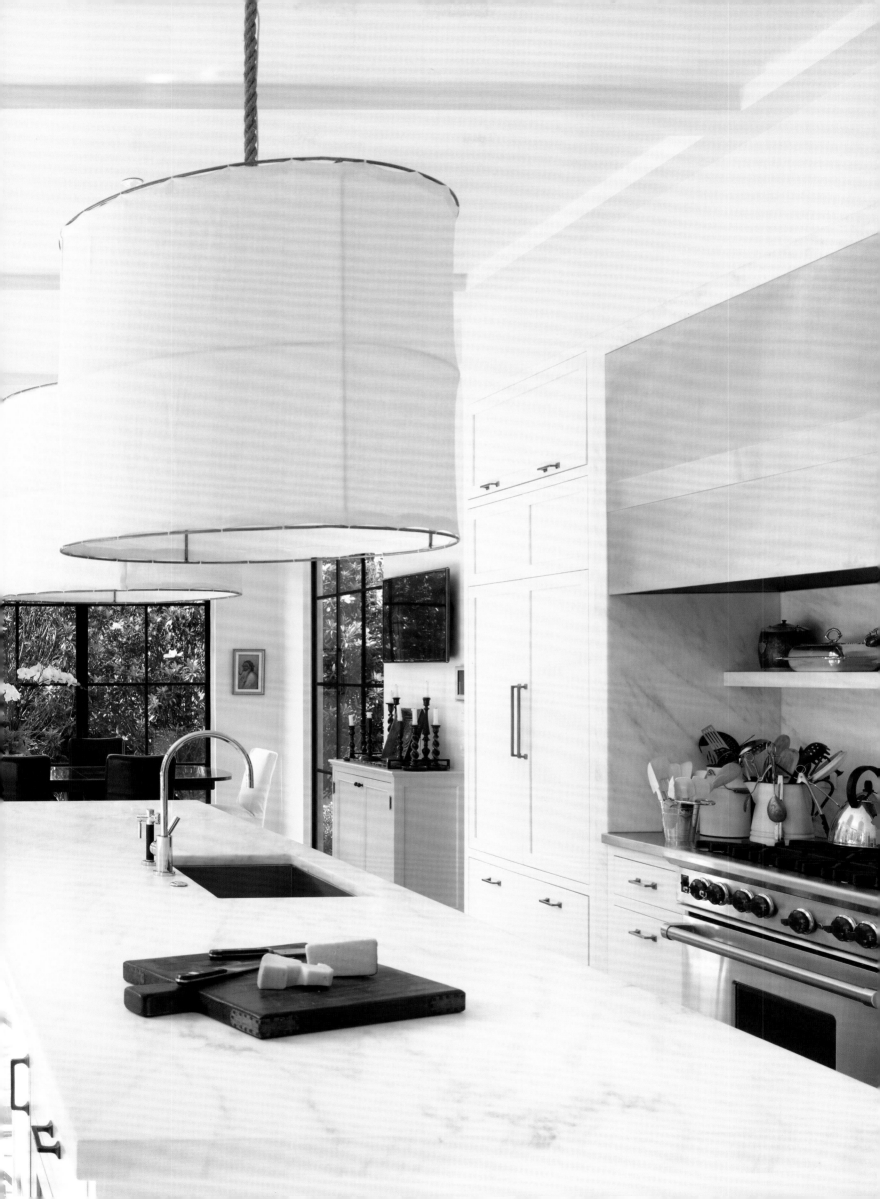

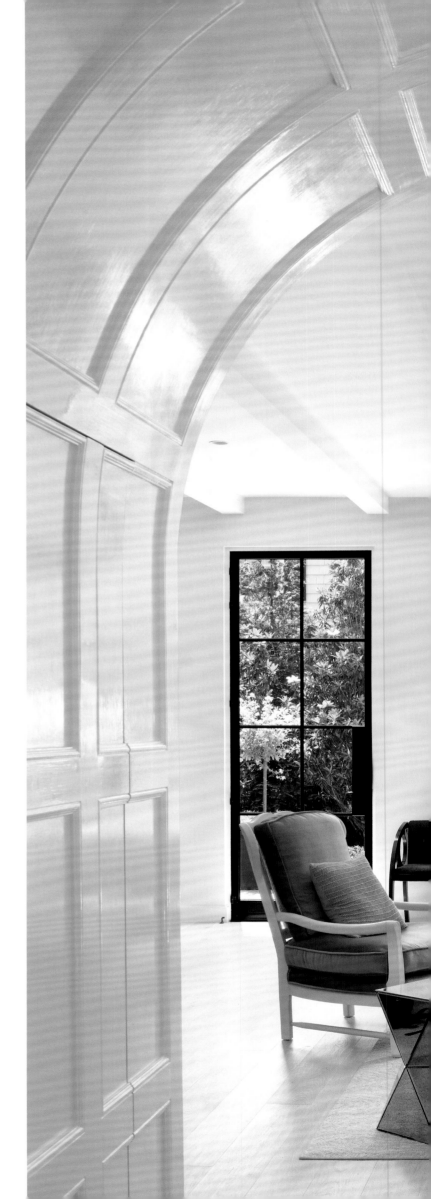

"We strive to create buildings that are timeless, yet not bound by historical reference. We place importance on natural, ecologically sensitive materials that weather and age well."

— Anne Decker

"At the same time, I like a bit of tension, a slight disorder in the harmony — both order and breaking the order — and the interjection of a bit of whimsy" she said.

She's also inspired by the search for compelling imagery through art, nature, and travel. "Travel pulls me out of the every day, creates room for the new and space to appreciate the beauty of the world around me — it is a jolt of inspiration to help see through fresh eyes."

While these sources of inspiration help inform Decker's work, so does her connection with clients. Whenever starting a new project, she aspires to establish a strong relationship with a sense of excitement and trust, and in the process find out what the client's unique needs and values are for their home.

"We believe that an enjoyable working relationship and constant and open dialogue are key to capturing the aspirations of our clients and ensuring trust," she said. "We take a very hands-on approach and believe it is very important that our clients feel involved throughout the process, and that our designs are very human-centered. Key to our work is that our buildings relate to their distinct site and context and inform a sense of place."

*Interior Designer: Linda Mann*
*Landscape: Lila Fendrick Landscape Architects*
*Builder/Contractor: Potomac Valley Builders*
*Photographer: Tom Arban Photography*

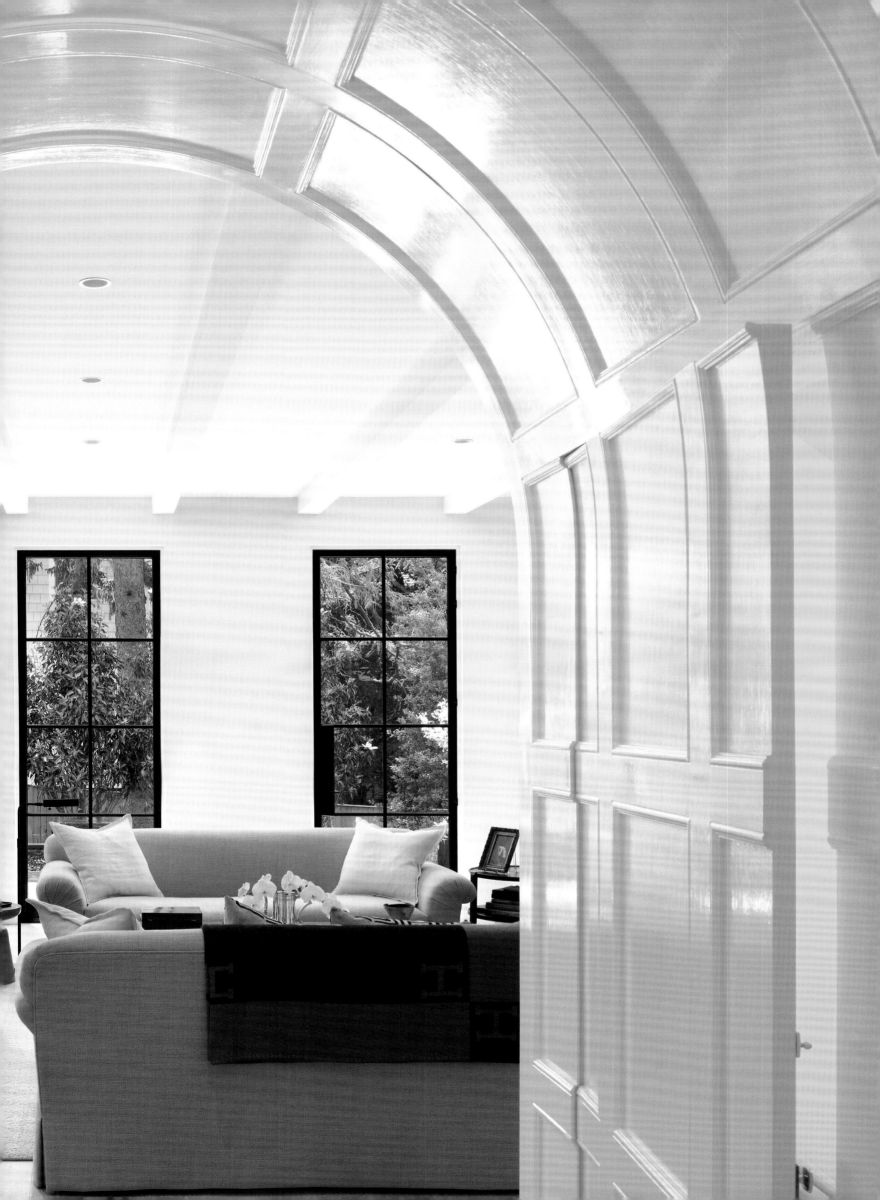

"The impact of light is critical to every project. Always try to allow as much light into rooms as possible."

— Stuart Disston

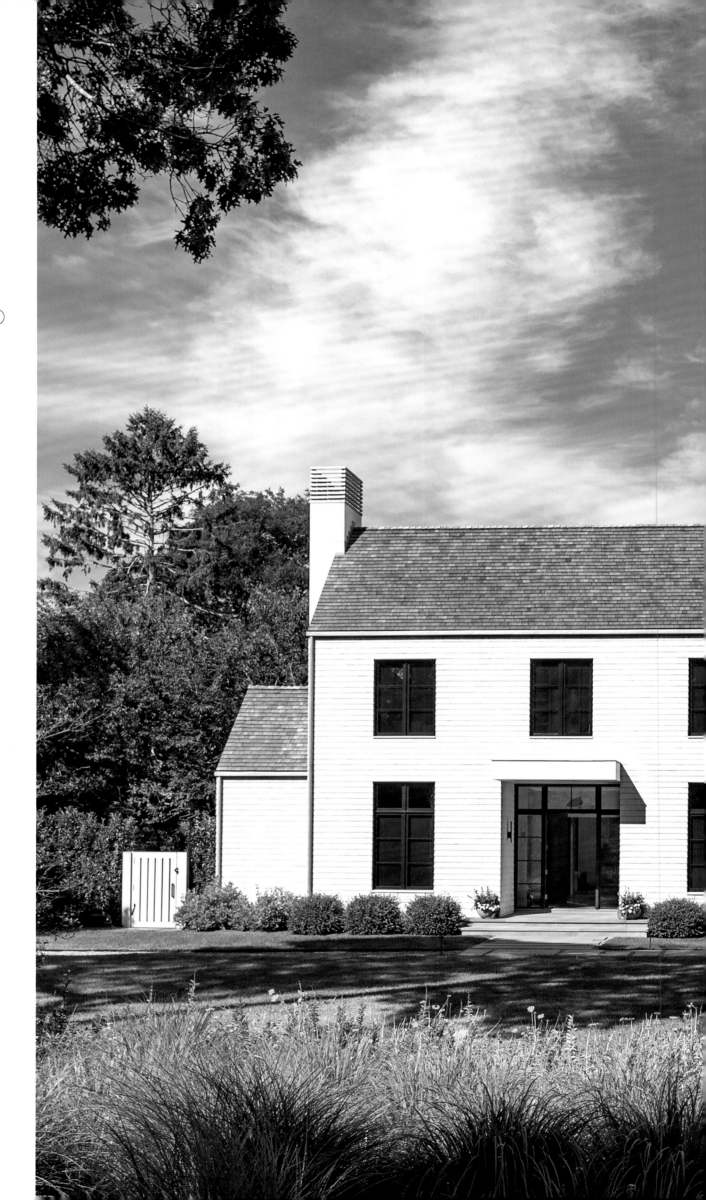

Stuart Disston & Joshua Rosensweig

Austin Patterson Disston Architecture & Design

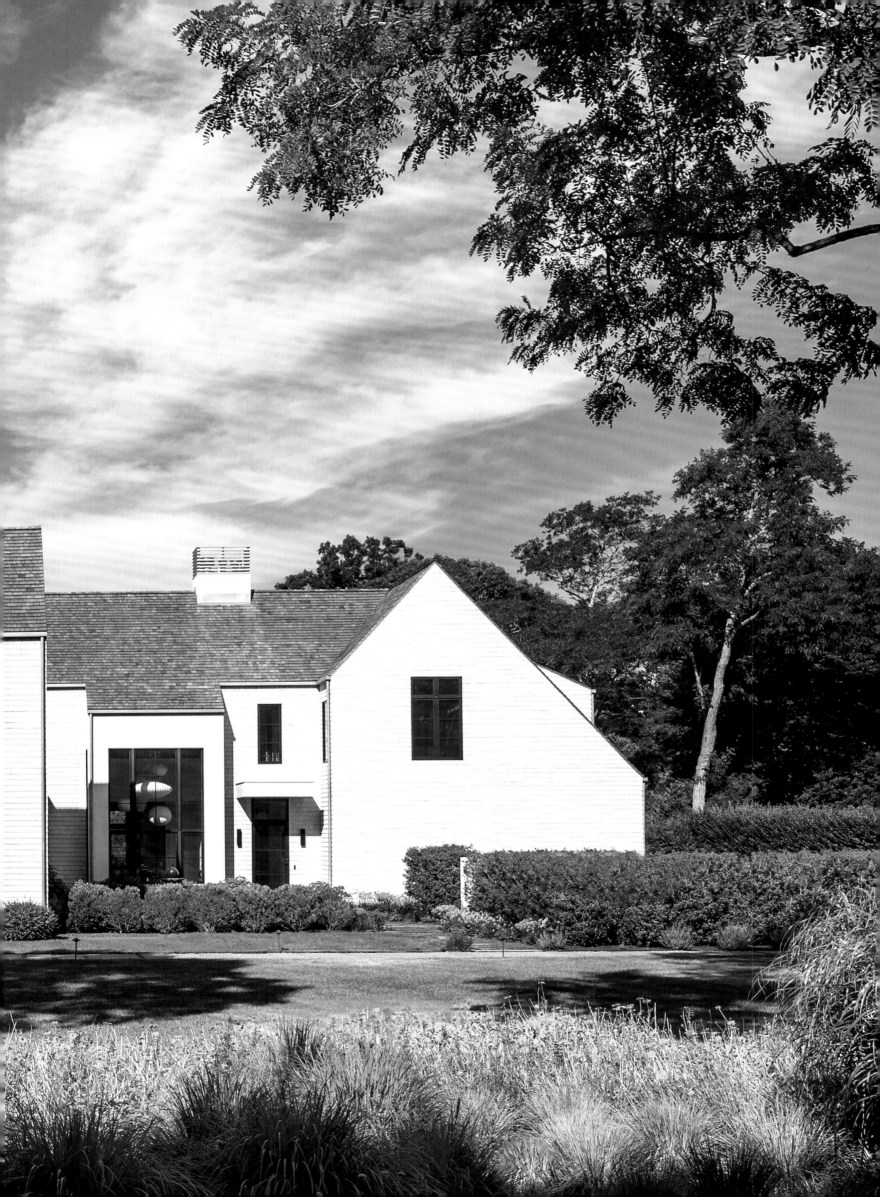

Stuart Disston and Joshua Rosensweig of Austin Patterson Disston Architecture & Design knew they had an interesting project ahead of them when their clients expressed a desire for a home that would showcase the outdoors and combine both modern and traditional architectural styles.

The pair, principals at APD Architecture & Design, specializes in bespoke projects, including residential, hospitality, and private clubs. With offices in Connecticut and New York, and projects internationally, the firm focuses its design approach on respecting the integrity of the built and natural contexts that make every building site unique.

When designing the Vernacular Redefined project, located in Quogue, New York, Disston and Rosensweig had the luxury of working with a comparatively large-sized lot. This enabled them to set the home back from the road, more than its neighbors, with a meadow in front and an ample backyard that accommodates a pool and lush gardens.

The clients' passions for design and horticulture led to a fun and meaningful collaboration. Not only did they contribute thoughtfully to the project as a whole, they also acted as both interior and garden designers.

During the early planning stages, there were multiple iterations of the house, with the homeowners open to suggestions and expressing enthusiasm about the idea of "colonial forms meet modern," said Disston.

In the end, this mix of styles came together perfectly. The house distills simple vernacular forms and classic architectural elements into a hybrid suited for modern living. The entry pays respect to the organization of the traditional façade in a modern way. Shingled window returns replace traditional casing work, and the traditional entry pediment is redefined with a floating plane. Other unique touches include the use of red and white cedar shingles and planks to create a soft material palette.

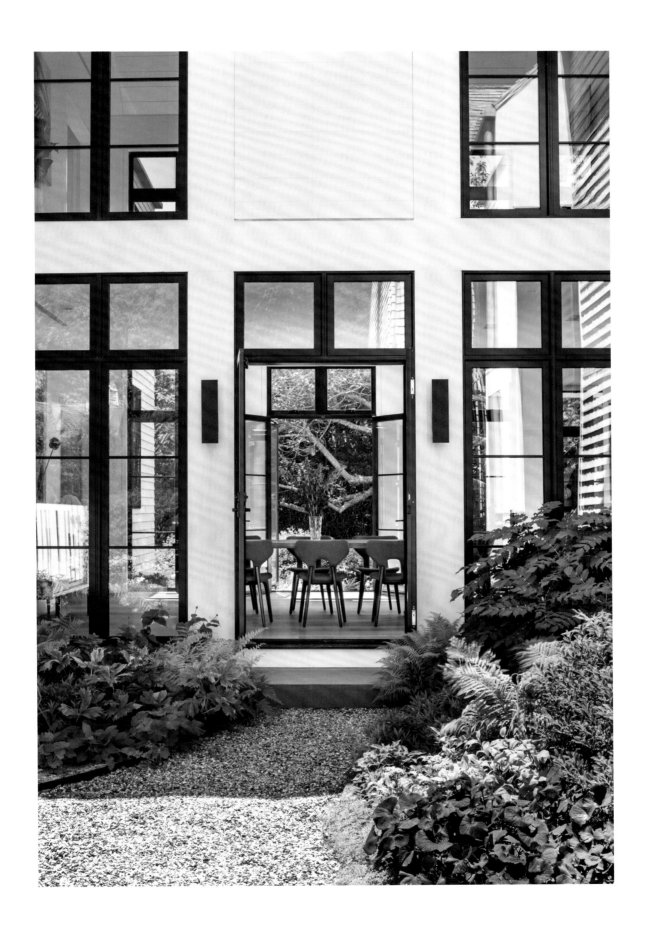

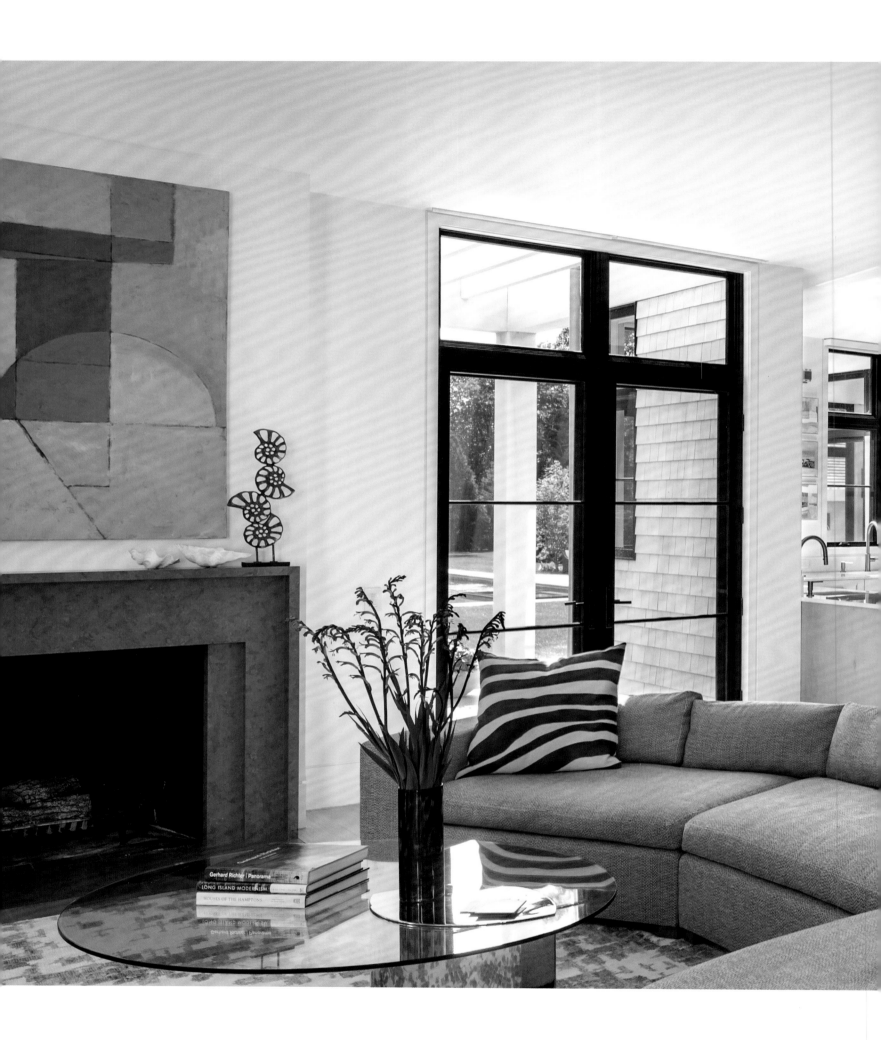

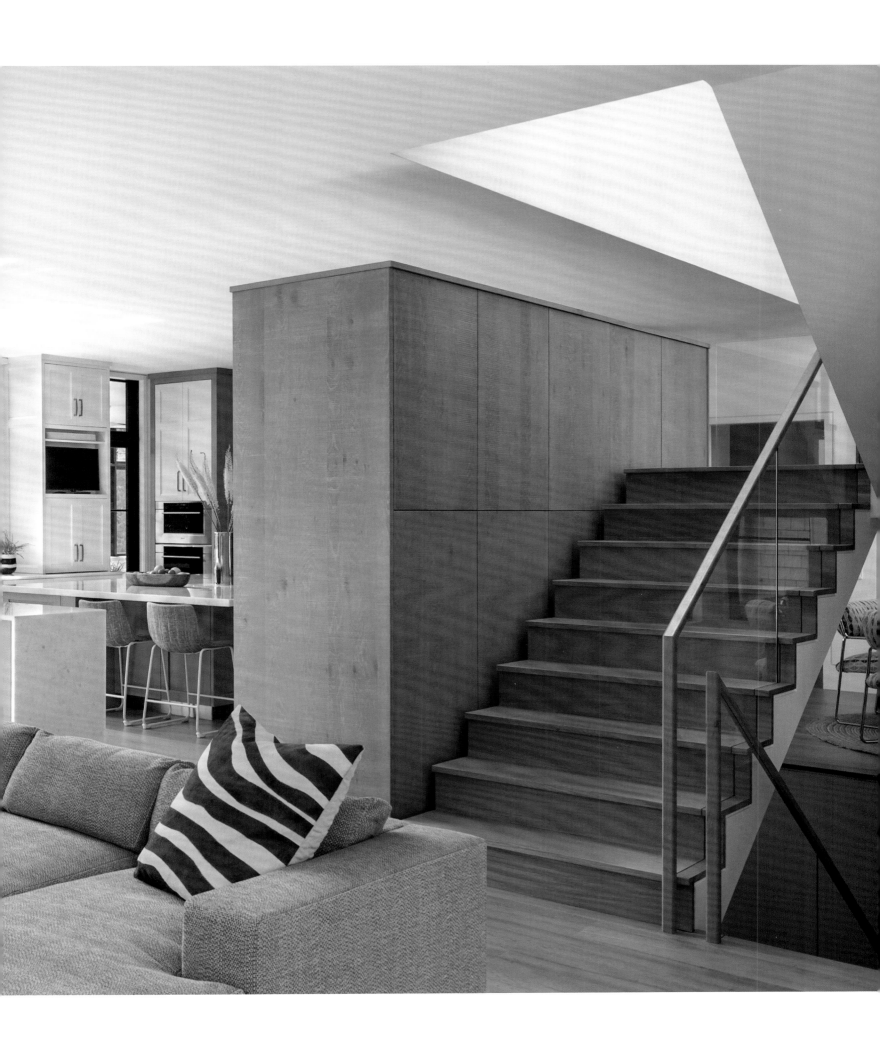

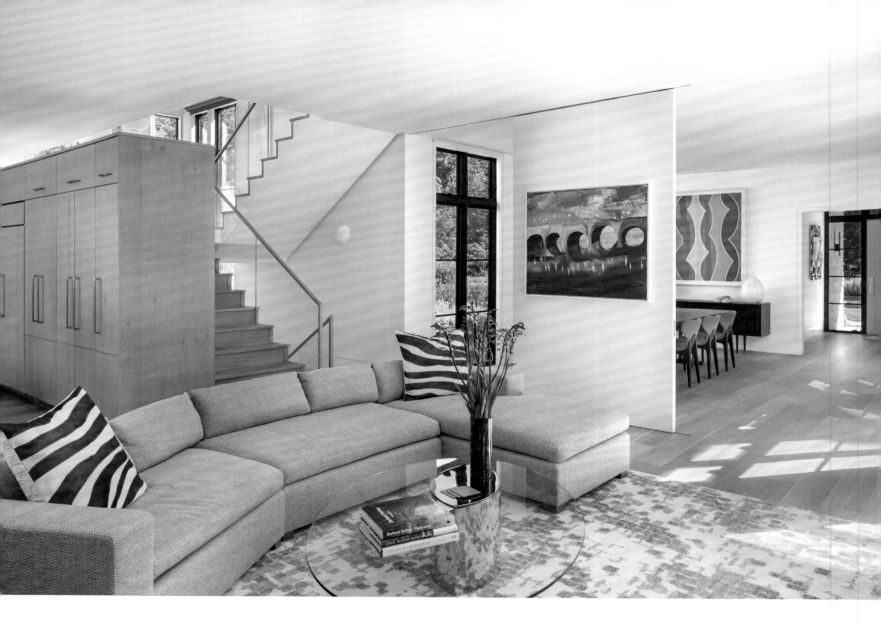

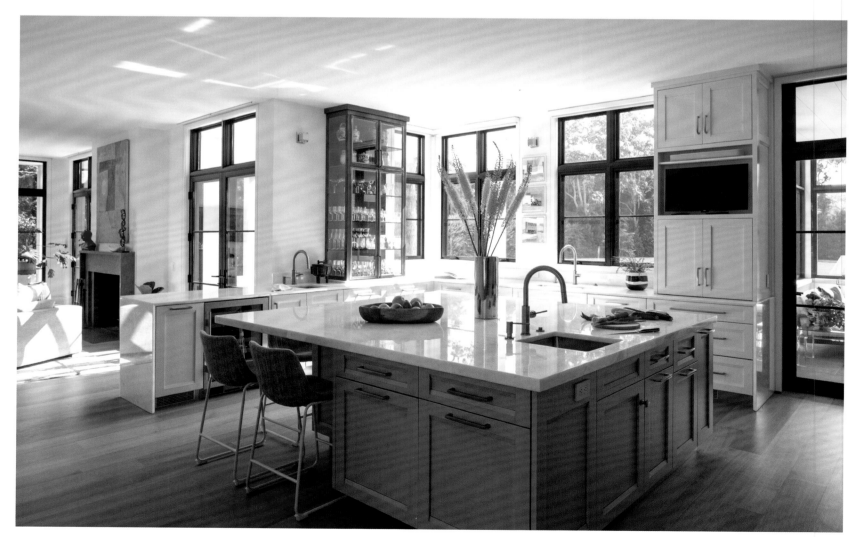

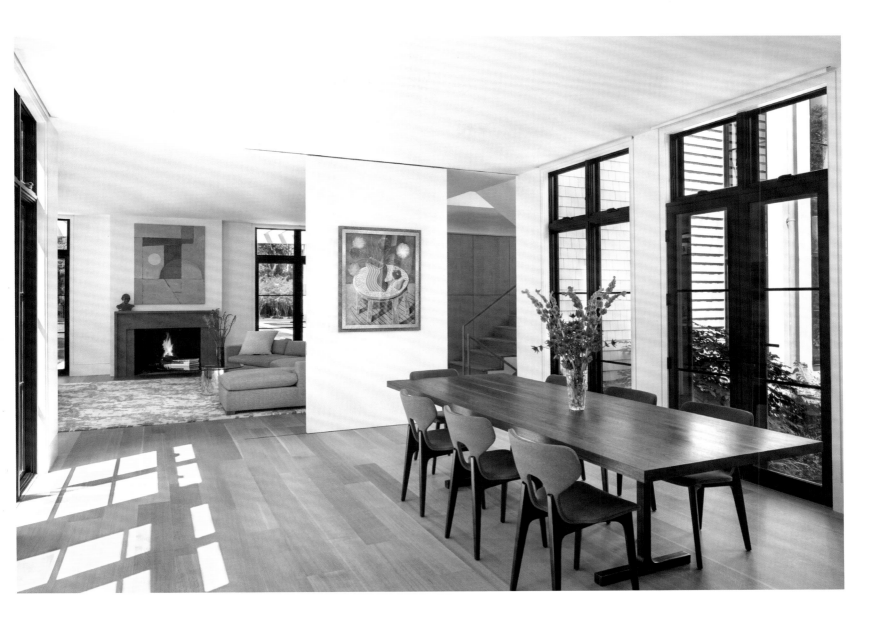

"We focus on bespoke projects. Our approach emphasizes tailored design solutions and attention to detail."

— Joshua Rosensweig

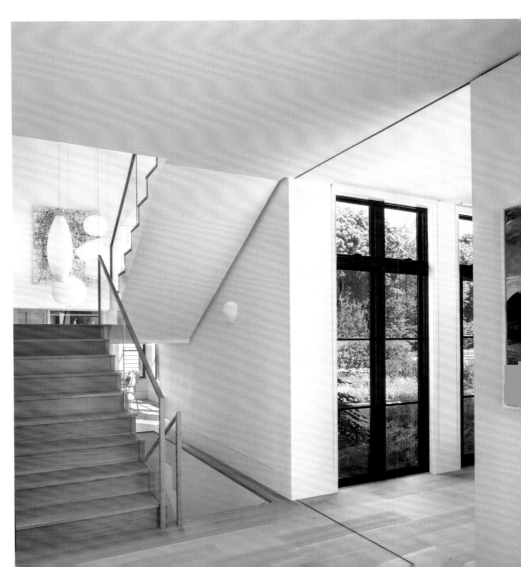

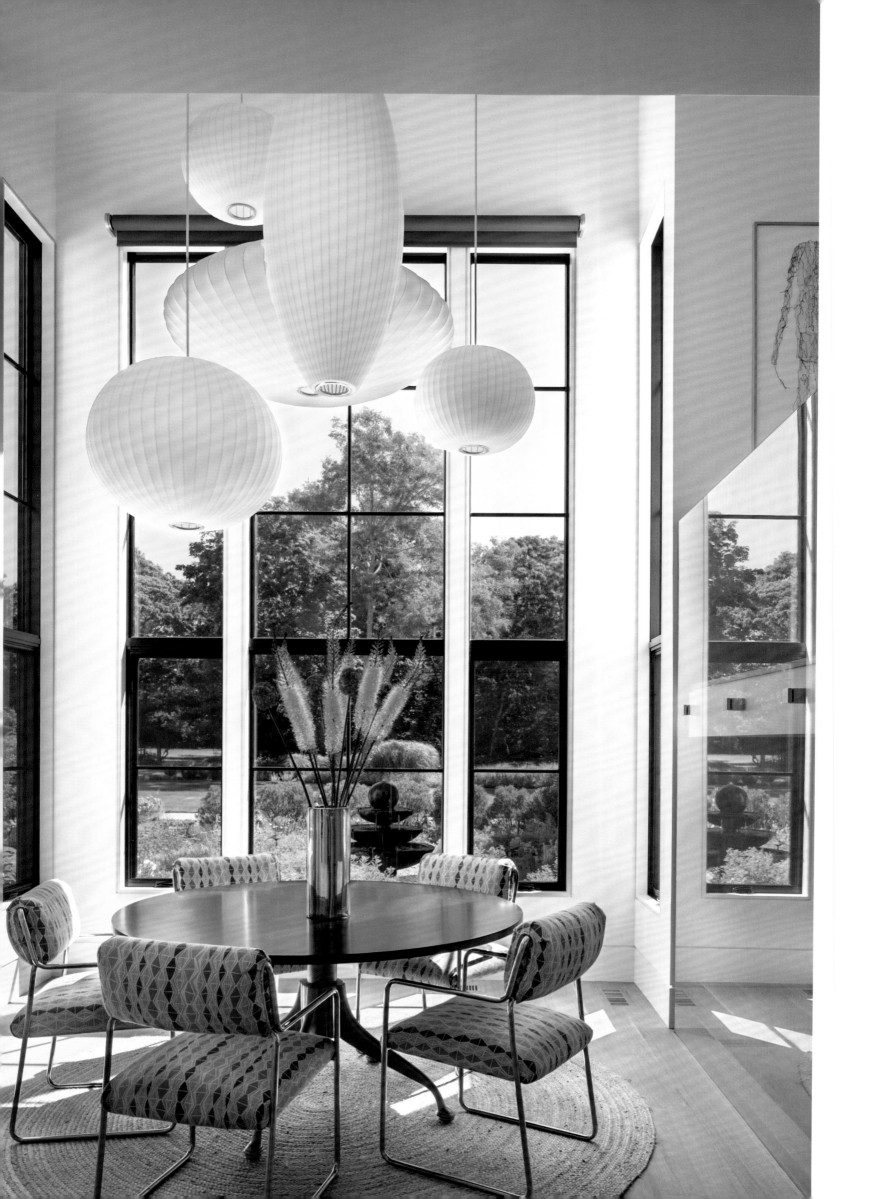

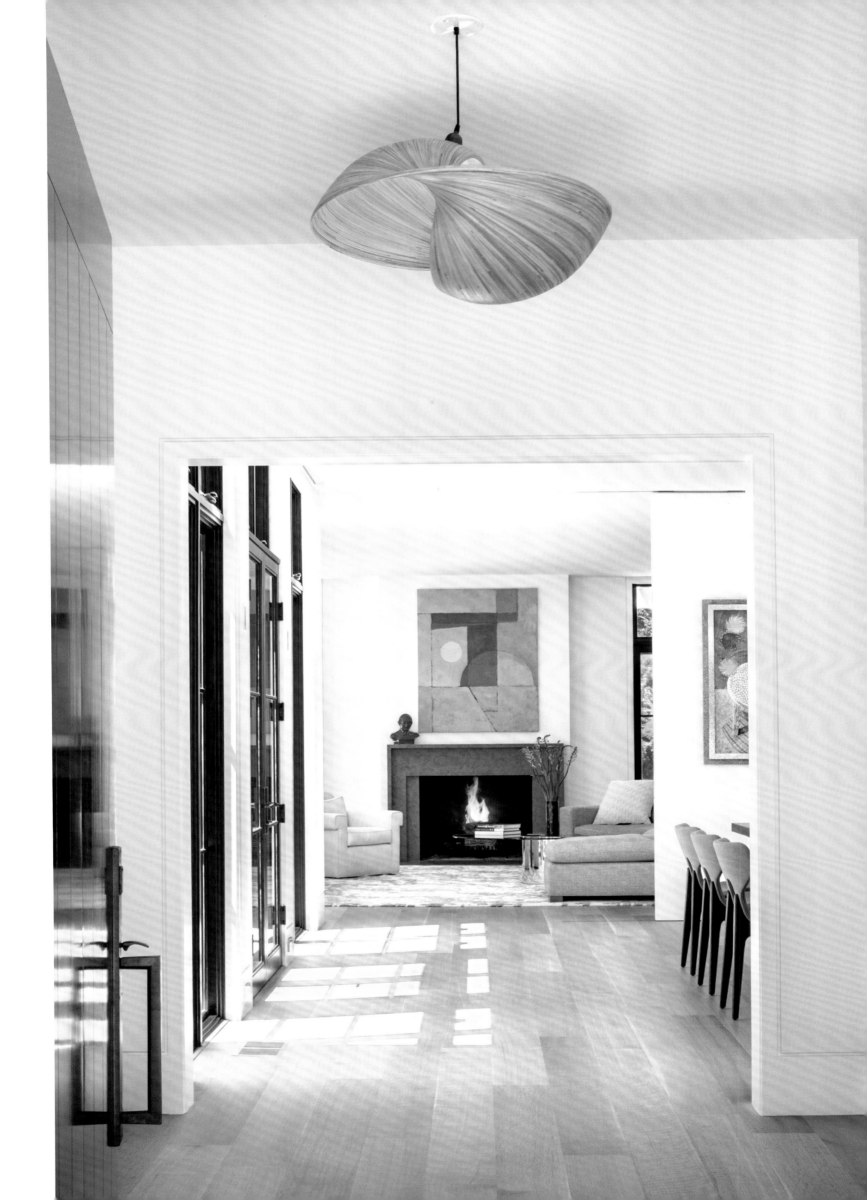

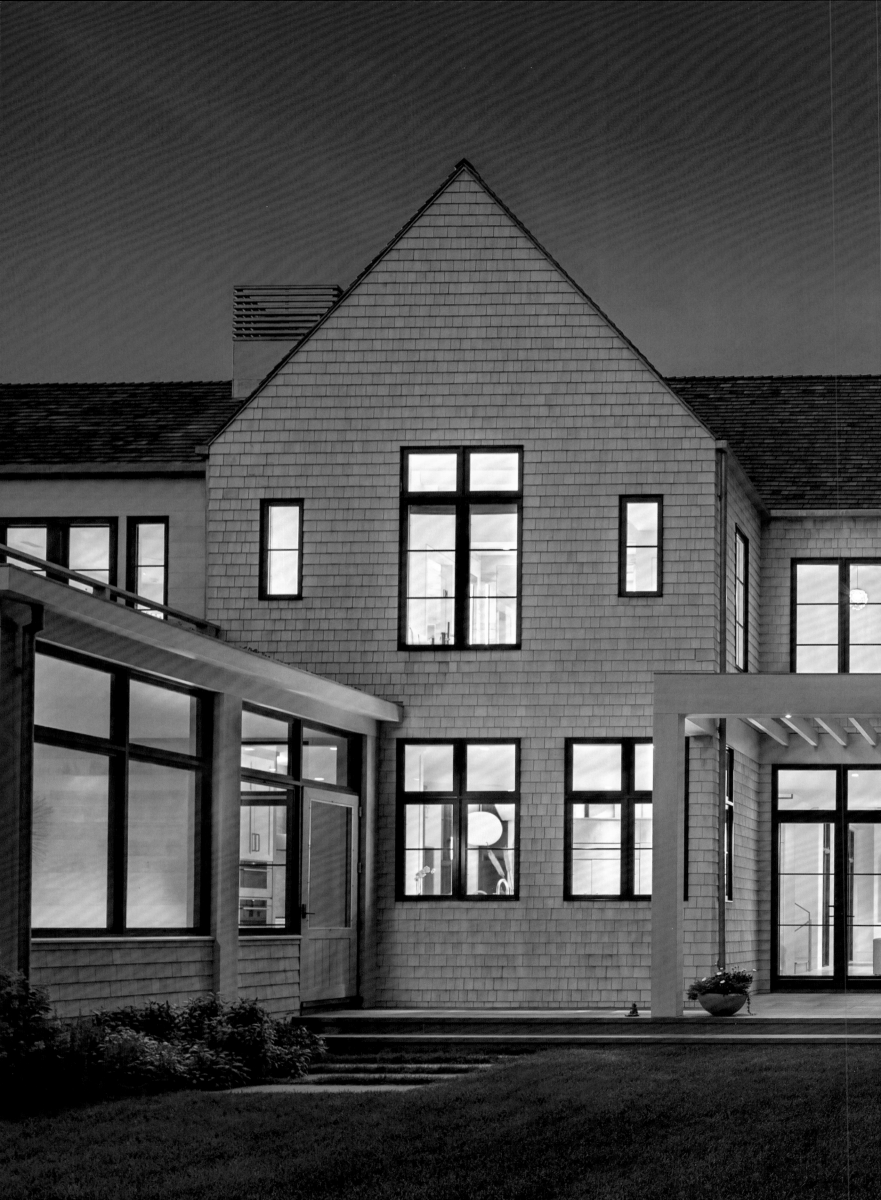

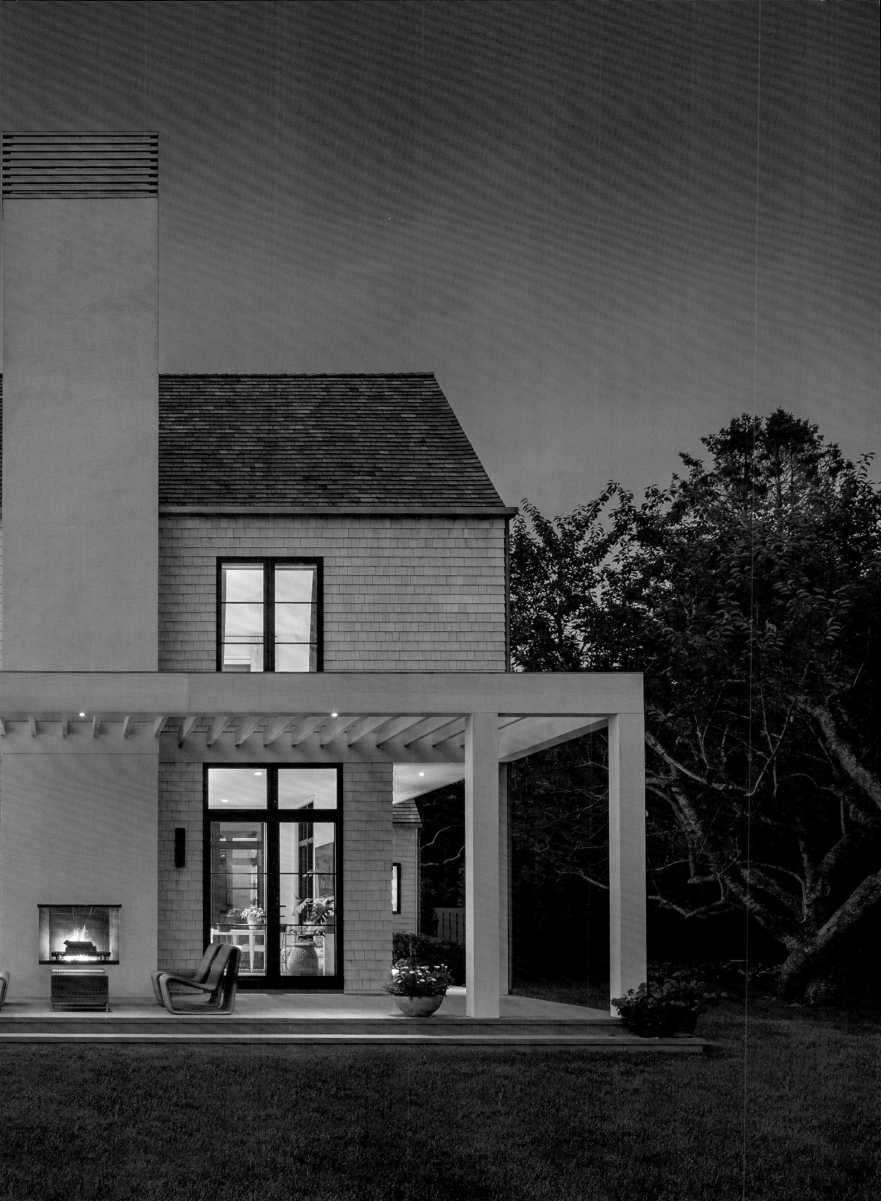

"The house is a play on a traditional New England colonial in a modern vocabulary," said Rosensweig.

Upon entering the house, you can see straight through the hall, dining room, and living room with the fireplace terminating the line of sight. The stairs are centrally located, allowing visual transparency to span vertically between three levels. The staircase landing overlooks the two-story breakfast room that has a floor-to-ceiling window with garden views.

One of the home's most striking qualities is how sunny and bright it is, as every room has multiple exposures to the outside. The breakfast room in particular is filled with morning sunlight, creating a warm and inviting atmosphere. Elsewhere, large glass openings provide sweeping views of the garden and grounds, lending added saturation to the bright spaces. A roof deck is bordered by a sedum roof, continuing the relationship between the architecture and the landscape.

Disston, Rosensweig, and their team at APD Architecture & Design found the collaborative process both incredibly interesting and rewarding. The charge of synthesizing the varied design inspirations and the family's programmatic needs into an organic, cohesive whole has made this one of the firm's most unique projects to date. The resulting home and grounds provide a curated, comfortable place for the household and guests to relax, unwind, and gain inspiration for their various creative endeavors.

*Interior & Landscape Design: Mary Vermylen, Owner*
*Builder/Contractor: AFC Construction*
*Photographer: Anthony Crisafulli Photography*

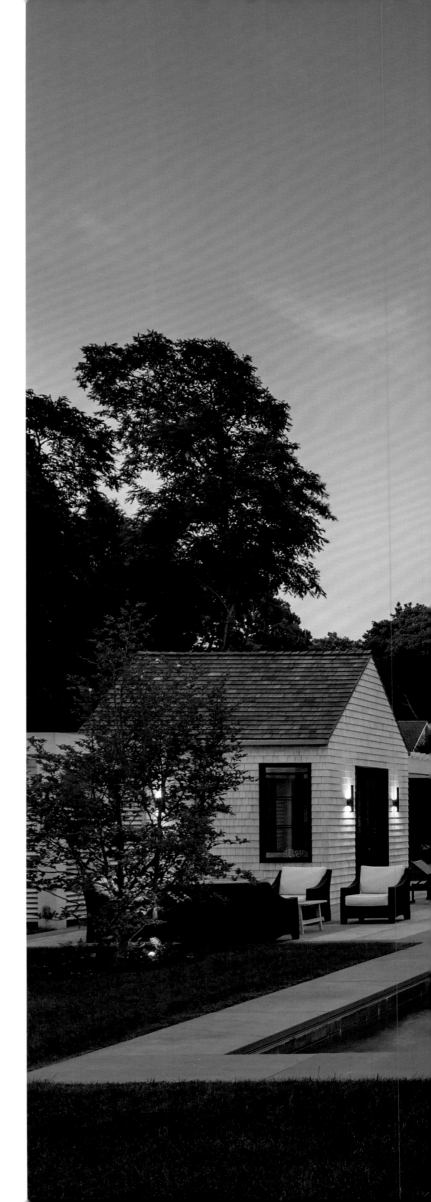

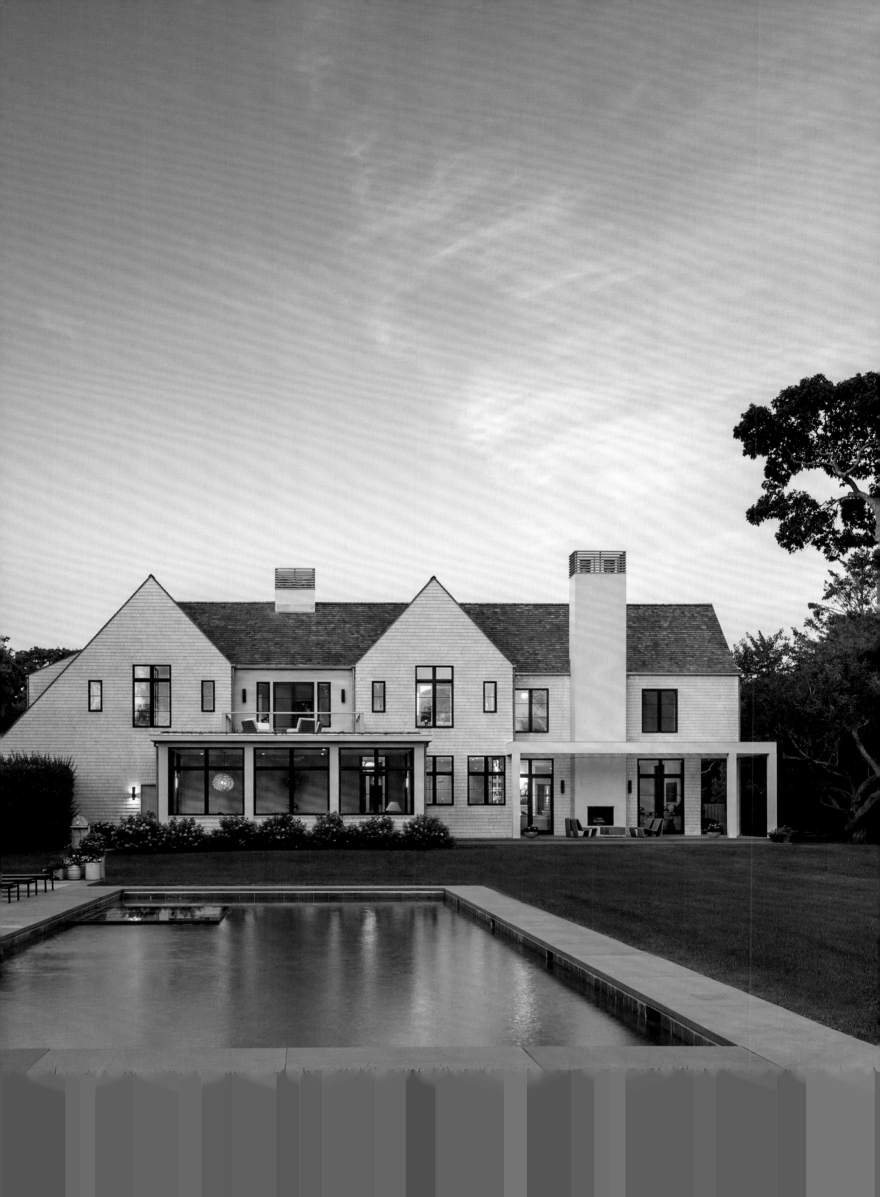

"Entrusting me to build your home is an enormous decision in my mind. But I like the responsibility of being an architect. It's a bit audacious to design a building that's in the public domain."

— Mario Egozi

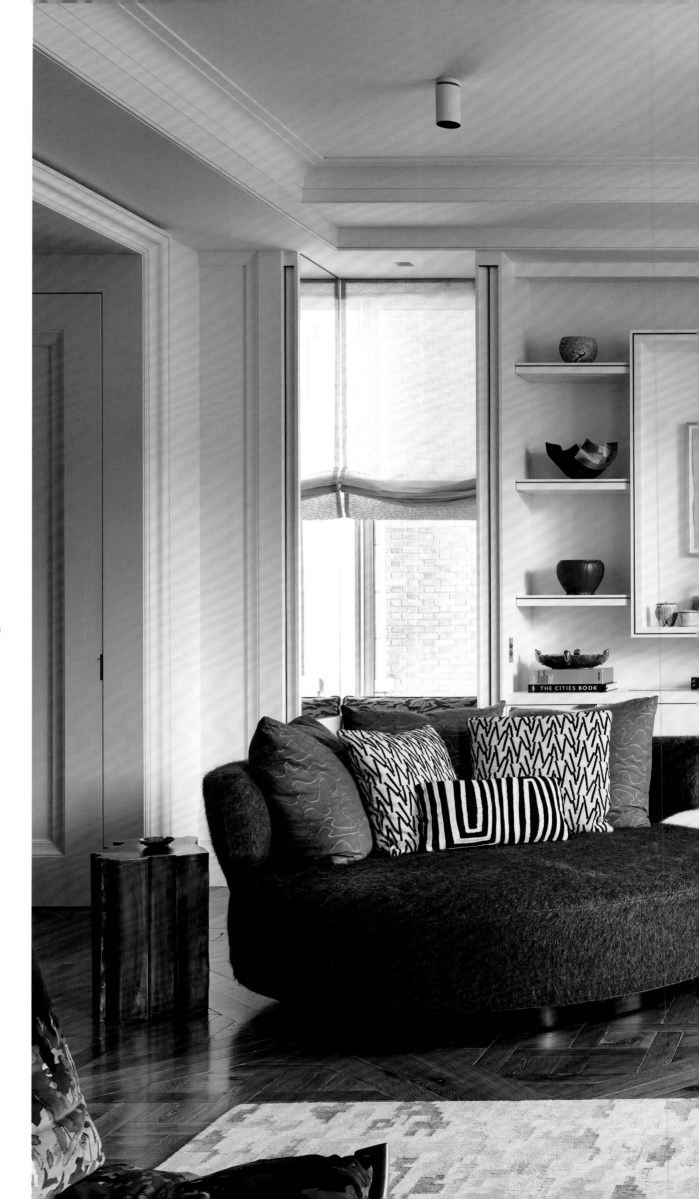

Mario Egozi

Mario Egozi Architect

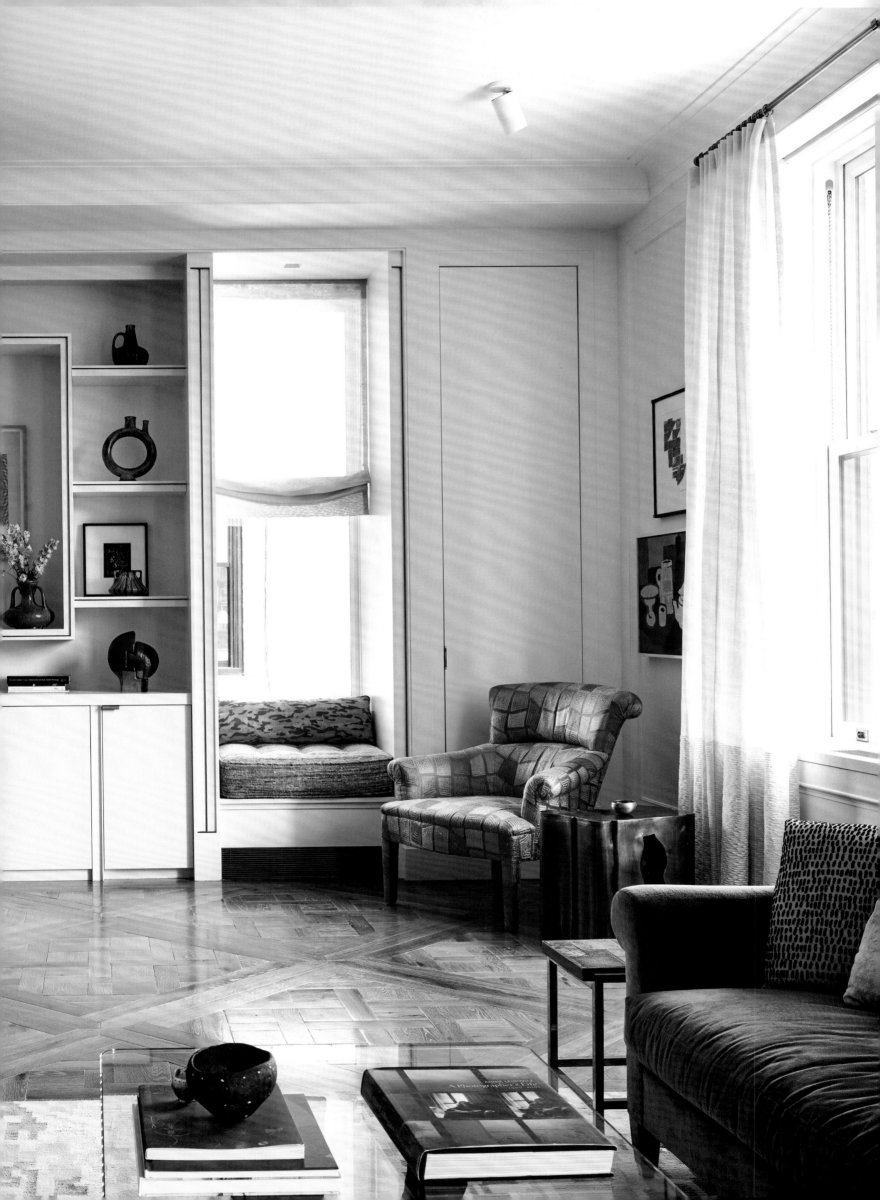

Whether admiring beautiful Miami Beach homes as a child on his 45-minute bus ride to school or infusing a client's Upper West Side apartment with a liberal dash of Paris, Mario Egozi has always viewed architecture as a transformative experience.

For Egozi, this has meant everything from using blue hues to recall varying shades of the sea, to deploying particular wood grains to convey the feel of a garden, to using a singular entry doorknob to welcome a visitor into a home full of circular and curving motifs.

Creating such an experience takes time and discourse with the client. A sole practitioner since founding his firm in 1982, Egozi limits his work to one to two projects a year, giving him ample opportunity to take a client through the process that can begin with choosing the real estate and concludes with choosing furnishings and other finishes.

"If someone is hiring an architect, they have their own fantasy. An engaged client will make for a more successful project," said Egozi, who says he wanted to be an architect as far back as junior high school. "Entrusting me to build your home is an enormous decision in my mind. But I like the responsibility of being an architect. It's a bit audacious to design a building that's in the public domain."

Which is not to say the Egozi relishes in the indulgent. The sailing enthusiast, who's done most of his work in either New York City, the Northeast, or South Florida, has long been fascinated by how boats are designed to maximize space efficiency.

"We are not sculptors, we are architects, and by profession, we are here to build for a purpose, not as an abstraction," Egozi said. "Without purposeful functionality, the project fails. There's rarely a reason to compromise function."

With that in mind, Egozi tries to preach a less-can-be-more ethos. Egozi, who splits time between New York and his native South Florida, is also a proponent of using local materials whenever possible in the name of sustainability.

"Homes built today are too large. We need way less than we think we do, and my mission is to at least have that conversation," Egozi said. "It is easy to design large where the premium of space is not considered. Efficient design, compact and well organized, is more difficult. We need to learn to live with less."

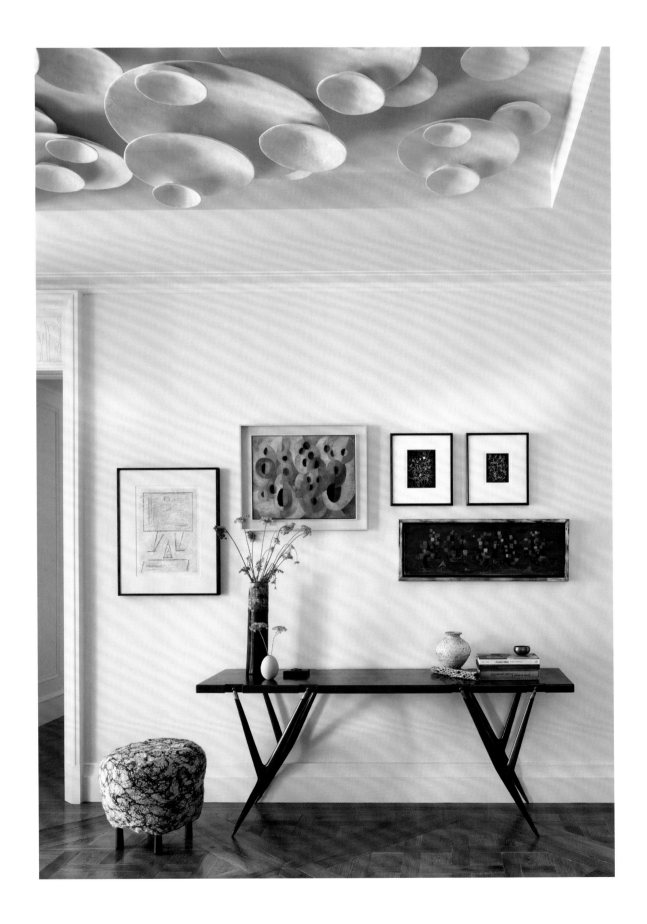

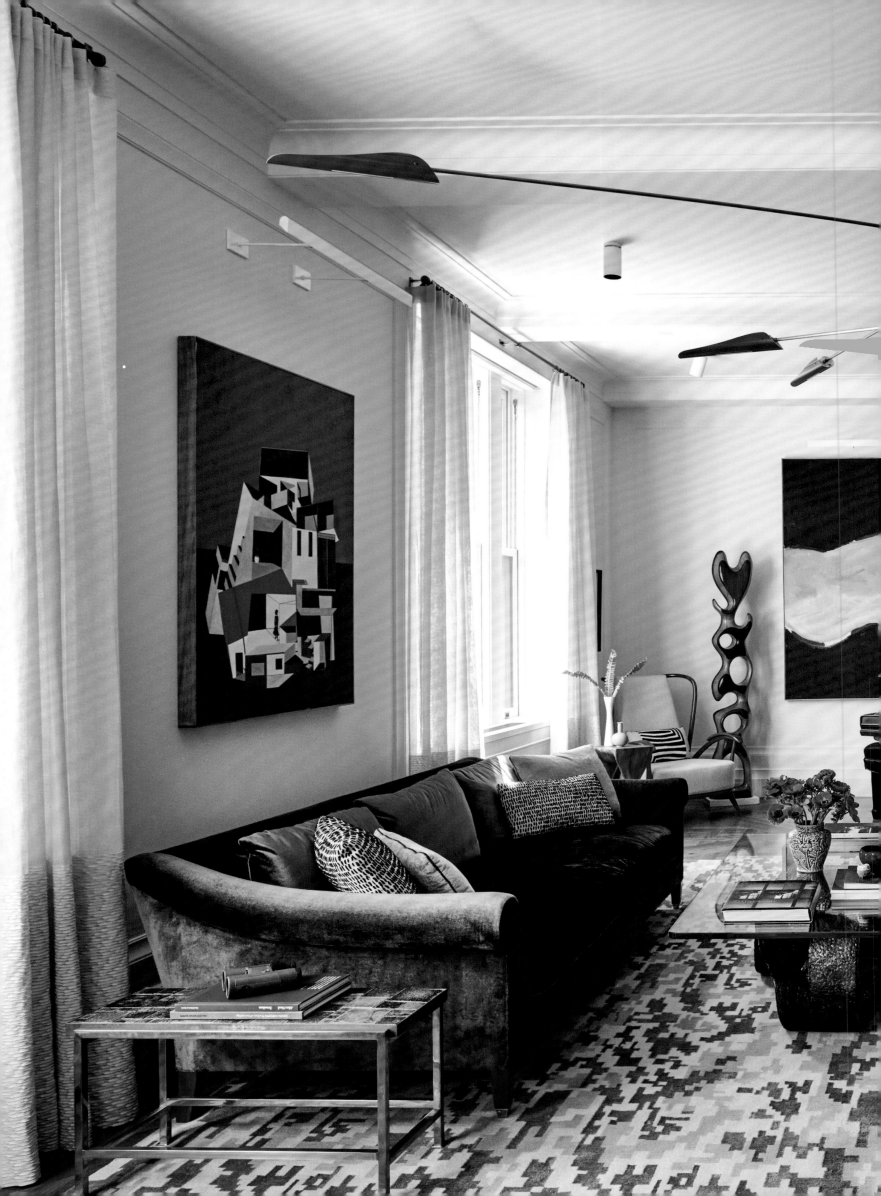

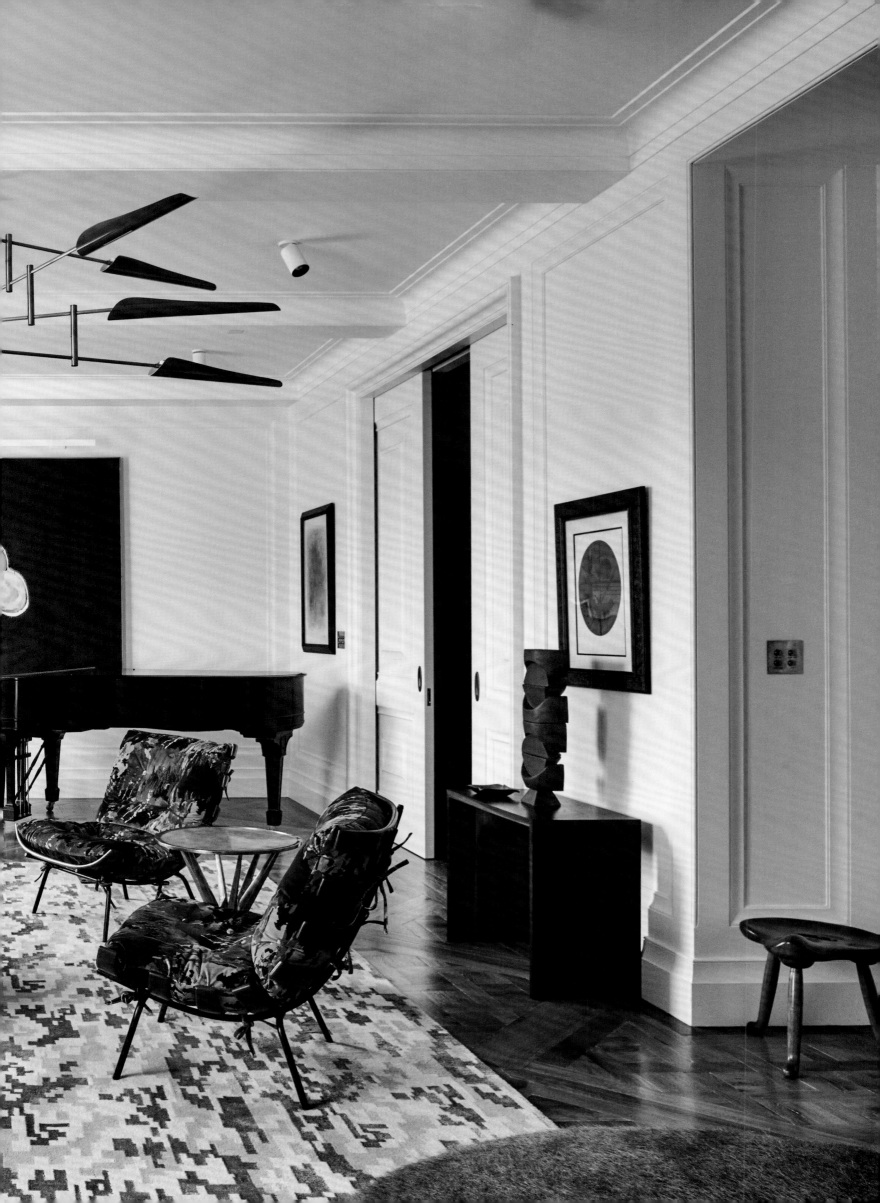

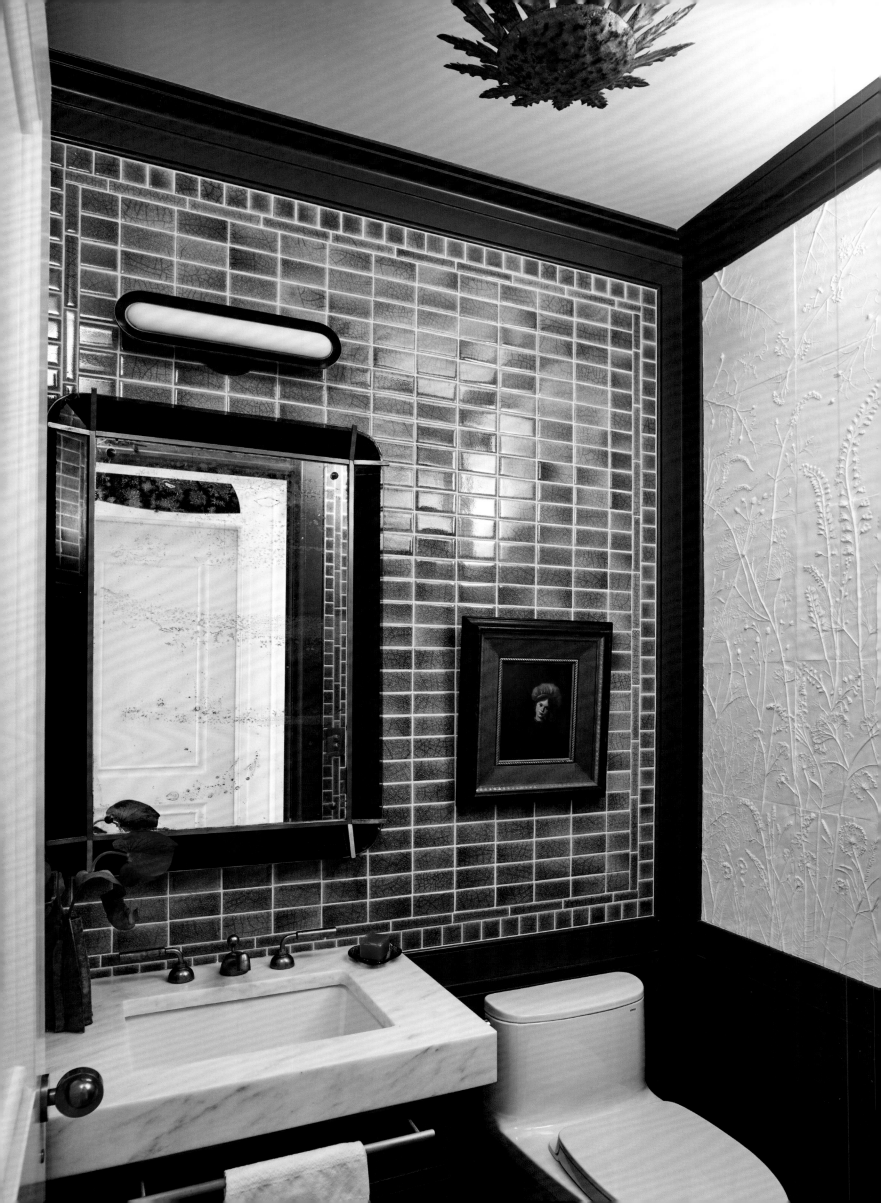

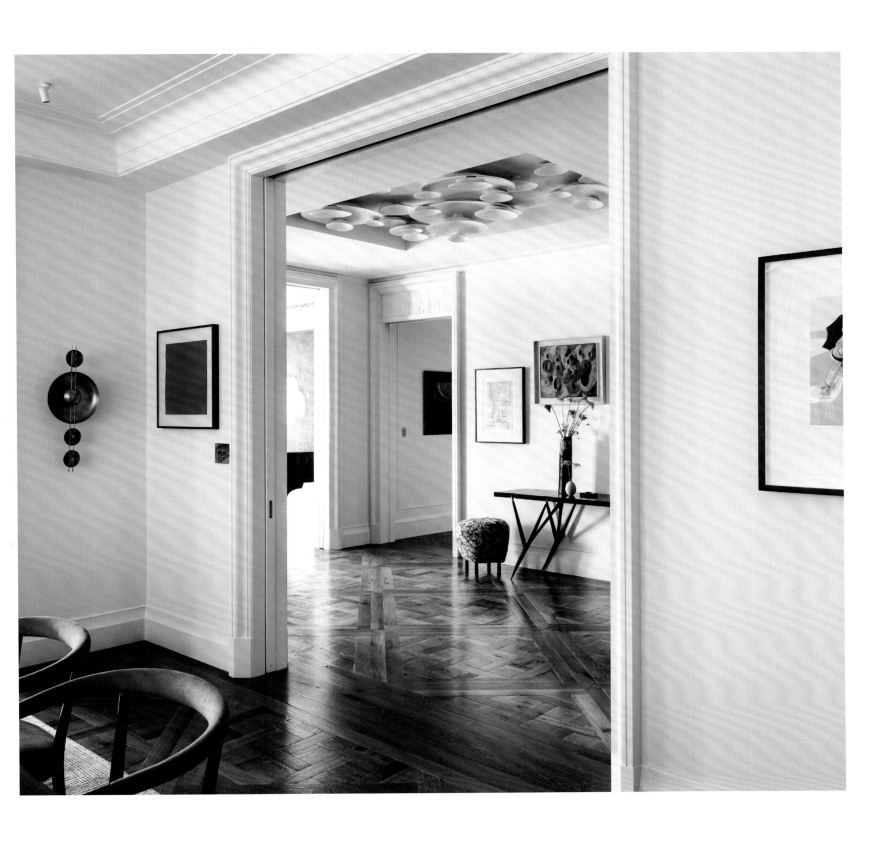

"Inspiration comes from everywhere.
I delight in the unexpected, in the
wonderment of surprise. A great
architect must be an artist."

— Mario Egozi

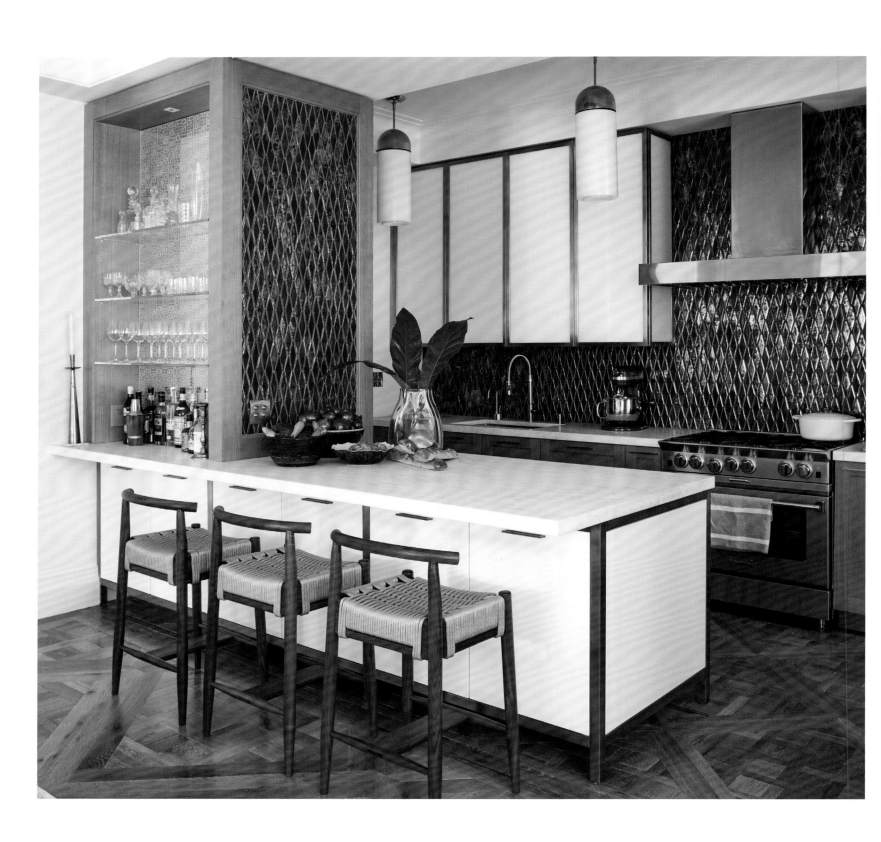

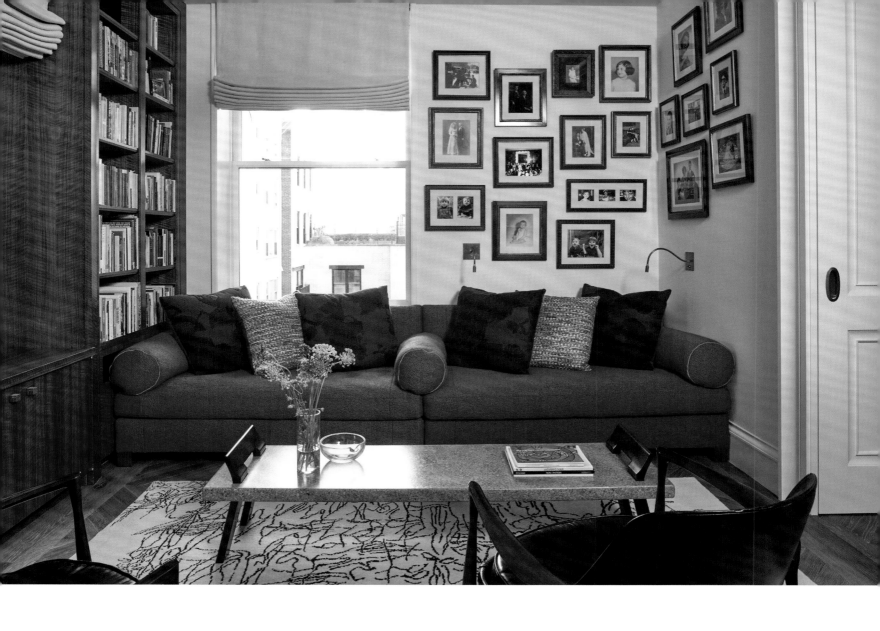

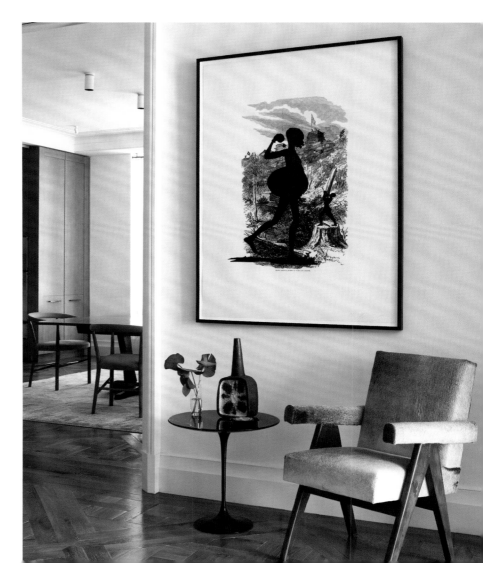

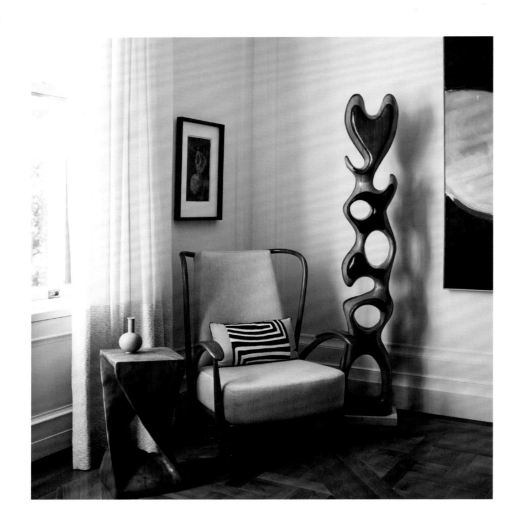

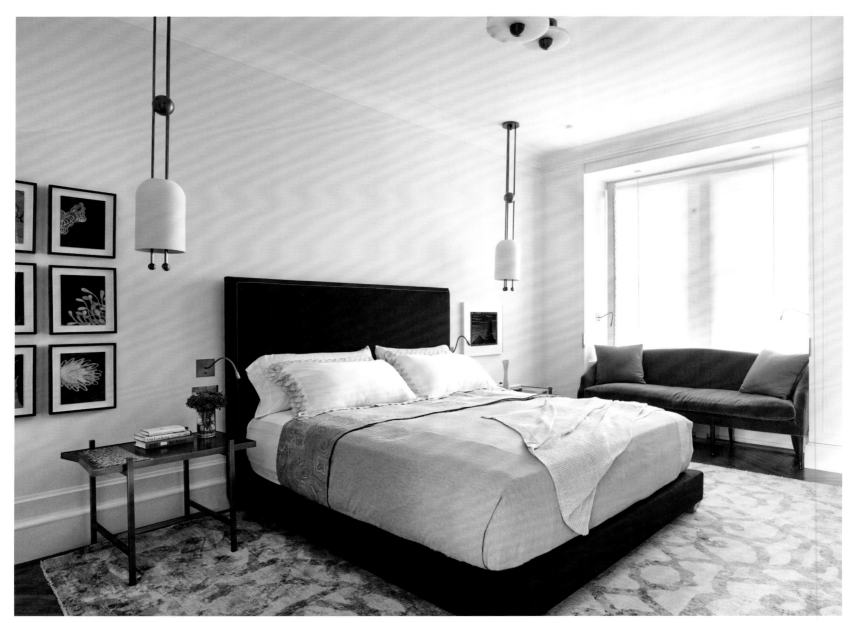

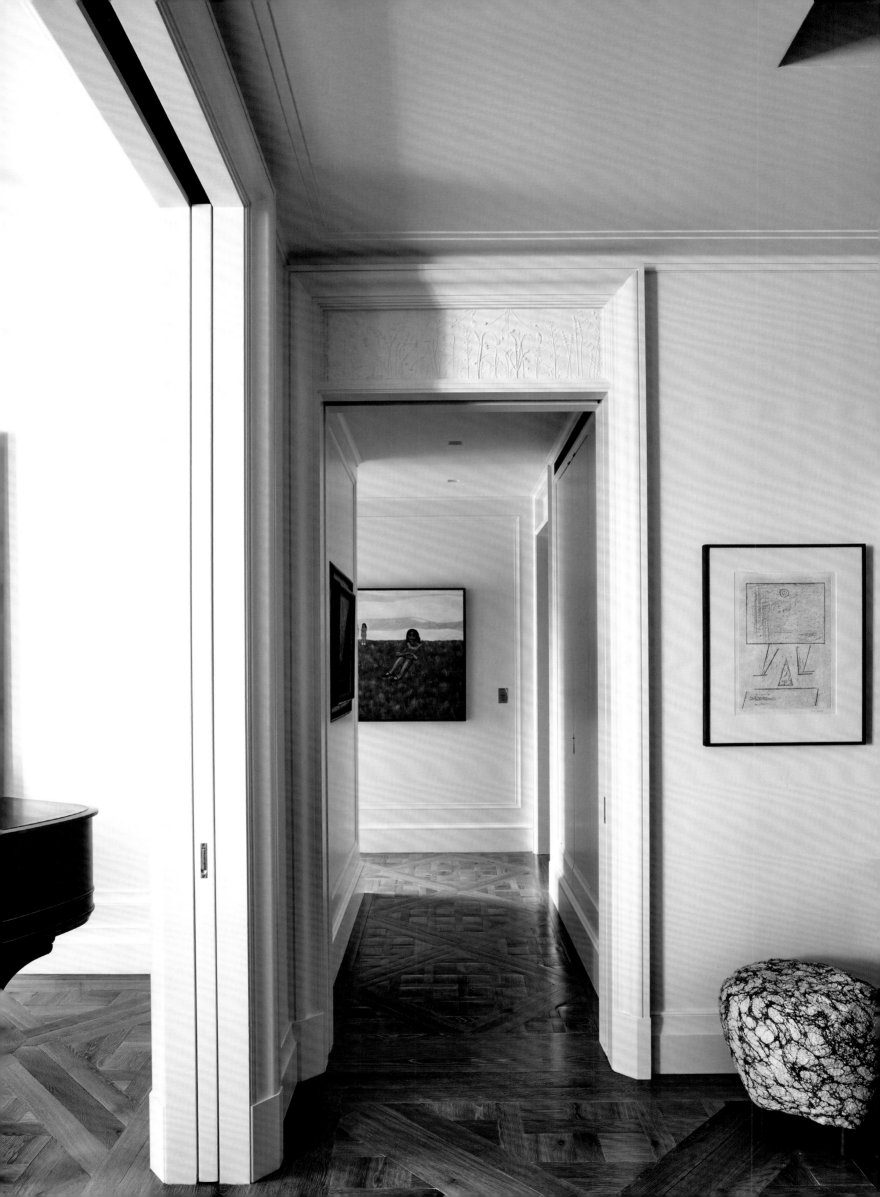

Still, Egozi, who says he's also inspired by Brazilian residential architecture and its integration of wood with glass, concrete, or steel, has embraced his own evolution toward taking a progressively bolder design approach, whether it be using furnishings and color motifs to play of a client's artwork or integrating particular spatial themes throughout an abode.

Case in point is the aforementioned Manhattan apartment. Taking his client's fondness for her Paris apartment into account, Egozi aimed to interpret how a Parisian apartment would feel if it were located on New York City's Central Park West.

With that in mind, Egozi stripped the 3,600-square-foot space down to its steel beams and concrete, laid down parquet flooring, and built in plaster moldings and fixtures throughout the home. Egozi also deployed five different shades of white on the interior walls in order to accentuate the pops of color from the furniture and artwork. The three-bedroom, three-and-a-half bathroom project was completed in 2021.

"Architecture, to me, is about spatial relationships with textural color painted upon it. Inspiration comes from everywhere," Egozi said. "I delight in the unexpected, in the wonderment of surprise. A great architect must be an artist."

---

*Interior Design: Mario Egozi*
*Builder/Contractor: Silverlining Inc.*
*Photographer: Richard Powers*

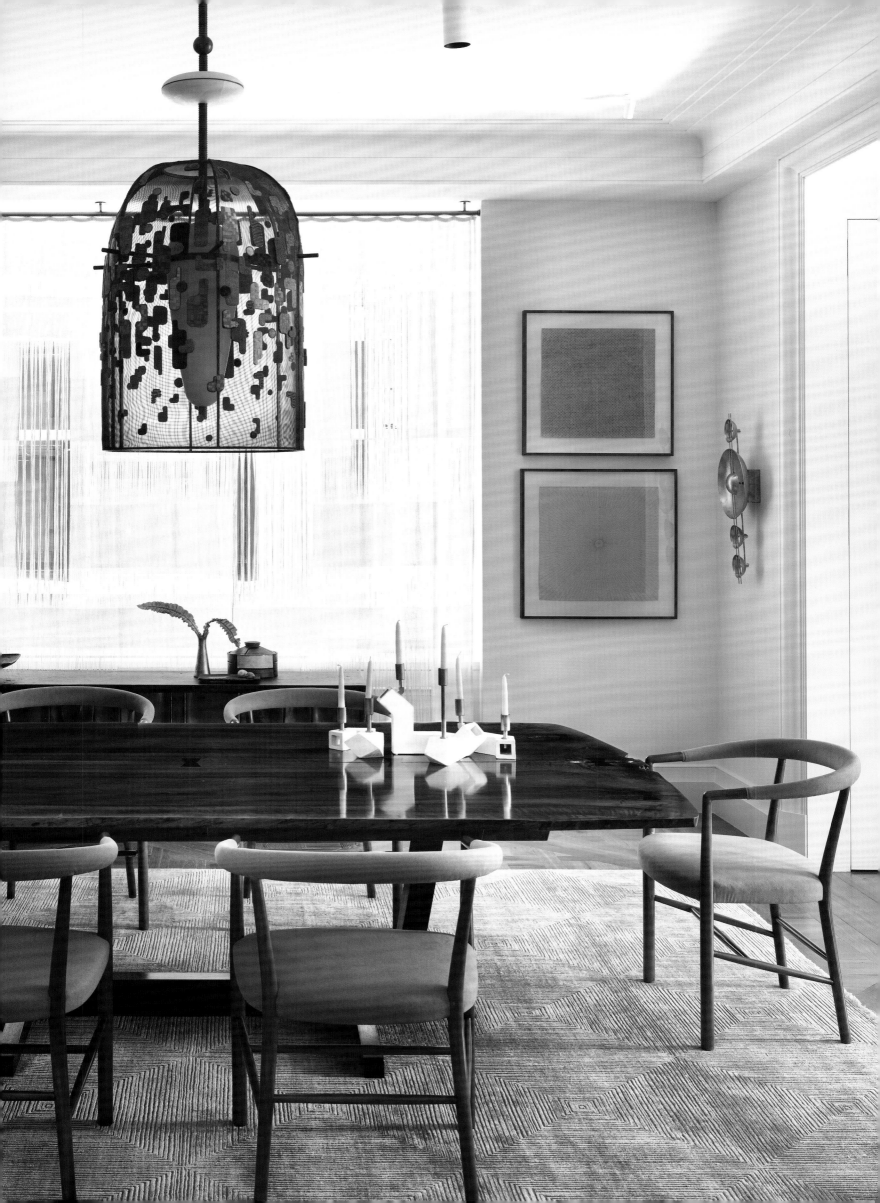

"I see design as a complex Rubik's Cube — you have to solve for all conditions to arrive at that perfect solution. And yet, great spaces embody something more — they transcend function to connect people with nature in a fundamental way."

— Allison Ewing

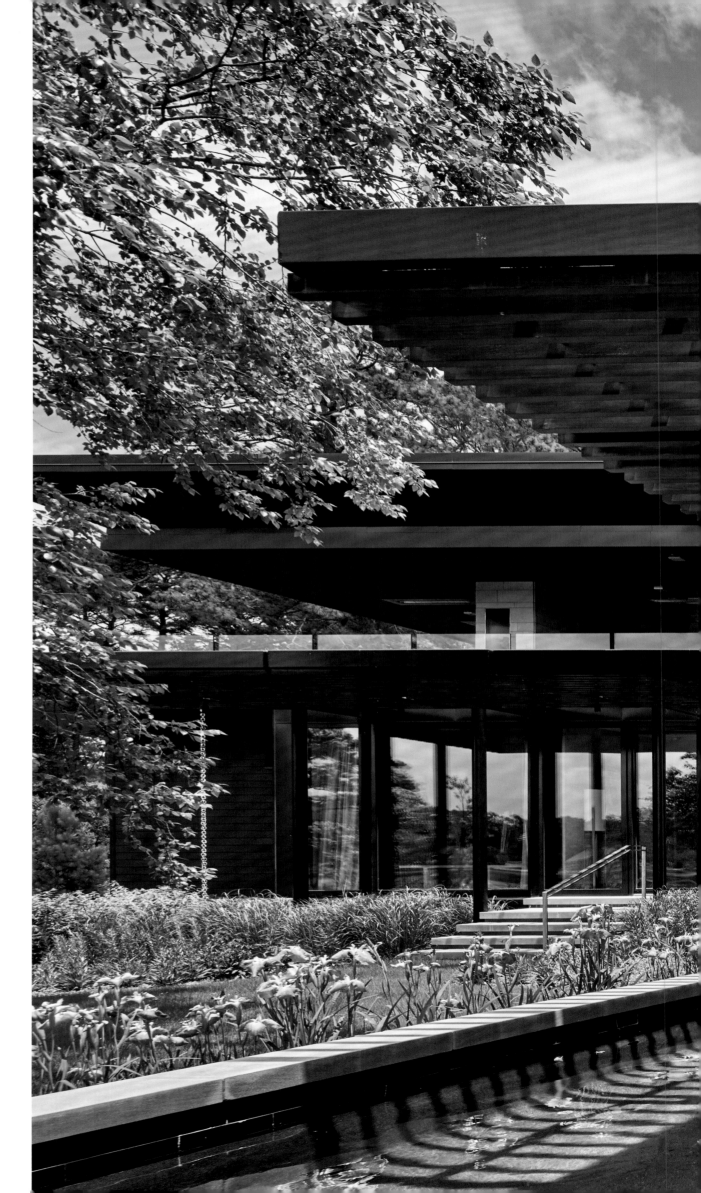

# Allison Ewing

## HEDS Architects

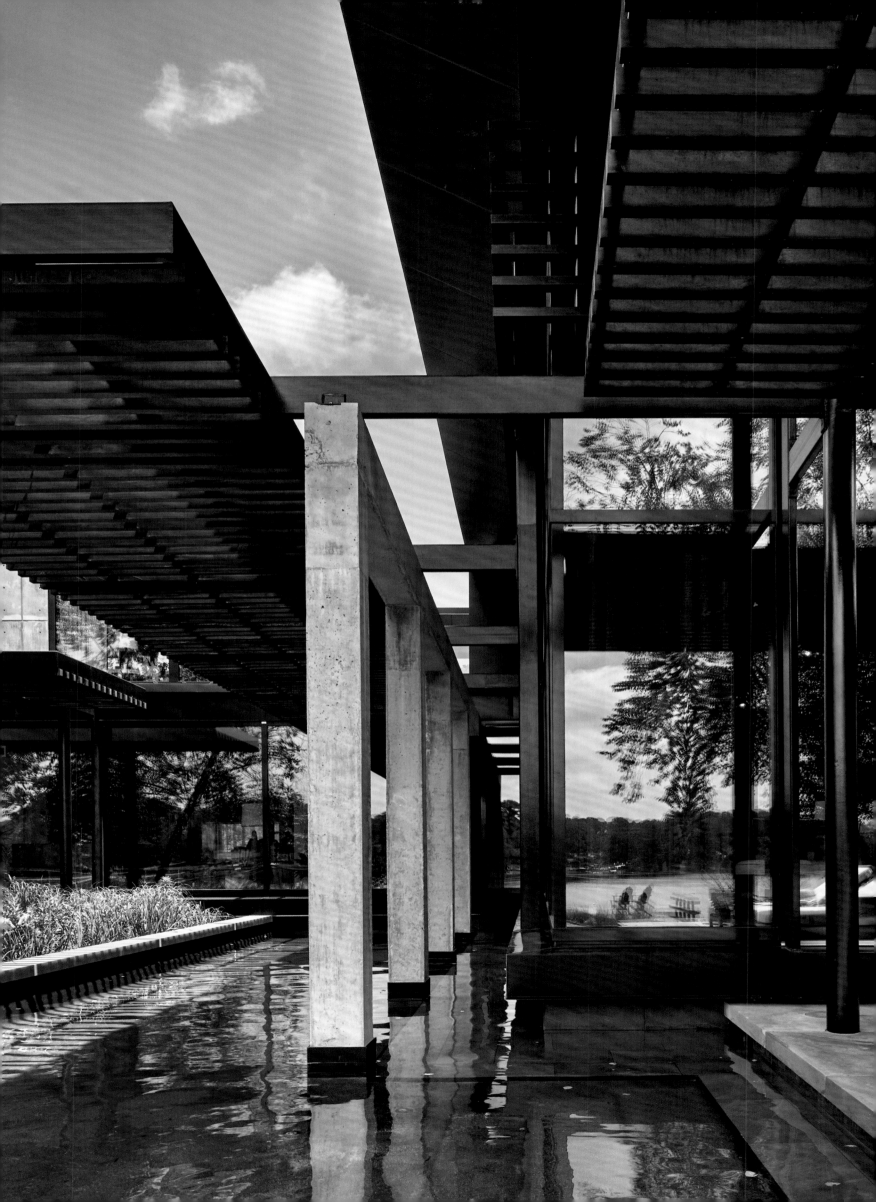

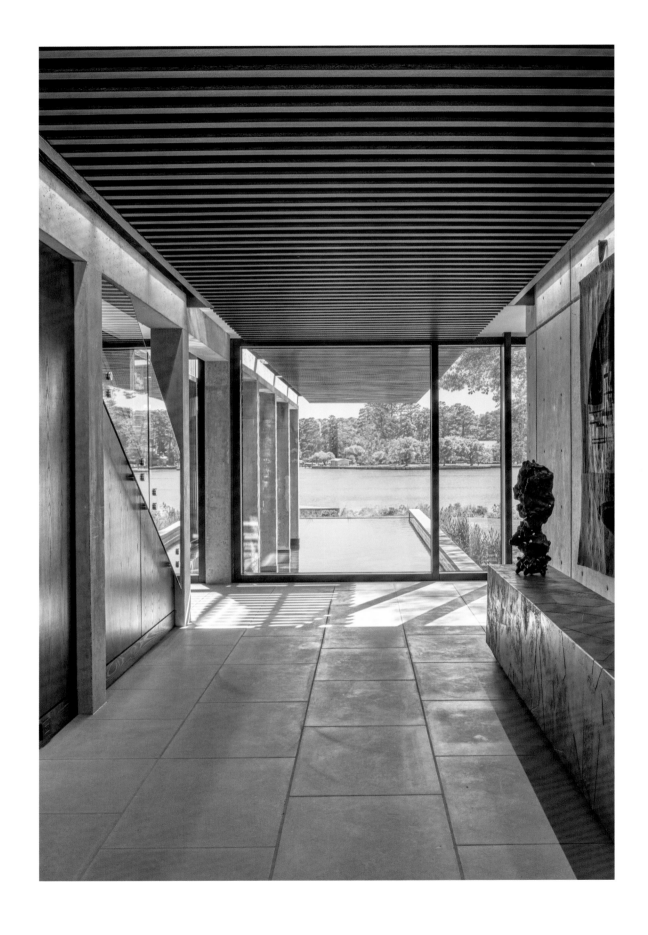

Growing up in rural Vermont, Allison Ewing lived in a 1770s-era house. A hay barn, contemporary to the house, was made from hand-hewn heavy timber. Its siding was vertical, rough-sawn boards with large gaps where sunlight filtered into the structure's dim interior, illuminating hay dust floating in the air.

"The space was as dramatic and magical as any of the great churches I've visited abroad," said Ewing, adding that her desire to recapture the qualities and feeling of that old barn ultimately inspired her to become an architect.

In pursuit of that dream, she earned her Master of Architecture from Yale University Graduate School of Architecture. She also traveled to Japan, where she was the recipient of a Monbusho Fellowship. She studied at the Tokyo Institute of Technology with a focus on traditional Japanese tea houses and how their rituals influenced the country's modern architectural expression. In addition, Ewing served as a design associate at the Italian firm Renzo Piano Building Workshop.

Ewing's international experience was an invaluable springboard for launching her career, which included serving as a partner at William McDonough + Partners. She co-founded Hays + Ewing Design Studio (HEDS) with Christopher Hays in 2005. The team has projects across the U.S., Canada, and Europe.

Working on such diverse projects as academic and cultural institutions, commercial buildings, mixed-use projects, and single- and multi-family residential, the firm focuses on the careful integration of buildings with their environment. HEDS is at the forefront of the green design movement, having worked on numerous projects that have been recognized for their excellence in sustainable design and commitment to ecological principles.

"We believe enduring architecture springs from a deep understanding of the place, the needs of the project, and the desires of our client merged with the integration of sustainable best practices," she said.

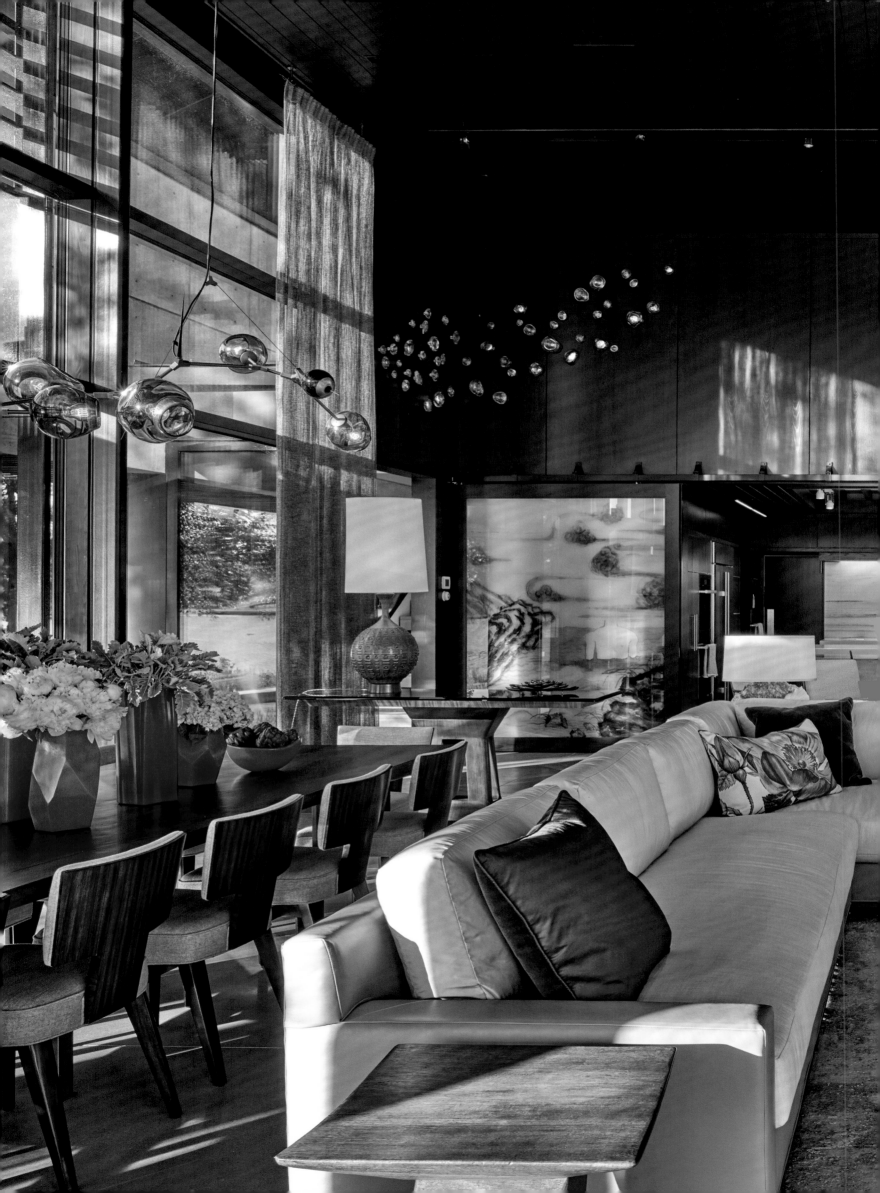

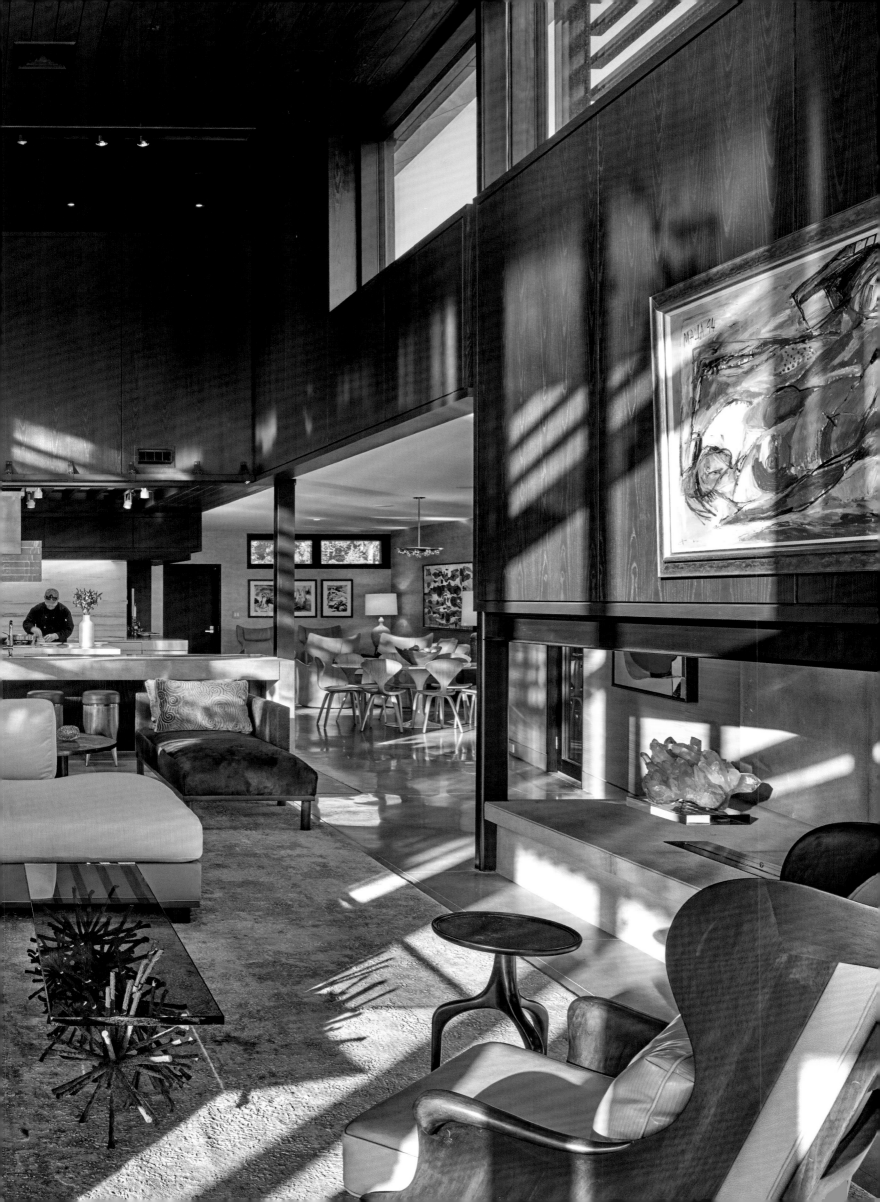

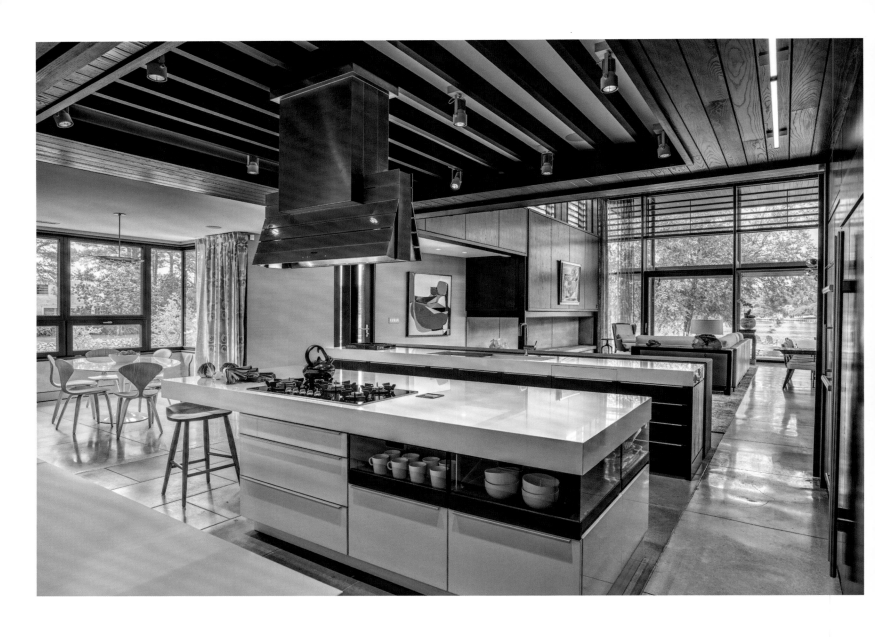

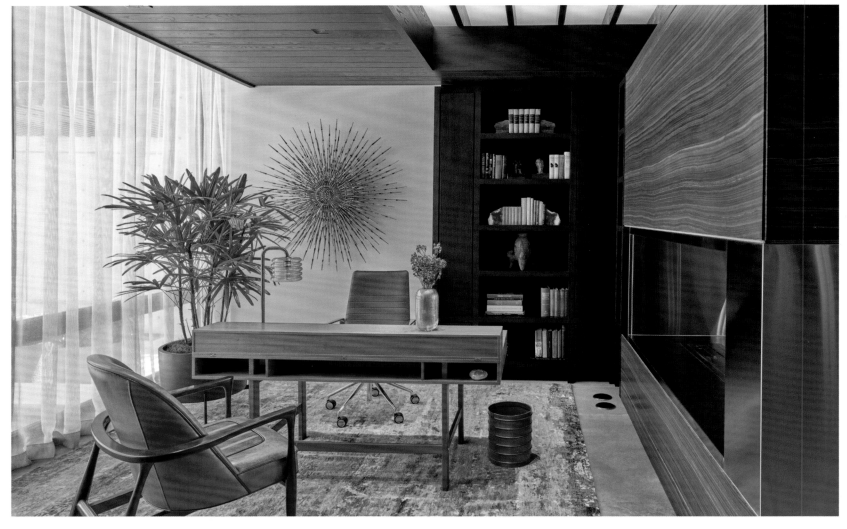

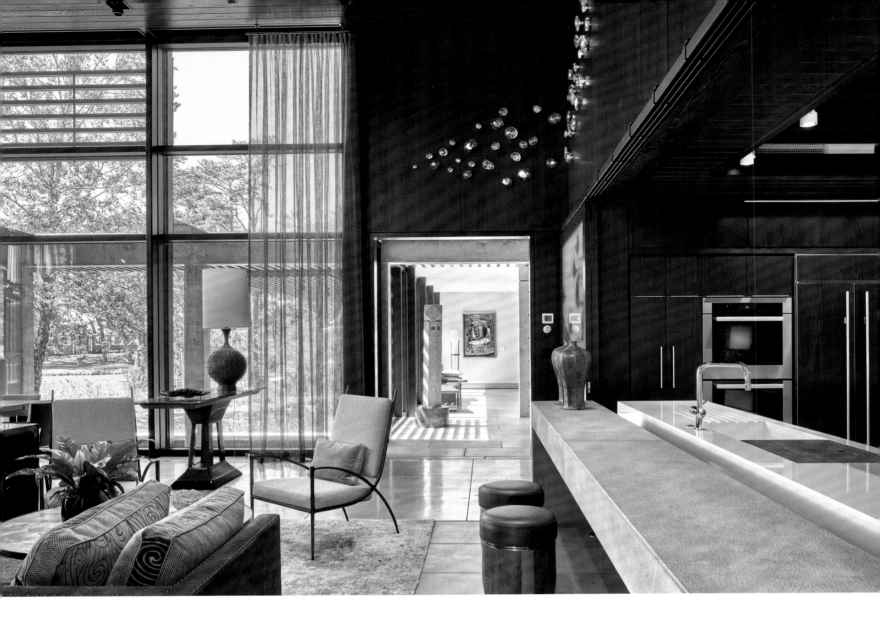

"I don't see function and
aesthetics in conflict —
there is a healthy tension
between the two and
the best of all outcomes
solves for both."

— Allison Ewing

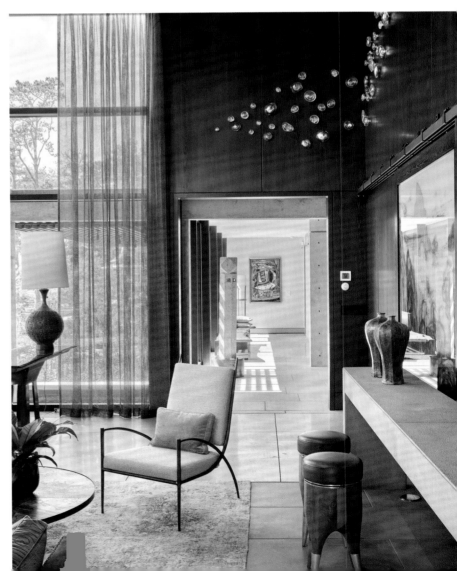

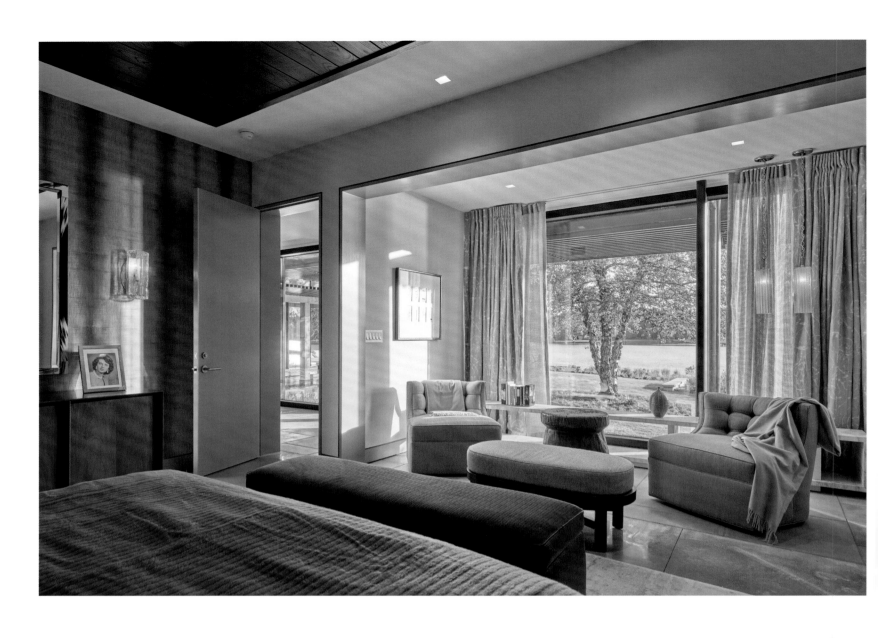

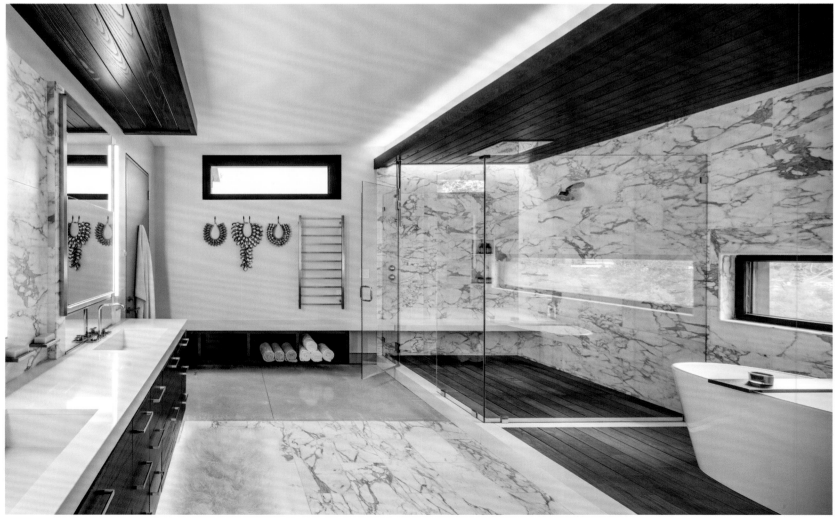

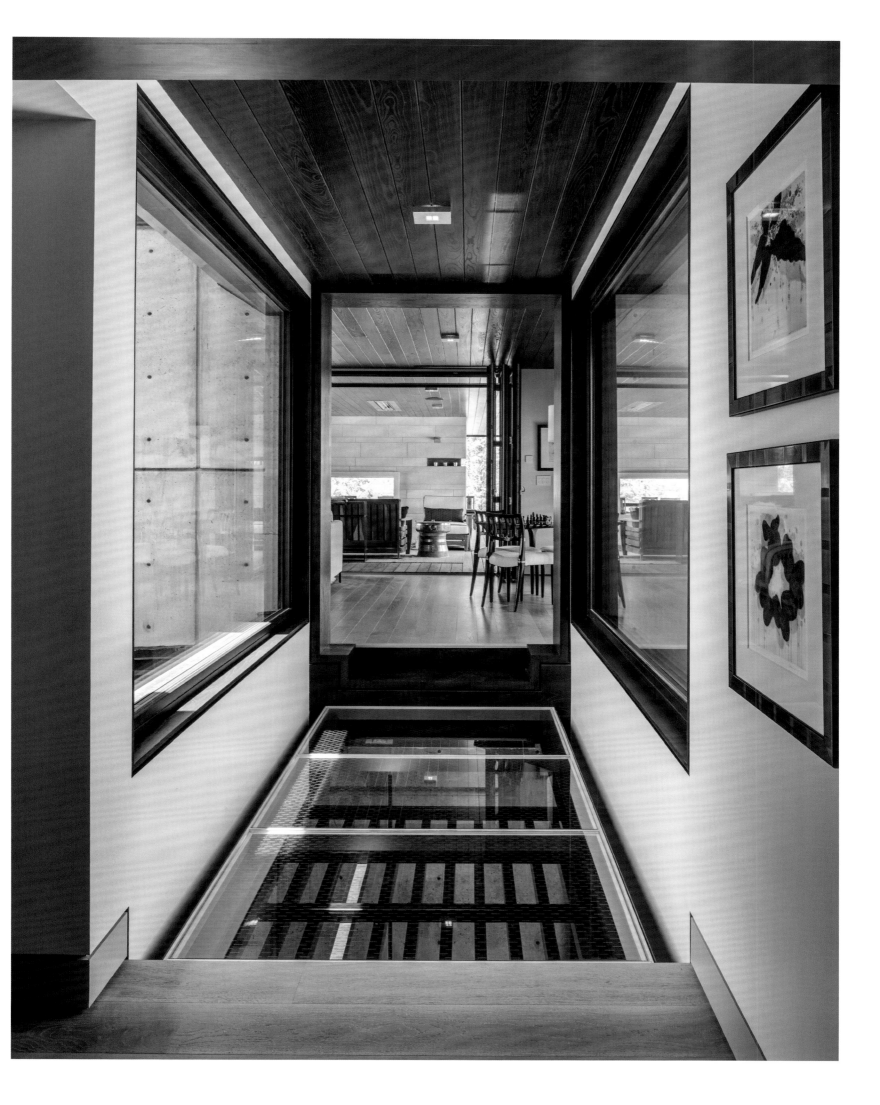

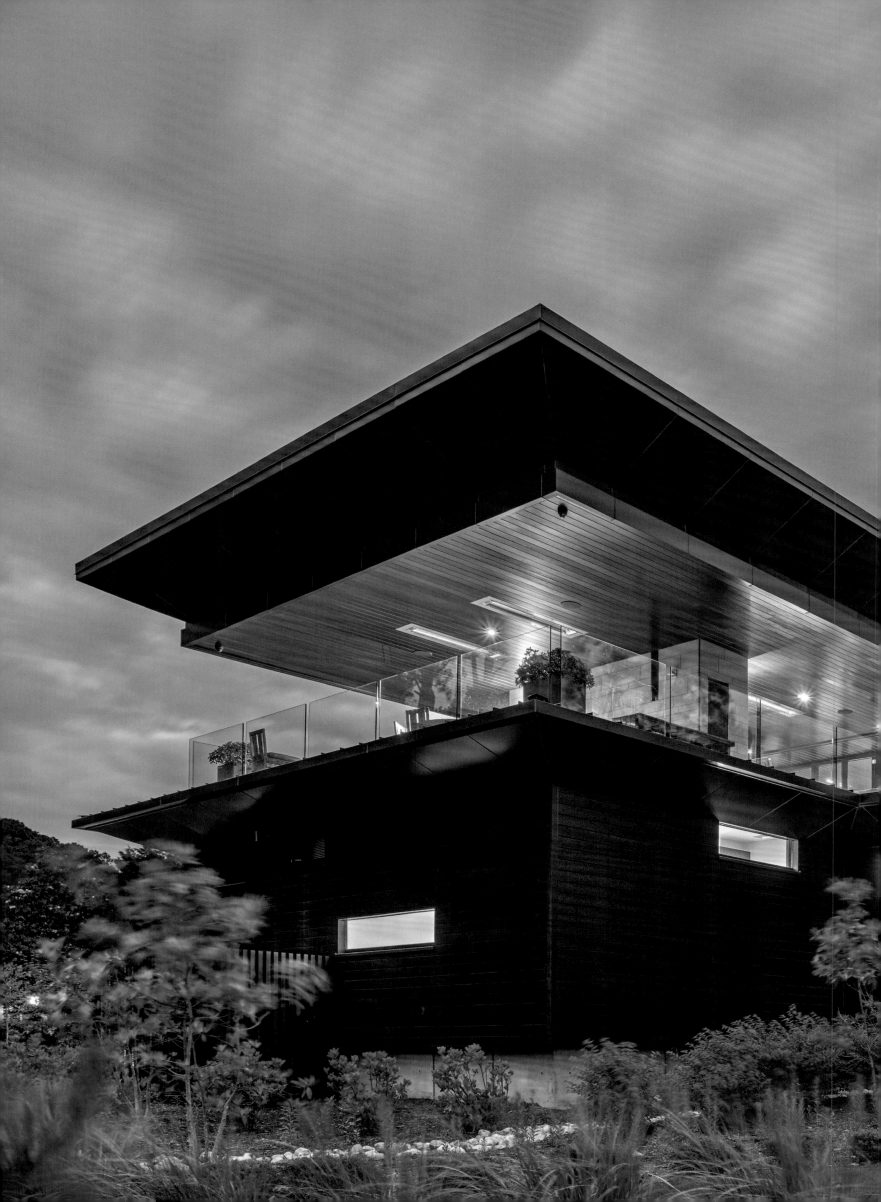

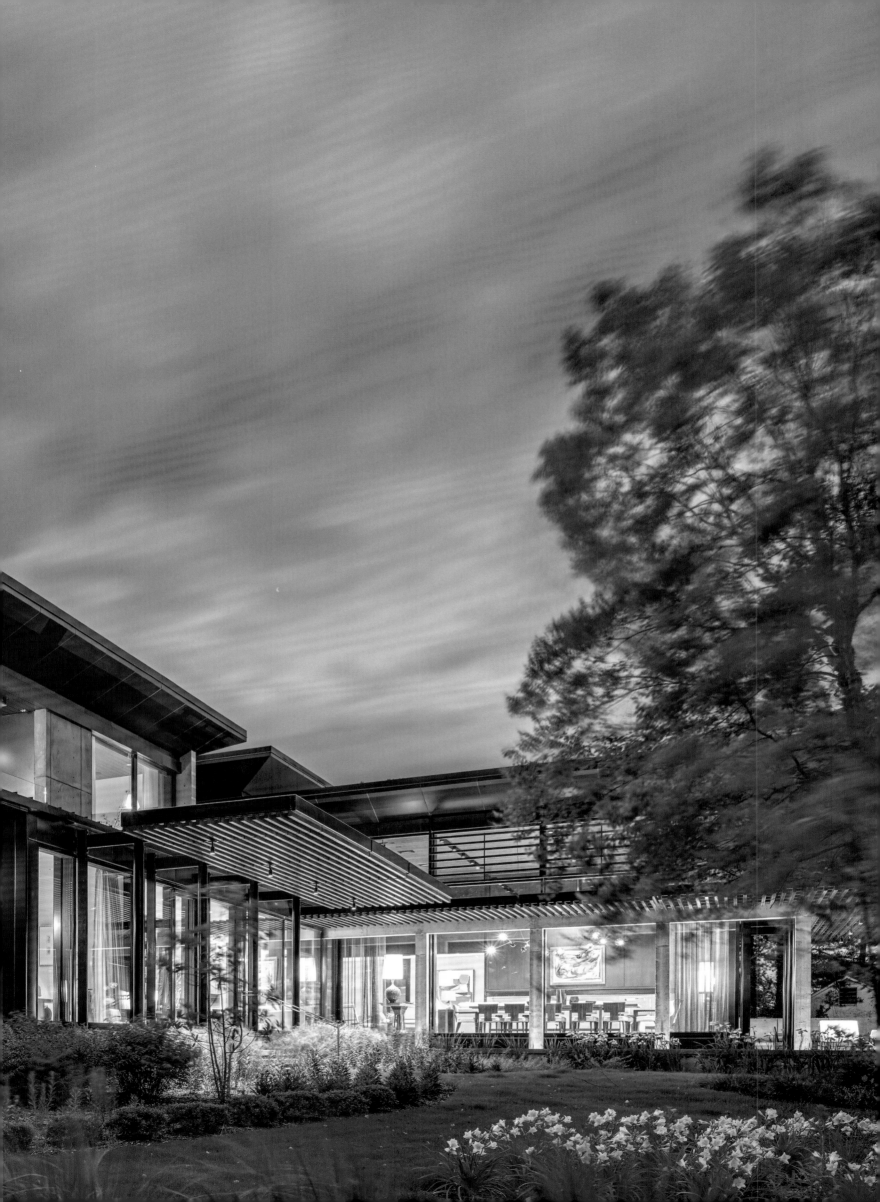

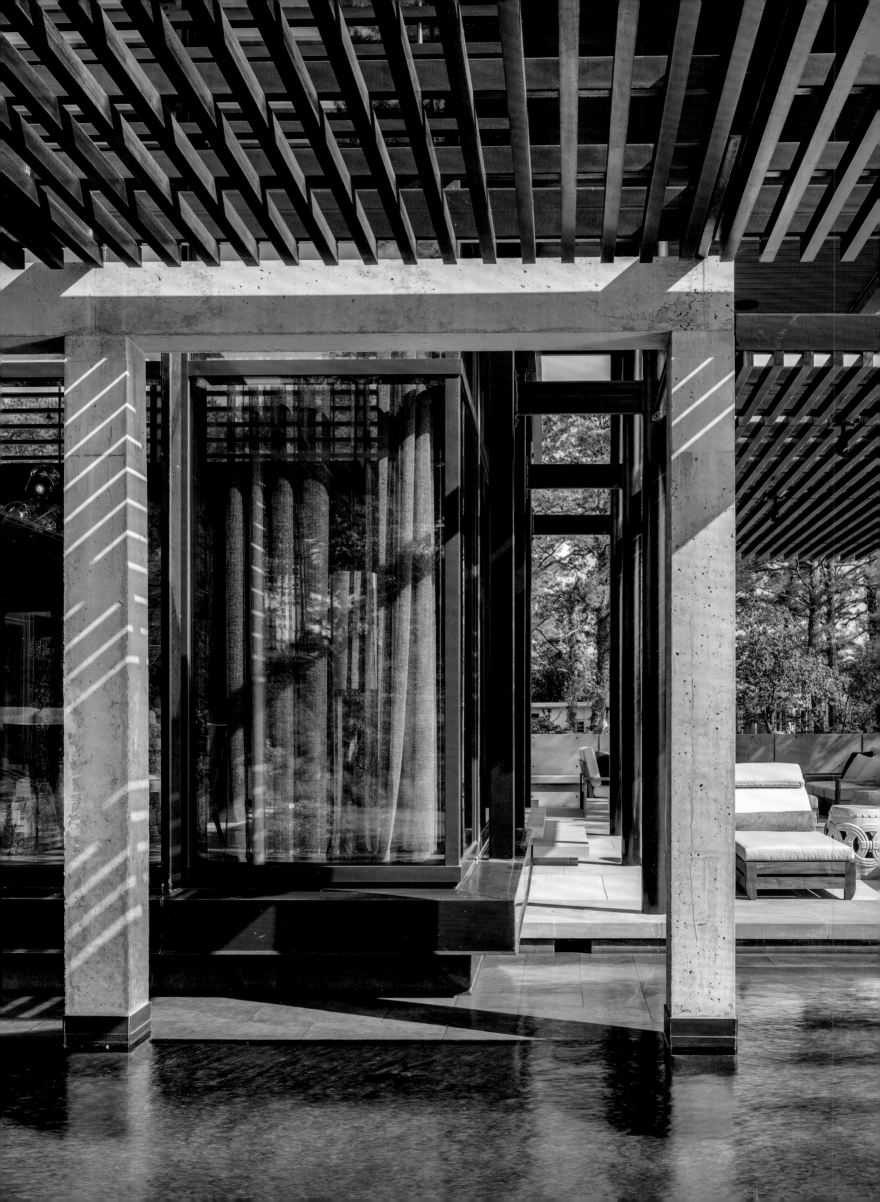

Ewing's international approach to architecture is on full display at a home her firm designed recently in Virginia Beach's Linkhorn Bay, which is part of the Chesapeake Bay watershed area. Situated on a small peninsula facing the woods and a river, Ewing said the Japanese concept of "shakkei," or borrowed scenery, informs the design of the house.

Ewing said the clients on this project were dissatisfied with the home they had built 20 years prior, indicating the quality of the spaces was not appealing and did not represent who they are. They wanted a home in which they could utilize all the spaces, and that also met their functional requirements while elevating daily living.

Ewing's design highlights include a linear fountain that strikes a line along the entry path and appears to slide beneath the house before reappearing at the pool beyond the foyer. The fountain and pool create a dramatic foreground to the water view, Ewing says, while a linear trellis that follows the entry path through the foyer and hovers above the pool helps further connect the homeowners to the views.

The home's roof overhangs and cantilevered roofs also accentuate striking views of the horizon. To create the appearance of a thin roof, Ewing angled and stepped the roof's edges and clad it with a composite metal panel whose sheen reflects the sky.

Creating this feature was a challenge, Ewing says, as she and her team worked to keep the appearance of the roof profiles thin, despite the 24-inch beams at the big cantilever, which help to protect the home against strong storm winds.

The home is air-tight, Ewing says, with insulation two to three times that of a conventional roof system, and employs a "Passivhaus" approach, a German building standard.

"Despite these challenges, the landscape and house siting do a good job of creating a beautiful place that feels integrated and full of nature," Ewing said. "The overarching goal is to make connections between people and nature while enhancing the environment."

---

*Interior Design: Antonio da Motta Leal*
*Landscape: Kennon Williams Landscape Studio*
*Builder/Contractor: J.M. Sykes Inc.*
*Photographer: Prakash Patel*

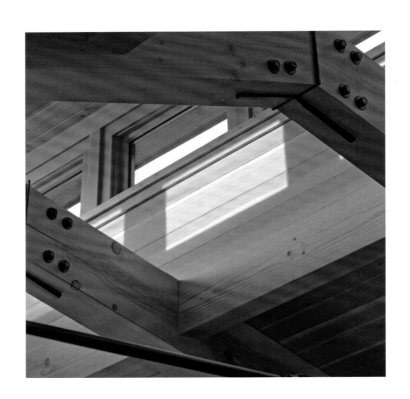

"I believe that every space
deserves beauty and purpose.
For more than twenty years,
our practice has sought
to enrich the evolving
conditions of daily life through
meaningful design."

— Marcus Gleysteen

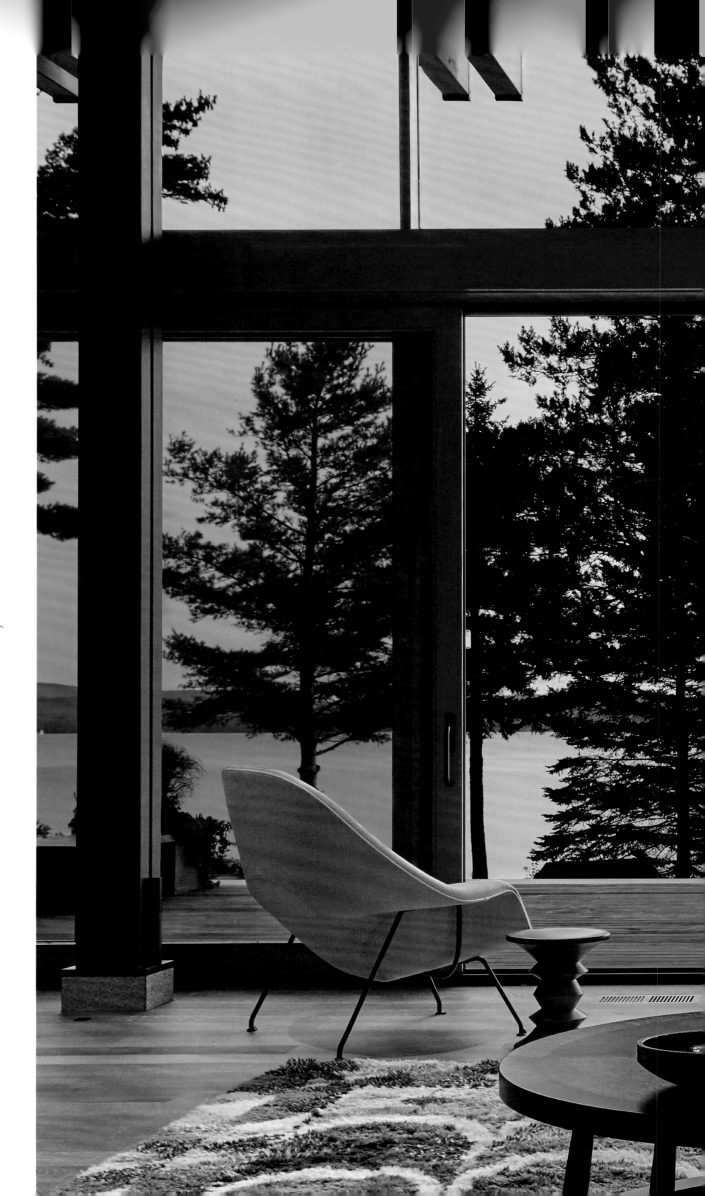

Marcus Gleysteen

Marcus Gleysteen Architects

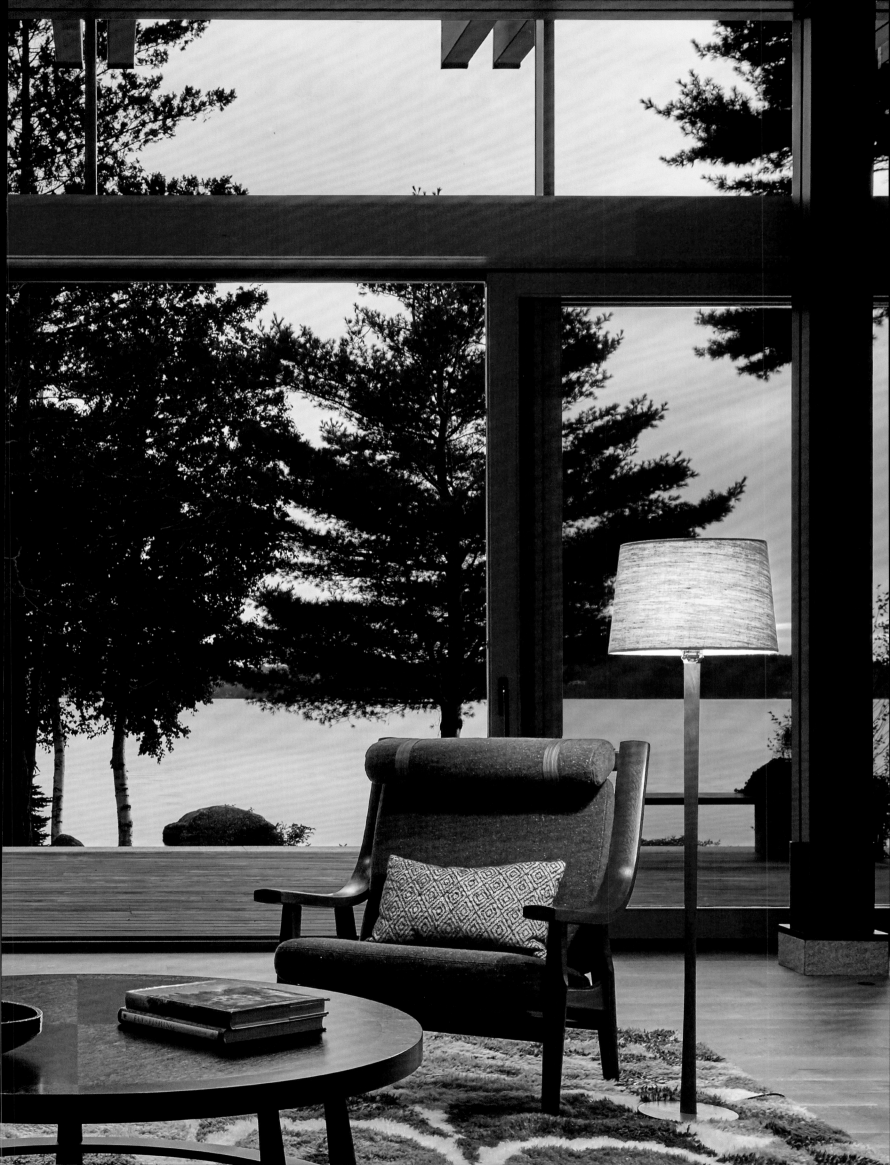

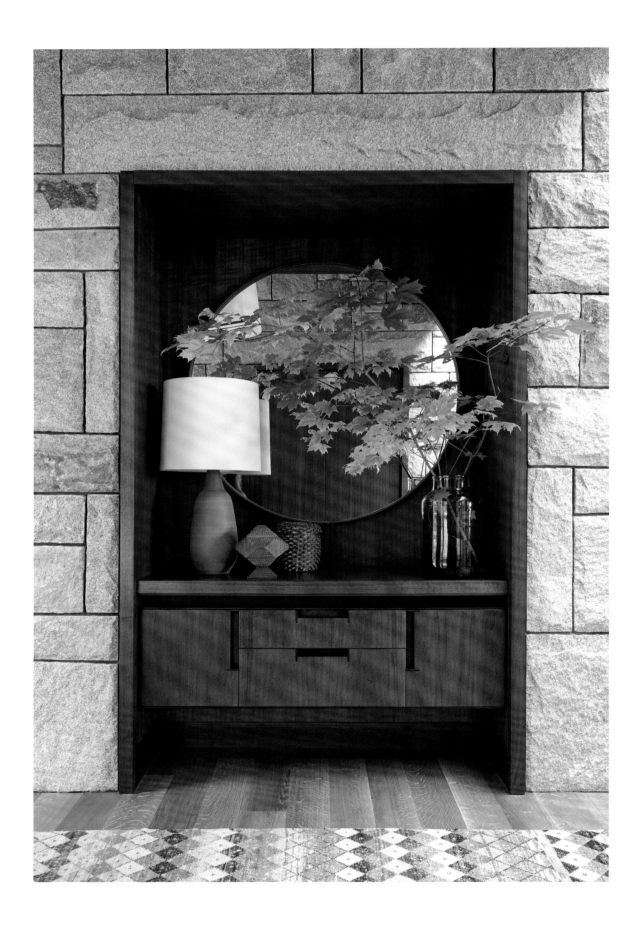

Born in New York, Marcus Gleysteen grew up in a number of different cities, including Washington, D.C., Stockholm; Paris; and Moscow. In high school, he learned basic wood framing while working construction alongside a U.S. Navy crew in Leningrad (now known as Saint Petersburg).

Later, he worked as a model maker for SITE, an architecture and environmental arts studio in New York City, while studying sculpture at the Cooper Union for the Advancement of Science and Art, where he earned a Bachelor of Fine Arts. He next graduated from Columbia University with a Master of Architecture.

Gleysteen's eclectic and international background served him well when he moved to Massachusetts and worked for some of Boston's most prestigious firms.

"The skill sets I discovered in art school, particularly drawing, were like superpowers once I became an architect," he said. "The sense of craft I developed while learning to weld steel, cast bronze, and carve stone was a great foundation for making sculpture out of buildings."

After years of working for other firms, Gleysteen, along with his wife Judy, founded the Boston-based Marcus Gleysteen Architects in 1996. Serving as principal-in-charge, Gleysteen said that over the years his firm has cultivated a more holistic approach to design.

"In addition to elevating the everyday, we consider larger aesthetic relationships," he said. "It's about bringing together various elements in a cohesive manner while carefully directing attention and perception. We have learned to allow some elements to remain very quiet."

Gleysteen said he owes part of his artistic evolution and inspiration to the geography he grew up around in Northern Europe, especially Sweden. "It's very similar to New England," he said. "The lake district and coastlines of Maine and New Hampshire look a lot like Scandinavia. These regions share an ethos of disciplined design and quality craftsmanship, as well as a practical sensibility that I find essential to our work."

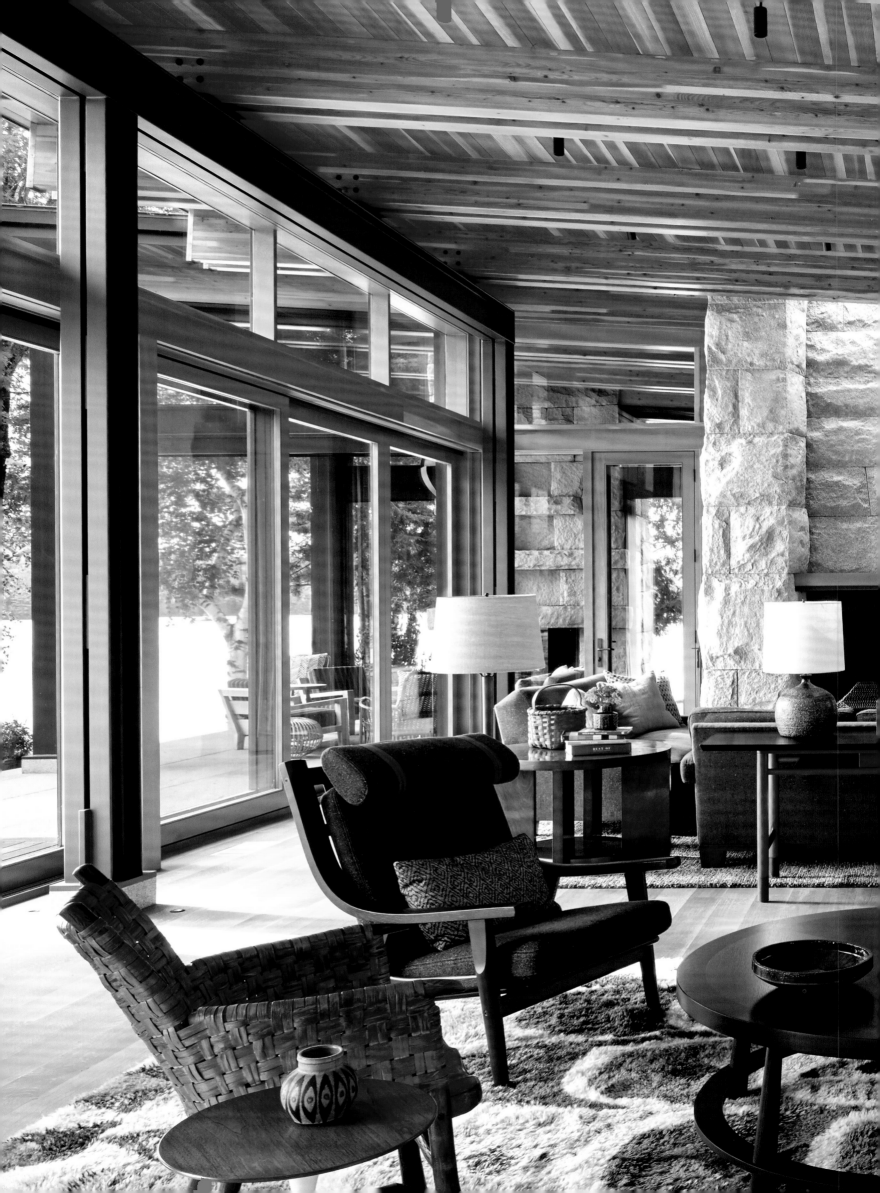

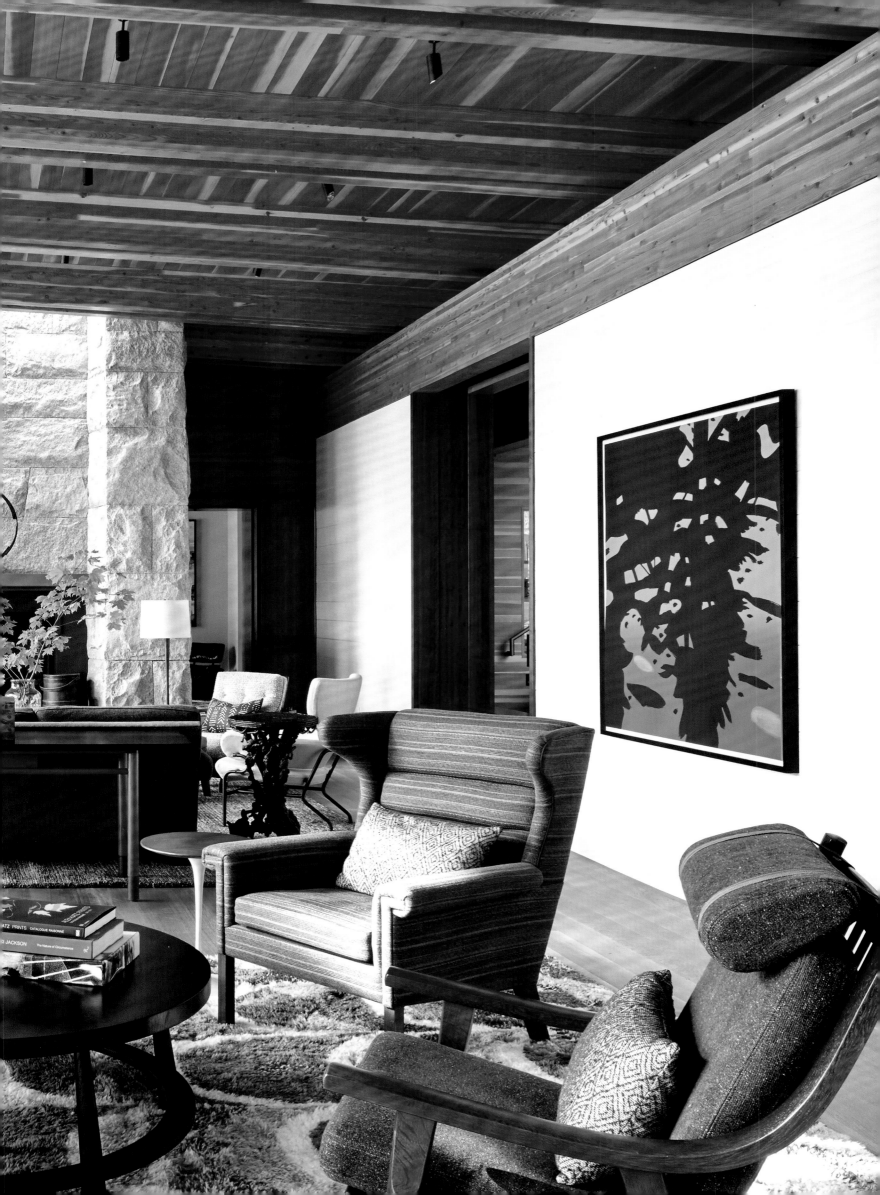

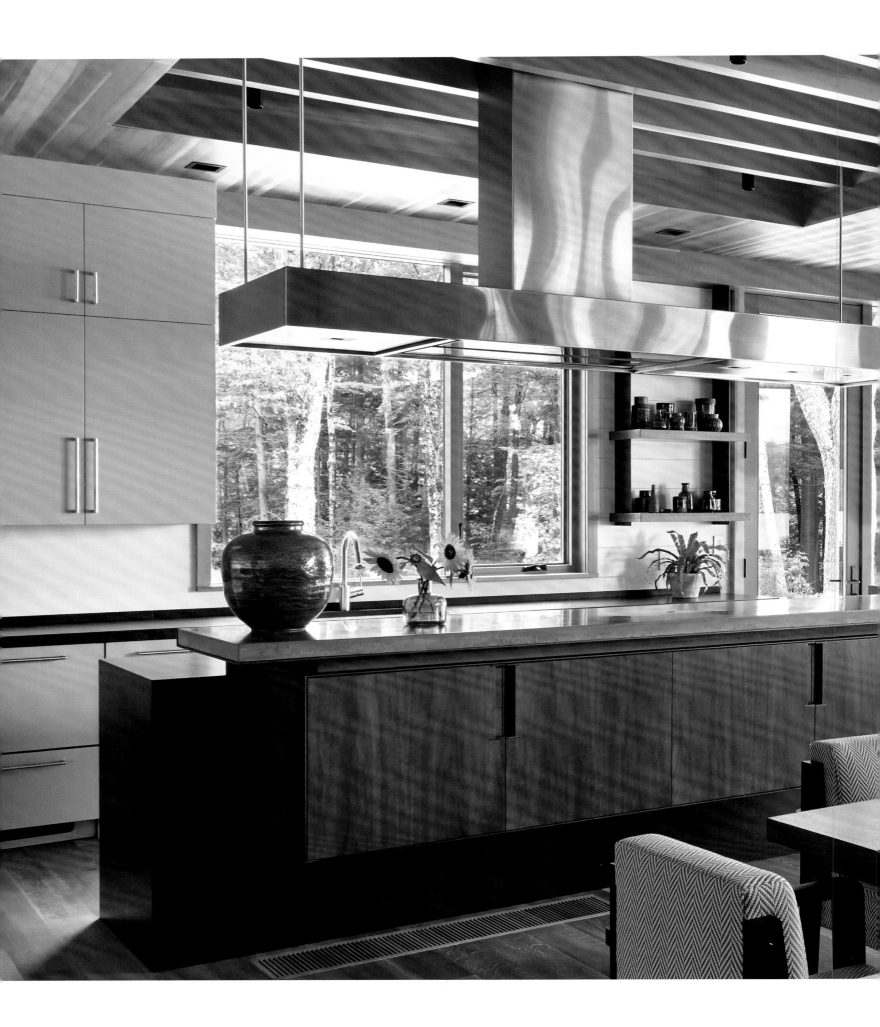

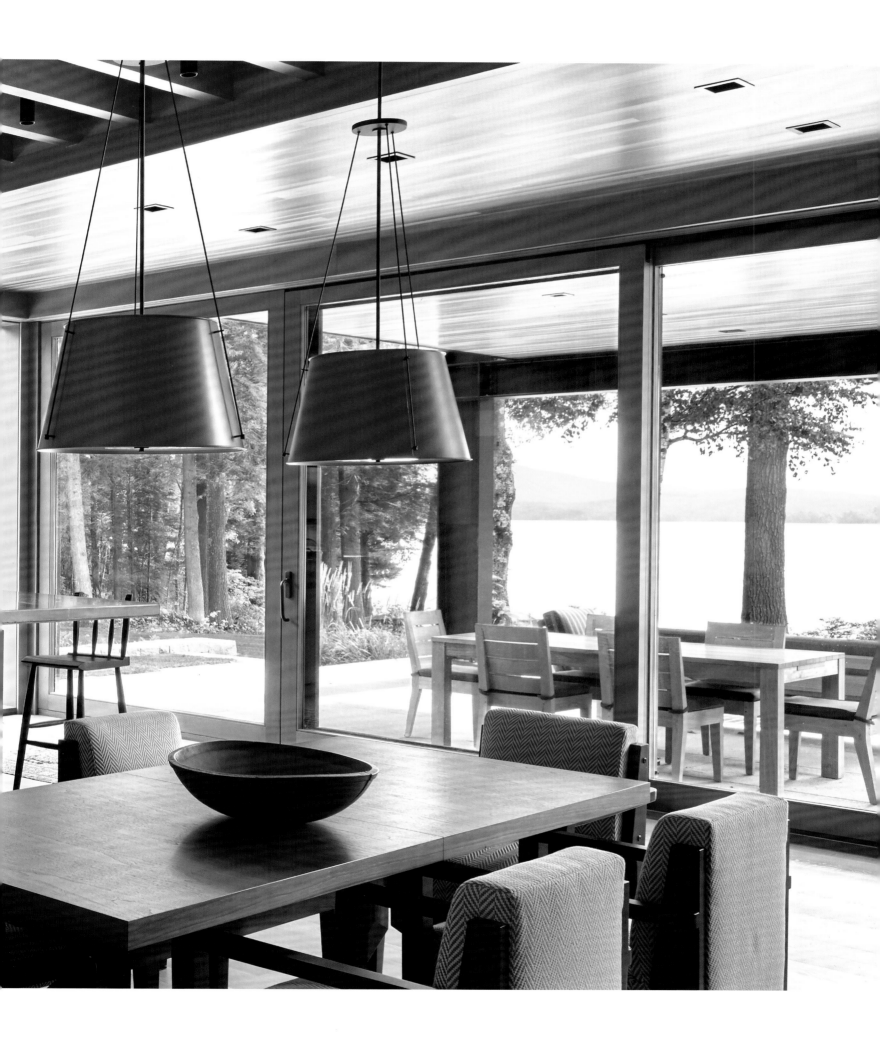

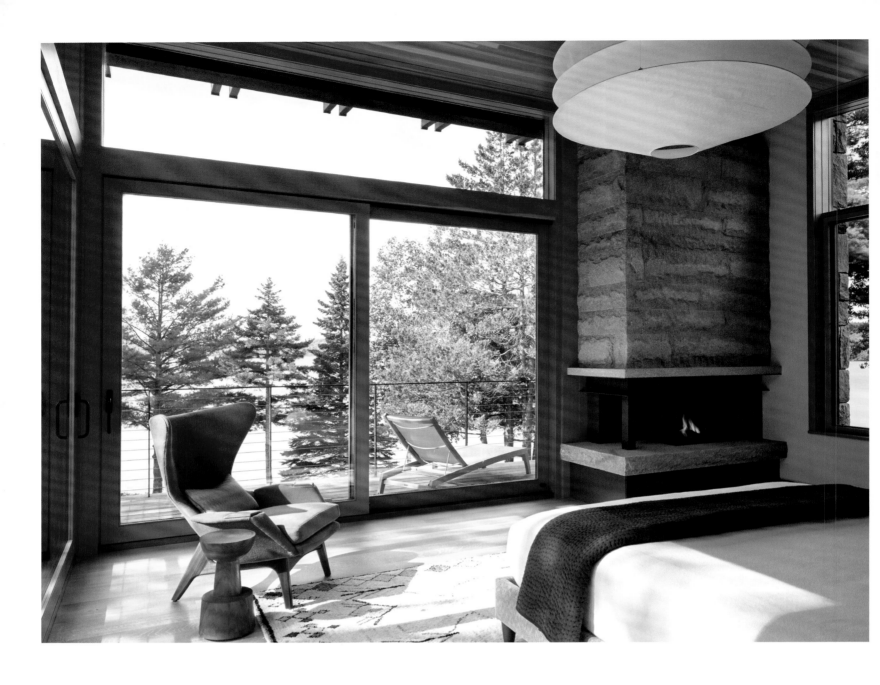

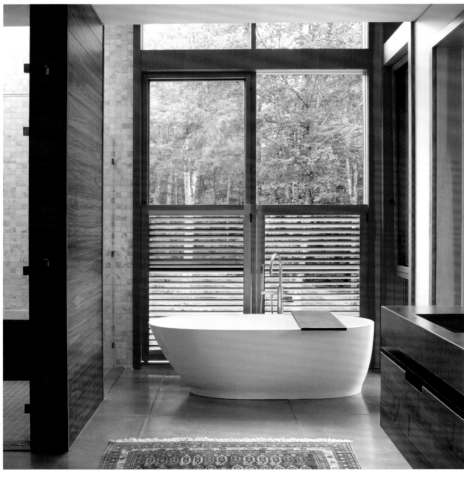

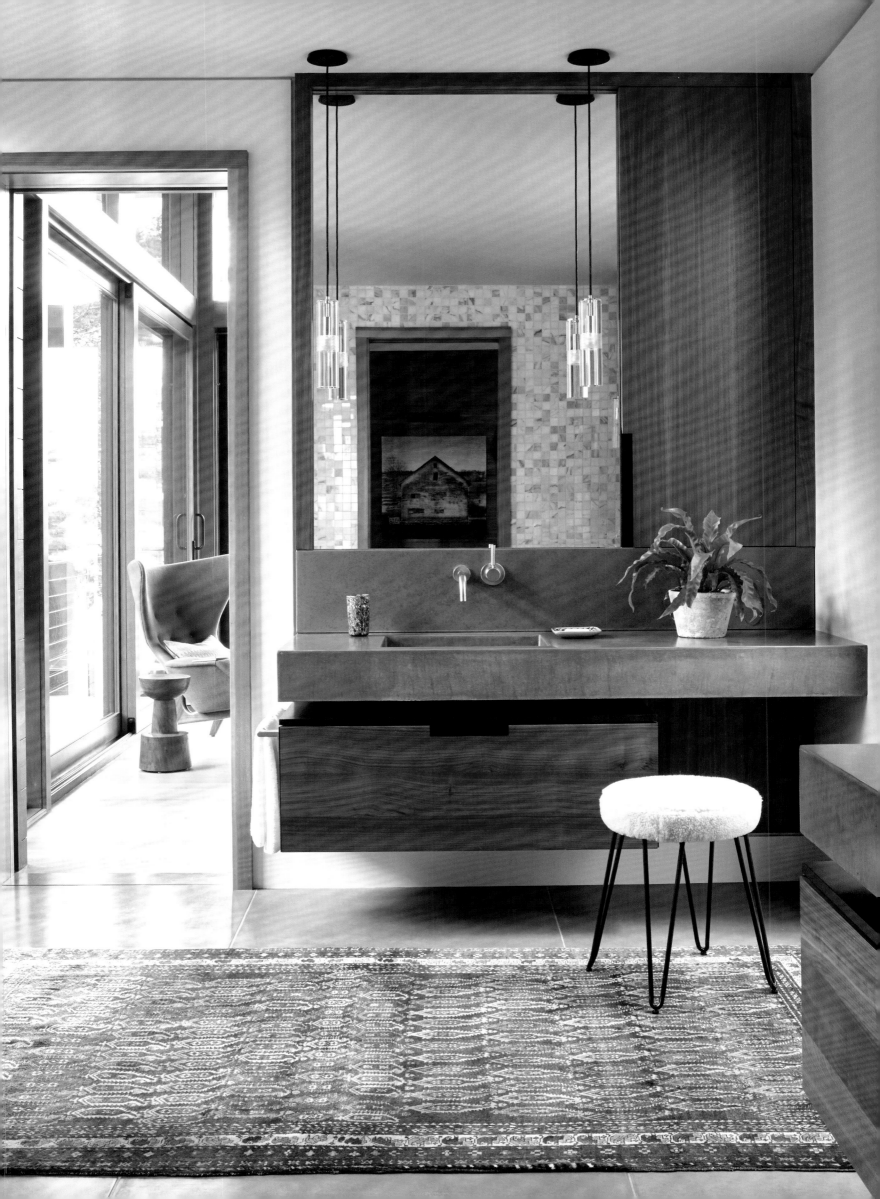

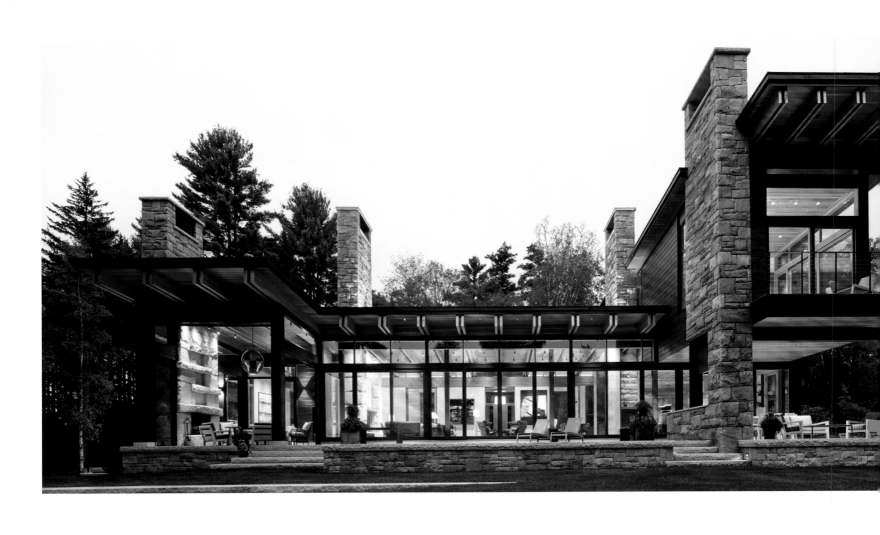
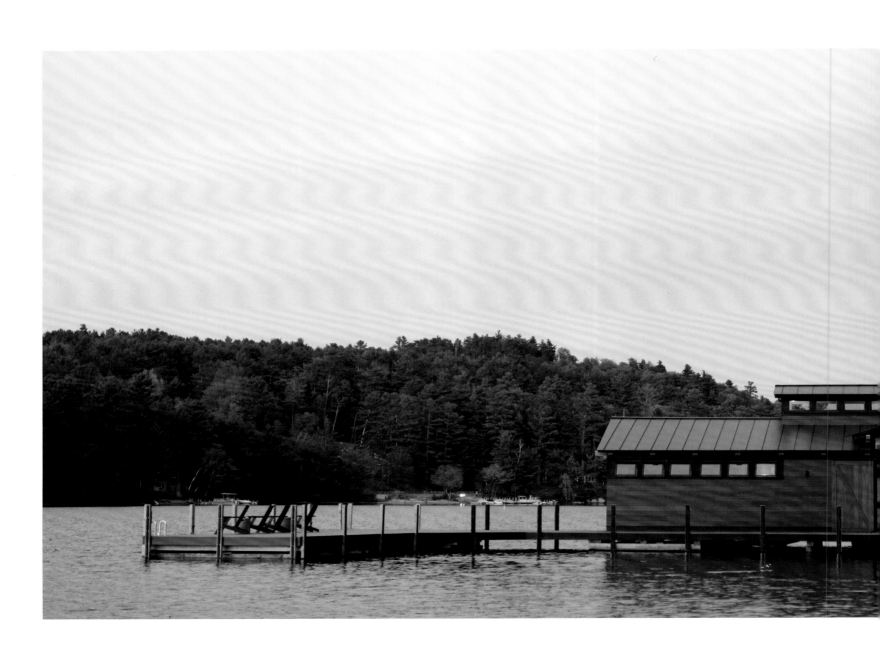

"We interpret our clients and their needs, keeping in mind that we are not going to live there. In the end, each house is a physical manifestation of the identities of the people who inhabit it."

— Marcus Gleysteen

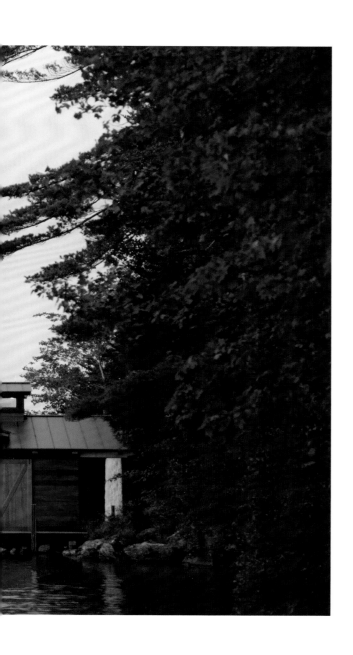

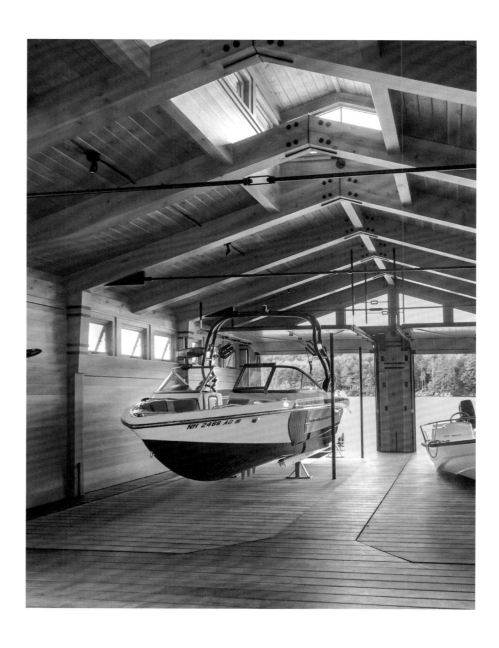

Gleysteen said that when working with clients, he sees himself as more of a guide than a leader. "Our primary responsibility is to help our clients articulate what they want so that we can give it to them. We also endeavor to introduce them to concepts we know they are going to like that might initially be out of their comfort zone."

In the case of the Lake Point House, the clients sought a permanent residence for their large family — a stunning and dynamic home that could accommodate day-to-day living as well as big parties and social events.

The Lake Point House is situated along the shore of the 4,136-acre Lake Sunapee in western New Hampshire. "The site was so beautiful that the architecture had to get out of the way," Gleysteen said. "The main approach was to make sure the house provided all its necessary functions while celebrating the site."

Gleysteen said one design choice that helped organize the mass of the project was separating two-bedroom wings by a single-story volume flanked by double chimneys. This enabled the house to sit gracefully as part of the landscape without dominating it. Additionally, the home was designed with a tripartite plan that demarcates three separate zones, making the structure equally comfortable and appealing whether it's used by two people or 20. The primary zone includes the kitchen, informal dining area, and master suite. The second is a private guest wing, while the third zone is a formal dining room and a great room for gathering and entertaining.

The expansive home employs a tectonic play of wood, stone, and steel, an homage to the rugged magnificence of New Hampshire. Unique interior touches include a massive fireplace in the great room which is composed of hand-chiseled granite and boasts custom doors that roll out from pockets set within the stone.

Offering spectacular lake views, the home's deep overhangs soar toward the sky while giving protection from the elements. Expanses of Vermont-quarried granite and layered columns establish an organic rhythm and ground the home in its woodland surroundings.

"For our firm, the beginning of the process is about really listening to our clients," Gleysteen said. "It's only after listening that we can apply our experience and skills, resulting in a project that exceeds their needs and desires."

---

*Interior Design: Heather Wells, Inc.*
*Landscape: Pellettieri Associates, Inc.*
*Builder/Contractor: C.W. Ostrom Builders, LLC*
*Photographers: Joshua McHugh, Marcus Gleysteen*

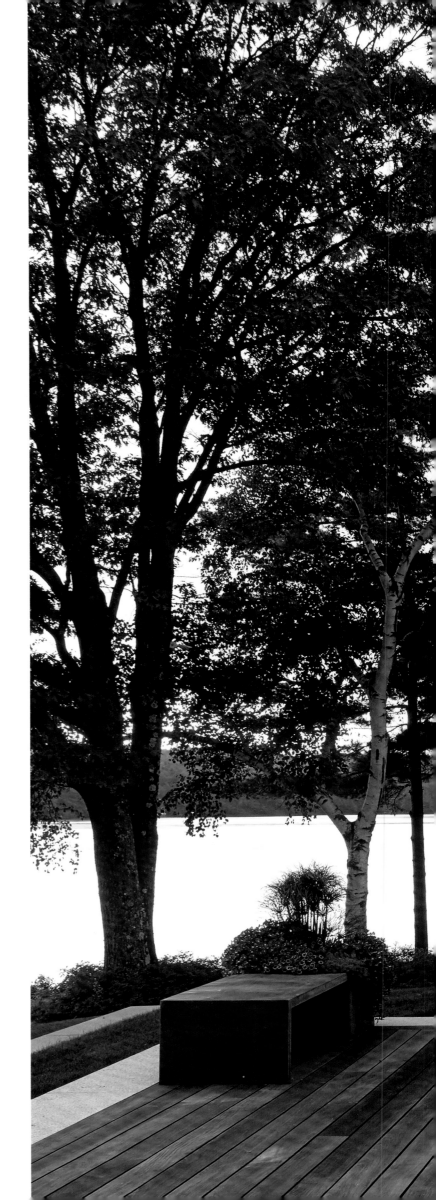

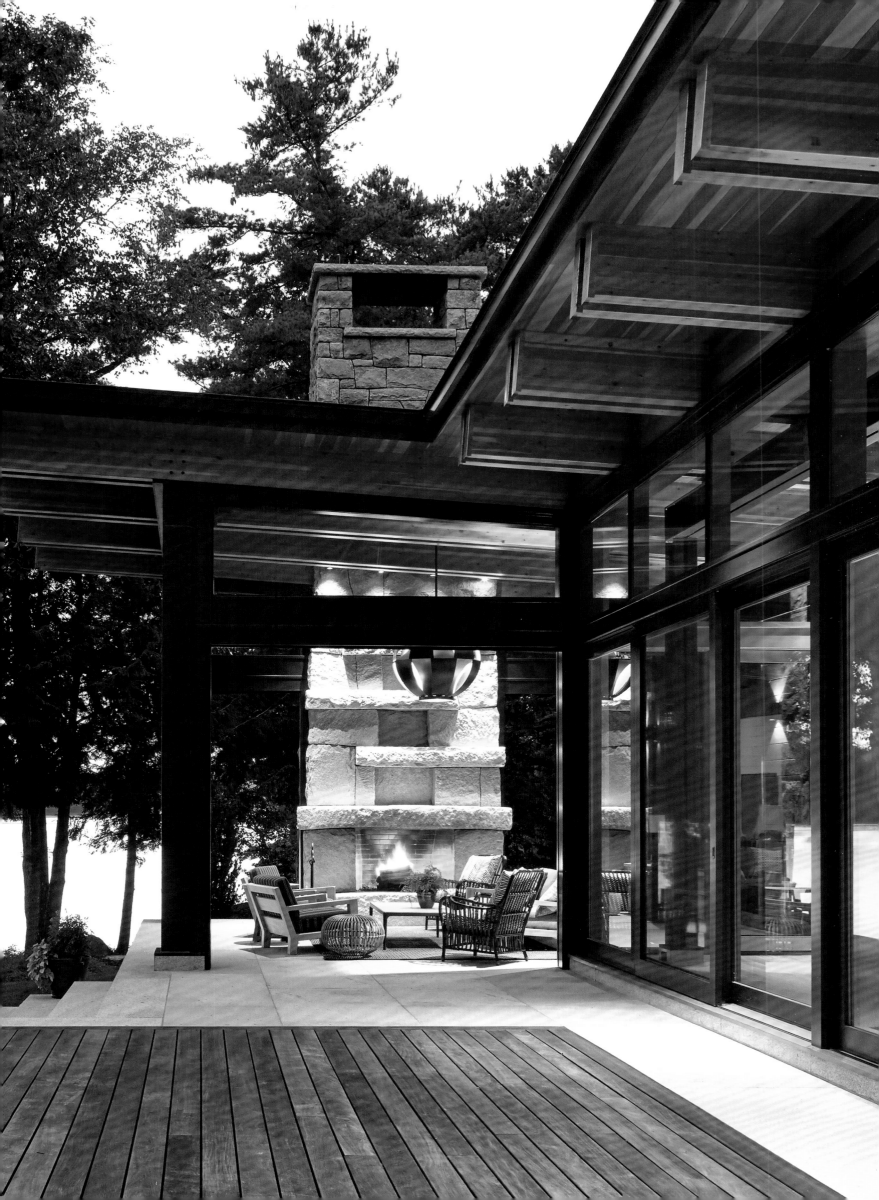

"I have become more confident in my abilities and more willing to take chances. That is also a function of experience, in that our clients are more willing to trust that we will create the home they imagined."

— Gale Goff

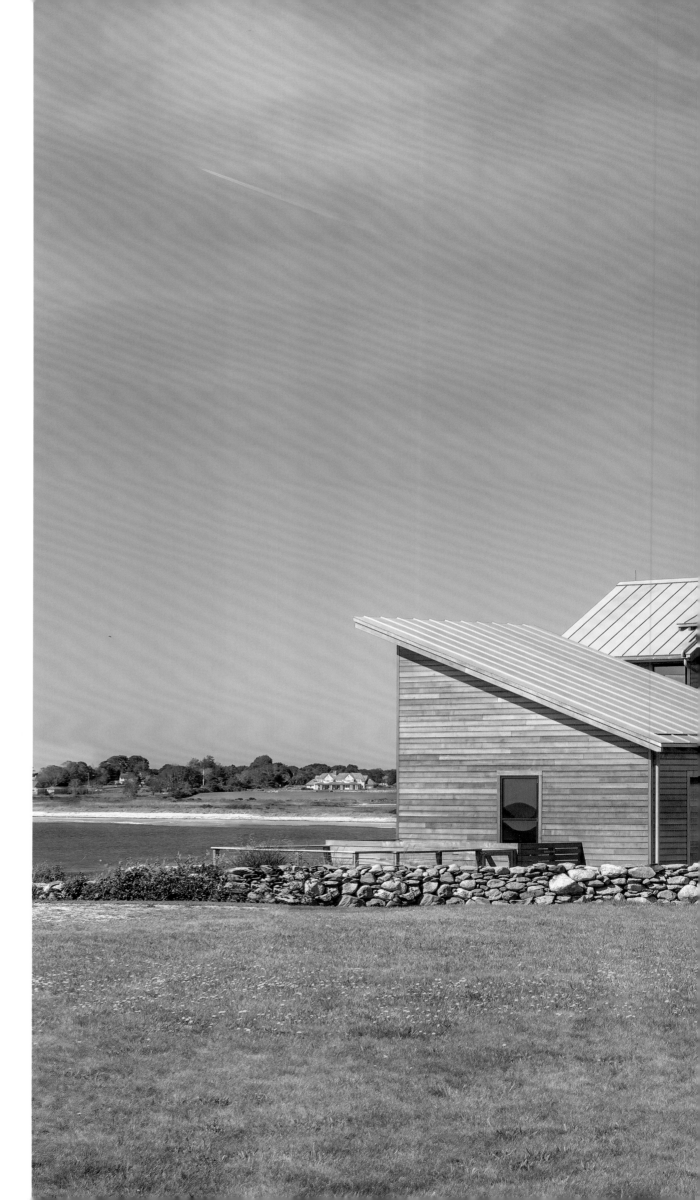

Gale Goff

Gale Goff Architect

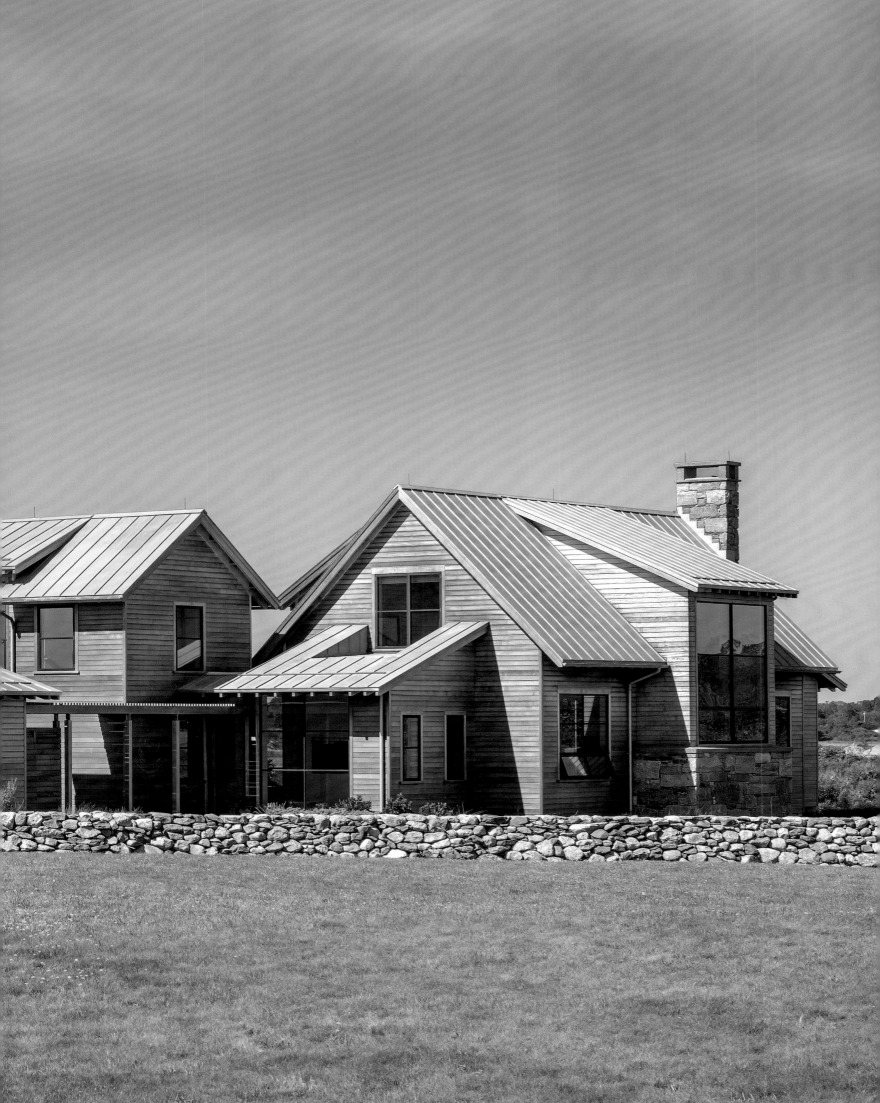

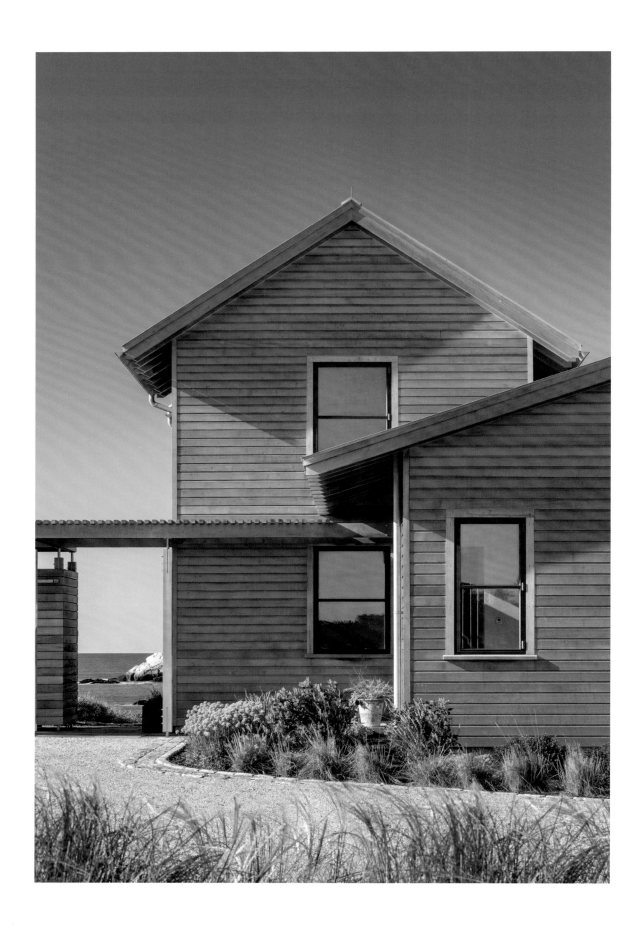

With more than 35 years of experience, Gale Goff said her work is strongly influenced by geography and a sense of place. Rhode Island is a state that boasts a rich architectural heritage, especially in the historic coastal areas of Little Compton and Newport.

"These fine examples of architecture have been an inspiration to me throughout my life," said Goff, who graduated from the Rhode Island School of Design. After working at various firms and 20 years as a design associate at Estes Twombly Architects, she founded Gale Goff Architect in 2010. Based in Little Compton, Rhode Island, the four-person firm also includes Barrett Borden, Pete Landis, and Jeffrey Scorza.

Most of the homes her firm designs are located on the coast, so Goff and her team place a great deal of emphasis on views and exposure. "The New England climate dictates the level of materials for the building envelope, insulation, and mechanical systems," she said, adding that there are iconic regional forms and materials that she likes to use in new and unpredictable ways. Lion Rock Farm is made up of a collection of gables and shed roofs, which are traditional to the area, but the massing and juxtaposition are her own interpretation. Goff feels that some of the more interesting houses have surprises and maybe a bit of humor.

These innovative design choices showcase Gale Goff Architect's approach, which includes using light, shadow, simple detail, technology, and classic New England forms to create residences that reflect the client's needs, wishes, and dreams.

Goff believes in carefully balancing function and aesthetics, with every square foot and design element serving a well-planned purpose. "If an element fulfills the need for which it was intended and is crafted beautifully in fine materials, it will be aesthetically pleasing," she said.

Goff said that when she begins a project, her first priority is to understand the features and restrictions of the site, especially if it's within the jurisdiction of the coastal and wetland agencies or in a flood/velocity zone.

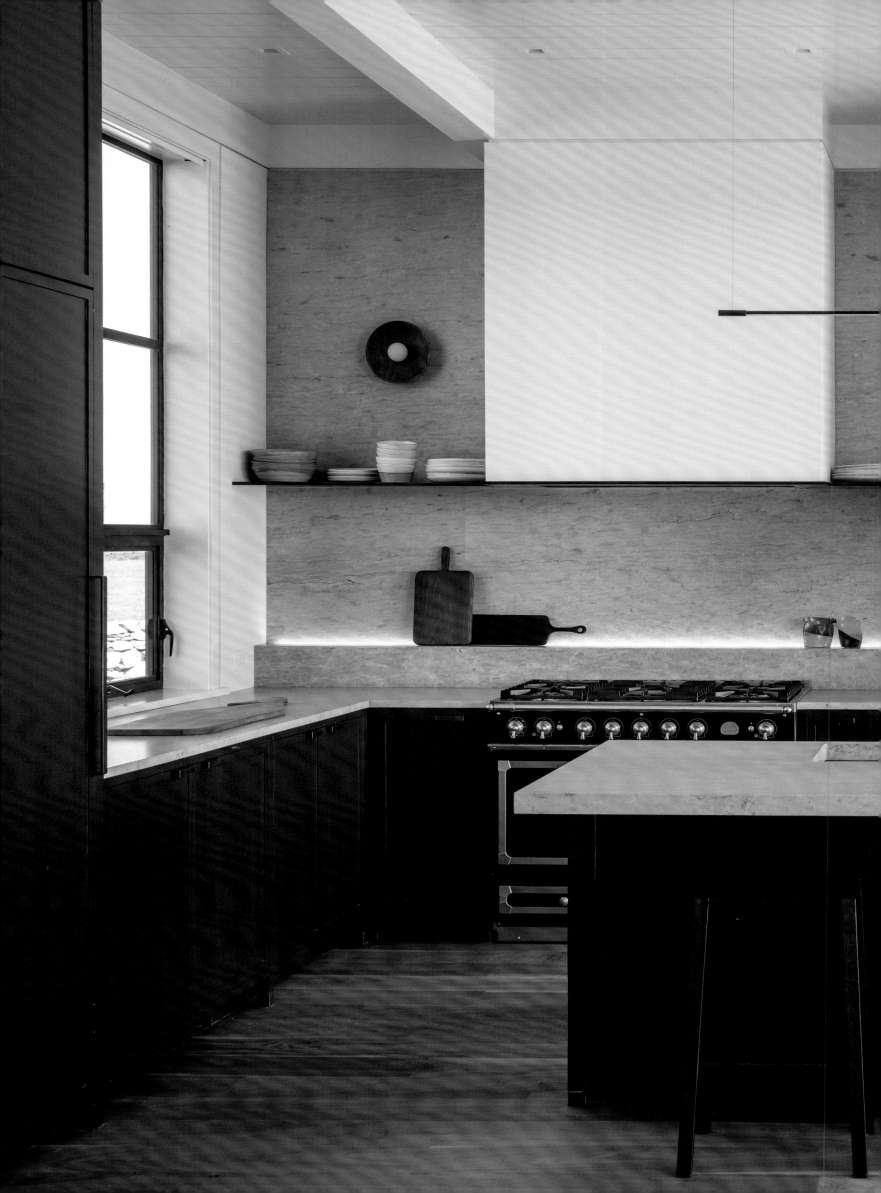

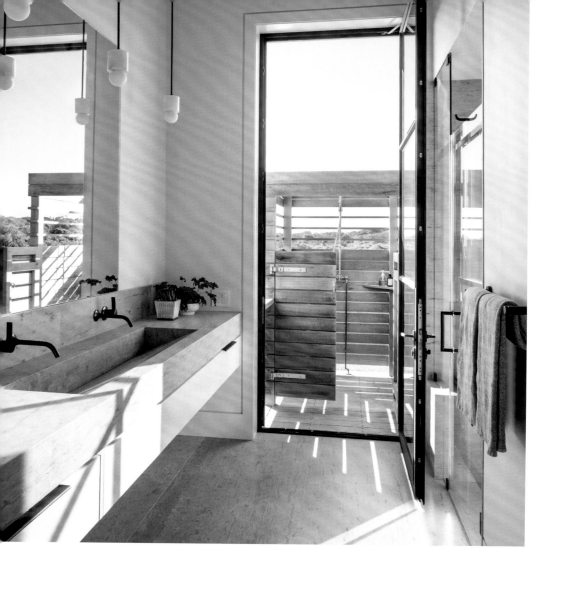
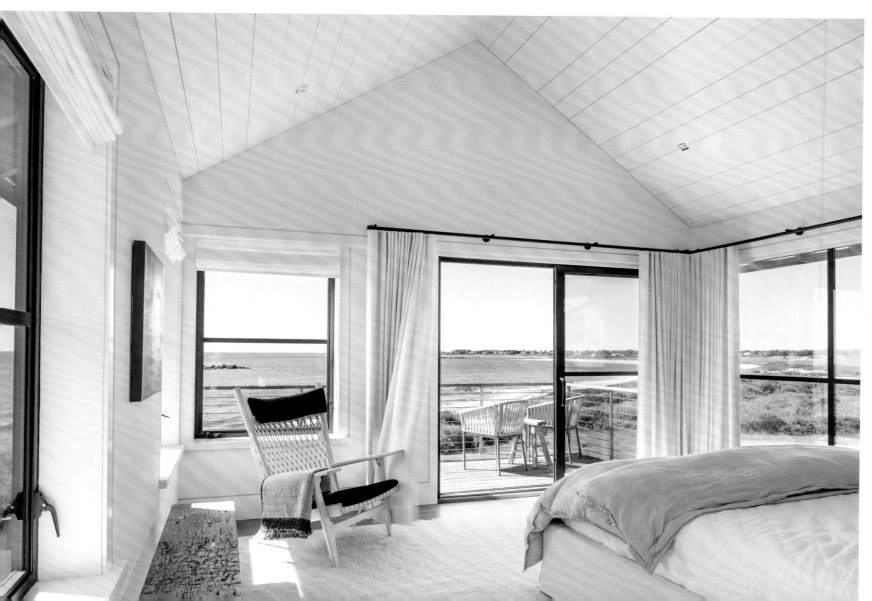

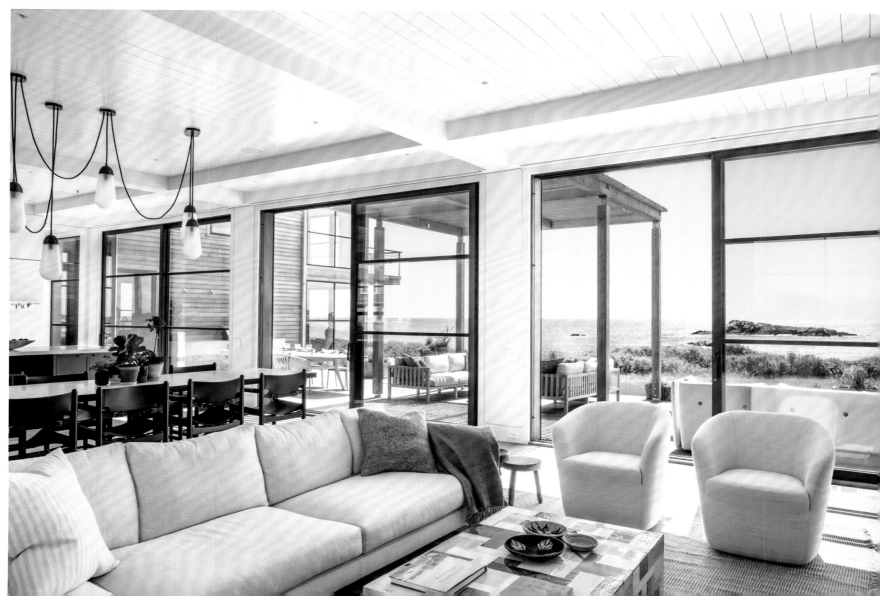

"The architectural field is always evolving with new technologies that provide an opportunity for creative expression and intimate interaction with one's clients."

— Gale Goff

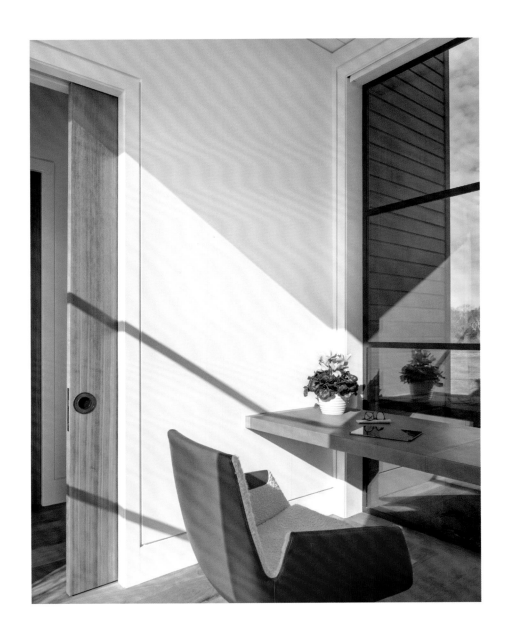

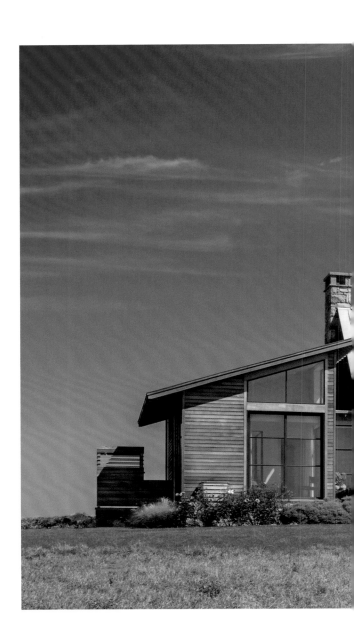

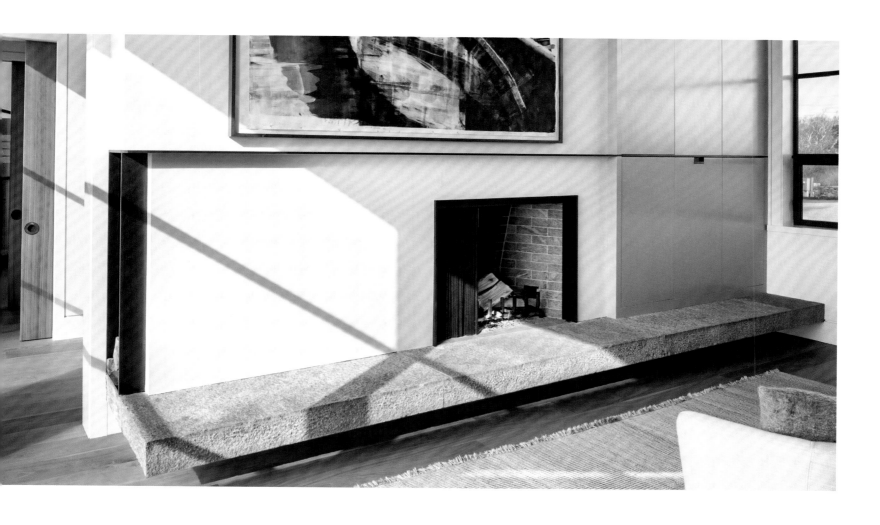

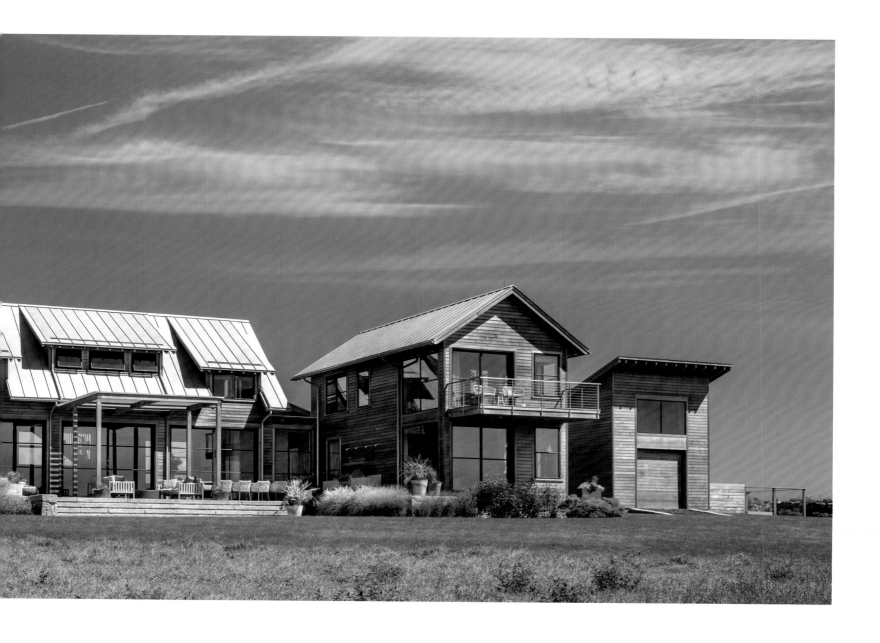

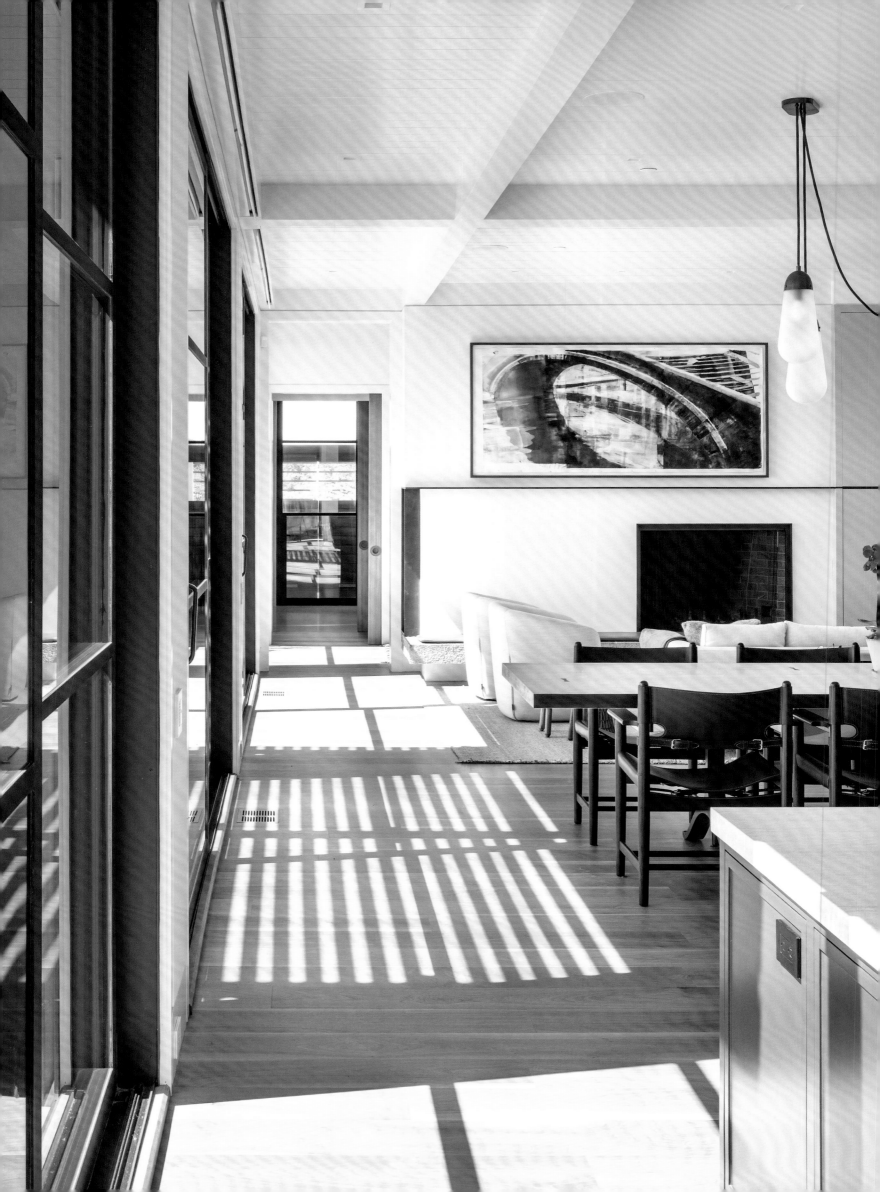

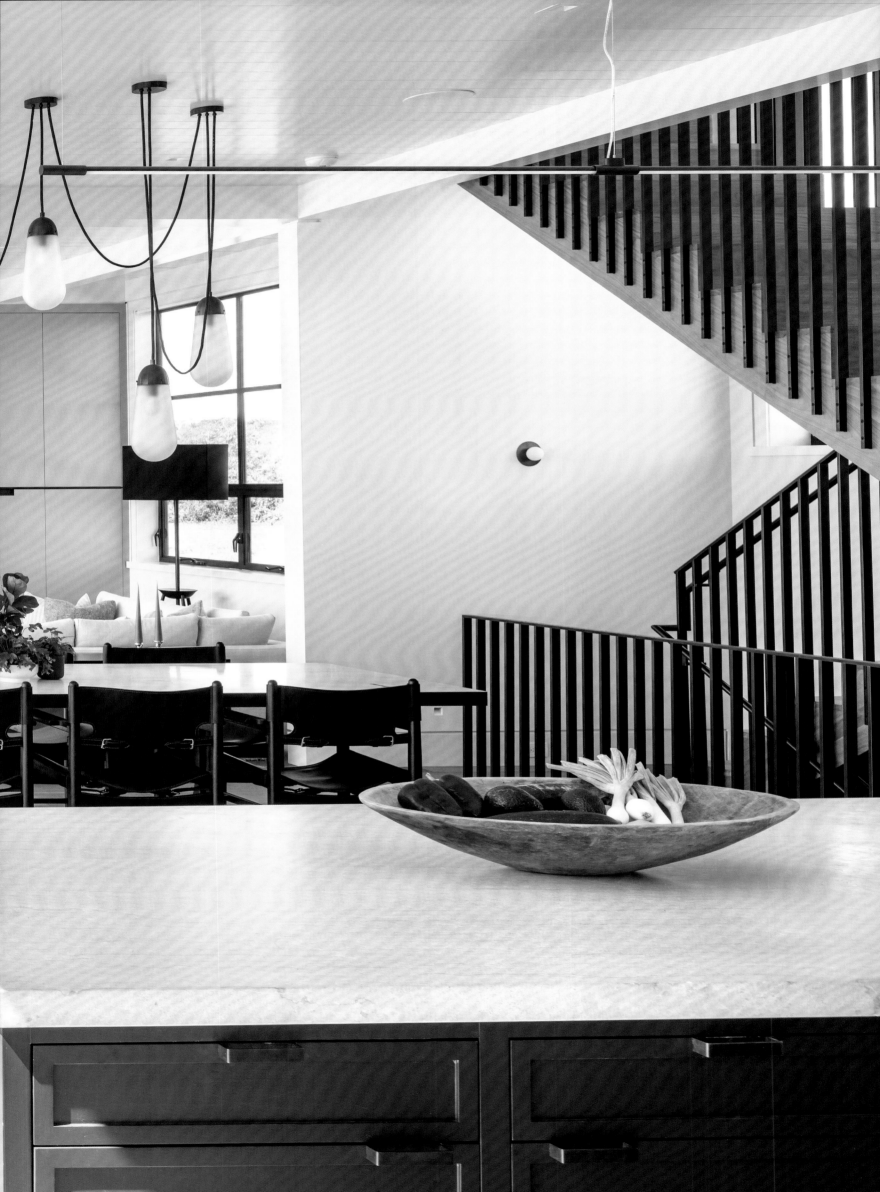

The Lion Rock Farm house posed a unique challenge, as the owners purchased a south-facing parcel that projects out into the Atlantic Ocean. The site, with its own micro-climate, is buffeted by ocean winds and salt spray. The home needed to be built with durable materials, high-performing moisture barriers, and top-notch carpentry detailing.

Goff said the clients wanted a home that could accommodate four generations of their active, growing family. After consulting with the homeowners about how they wanted to move through the house and what views were important to them, she designed a residence that is a collection of volumes organized along a spine that begins and ends with an outdoor shower.

The garage has ample storage for bicycles, surfboards, and kayaks. The east owners' wing extends toward the water and has a private study below and a suite/balcony above. The central great room incorporates a cook's kitchen, pantry, dining, and living room with a wood-burning fireplace. A bronze and walnut staircase leads to the second-floor guest bedrooms. The west wing is a private guest retreat and terminates with a private outdoor shower. All the spaces have expansive views of the Atlantic through massive stainless-steel windows and sliding doors.

Interior details include floors that are a combination of quarter-sawn walnut and fossilized stone tiles with a narrow linear bronze threshold between. Bronze detailing was used throughout, including the fireplace mantel, stair railings, kitchen shelf detail, and hardware on the custom walnut doors and cabinets.

To help protect the home against the elements yet maintain the design intent, Goff used exterior materials that are both resilient and elegant. The exposed foundation is hand-selected granite lintels, while the patio is historic bluestone pavers. The exterior siding is tongue and groove Alaskan yellow cedar and an Accoya rain screen. The standing seam roof is zinc-coated copper.

"My job is to listen carefully and then create the house that my clients will be happy with," Goff said. "It isn't always what they think they want, but I try to read between the lines and expand their imagination to explore the possibilities and achieve a better house."

*Interior Design: C&J Katz Studio*
*Landscape: Martha Moore*
*Builder/Contractor: Jacob Talbot Fine Homebuilders*
*Photographers: Warren Jagger, Anthony Crisafulli*

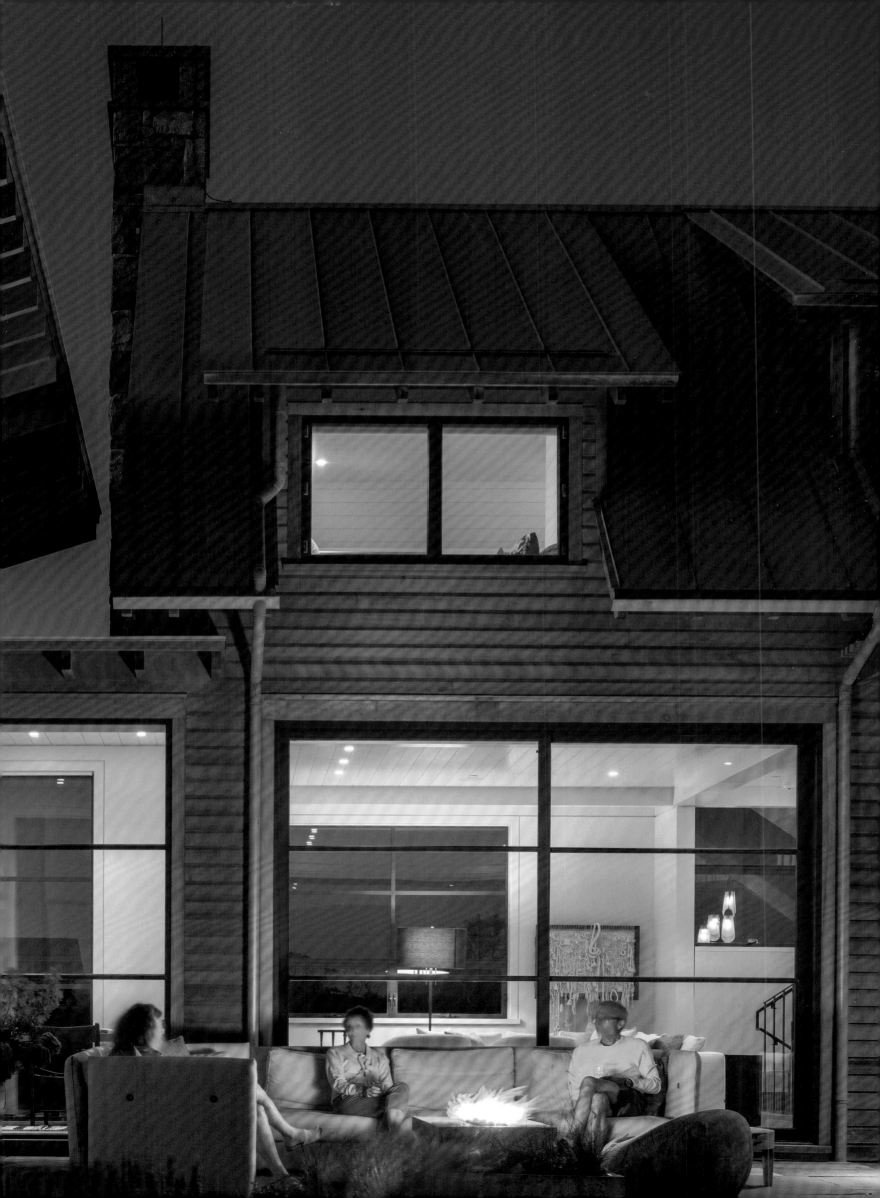

"Design solutions arrive through the thoughtful manipulation of light, color, texture, form, and geometry — culminating in architecture that is simultaneously complex and distilled."

— Robert Gurney

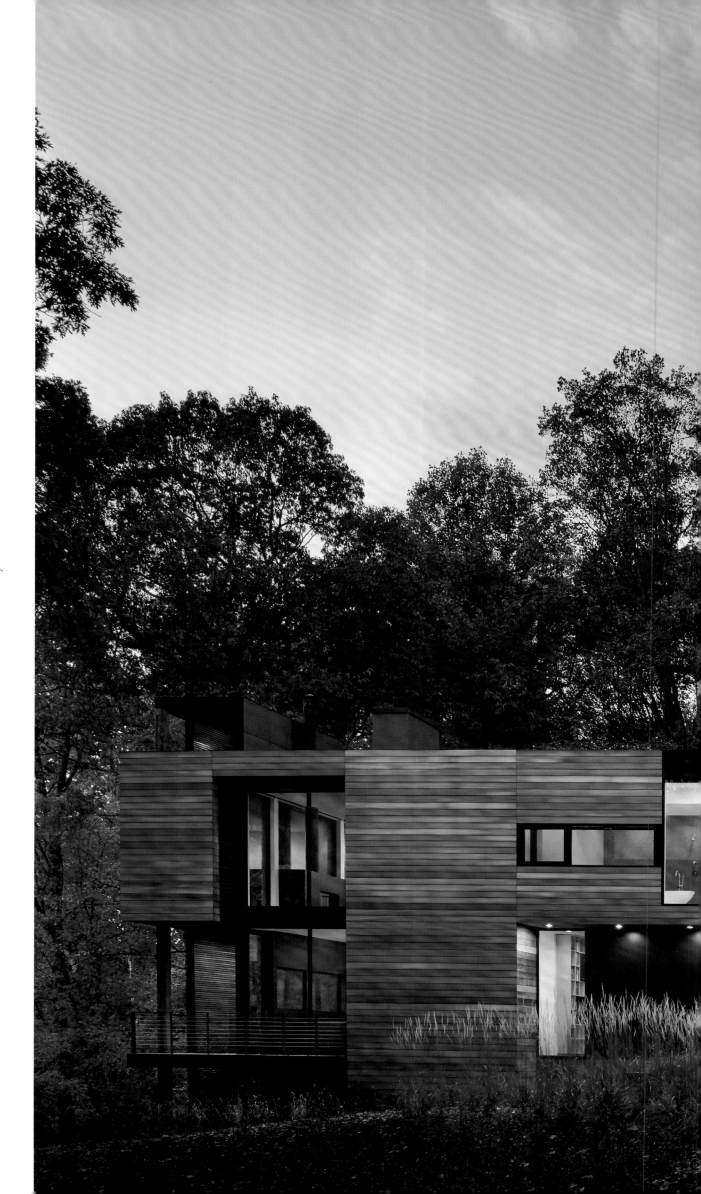

# Robert Gurney

## Robert Gurney Architect

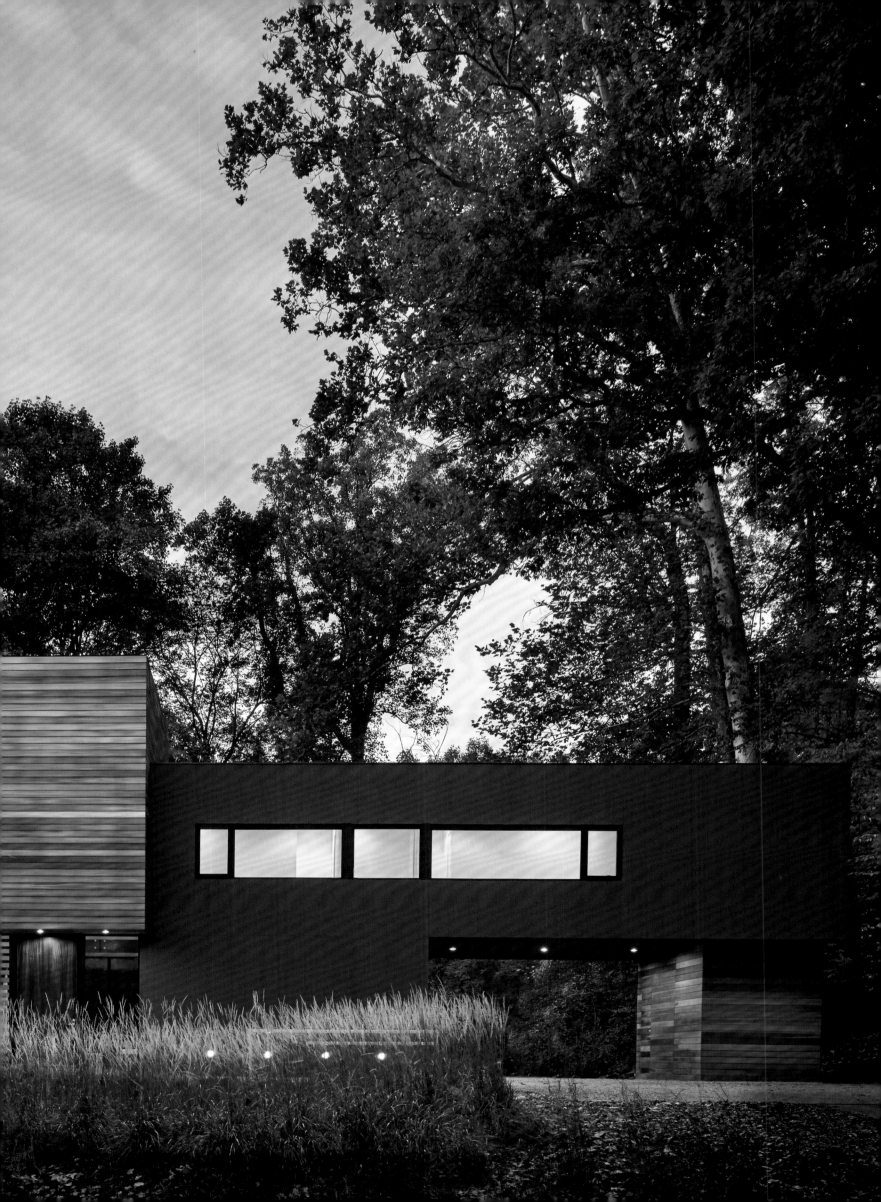

At his Washington, D.C.-based firm, Robert M. Gurney and his team are dedicated to the design of modern, meticulously detailed, and thoughtfully ordered residential and commercial projects. Rather than focus on aesthetics, Gurney said his firm prioritizes work that is "pragmatic, site-responsive, client specific, and spatially organized," resulting in tranquil, minimal spaces that are influenced by the topography, vegetation, climate, and a historic sense of place.

"Design solutions arrive through the thoughtful manipulation of light, color, texture, form, and geometry, culminating in architecture that is simultaneously complex and distilled," he said.

When starting a new project, Gurney said he first visits the site and discusses with the client what spaces they require and how they would ideally live in those spaces.

"We listen to our clients and are open-minded," he said. "We ask the same from them."

One of the firm's newest residential projects is in Mohican Hills, a small community in Glen Echo, Maryland, that's adjacent to the scenic Potomac River. The community boasts an unusually high percentage of contemporary and mid-century modern houses relative to most Washington, D.C., suburban neighborhoods, Gurney said.

The Mohican Hills house is situated along the ridge of a steep, sloping lot overlooking the river. A linear composition of spaces arranged along the ridge and open to an existing clearing provides a large lawn with minimal site intrusion and preserves most of the area's mature trees.

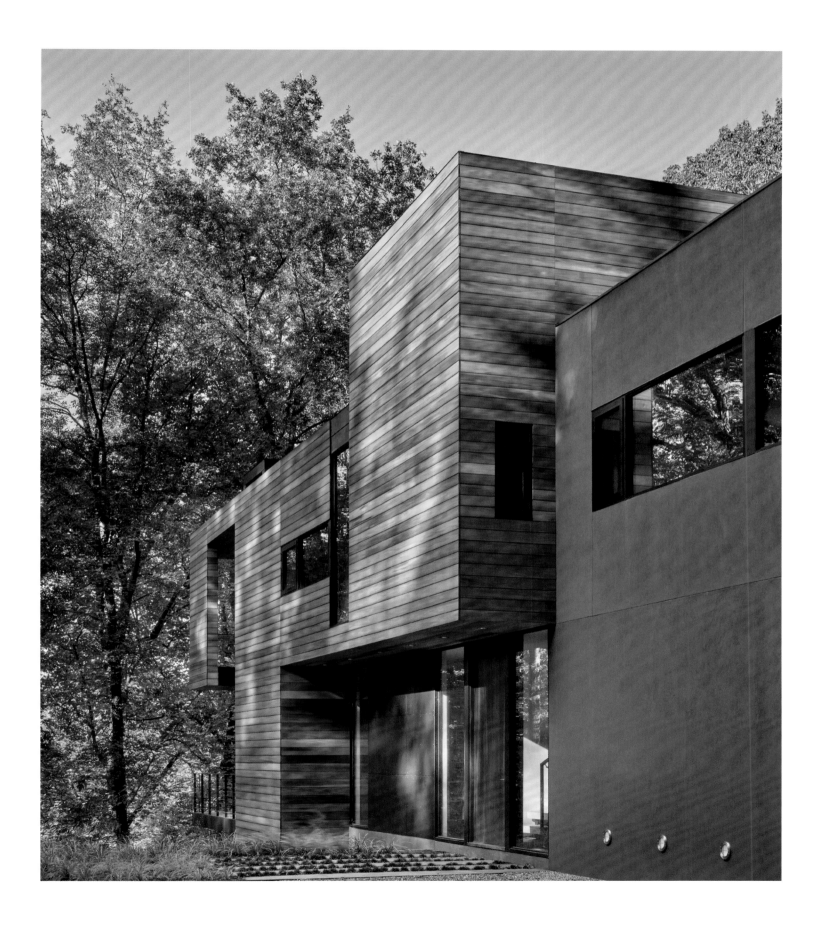

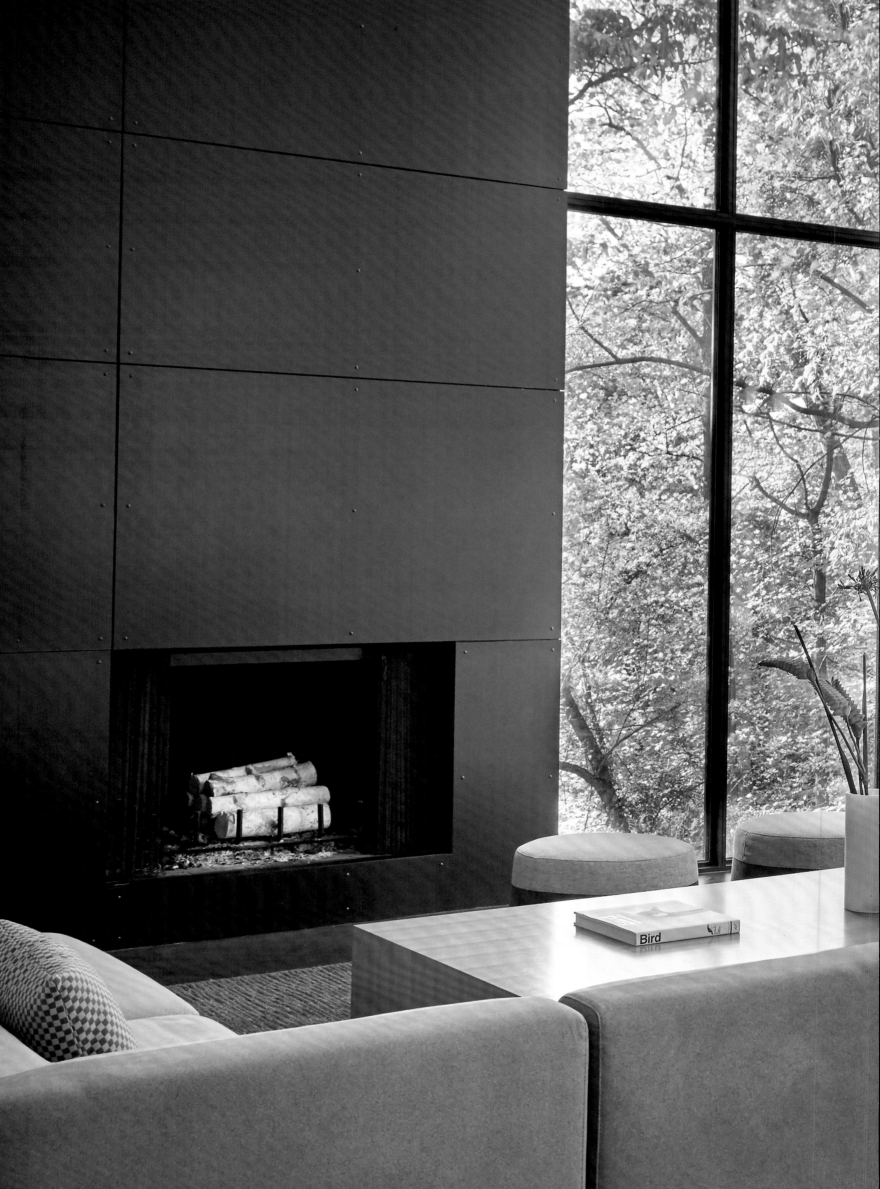

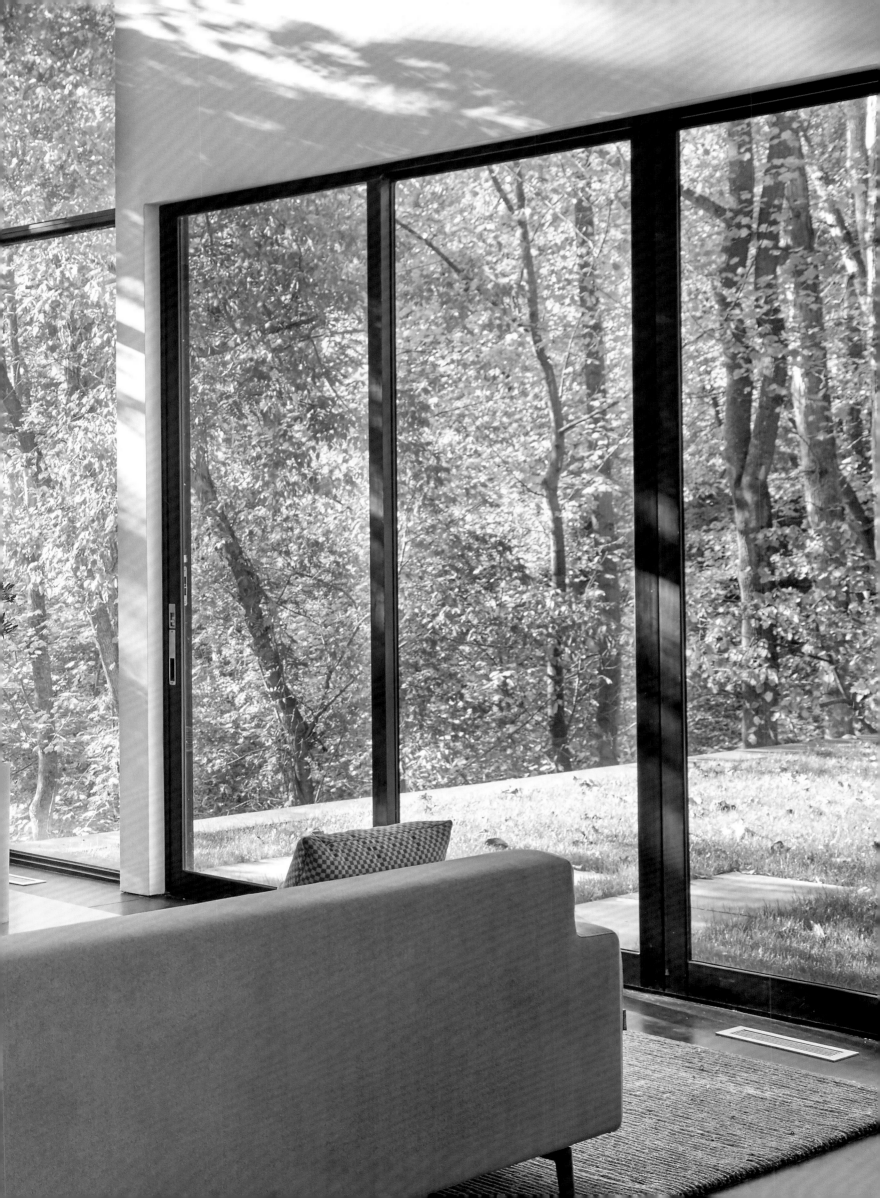

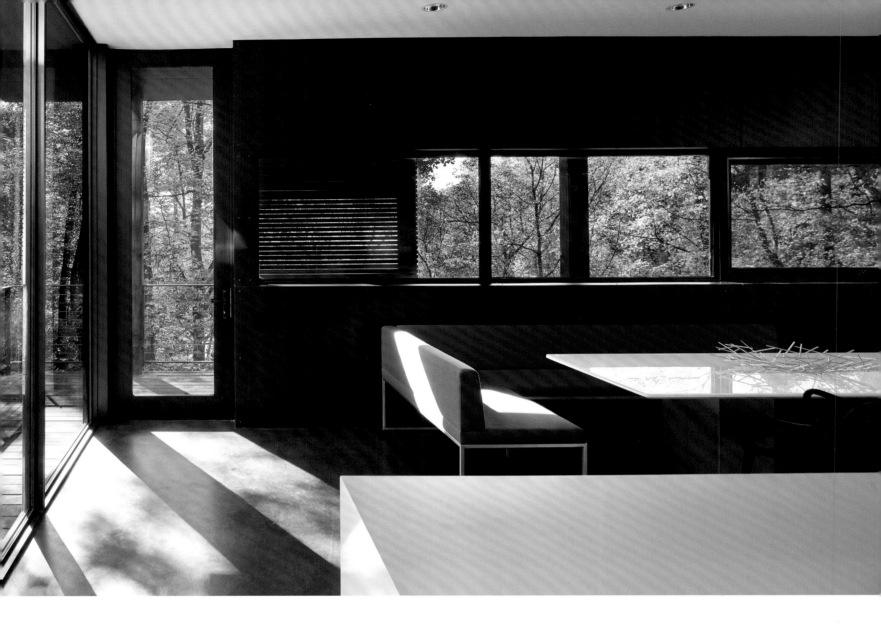

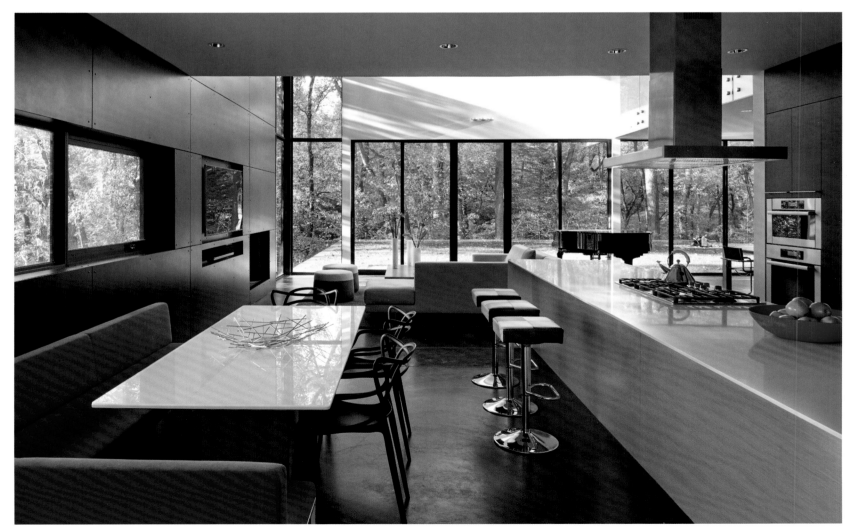

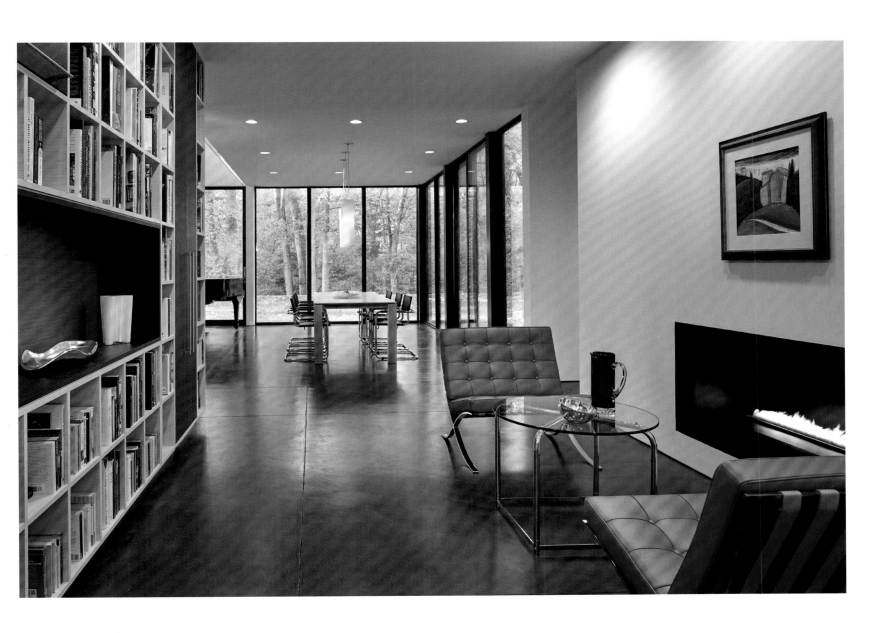

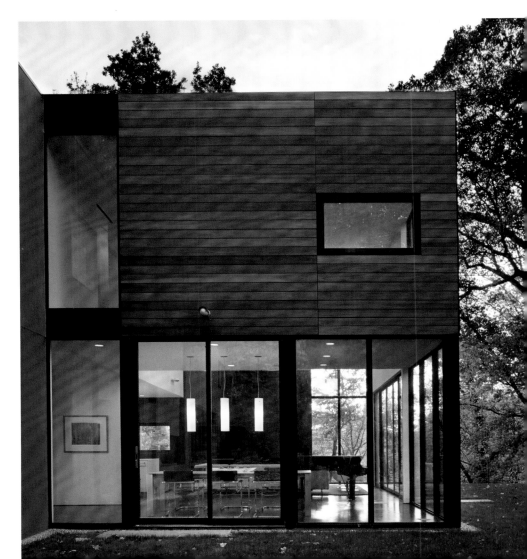

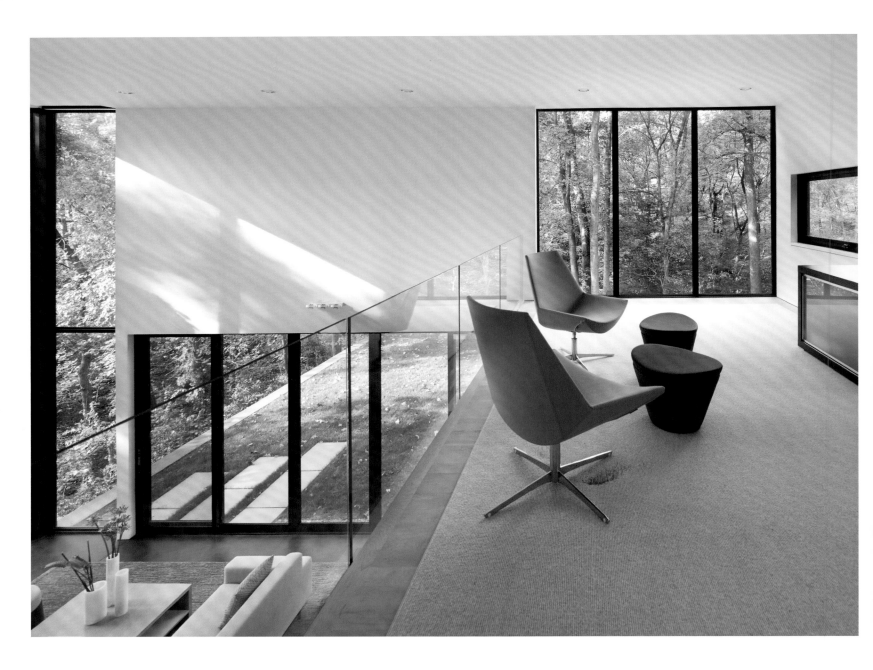

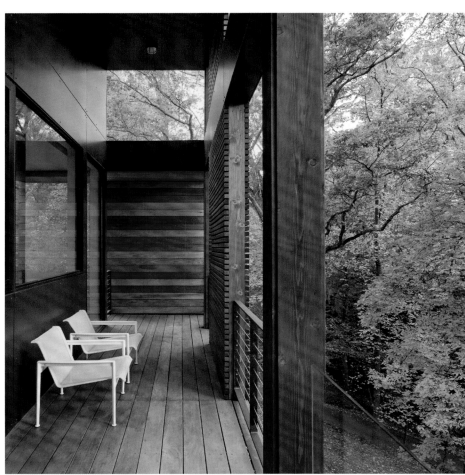

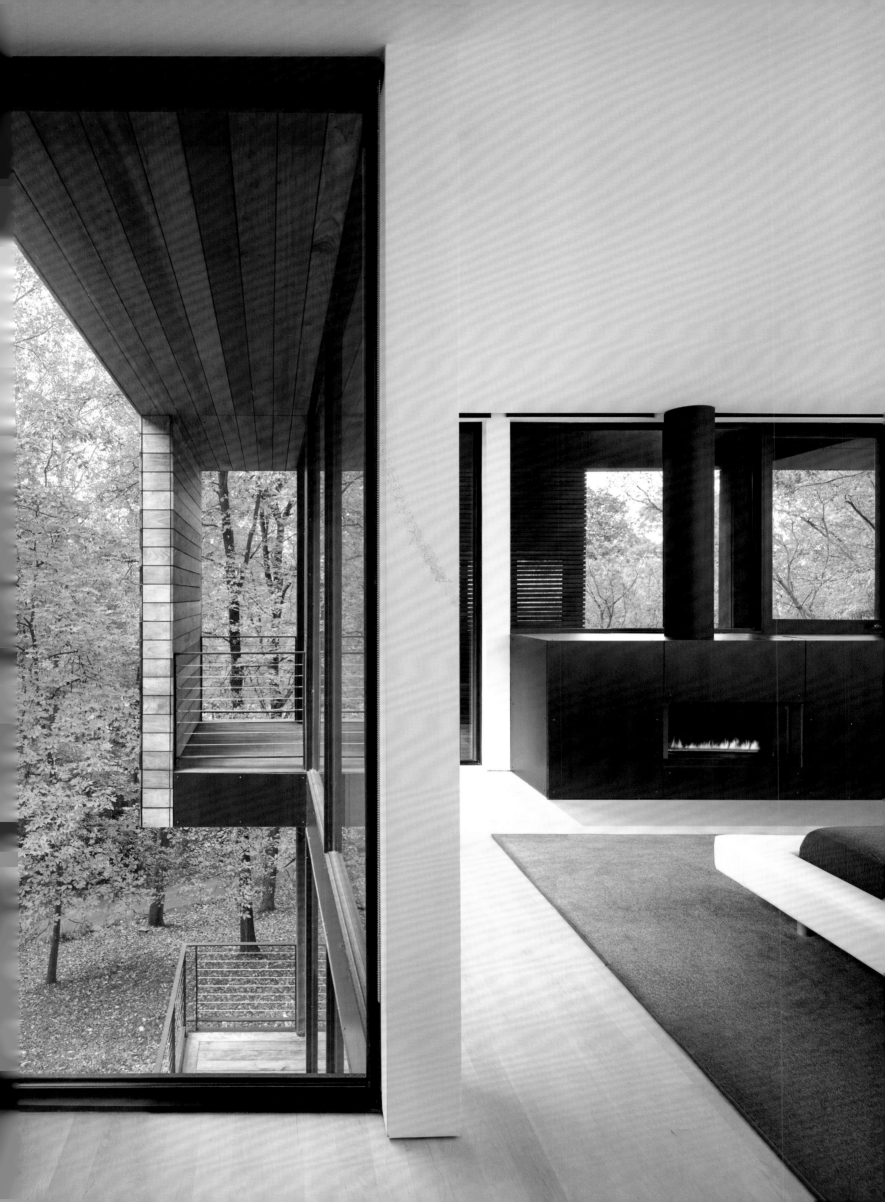

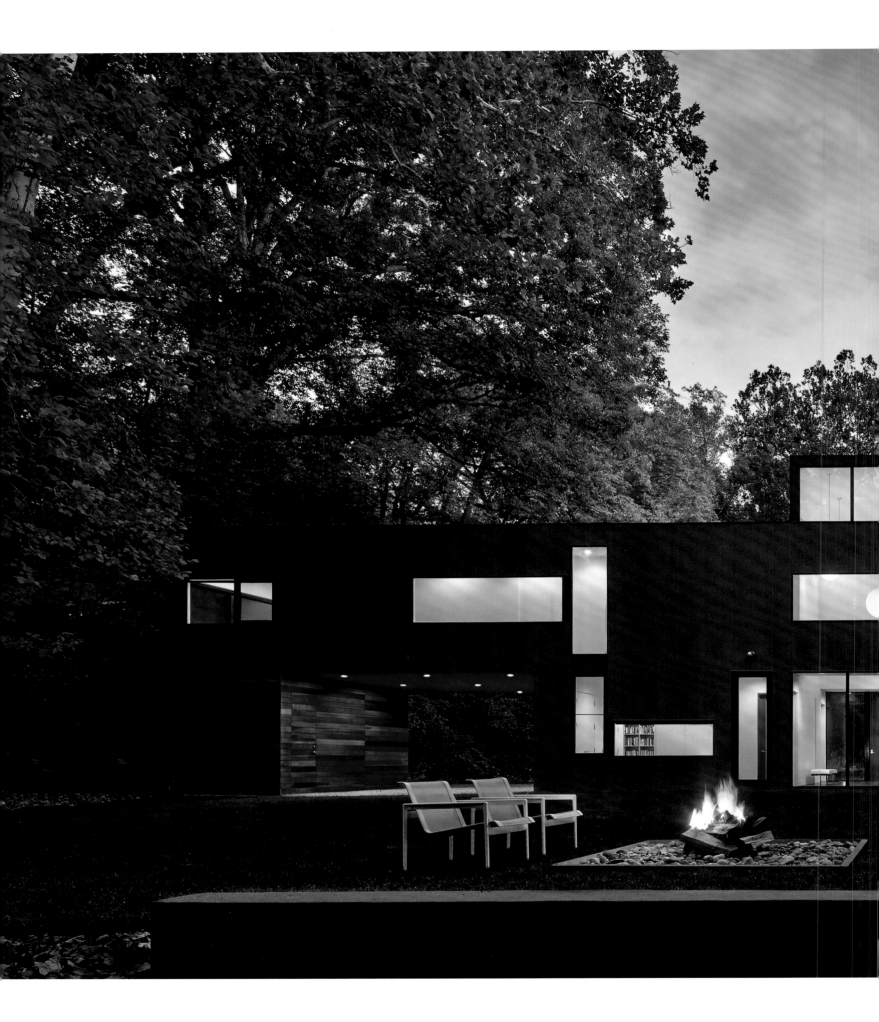

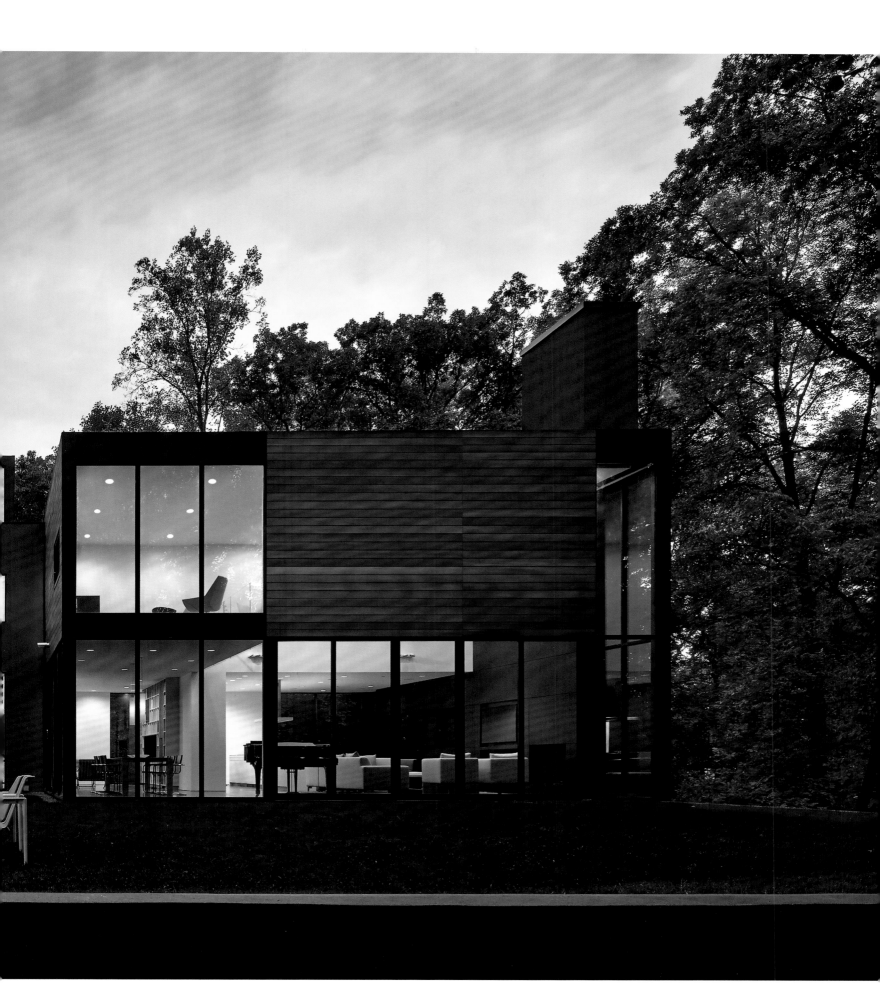

"Our work is pragmatic, site responsive, client specific, and spatially organized. Aesthetics are never considered."

— Robert Gurney

The house is organized around a two-story living space with an open floor plan that integrates a high-ceilinged volume with intimate spaces adjacent to the double-height space. A small office on the first floor is separated from the living spaces and is convertible to a fifth bedroom. A three-story entry volume separates the primary bedroom area from the other bedrooms.

"Expanses of glass provide views into the wooded landscape toward the distant river and animate the house with light," Gurney said. "A combination of intersecting spaces ensures light penetration at all times of day and all times of the year."

Gurney also implemented many sustainable design features with the Mohican Hills house, including a concrete slab that runs throughout the main floor that provides passive solar energy assistance.

"The concrete is stained dark to increase the potential solar gain and storage," he said.

In addition, expanses of energy-efficient glass provide an abundance of daylight while solar-sensitive shades mediate heat gain. Energy-efficient appliances, high-efficiency HVAC equipment, wall and ceiling infrastructure with maximum insulation, and a ventilated building envelope are employed to help reduce fossil fuel consumption.

Large, operable windows and doors are located to provide natural ventilation and direct access to the outdoors, while thermally modified wood siding is employed as an alternative to exotic or expensive hardwoods.

*Interior Design: Therese Baron Gurney*
*Landscape Architecture: Kevin Campion*
*Builder/Contractor: Steve McCaughan*
*Photographer: Anice Hoachlander*

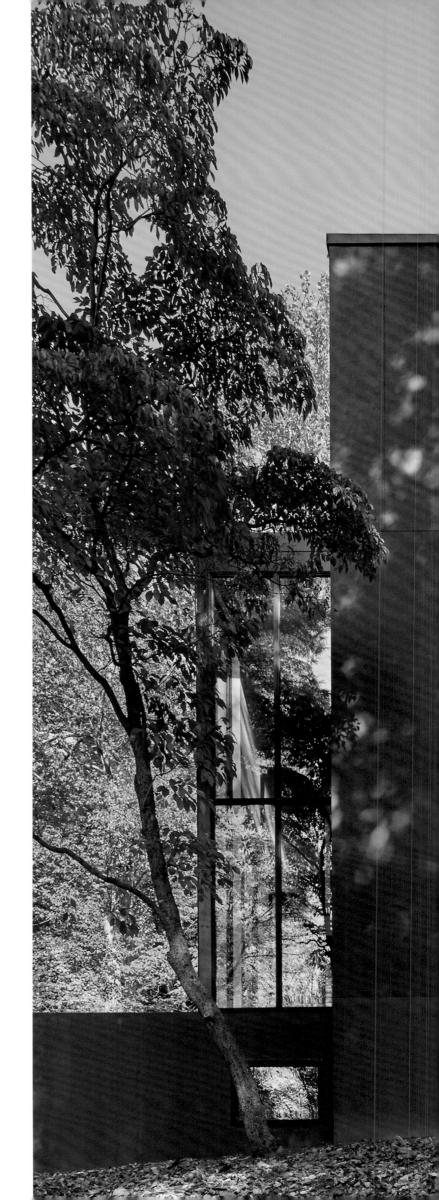

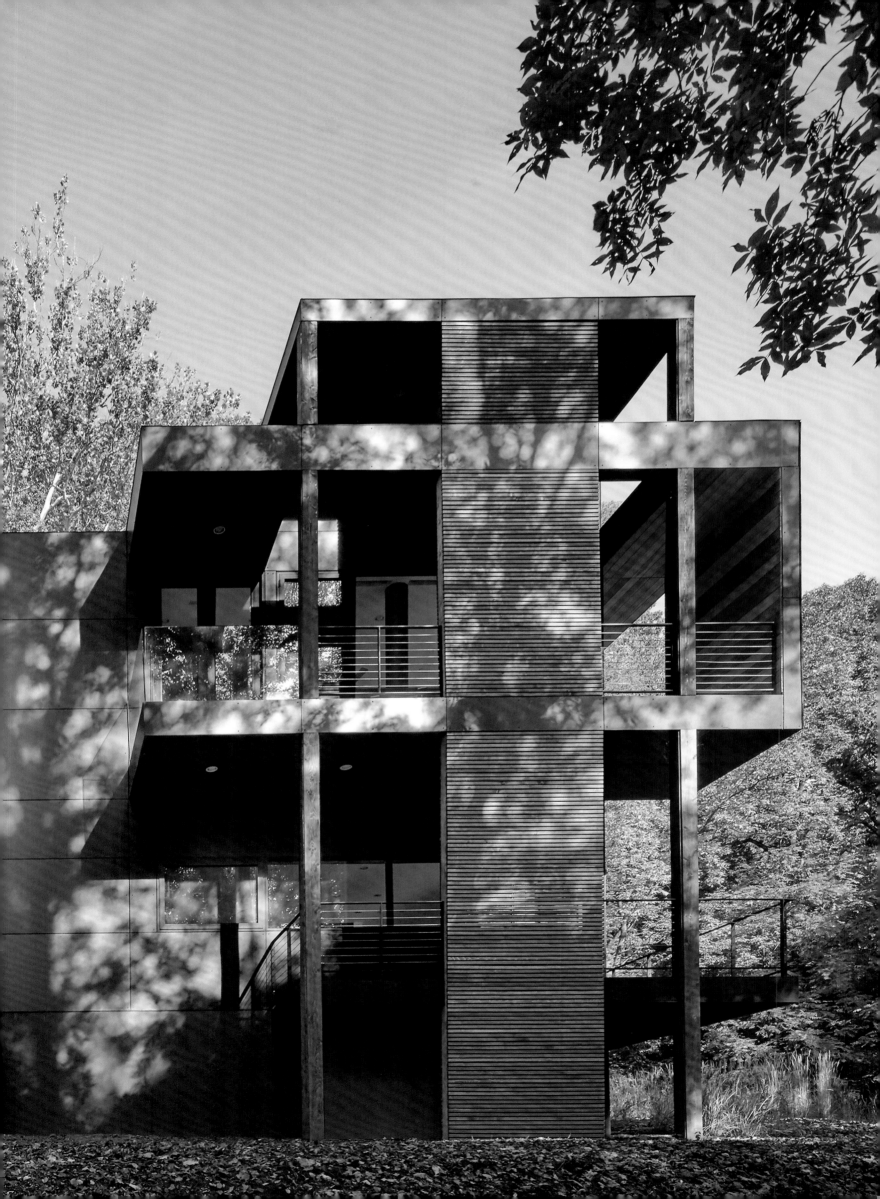

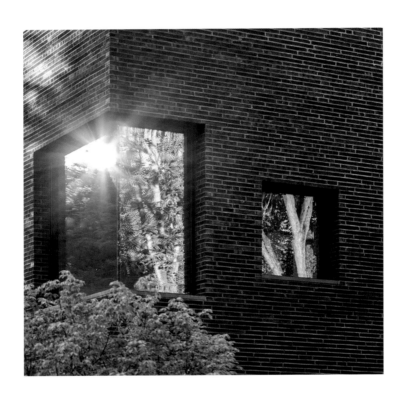

"Psychology is woven into the science and art required to make architecture — an essential part of our design process comes from taking the time to identify our clients' dreams."

— Pierre-Henri Hoppenot

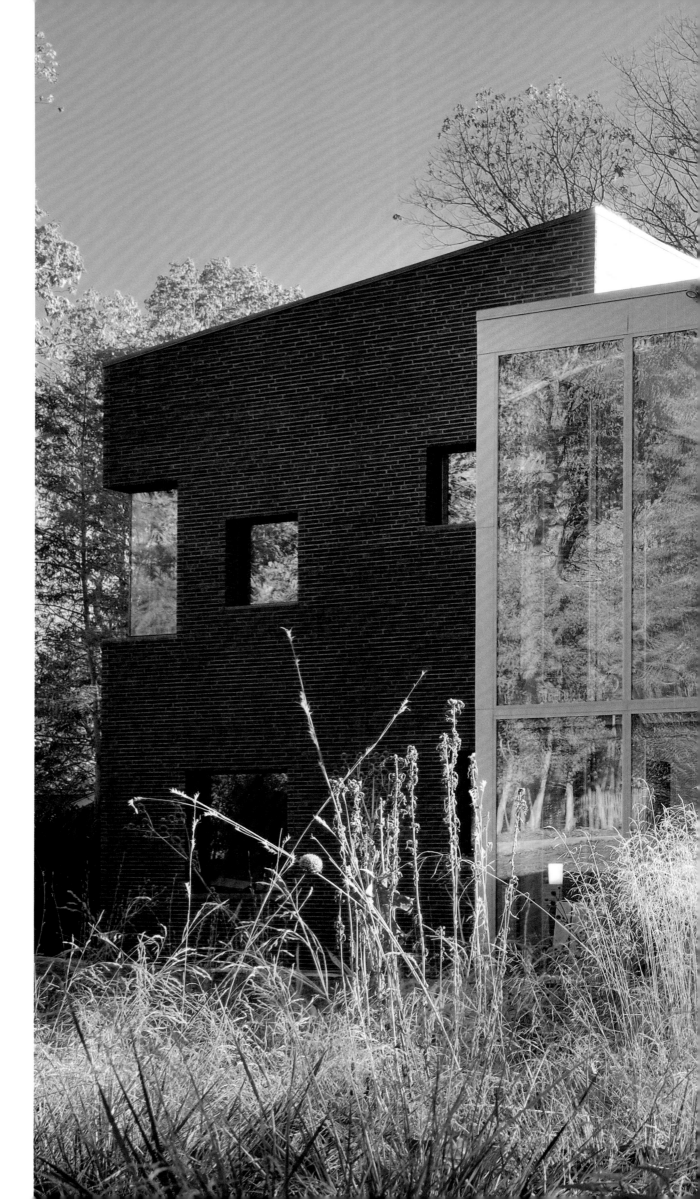

Pierre-Henri Hoppenot

PHH Architects

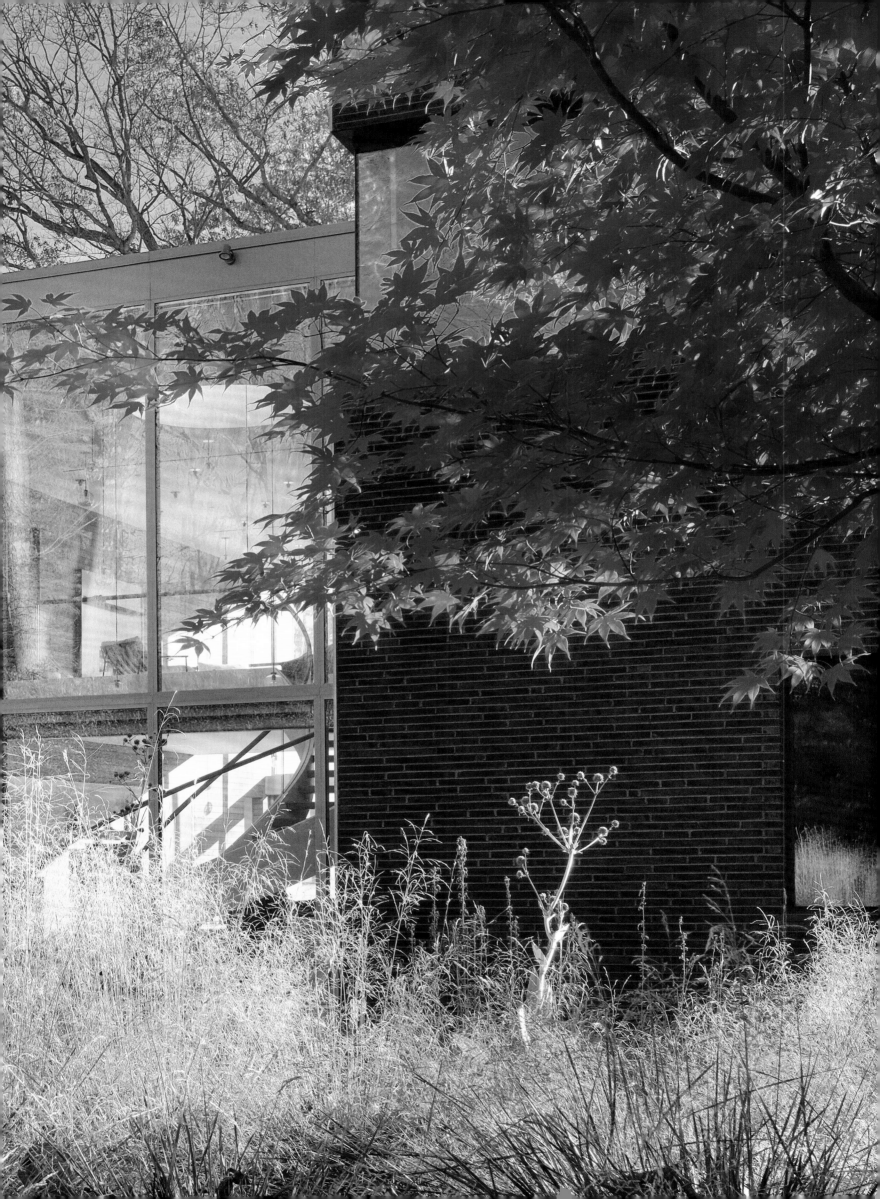

Pierre-Henri Hoppenot founded Brooklyn-based Studio PHH Architects in 2016 after six years of working at globally recognized firms like Rafael Vinoly and Weiss Manfredi. With residential and commercial projects across the United States and abroad, Hoppenot says the studio's work is based on attentiveness and sensitivity to cultures, history, and context, with a focus on creating highly crafted and site-sensitive places.

"One of the most important aspects that drives the architecture we create is empathy, and the ability to understand our clients deeply while simultaneously keeping our eye on the functional, spiritual, and aesthetic drivers," he says. "We believe that only from immersing ourselves in diverse views can spatial and material poetry emerge."

And this poetry is reflected in spaces that are "woven" into the landscape, in which the architecture can be viewed as a piece of art. "What is functional, tactile, and warm from close up may become abstract and ephemeral from a distance."

As part of his approach to design, Pierre-Henri says he guides conversations with clients, providing options while keeping an eye on the big picture and the architectural cohesion. Each conversation takes him and his clients one step closer to their home, which he says should serve as a space where the heart rate slows and the world can fade.

"Humans are innately connected to nature, light, materials, and sounds. A space's ability to reconnect us to these basic human needs is always a priority."

Wherever a project is based, he spends time learning about local materials, methods of construction, and other influences. "Sun paths, prevailing winds, and context inform passive and active sustainable systems, which are proposed and incorporated in the early planning phases. This is why we do not have a specific style. We cannot design the same home in Seattle Sound, New York City, Baja California, and the French Alps, but the underlying drivers remain the same."

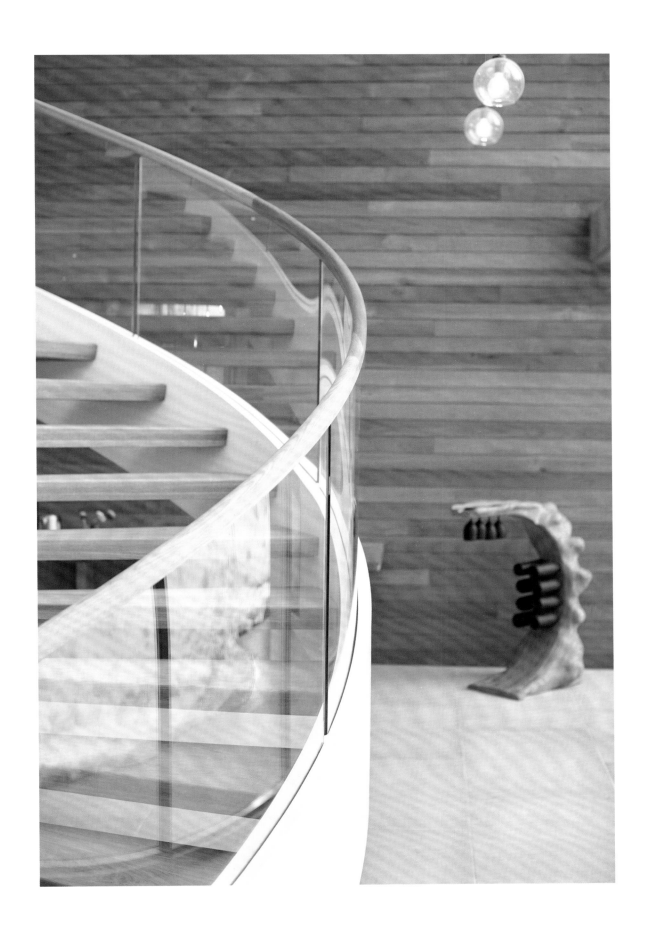

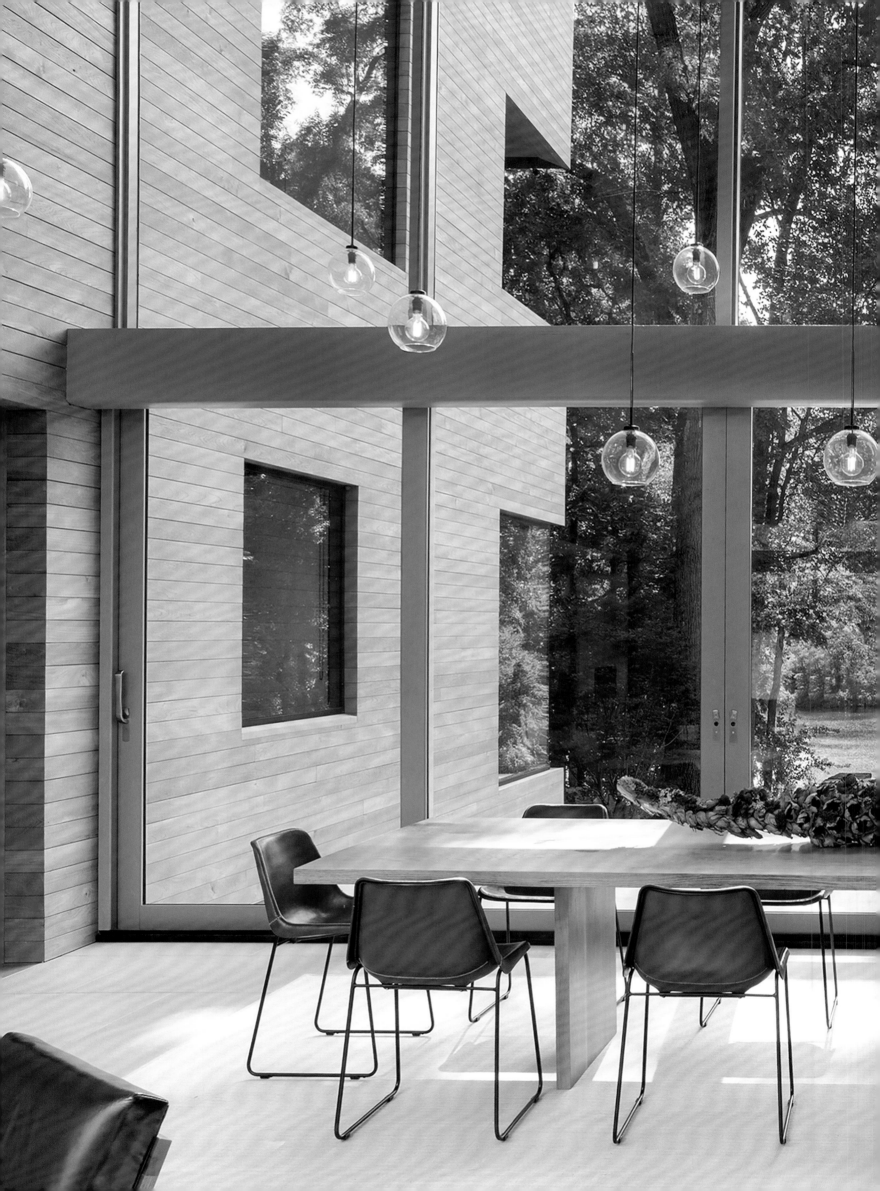

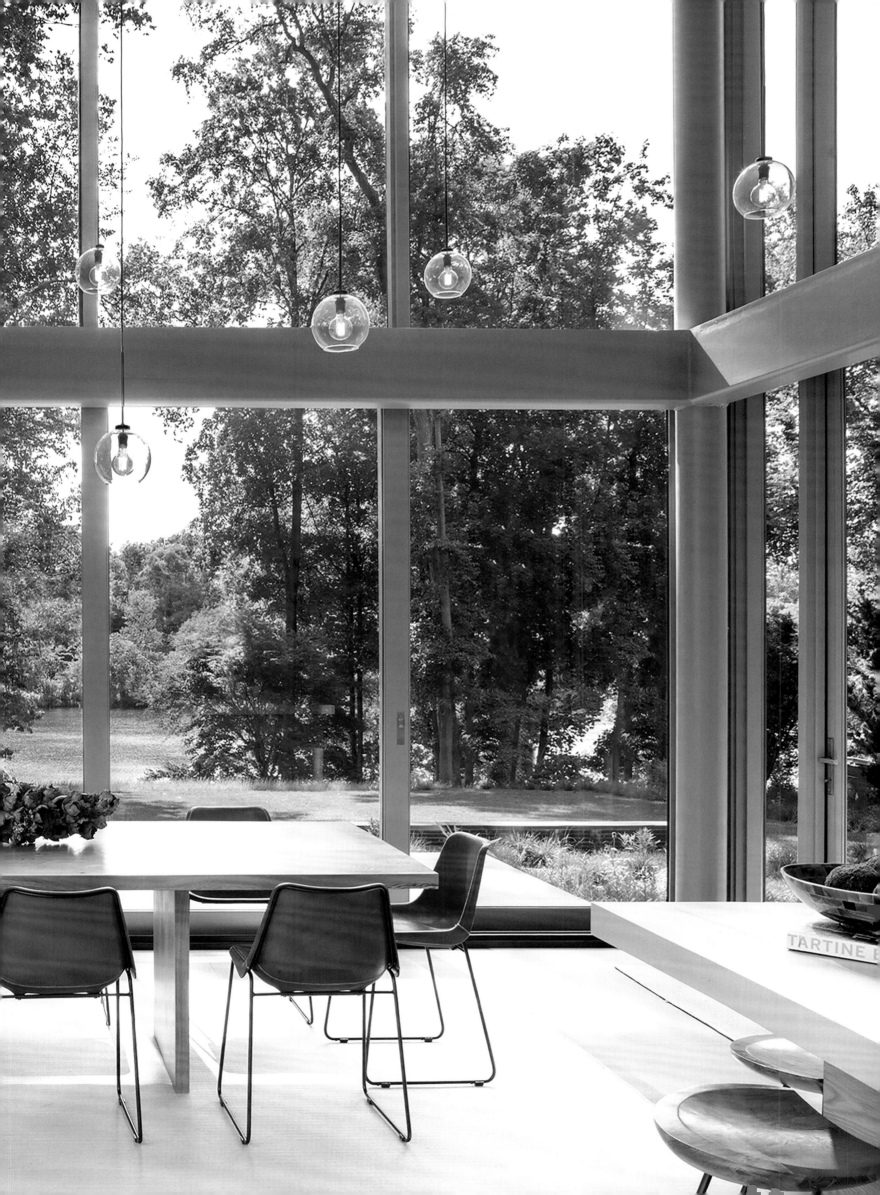

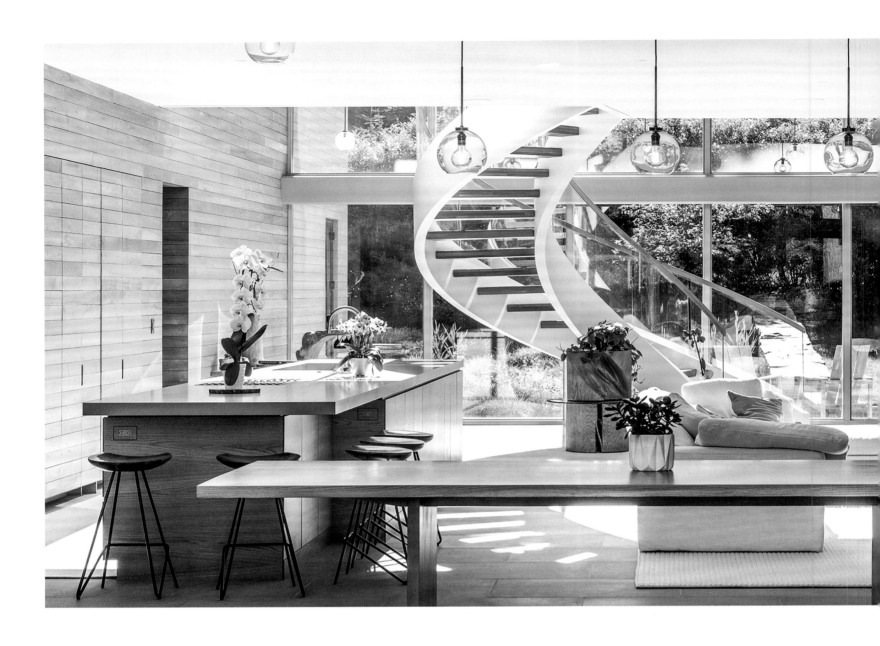
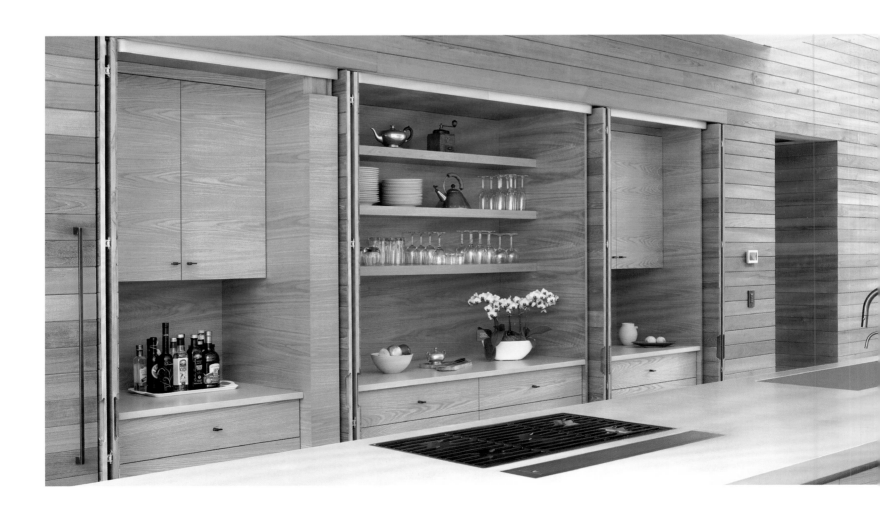

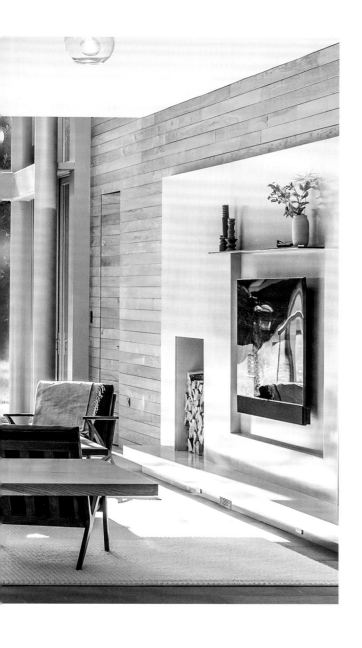

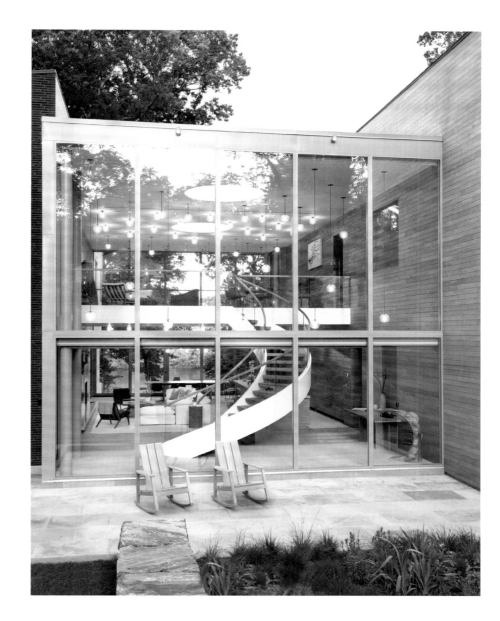

"Humans are innately connected to nature, light, materials, and sounds. A space's ability to reconnect us to these basic human needs is always a priority."

— Pierre-Henri Hoppenot

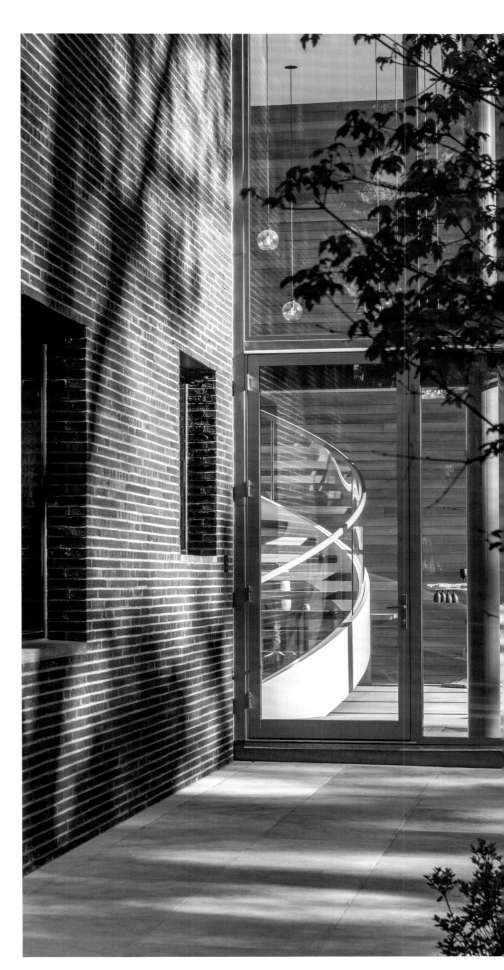

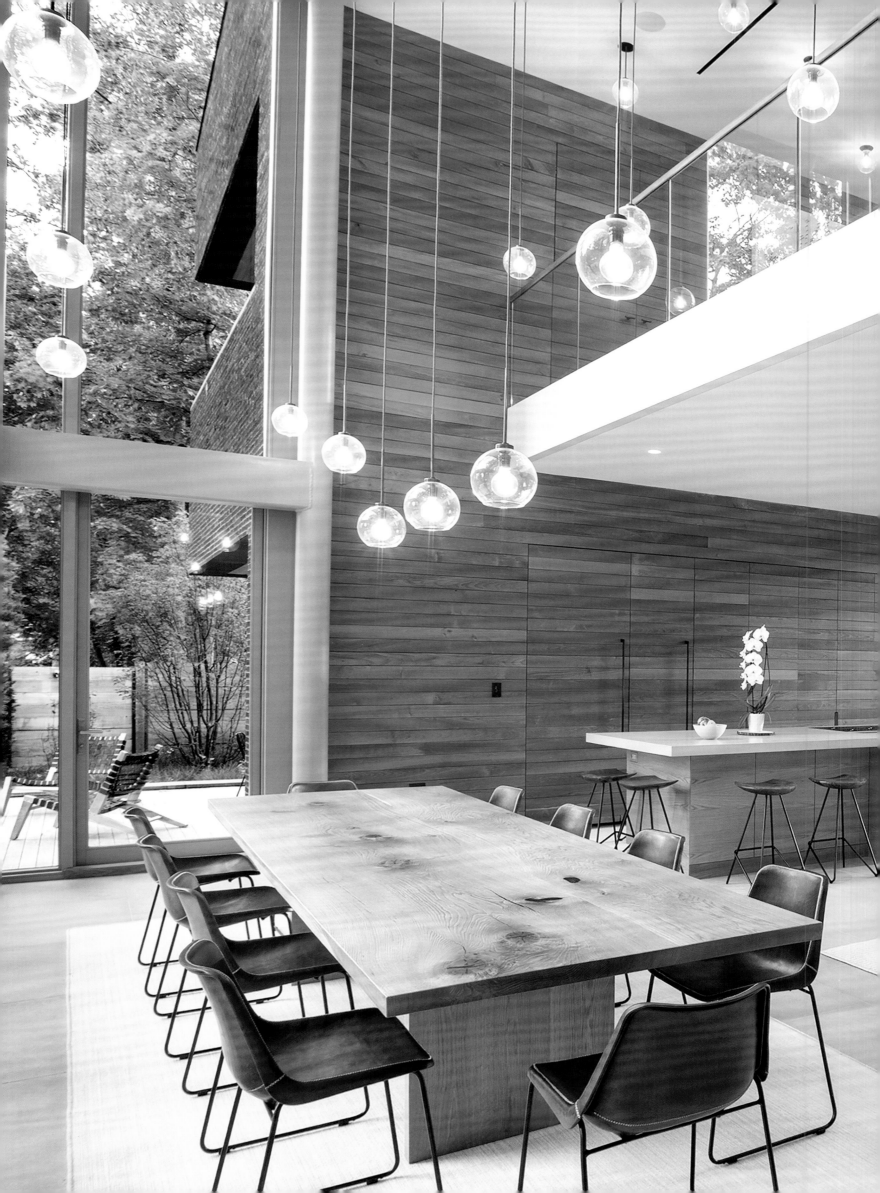

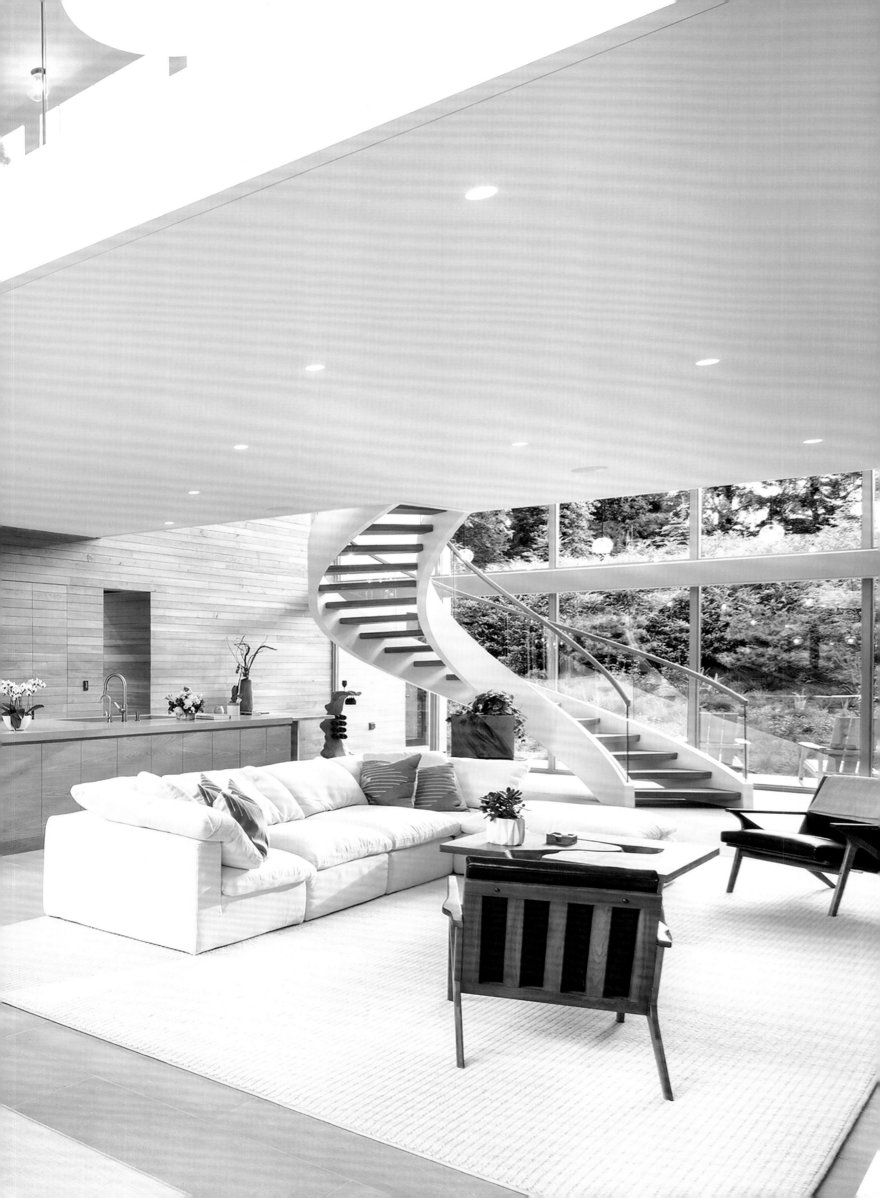

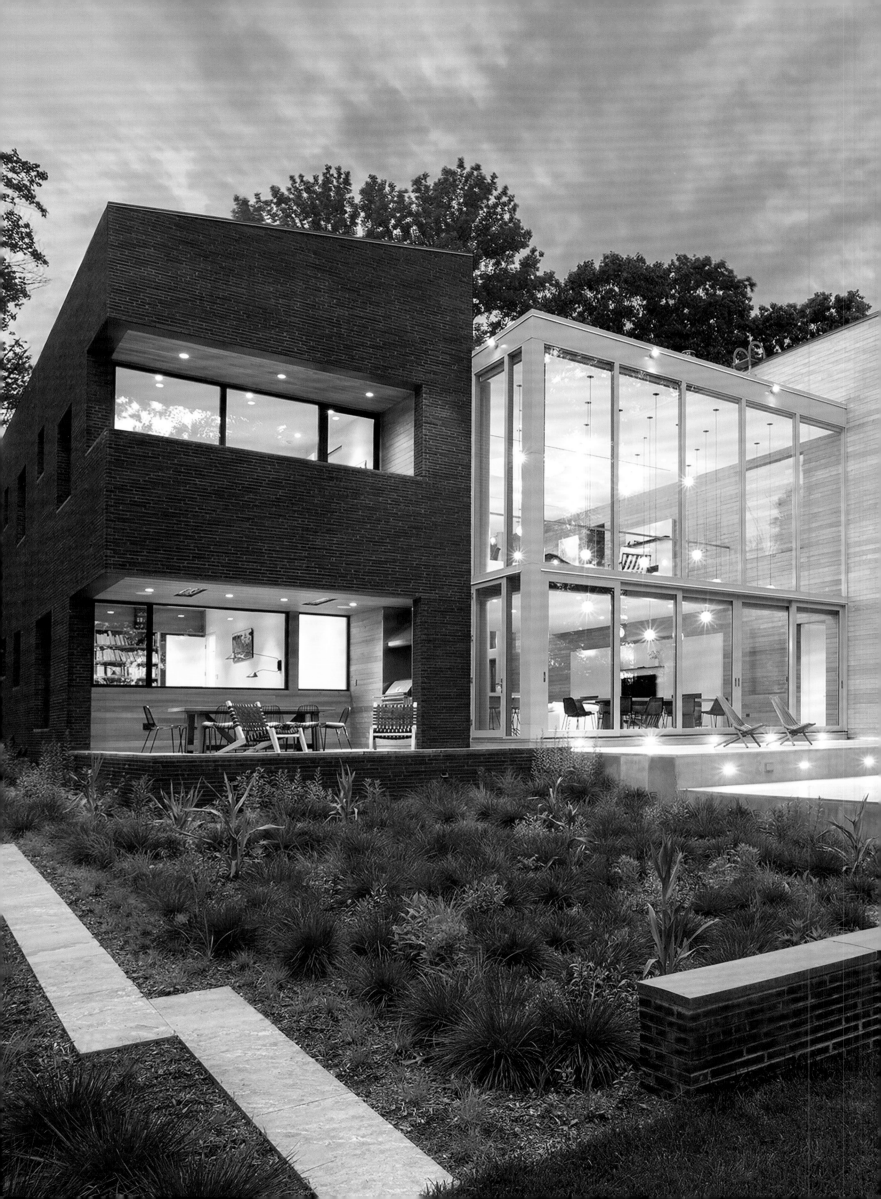

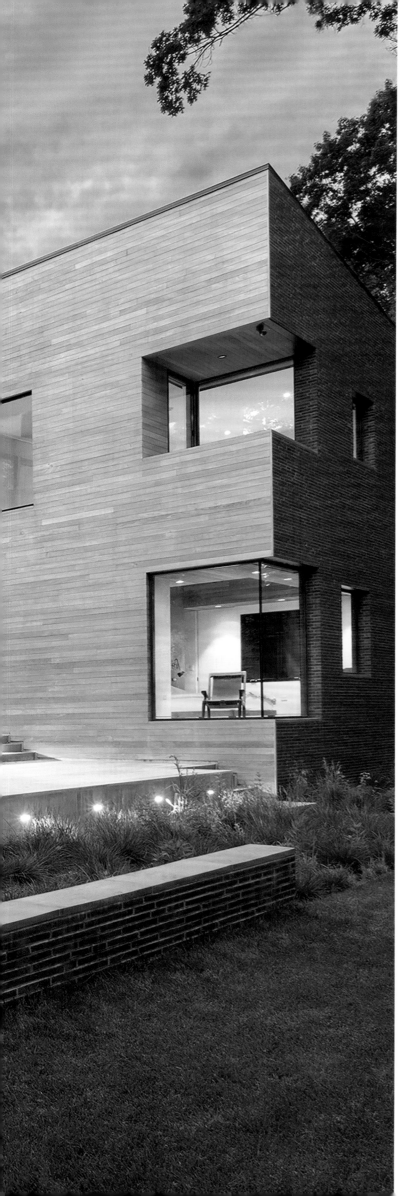

For Studio PHH Architects' La Clairière home in Princeton, New Jersey, Pierre-Henri says the clients were looking for a permanent family home that could serve as a peaceful retreat as well as a space where they could connect with family and friends.

Nestled within a forest and situated on the shore of Carnegie Lake, the house boasts expansive floor-to-ceiling windows, capturing both sunrise and sunset within the same space. "The careful siting of the house shelters the space from the southern sun and provides diffused natural light all day, minimizing the need for artificial lighting," he said.

The 8,200-square-foot home is designed as two solid masses, each a carved monolith containing a variety of private spaces, including bedrooms, the primary suite, garage, office, mud room, and laundry room.

In between these two private masses is the home's main gathering area, which includes the kitchen, dining, and living rooms. The wood walls in the central space are old-growth teak, re-used from building demolition sites in Burma. Above the main communal area is a mezzanine with incredible views of the lake and the surrounding treetops. On the roof, carefully concealed solar panels offset all of the home's energy usage.

"The biggest challenge was to make the house disappear within the landscape," he said. "We strategically moved the house further away from the edge of the lake and chose a natural dark exterior material, allowing the mass to recede between the trees and become almost invisible."

---

*Interior Design: Studio PHH Architecture*
*Landscape Architecture: Andrew Zientek Landscape Architecture*
*Builder/Contractor: Lasley Brahaney Construction*
*Photographers: Tom Grimes, Glen Gery, Austin Nelson, Andrew Zientek*

"A dream project is one where the owners, architects, and builders are open-minded and ready to explore possibilities in a way that uncovers a unique building and place that would only be that good on that site at that time."

— Caleb Johnson

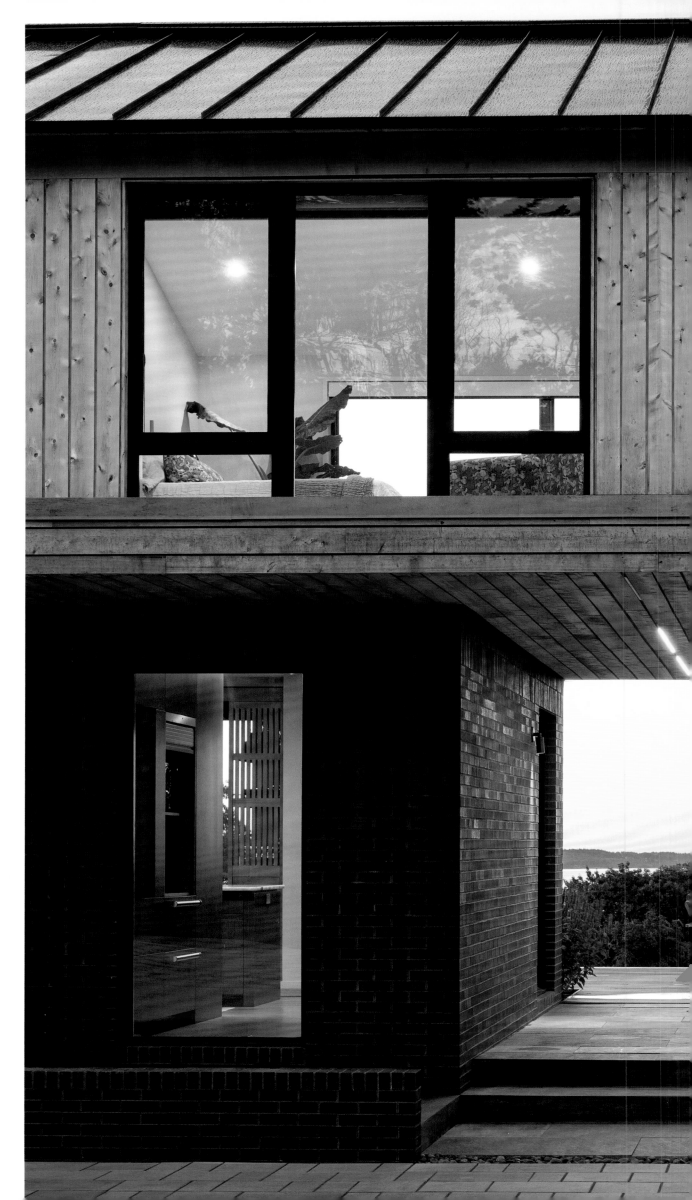

Caleb Johnson

Woodhull

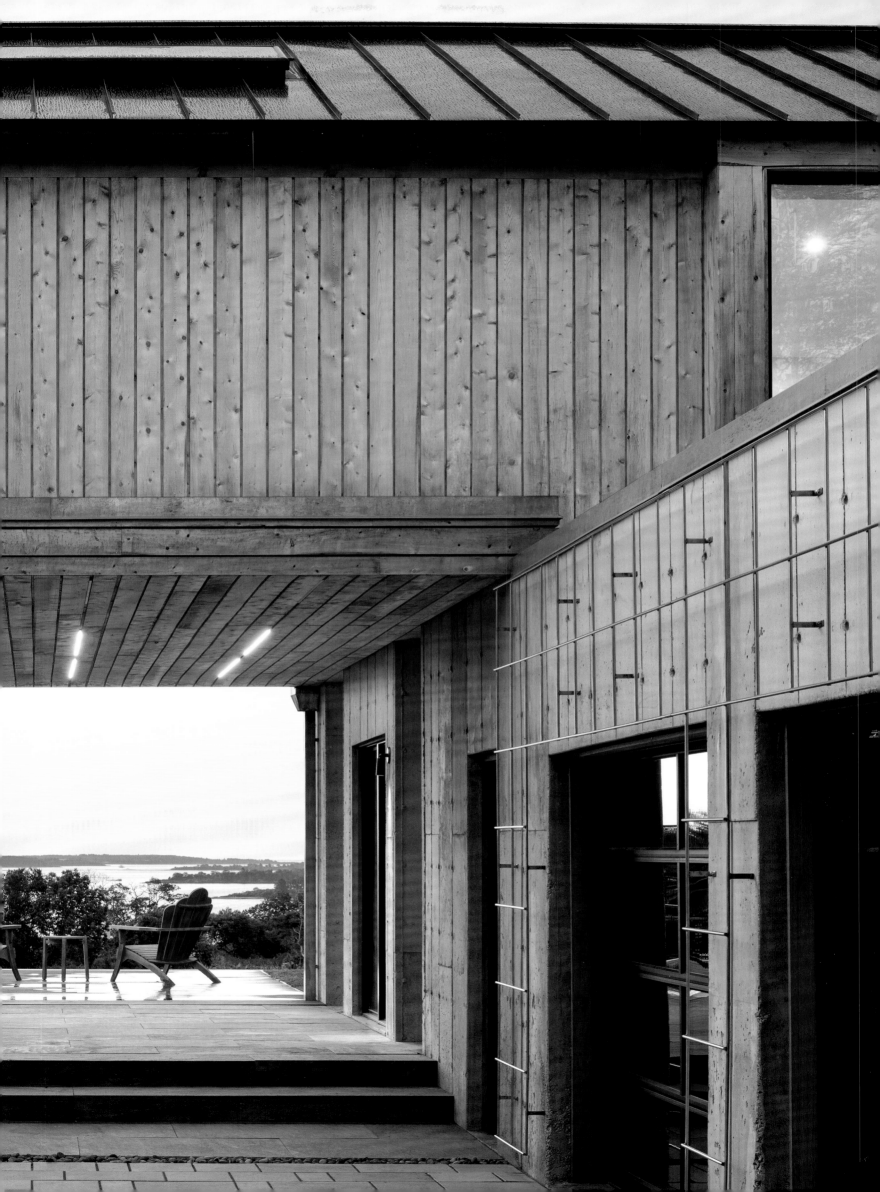

Caleb Johnson originally wanted to be a fine artist, but by his junior year in high school he was having doubts if that was the right path for him. Already skilled at technical drawing, he began to focus instead on pursuing a career as an architect. Besides, he'd always been the kind of person who liked to visualize how to make places and spaces better.

"I always need a project," he said. "Architecture seemed like a good fit."

Johnson started reading books about the profession and studying everyone from Philip Johnson and Louis Kahn to Leonardo da Vinci. After graduating from Andrews University in Michigan, he picked up *The New Cottage Home* at a bookstore while on a trip to Chicago. He was immediately drawn to the architectural projects in Maine — the rugged, outdoorsy settings appealed to him, as did the use of stone and wood.

In 2003, working out of his Maine home, he started Johnson and Bell with award-winning architectural photographer Trent Bell. Three years later, Johnson took over full ownership, naming it Caleb Johnson Studio, and later Woodhull. Johnson serves as the founding principal of the firm, which has offices in Portland, Maine, and a millwork shop in Brunswick, Maine.

"It always feels like we're a startup, even though we have been around for 20 years," said Johnson. "Our highest priority is providing the best workplace possible for our employees and partners while producing the best work we can do at any given time."

Looking ahead, Johnson said he would like to increase the manufacturing capacity of his firm so he and his team can do more bespoke buildings of higher design and construction quality in fewer months with more predictable customer service and better financial and schedule results.

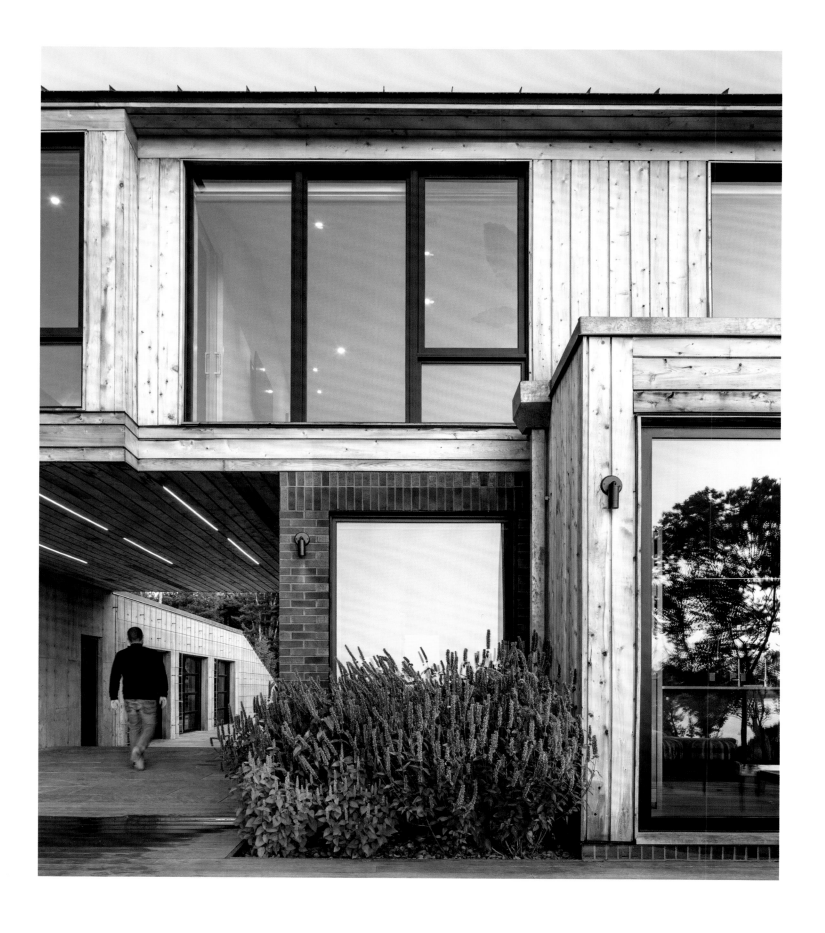

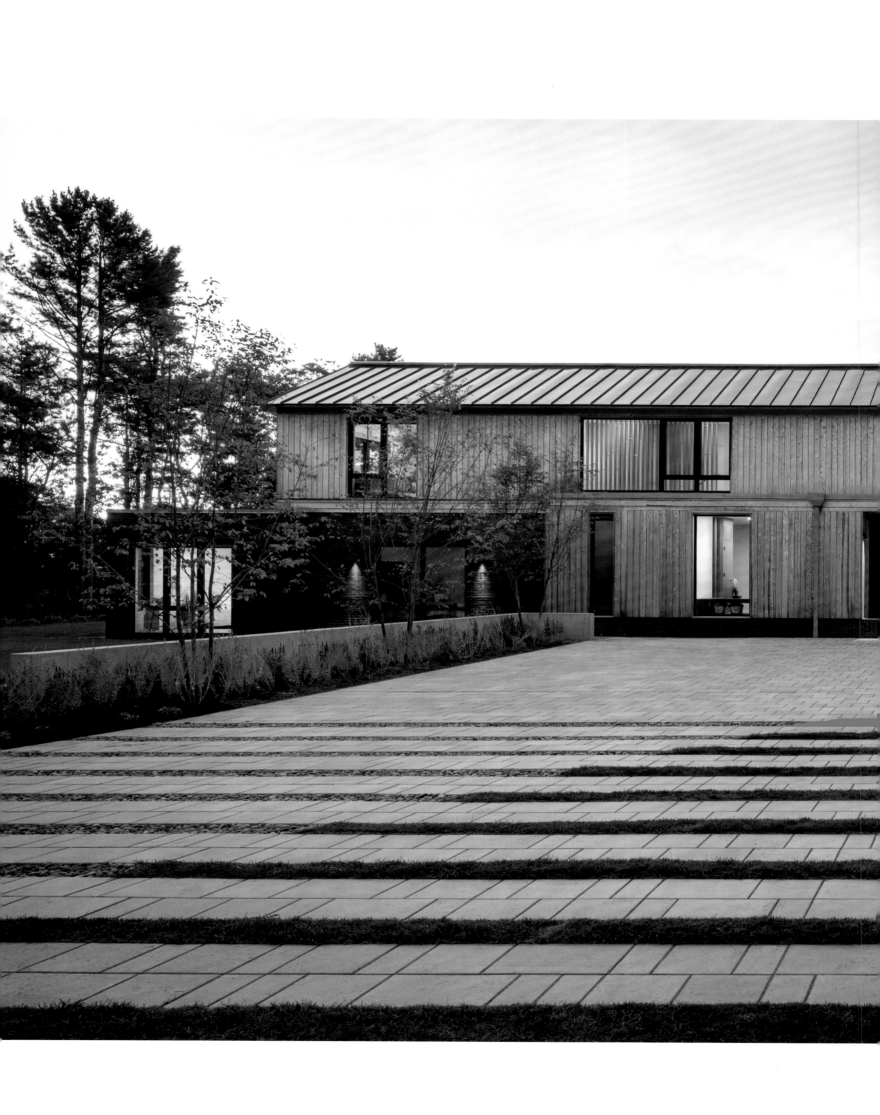

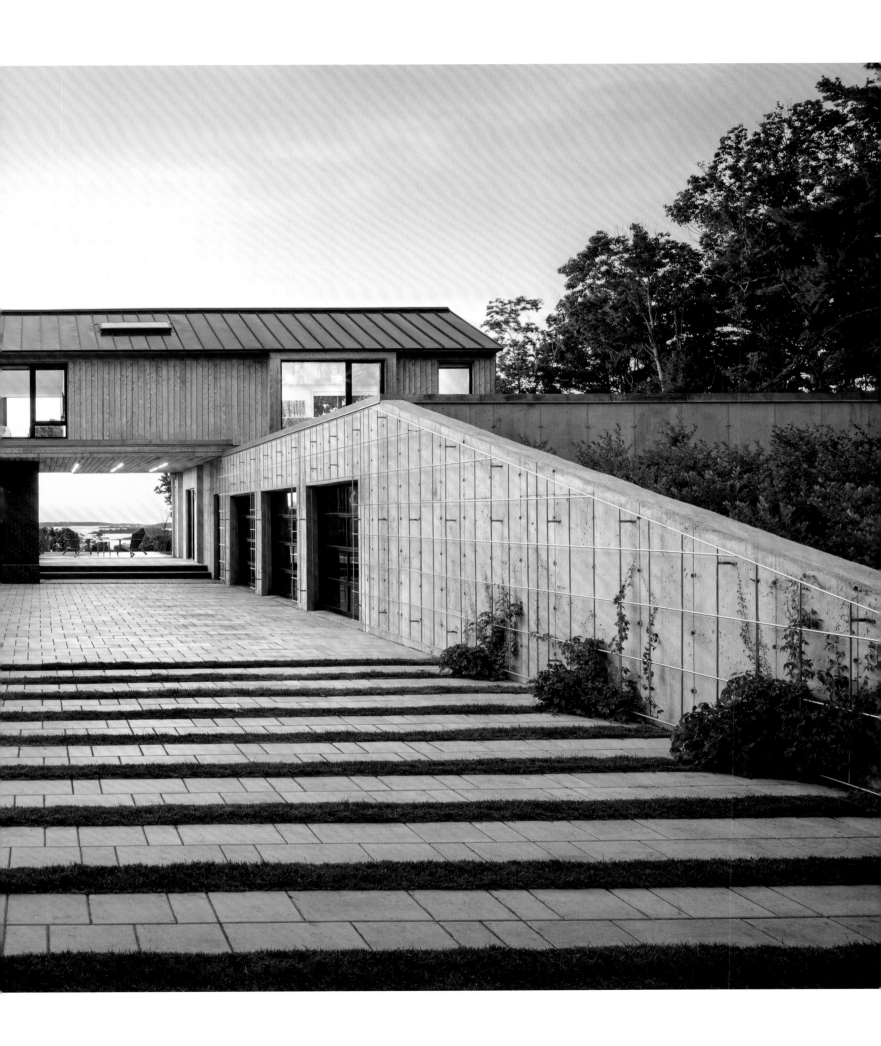

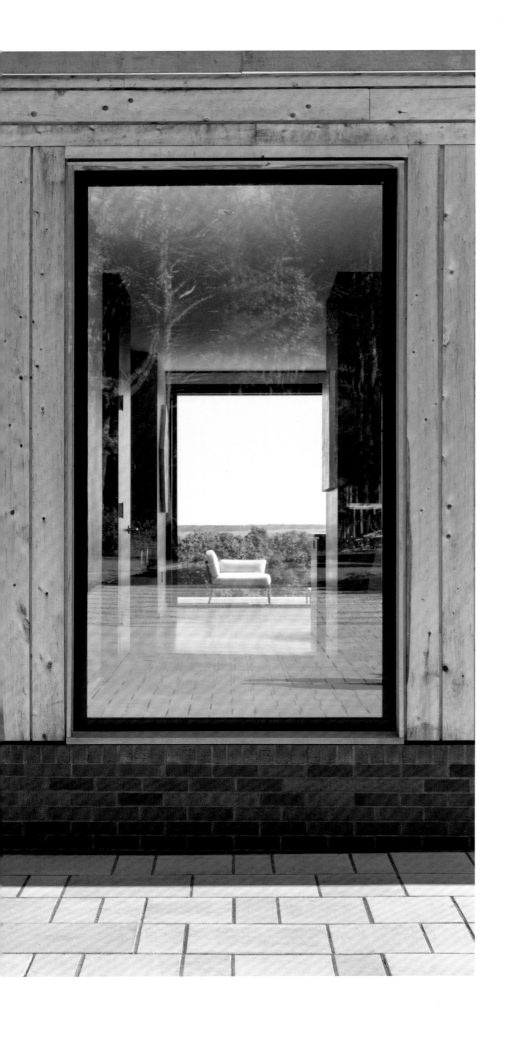
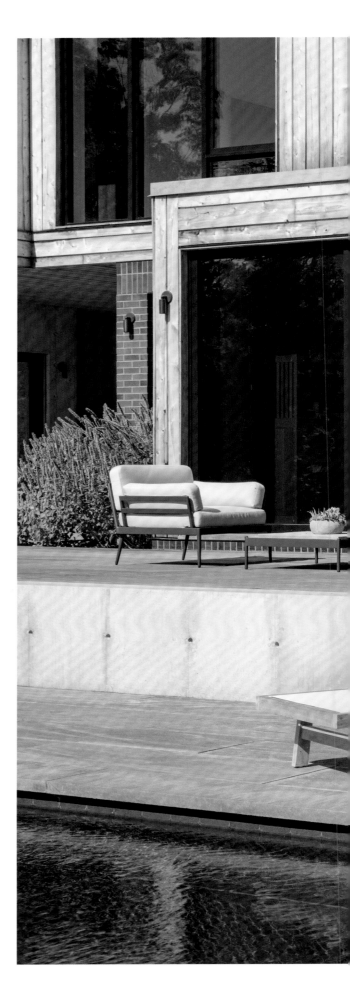

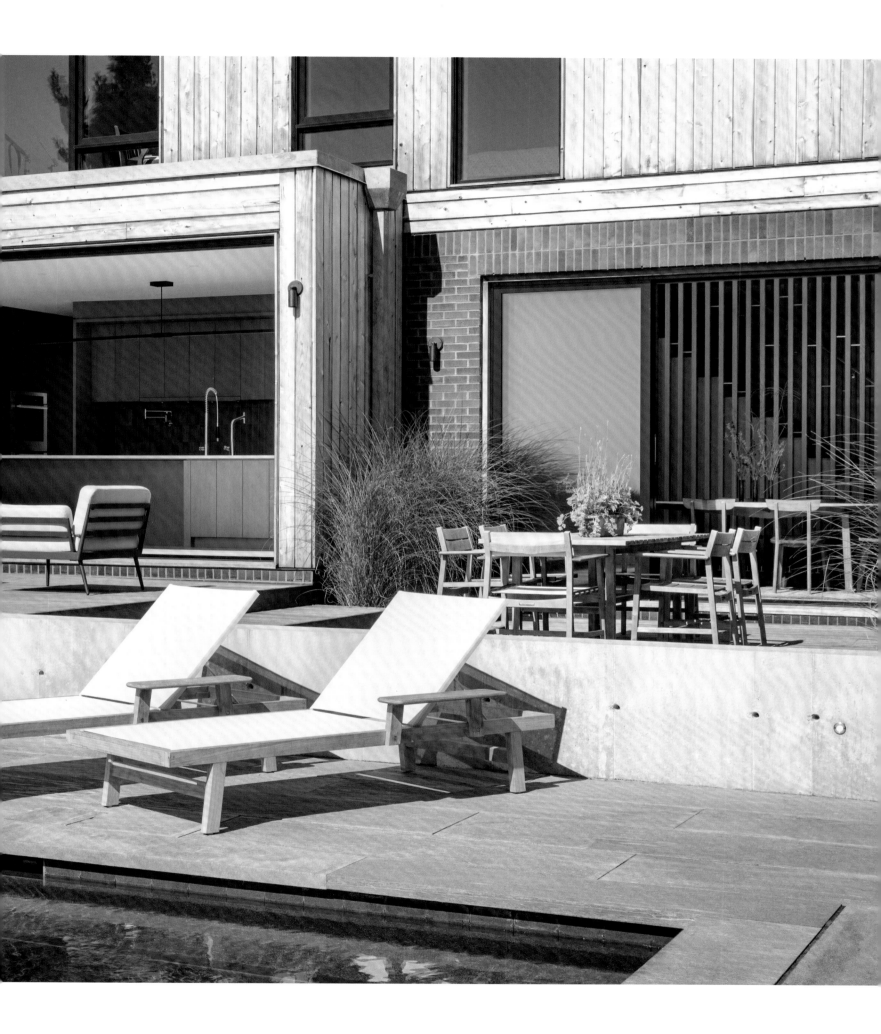

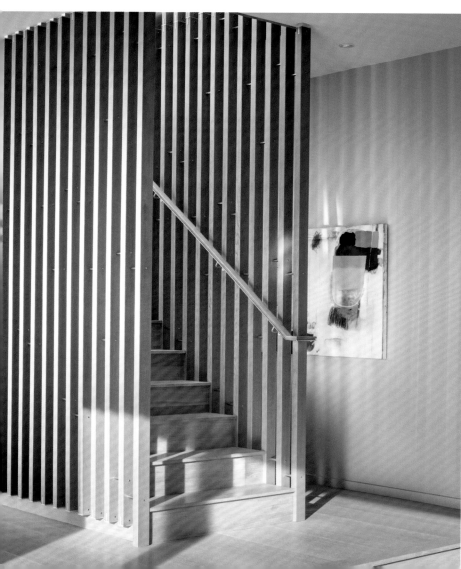

"Most of our projects are surrounded by natural beauty, so we are often trying to get our projects to blend into the landscape by using local wood and stone and constantly trying to design things where there is an easy intersection with the natural world and what we build."

— Caleb Johnson

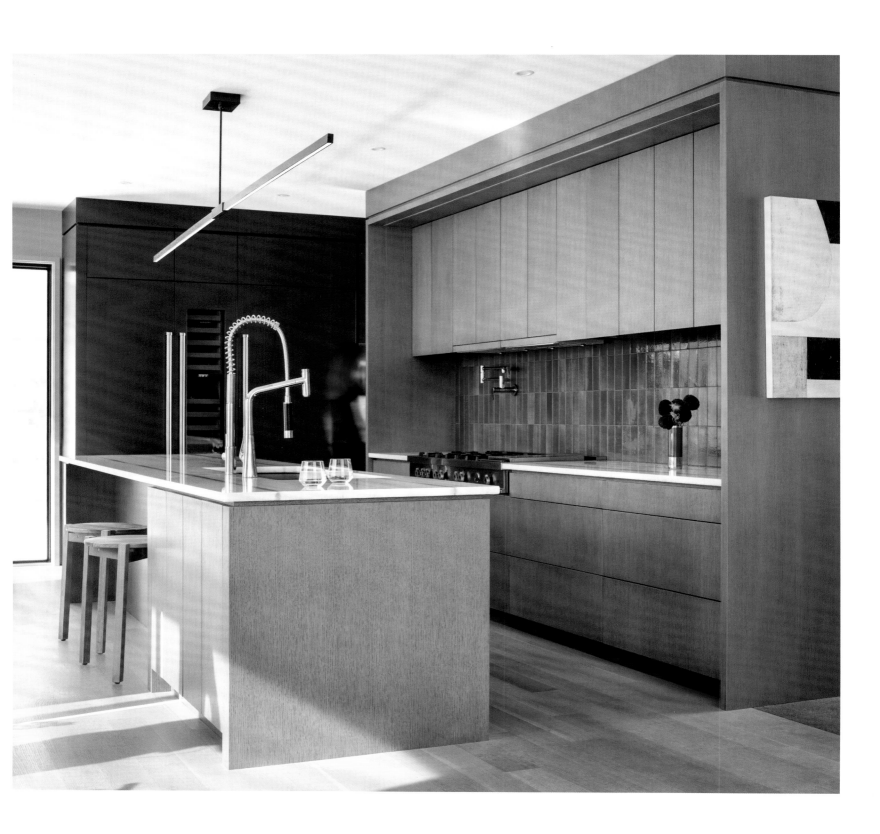

When starting a new project, Johnson said he likes to walk the site or existing building with the client and ask them about their family, dreams, and how they envision the project taking shape.

"We need to understand to the best of our abilities what is special for each client," he said. "We search for the heart of the project and find it in different spots, whether it's the family's generational history on a property, their love of wood, or a specific style of architecture."

For the Spears Hill home, Johnson said the clients were coming together as a new family, and they loved modern architecture and had a good understanding of how the design process worked. "We met at least every other week at the beginning of the project and got suggestions, approvals, and rejections of ideas throughout the design and construction process," Johnson said. "They were ready to build a home that was just for them."

The home site is on a hill overlooking Casco Bay, an inlet of the Gulf of Maine on the state's southern coast of Maine. The clients wanted nearly every room to take the long view to the horizon, Johnson said, which resulted in a long linear arrangement of rooms, allowing the occupants to absorb the vastness of Casco Bay from all spaces within.

"Not wanting to cut off the waterside of the house from the roadside, we chose to allow views and foot traffic straight through the building by creating a sort of hole through the primary floor. On entry by car or foot, the view out to the bay is always front and center, so you don't feel like you are on the back side of the building at any point."

Other design touches include custom colors and tiles, while a staircase of aluminum and oak creates a stunning centerpiece. Walls of windows fill each room with sunlight, especially the spacious kitchen, a popular gathering place where the homeowners and their guests gather, creating memories and soaking in the awe-inspiring coastal views.

---

*Interior Styling: Tyler Karu*
*Landscape Architecture: Soren DeNiord Design Studio*
*Builder/Contractor: Woodhull*
*Photographer: Trent Bell*

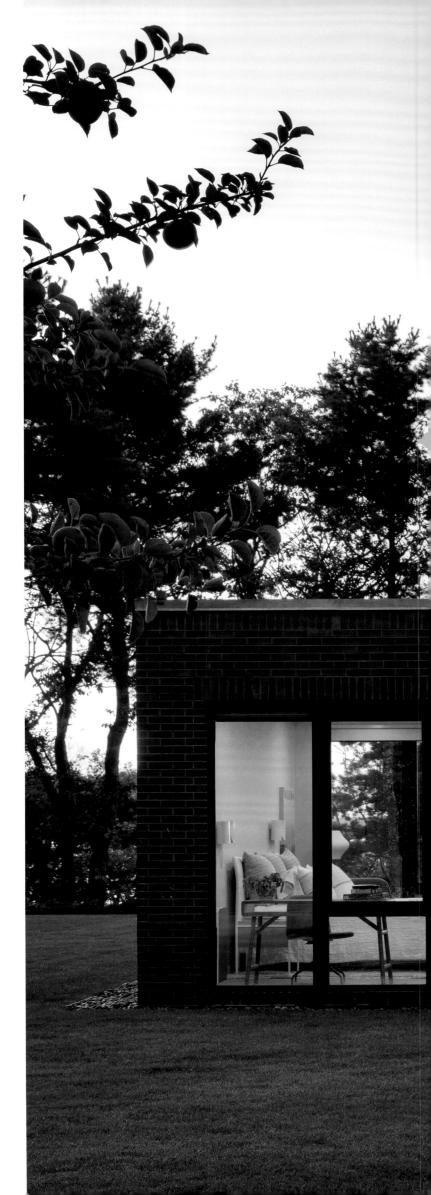

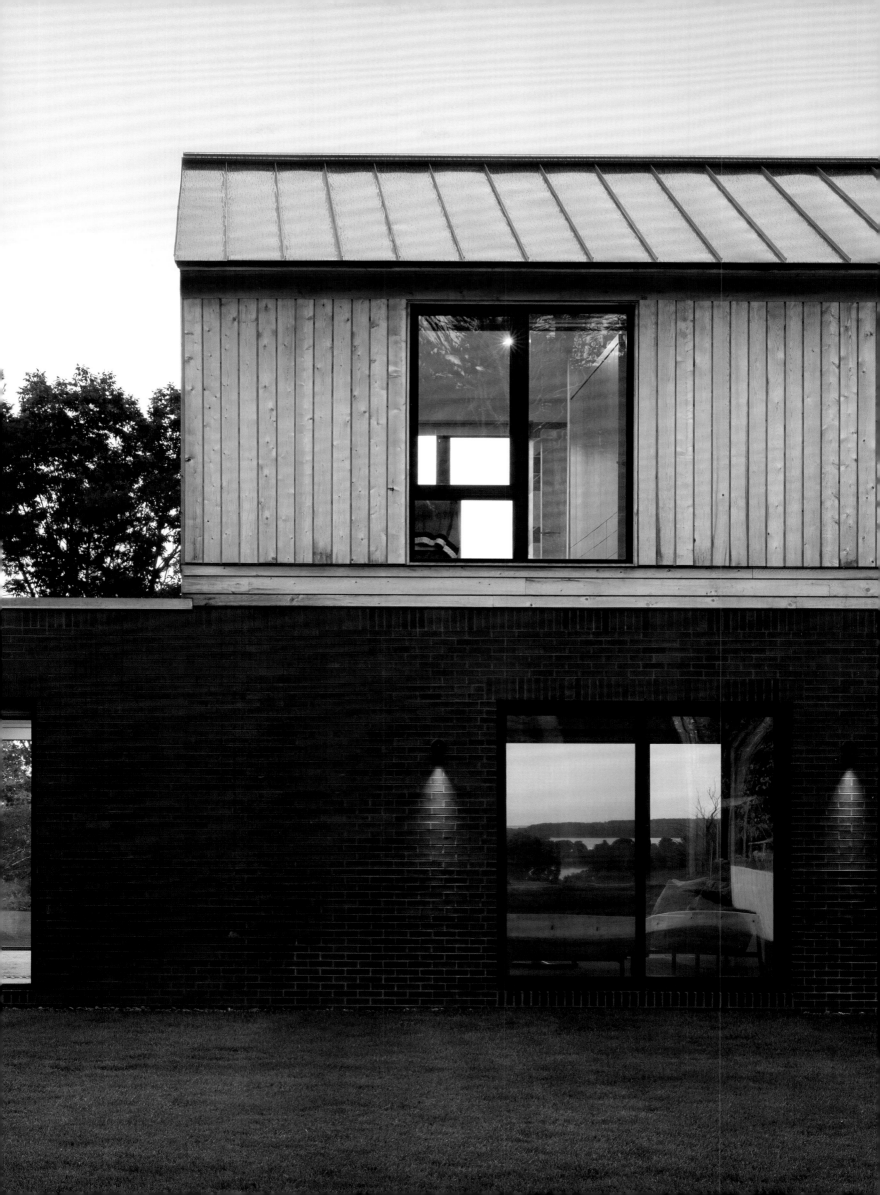

"I have changed in many ways since I began to practice architecture and with the change, my appreciation of the value of design increased with it, including the influence that aesthetics has in our lives."

— Sussan Lari

Sussan Lari

Sussan Lari Architect, PC

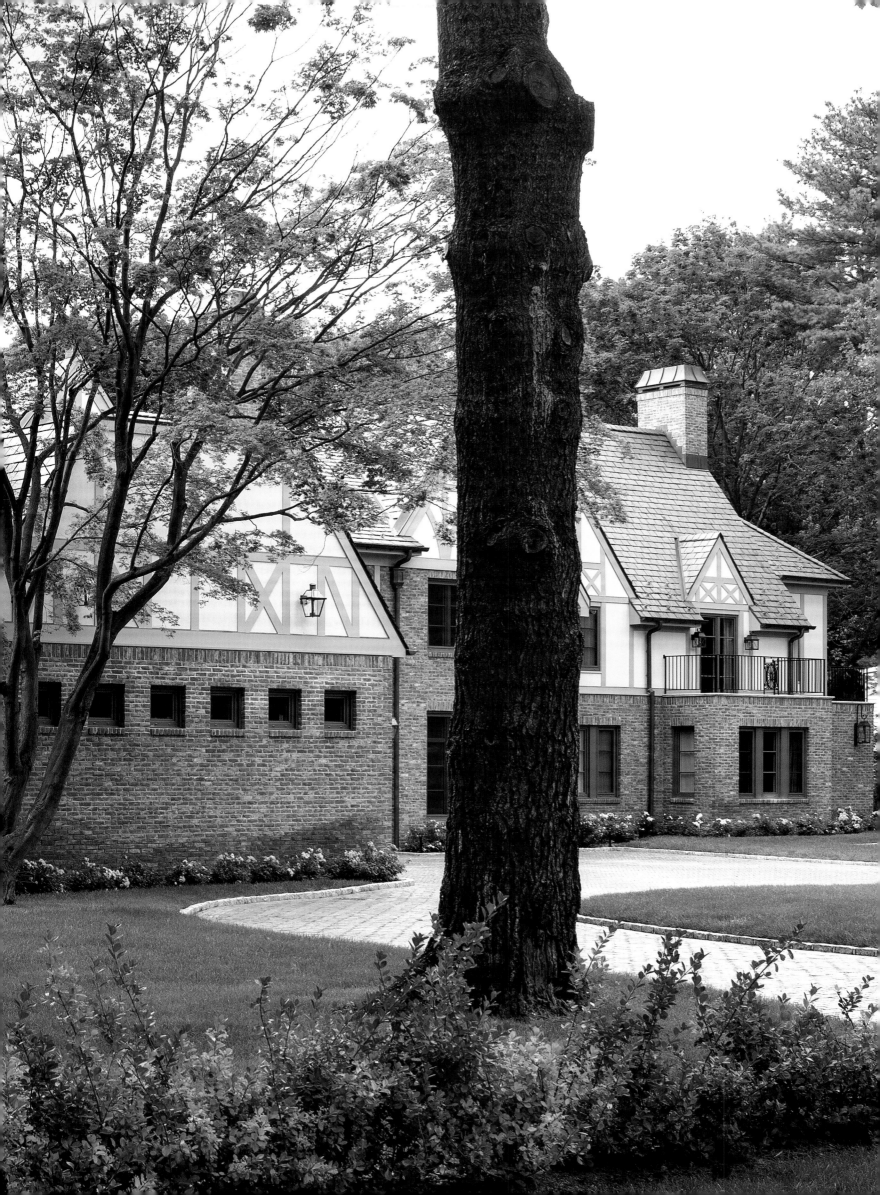

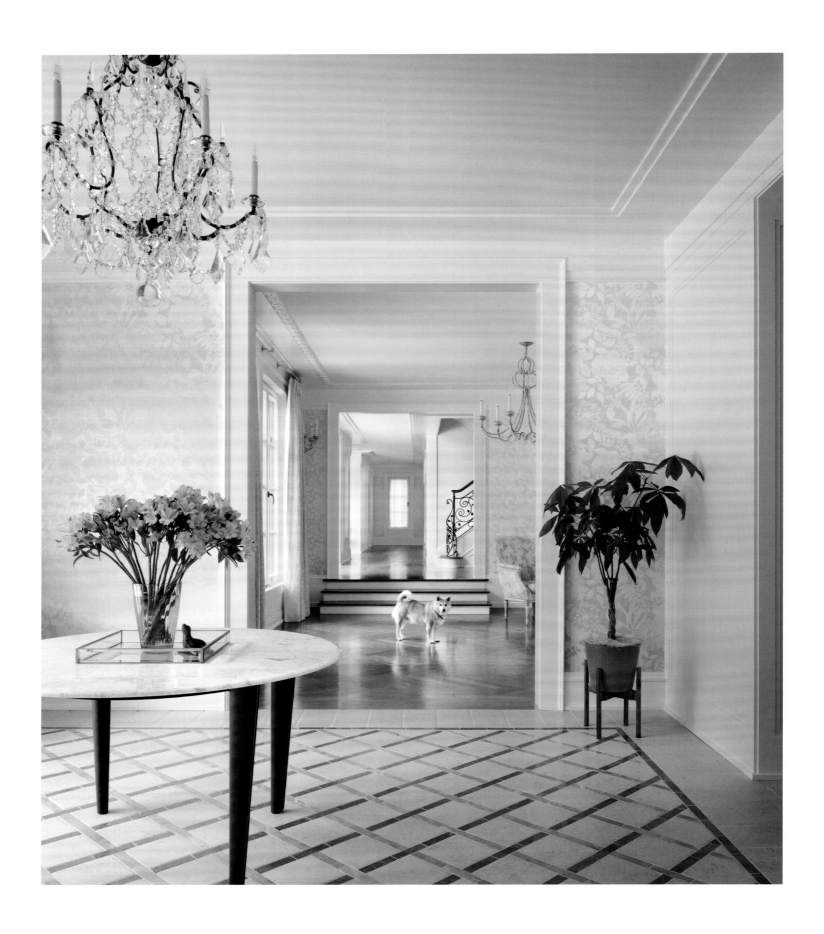

From a young age, Sussan Lari defied expectations and cultural norms to chase after her dream of becoming an architect. Lari was born and raised in Iran, where students must declare their academic majors when they enter high school. At the time, Lari was attending an all-girls French Catholic private school, which only offered a home economics major. Even at a young age, Lari knew she wanted to be an architect, so she changed schools in order to major in math — which was a requirement in order to be admitted into an architectural school.

"I got my high school degree in math, and then I entered a national competition exam to enter the Tehran University School of Architecture," she said. "I was one of 17 women admitted."

Lari then moved to the United States, where she continued her education at the University of Pennsylvania, earning two master's degrees in architecture and planning. She launched her career at the Eggers Group in New York, where she worked her way up to vice president. After 13 years at the firm, she founded Sussan Lari Architect PC in 1992. Headquartered in Roslyn, New York, the full-service architectural and design firm has completed more than 70 projects for residential and commercial clients throughout the region.

"I have a boutique firm with four full-time employees," Lari said. "Although the skill sets of each employee are different, they are involved in the life of each project from the beginning to the end. They all participate in different stages and are intimately familiar with every one of them."

Whenever starting a new project, Lari said that in order to get to know her clients, including their likes and dislikes, she asks them to create three separate lists: what they absolutely must have, what they desire to have, and what they dreamed they could have but don't think is doable or feasible.

"At the end, they often get all the items on the first two lists and some of the items on the last list. It's a collaboration that makes the process more enjoyable for them and they feel more connected to their home while it's being designed."

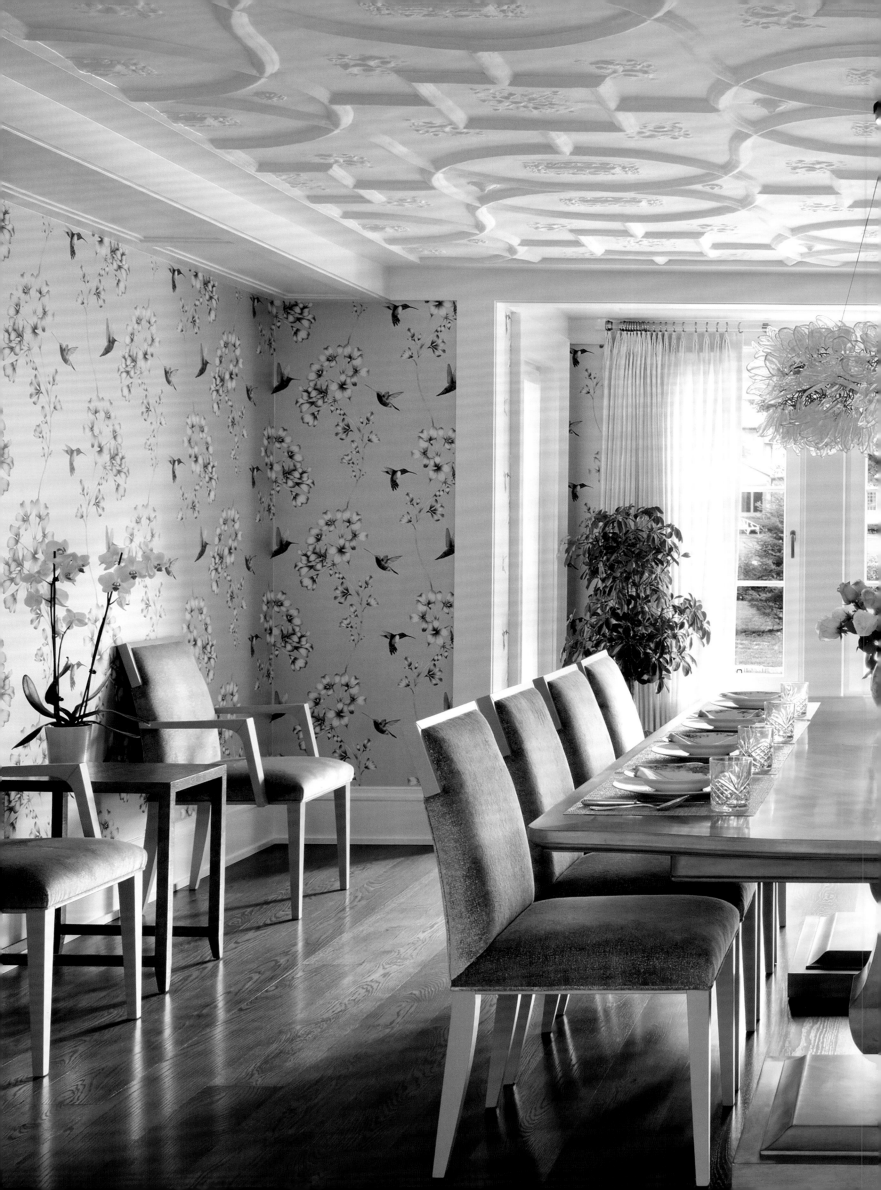

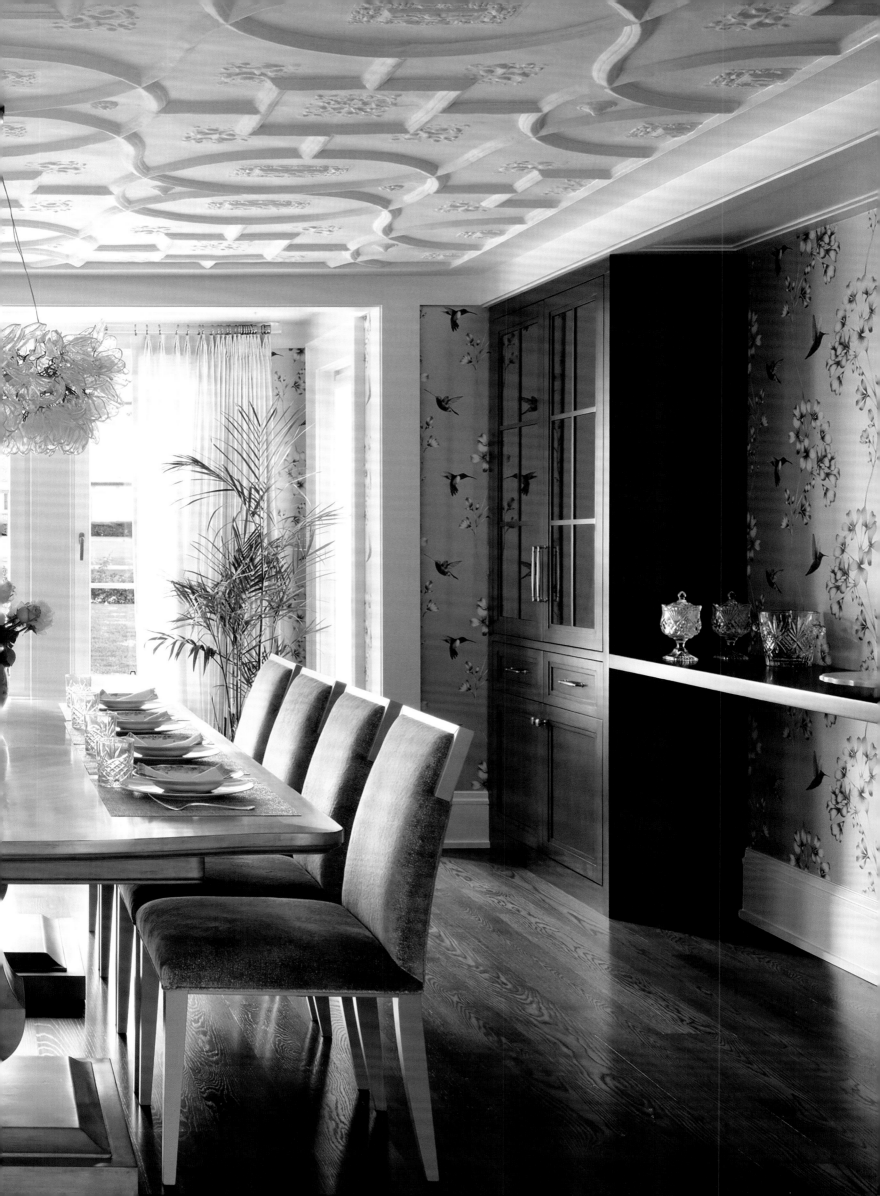

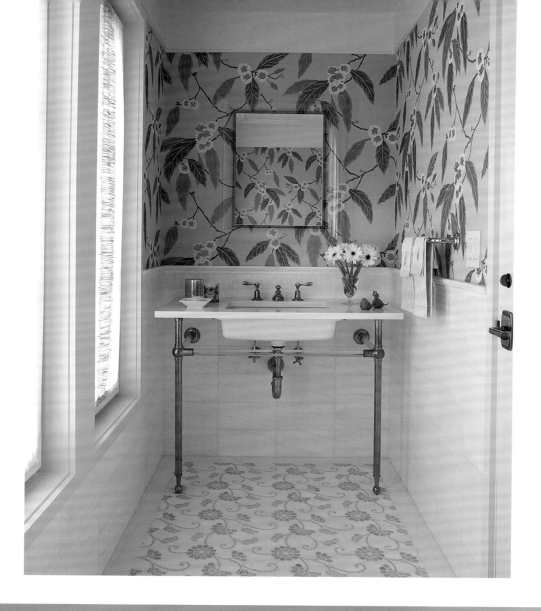

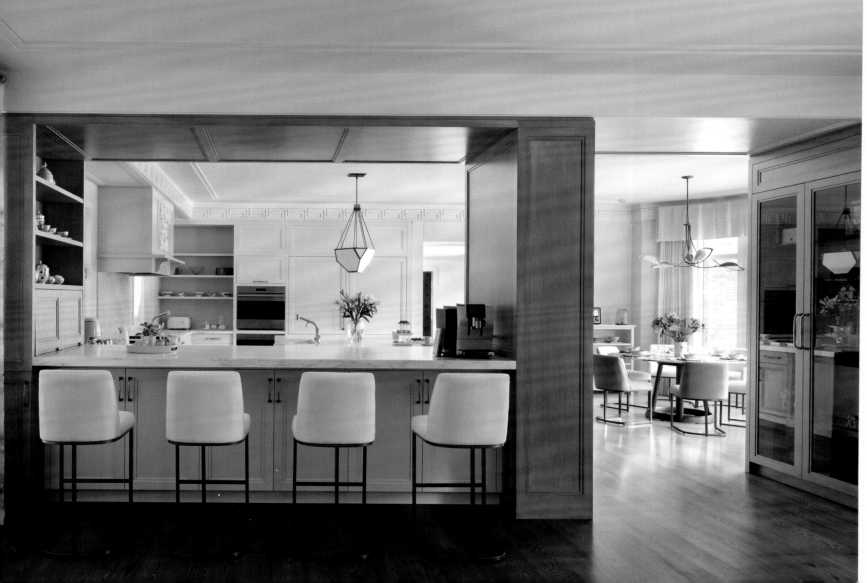

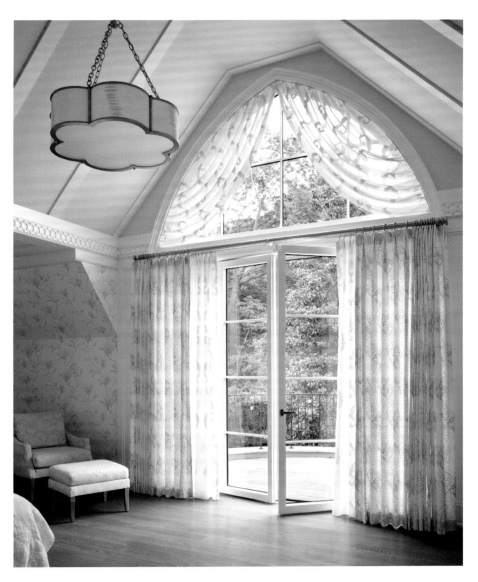

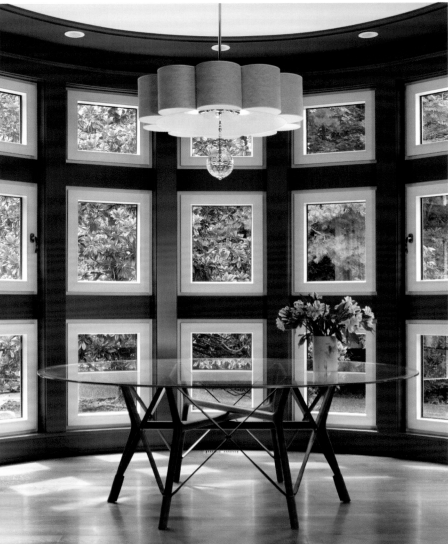

"Functionality, practicality, and aesthetic values are equally important. I will never sacrifice one for the other."

— Sussan Lari

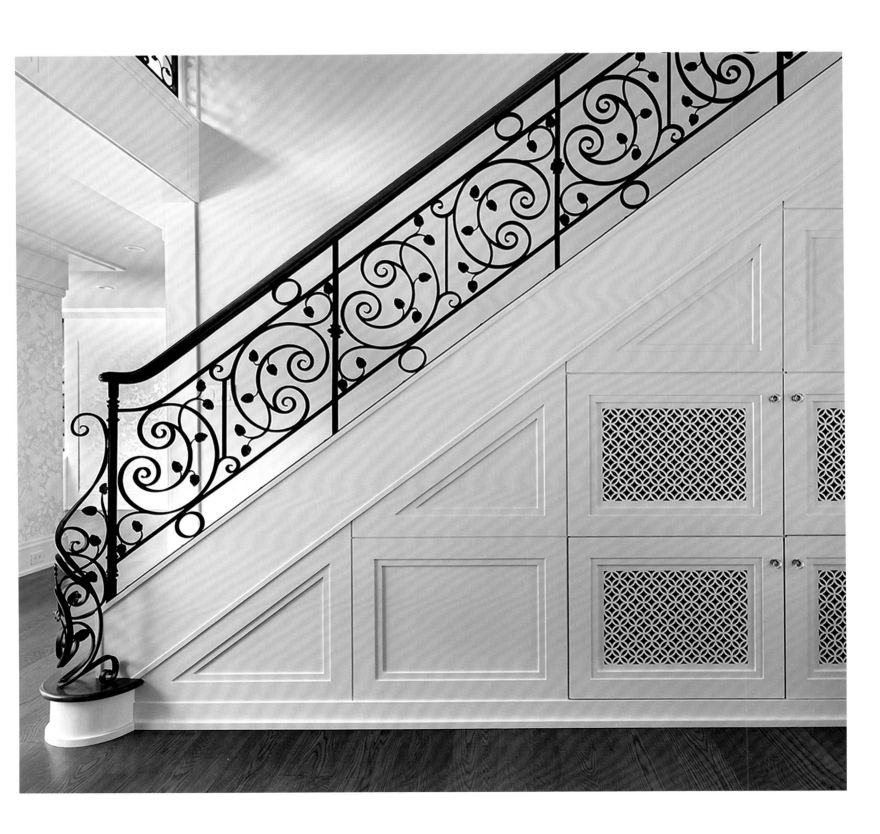

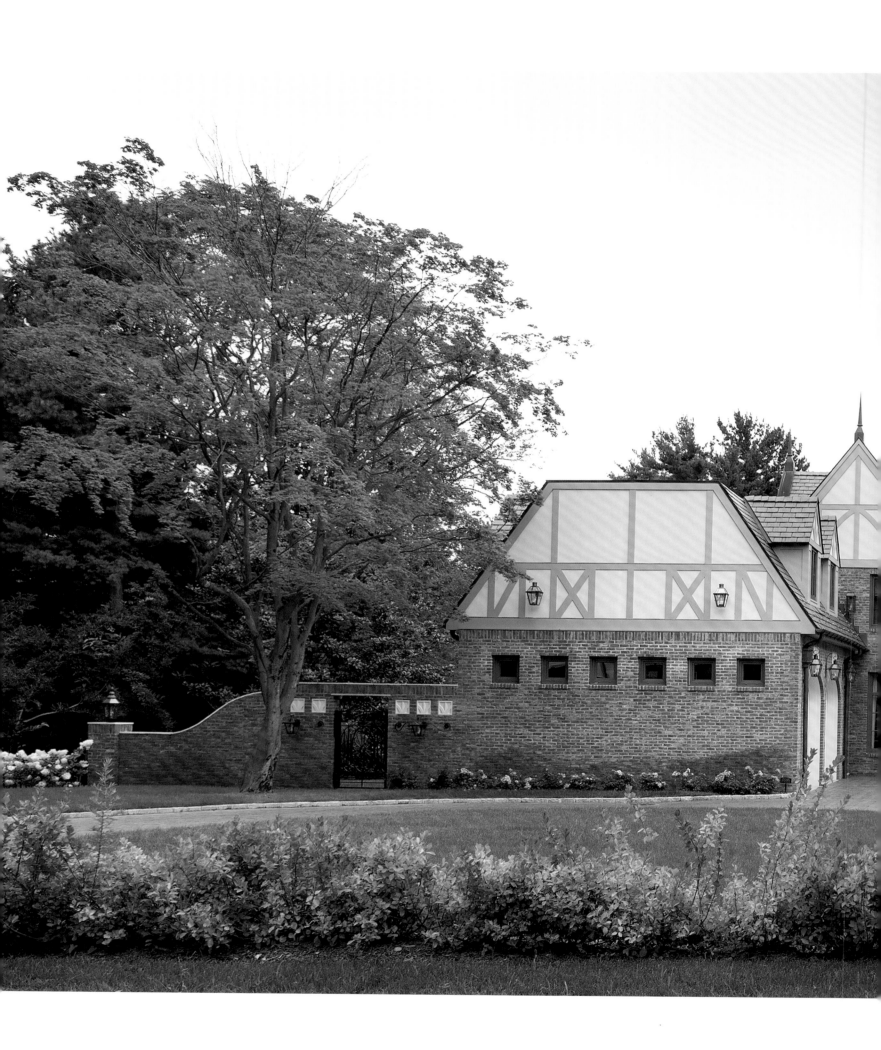

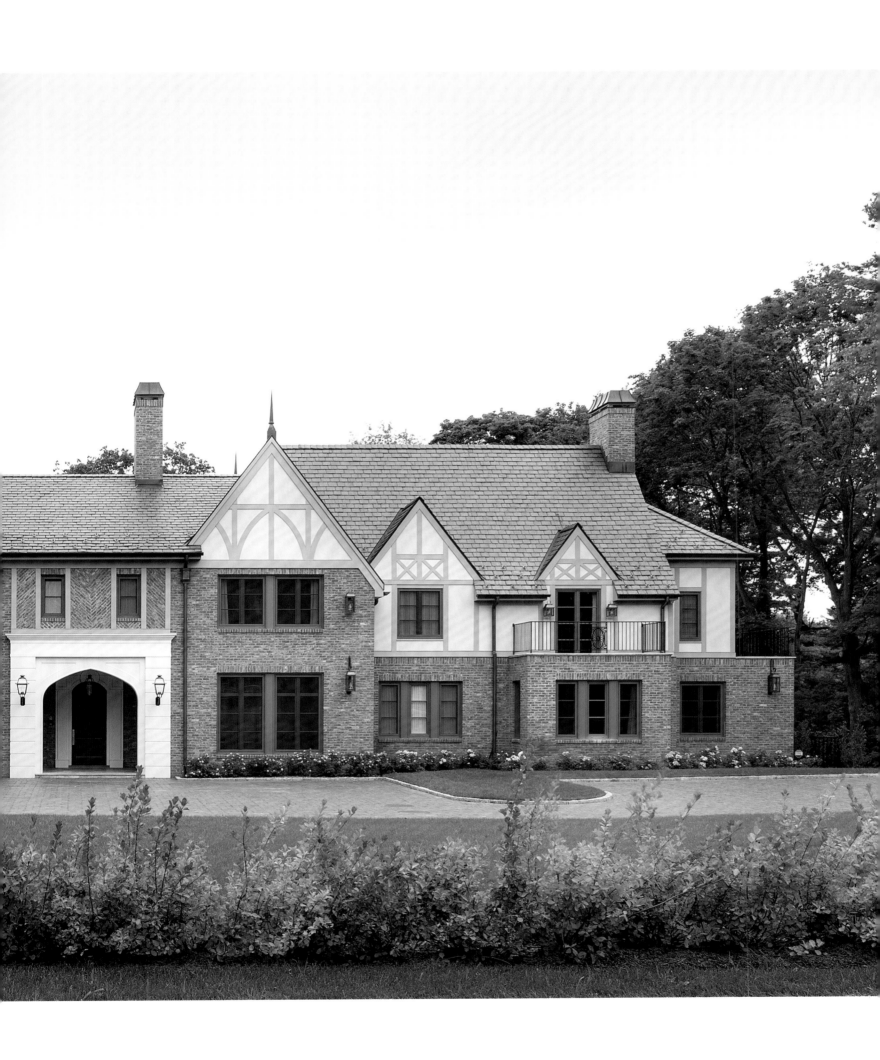

For one of Sussan Lari Architect's newest projects, dubbed Henhawk, the clients were a young couple who were both attending graduate school. During the three-year duration of the project, the couple also had their first child.

"Their desire to have a beautifully well-designed house at that young age was inspiring. I had a strong sense of responsibility toward them and their trust allowed me to be creative, free, and playful with architectural detailing." The lot had a massive magnolia tree, which was a big determining factor in the siting and location of the house. Lari said she positioned the home's library/home office and primary bedroom to provide expansive views of the tree and beyond.

While the COVID-19 pandemic disrupted construction for about two months, Lari said the home turned out the way the clients envisioned. Moreover, it's indicative of what she considers to be a dream project, with features like plenty of natural light, natural materials, and being well-connected to the nature surrounding it.

"Dream projects come from clients that are open to new ideas and do not come to us with a set design in their mind. Our design creativity very much depends on how open our clients are and how free we are in our design process."

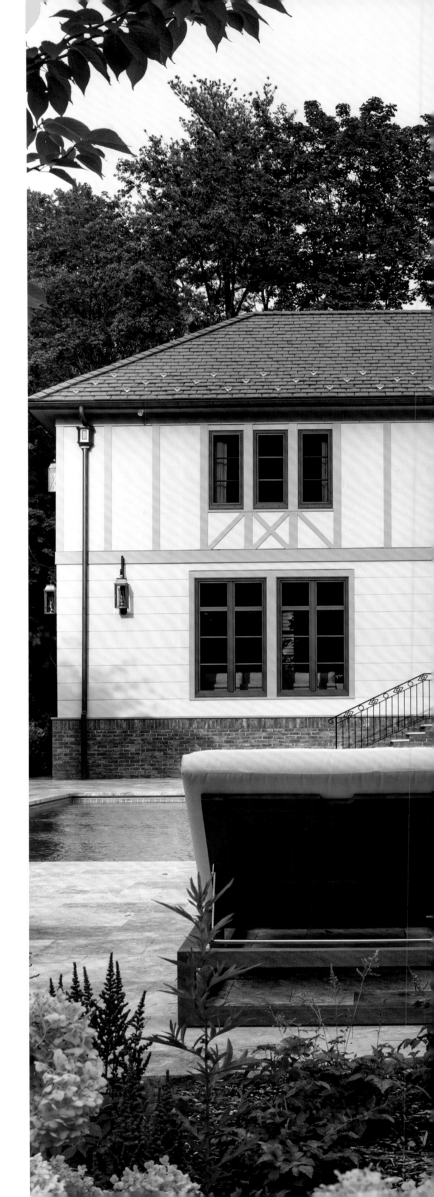

*Interior Design: Sussan Lari Architect PC*
*Landscape Architecture: Sussan Lari Architect PC*
*Builder/Contractor: RBJ Contracting Corp. as CM*
*Photographers: Peter Rymwid, David Mitchell*

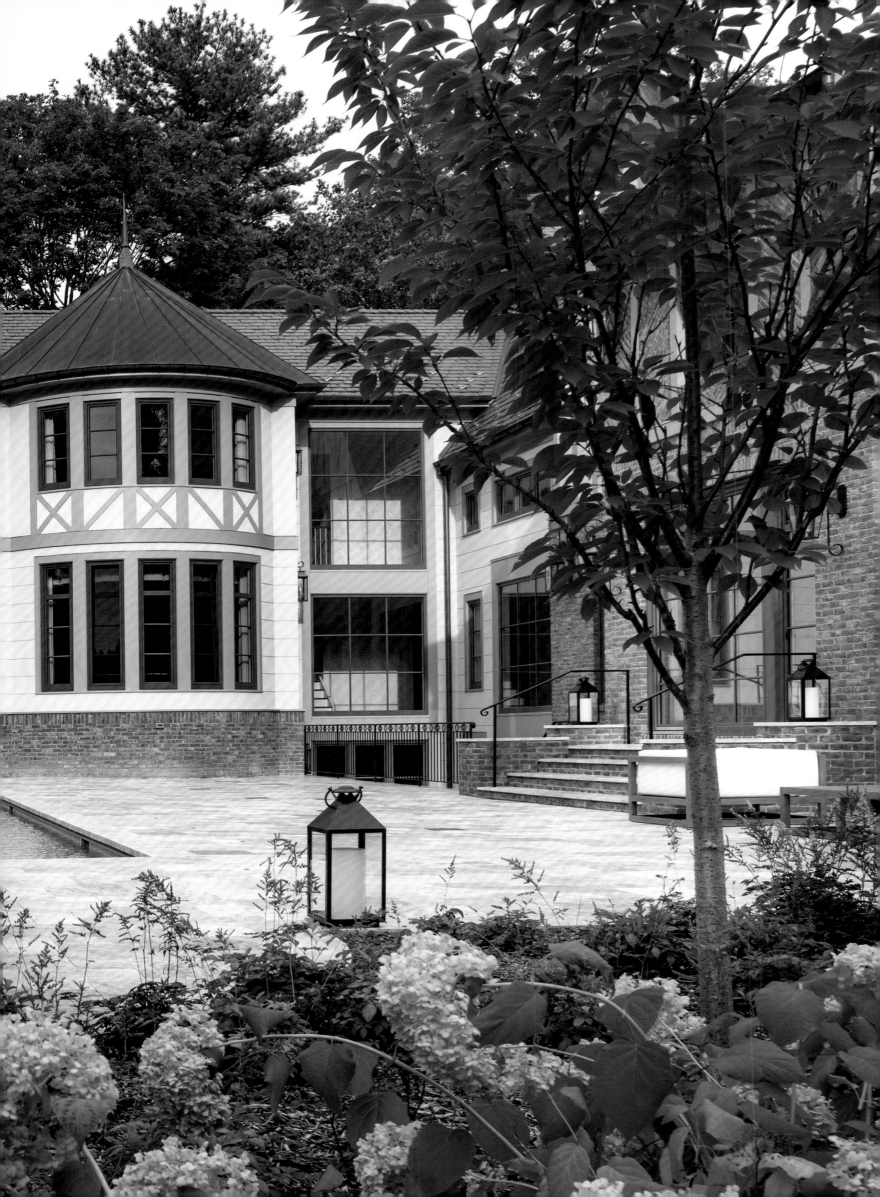

"Each home reflects the true nature of place. Finding authenticity in each project is the net result of understanding the client, the site and the program."

— Brian Mac

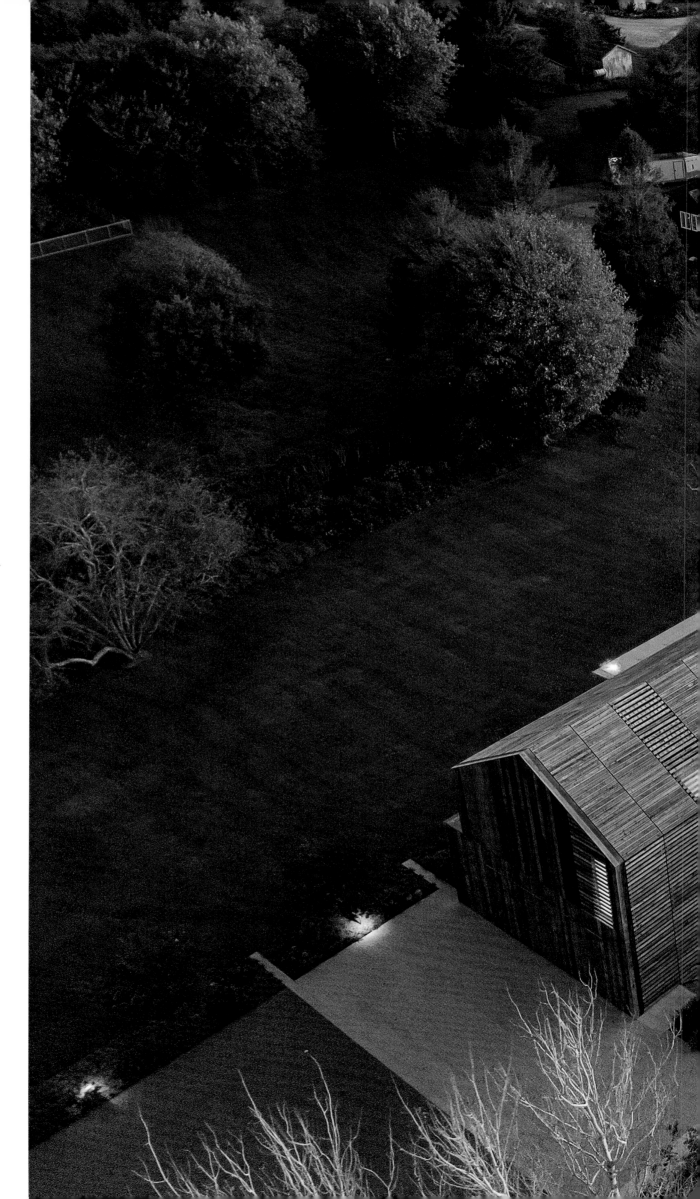

Brian Mac

Birdseye

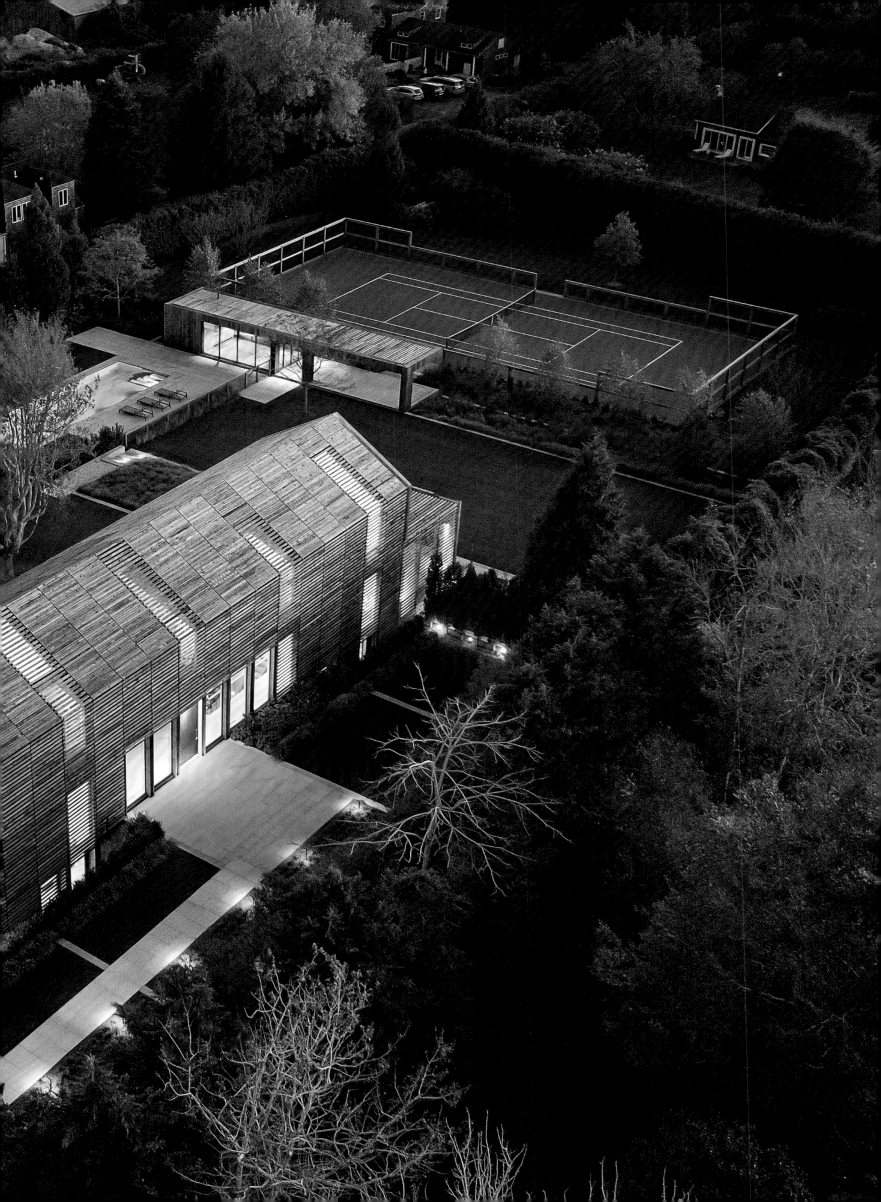

The work of Vermont-based architect Brian Mac has long been informed by a combination of the exotic and practical. While the Michigan native cites his travels to places as diverse as Morocco, Copenhagen, and Newfoundland's Fogo Island as continual sources of inspiration, Mac, a principal architect with Richmond, Vermont-based Birdseye, traces his early motivation back to middle school.

"My grandfather was a draftsman for Alcoa in Pennsylvania, and I loved all of his drafting tools. He inspired my initial interest in drawing. Drafting manually was always a pursuit of organization, art, and mechanical skill. I liked the idea of pursuing a profession that combined art and craft," said Mac, who would later receive his Bachelor of Architecture from the University of Detroit. "Today, places that inspire me usually have a mix of natural beauty, cultural diversity, and are architecturally interesting, both in historical and contemporary language."

Such influences are illustrated by the 100-plus homes Mac has designed with Birdseye since founding the architecture firm in 1997. Starting with the centuries-old language long used by barn and farm-structure builders throughout the Northeast, Mac continually updates that functionality ethos to put a modernist twist on the traditional farmhouse vernacular. "Vermont has deep agrarian roots," Mac said of his adopted home state.

Case in point of that regional influence is Lathhouse, the award-winning home completed in Sagaponack, Long Island, in 2020. A lath house is a plant- or crop-housing structure built primarily with spaced, wooden slats, or "laths," that simultaneously prevent excessive sunlight while permitting air circulation. With Lathhouse, Mac manages to deploy reclaimed fence wood to explore this motif as a siding element on the property's main house, guest suite, pool house, and garage, all while complying with the Hamptons' strict zoning requirements.

"I think my never-ending aspiration to pursue excellence in design gets me closer to becoming a better architect. I also have a desire to never give up on an idea," said Mac, who added that he embraces the challenge of creating an aesthetically-pleasing home without sacrificing functionality. "The balance is inherently there if they are not separated when thinking about concept. Design is a holistic endeavor. 'Everything at once' is how I see each idea."

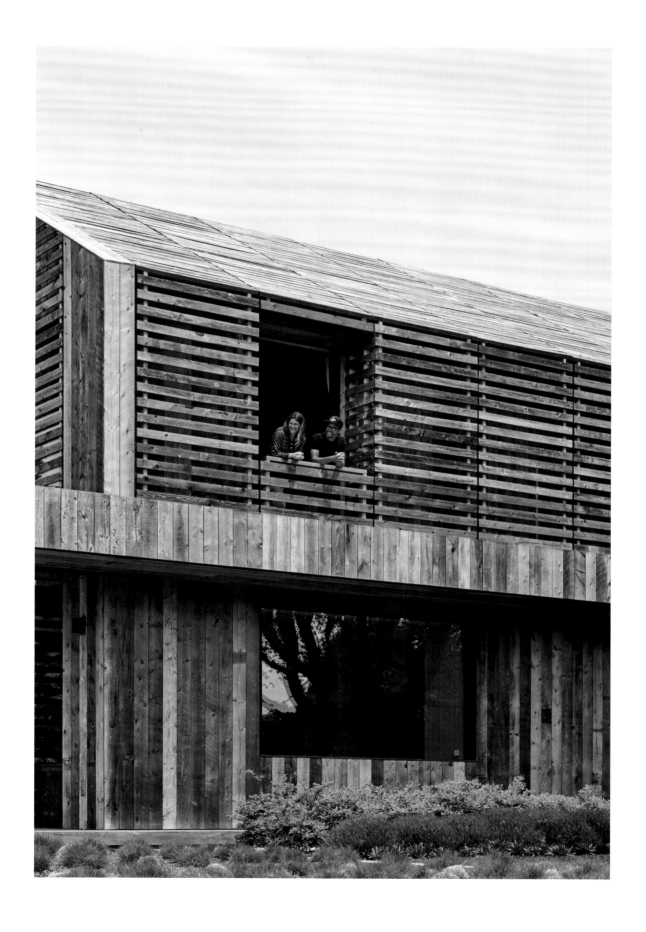

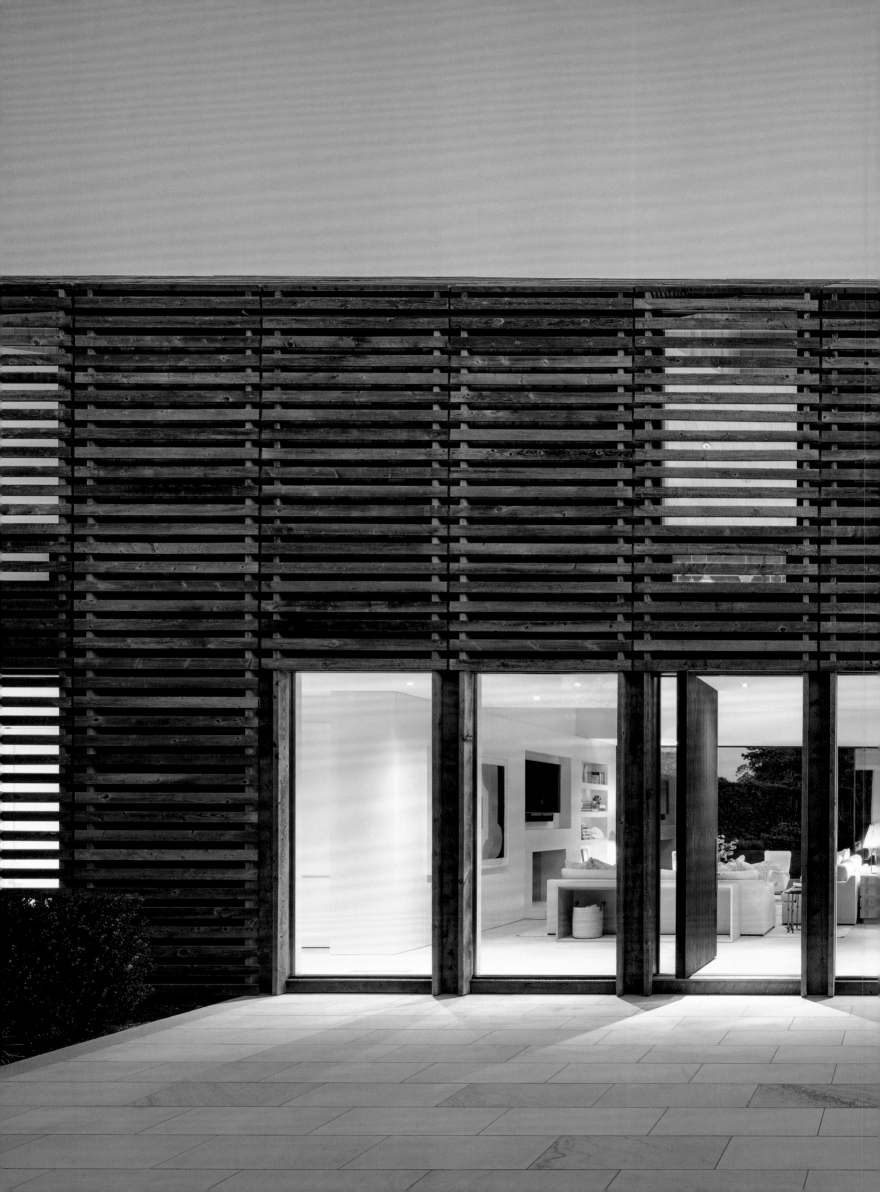

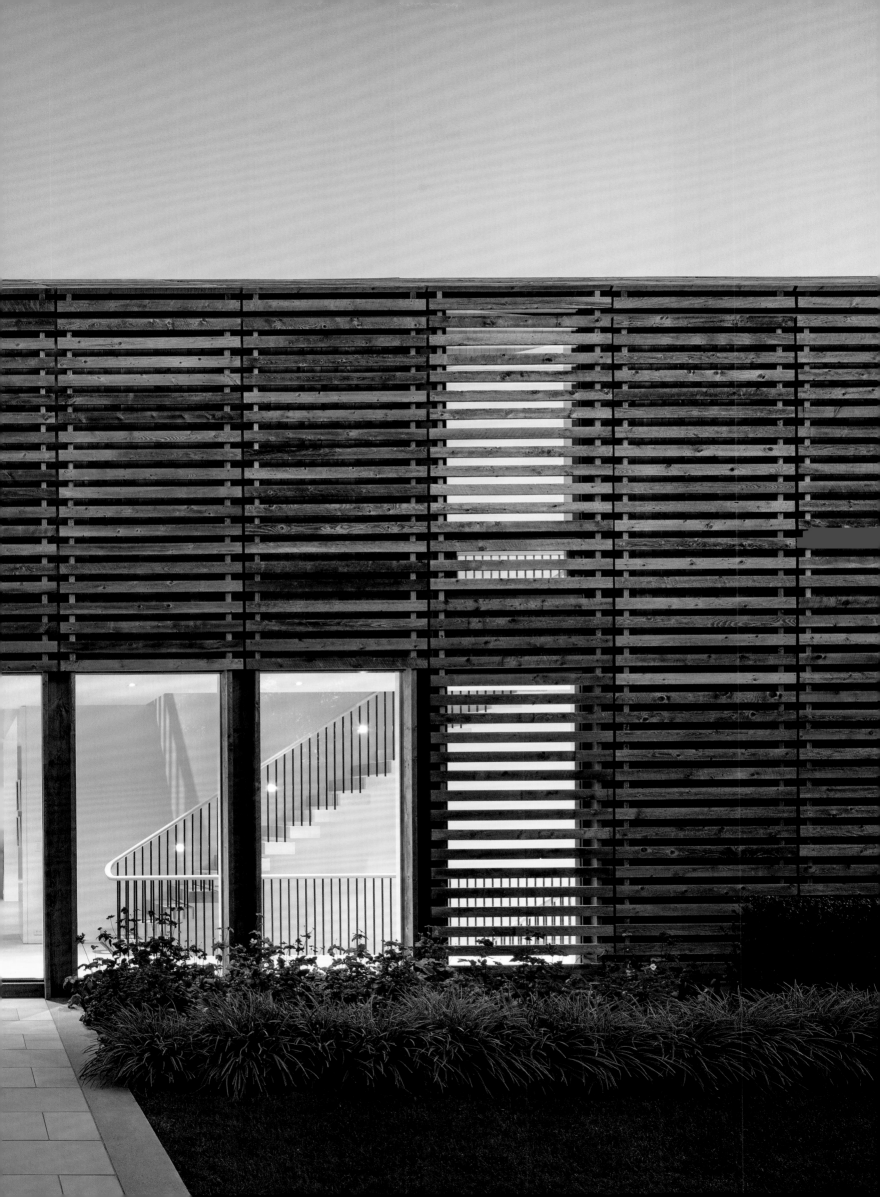

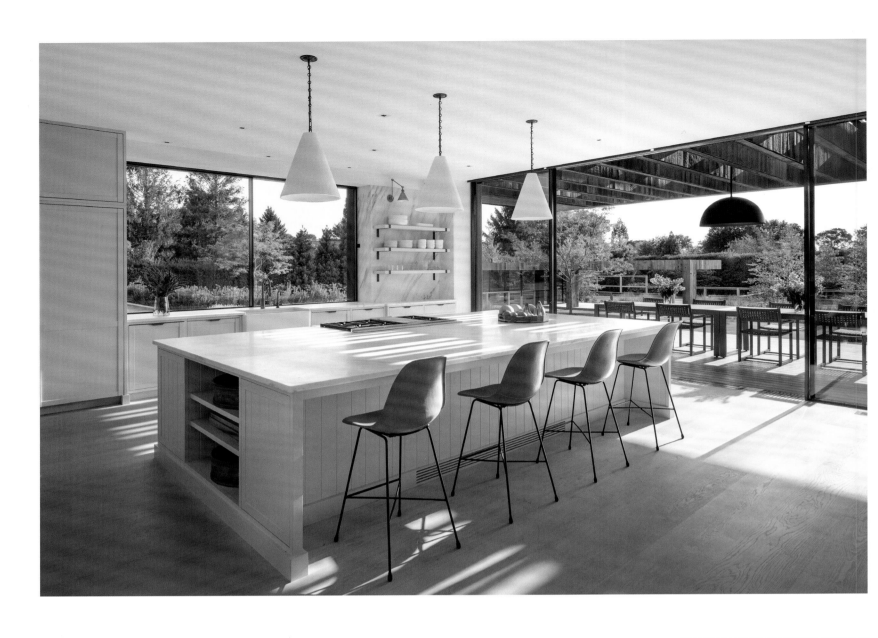
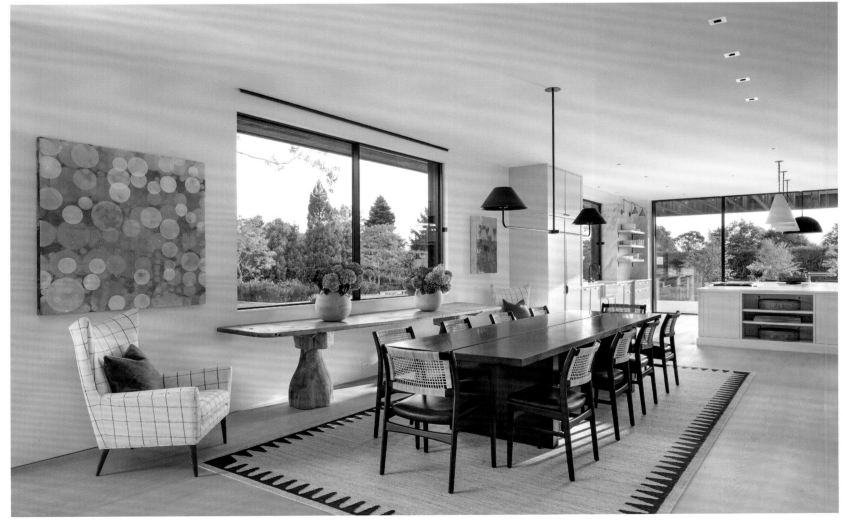

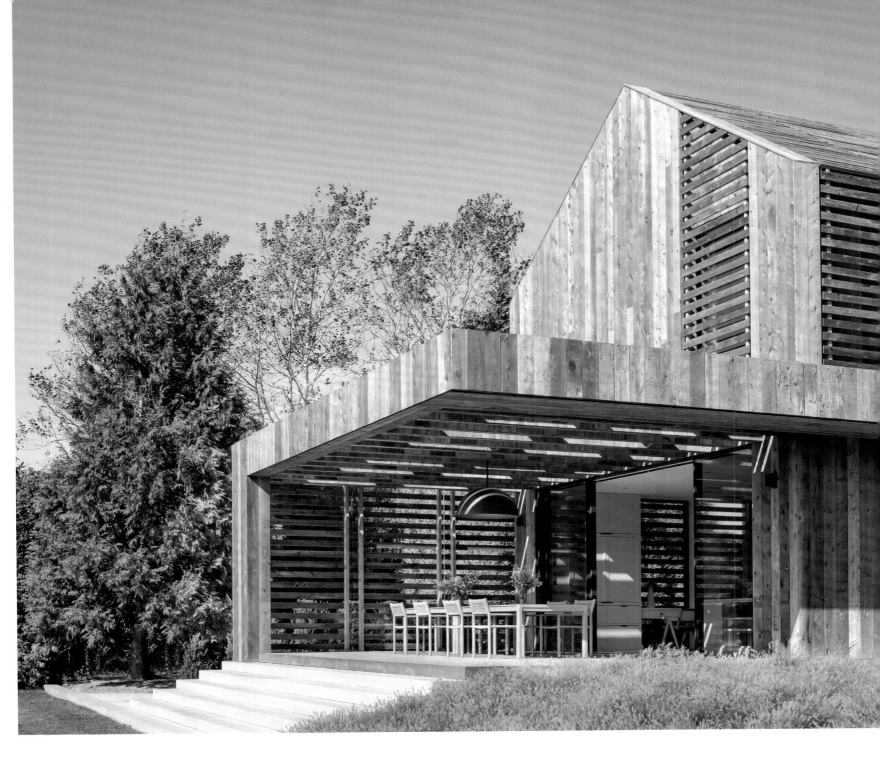

"Every idea we have is pushed forward with confidence because of our commitment to understanding materiality, technology, sustainability, and building science. We get better when we learn and work with those who do the work, supply the materials, and give us the data. In ten years, I want us to be as passionate as we are today about architecture."

— Brian Mac

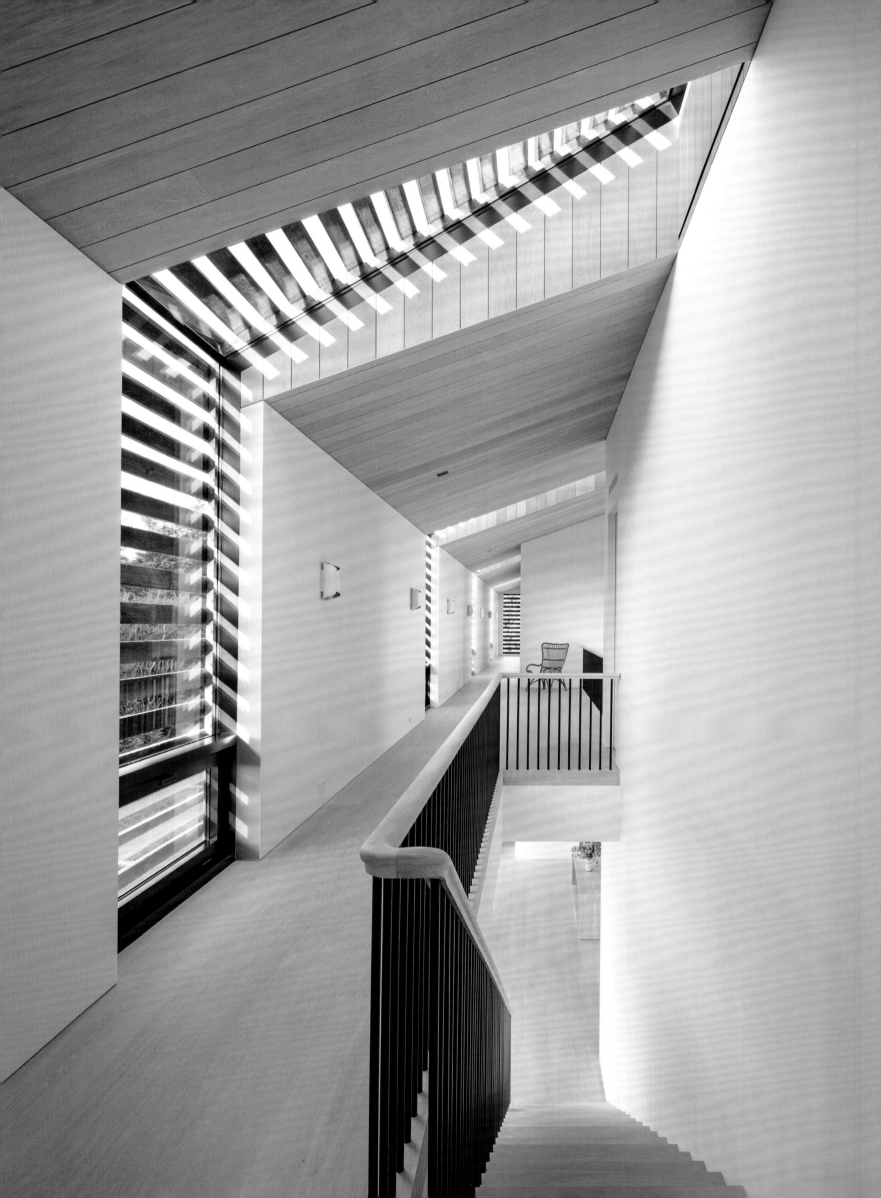

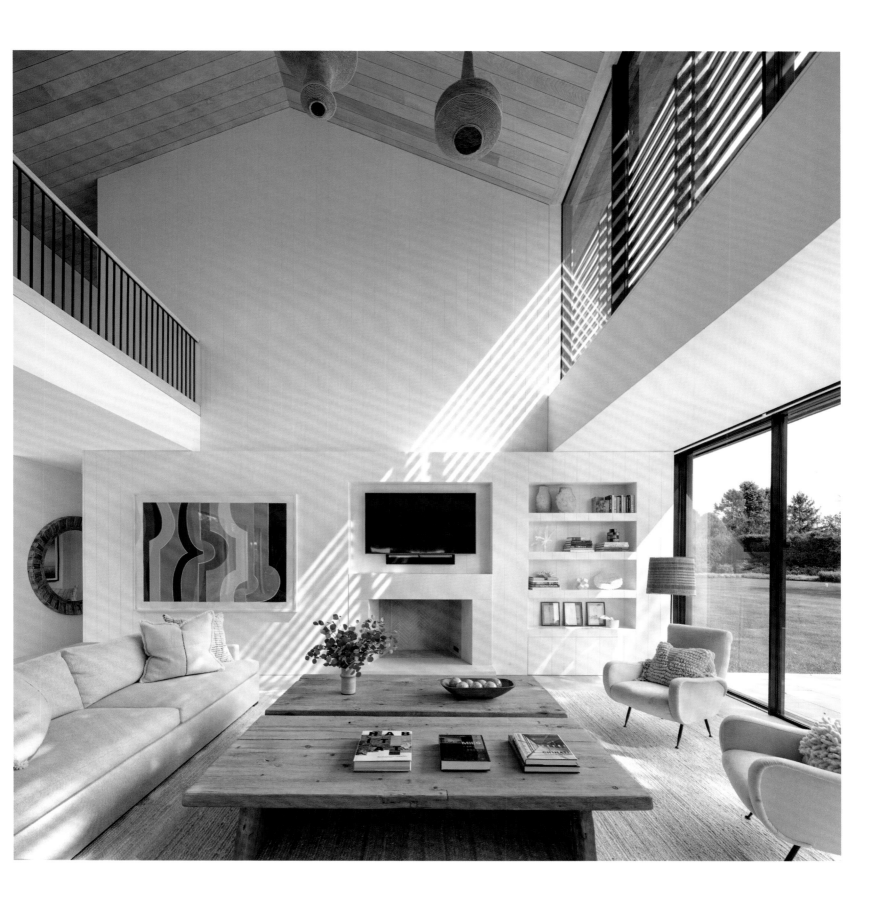

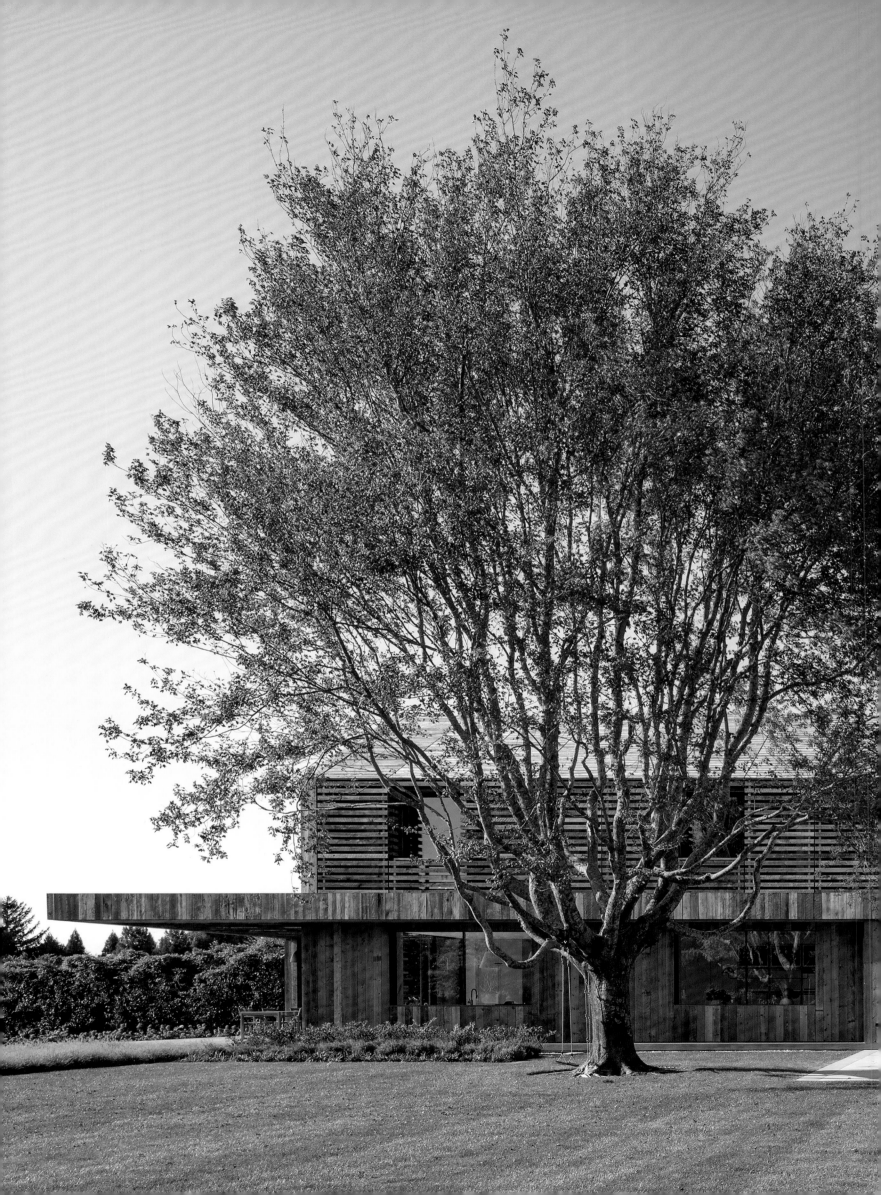

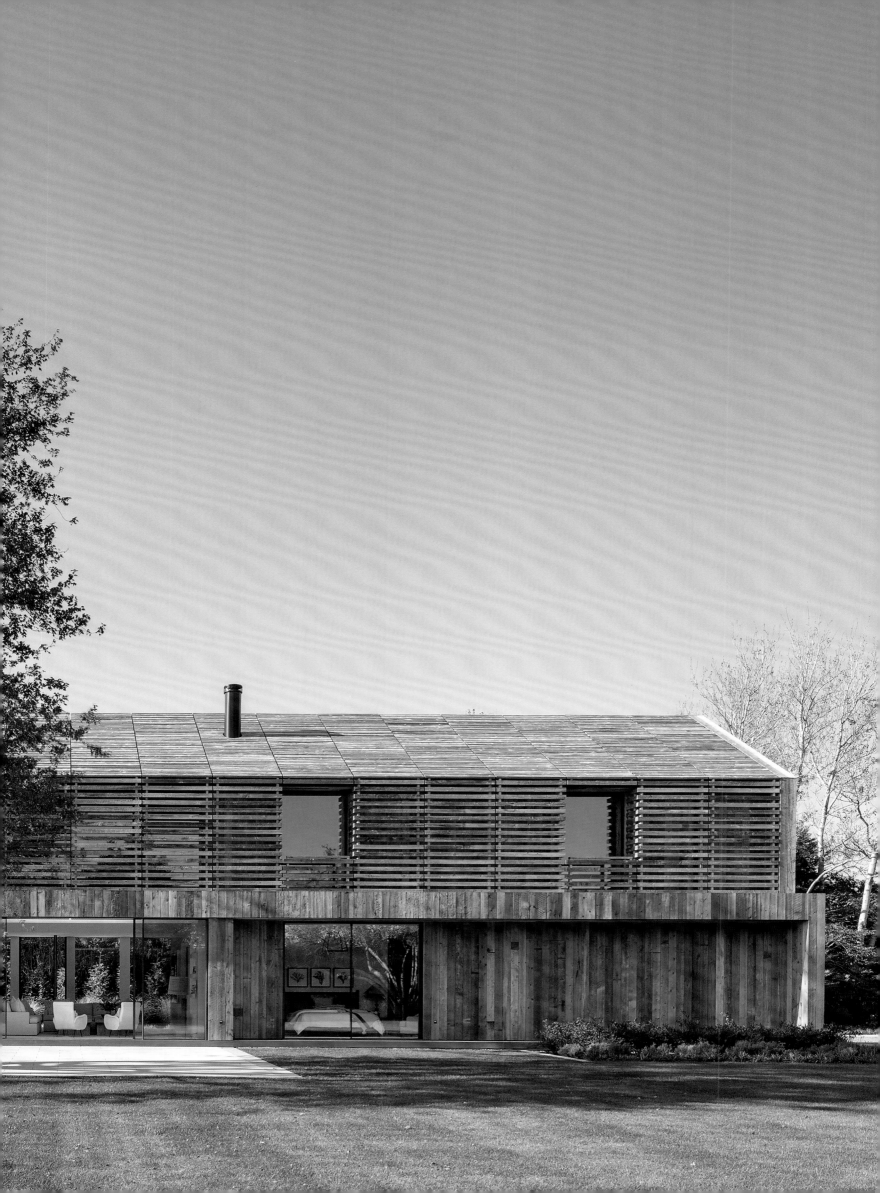

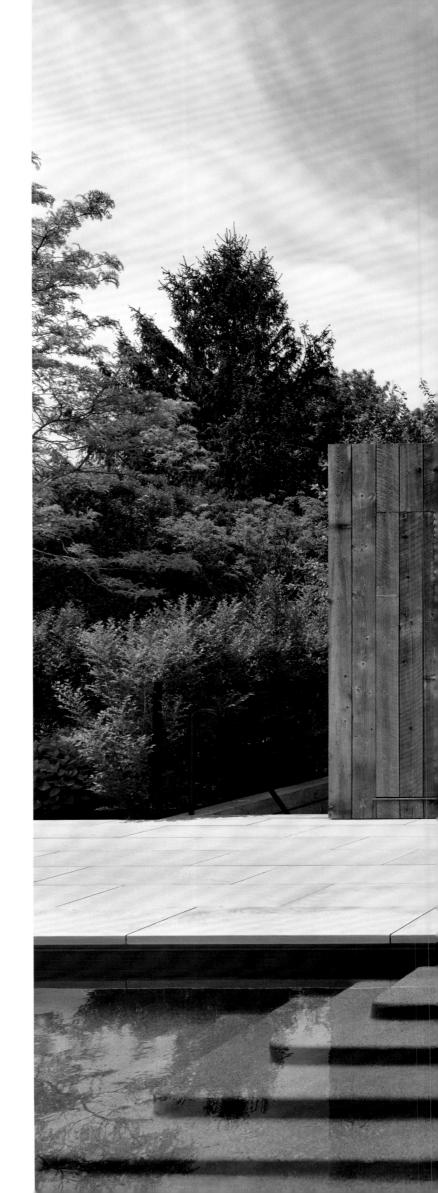

Having celebrated his 30th year as a licensed architect in 2022, Mac has also long been inspired by the buildings of historically world-renowned architects such as Frank Lloyd Wright, Le Corbusier, and Eero Saarinen.

But Mac also cites the work of British-Iraqi architect Dame Zaha Hadid (London Aquatics Centre, Guangzhou Opera House), Ghanian-British architect Sir David Adjaye (Washington, D.C.'s National Museum of African American History and Culture), and Japanese architect Kengo Kuma (Tokyo's Japan National Stadium) as more contemporary motivation.

Additionally, Mac says minimalist American artist Donald Judd, Danish architect and furniture designer Hans Wegner, and Tyler Hays (founder of designer BDDW) also inform Mac's work.

Most importantly, though, Mac is spurred on by a combination of the ideas of his clients and the opportunities offered by a particular building site.

"The dream project is hinged to the dream client," said Mac. "We work with brilliant people who are very successful. Listening to their input is vital to the success of the project. I learned a long time ago to be open to input about design. Ideas are fluid, and there is always opportunity to explore potential."

---

*Interior Design: Brooke Michelsen Design*
*Landscape: Wagner Hodgson Landscape Architecture*
*Builder/Contractor: Wright & Co. Construction Inc.*
*Photographers: Michael Moran, Peter Murdock*

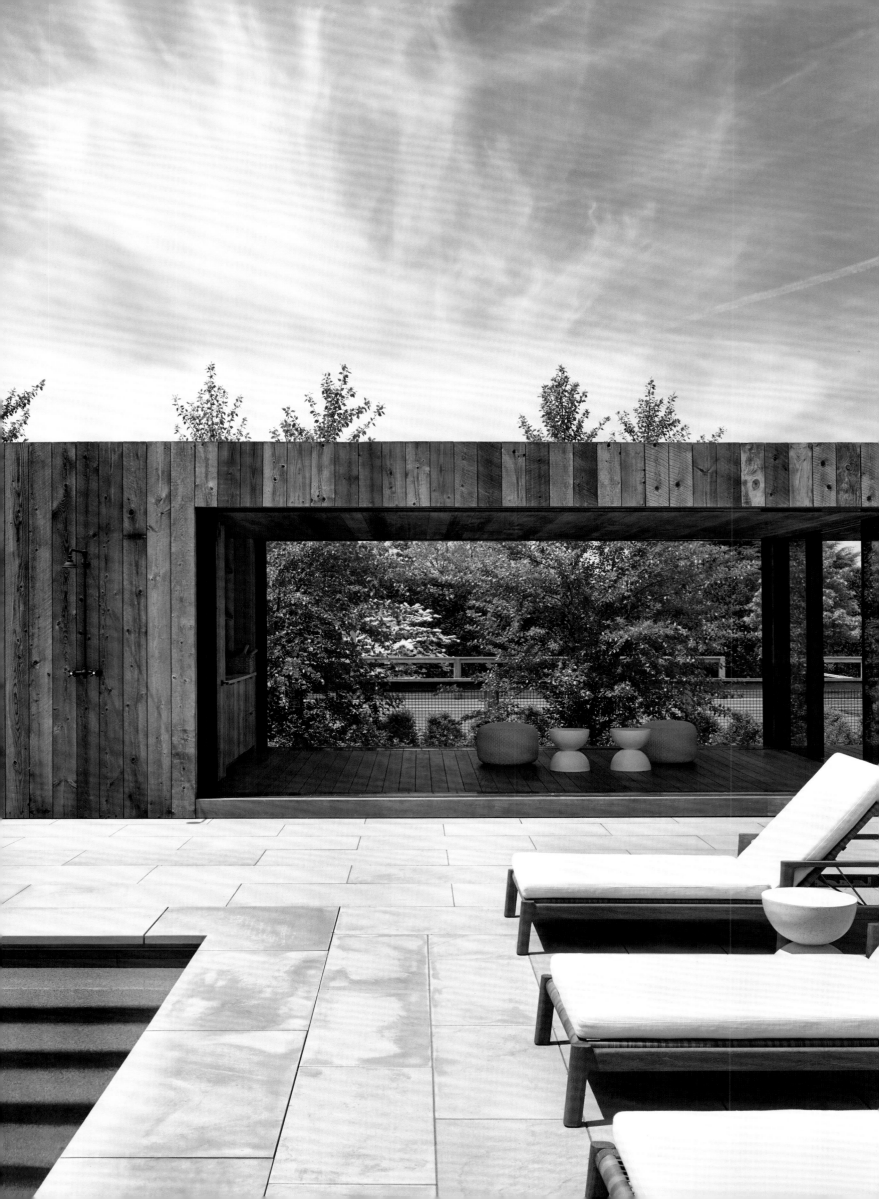

"No project is the same, no site is the same, no client has the same requirements or demeanor and they are always excited to embark on their dream — so the excitement is invigorating."

— Brian Mann

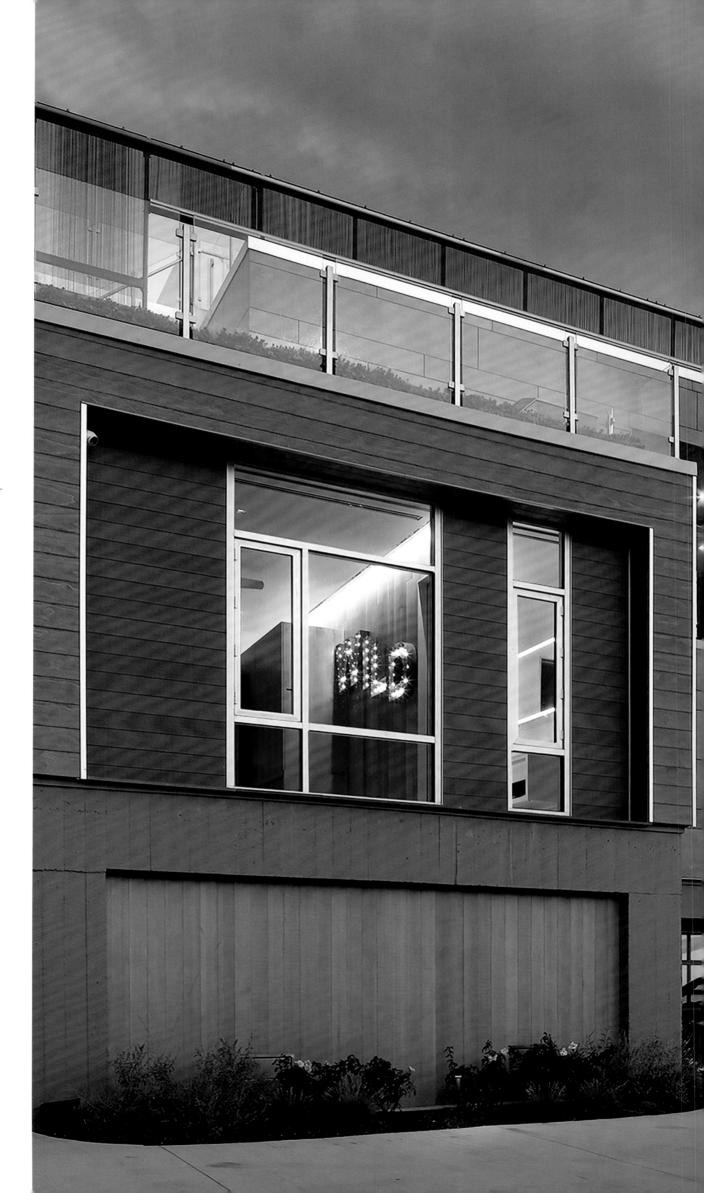

Brian Mann

The OMNIA Group

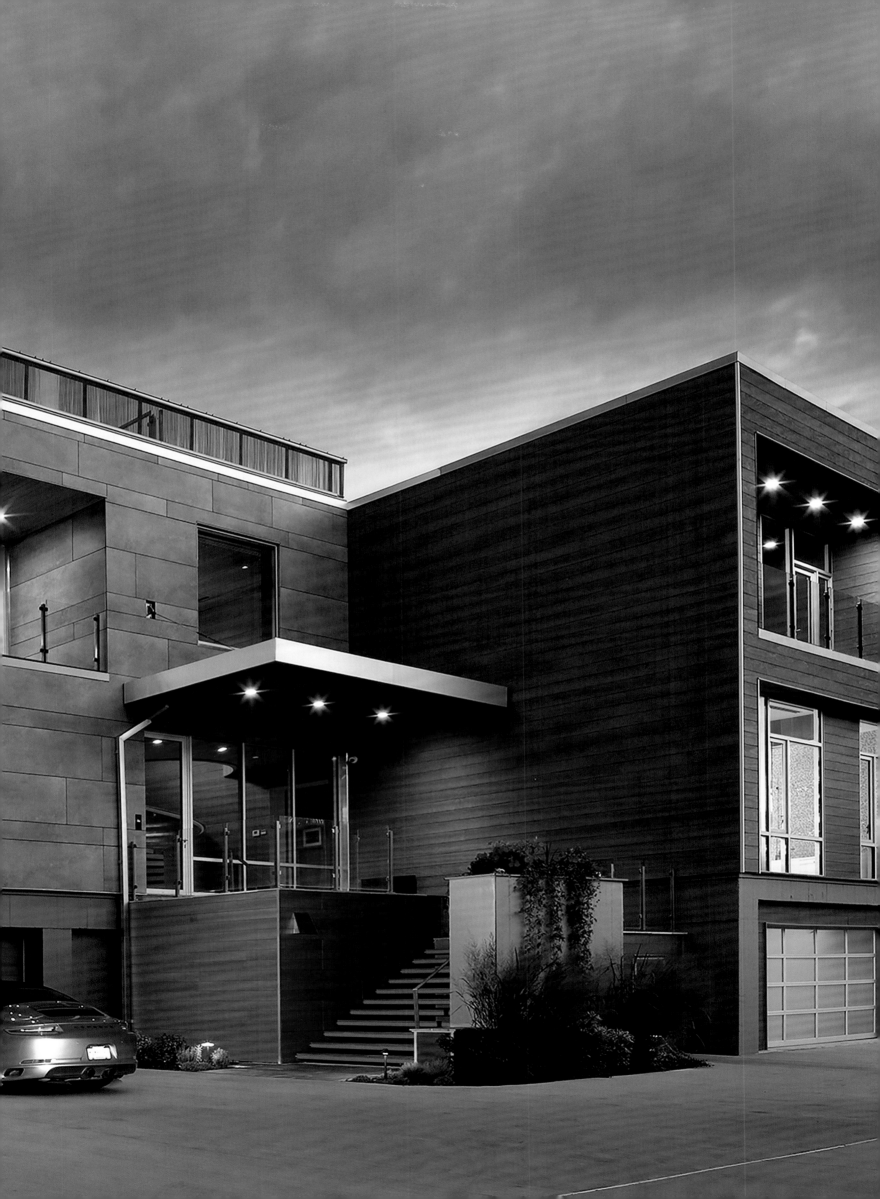

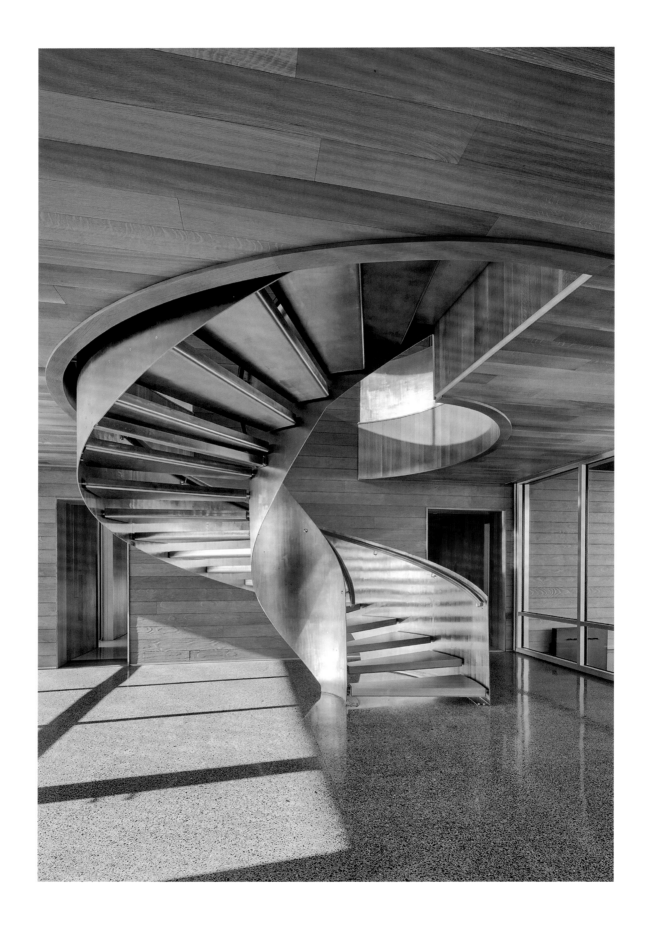

With a talent for drawing and carpentry and a passion for science, Brian Mann said he was destined to become an architect. When he discovered that the University of Pennsylvania had an undergraduate dual degree in design and structural technology that combined theoretical architectural studies with engineering, he knew it was the perfect fit.

"The more exposure I got to the practice of architecture, the more my passion for it grew," he said.

Mann and his business partner Gene Grimaldi founded The OMNIA Group Architects in 1993. Based in Hatboro, Pennsylvania, the firm works on residential and commercial projects and serves clients throughout the Eastern U.S. The company's name, which means "everything" in Latin, represents the initials of Mann's and Grimaldi's children.

Mann said his firm brings fresh, cross-disciplinary ideas to each project, along with an intuitive sense of creativity and ingenuity. "OMNIA is a purposely flat organization where traditional roles are blurred so that individuals can express their own talents and passions," he said. "We keep it loose but are demanding of detailed thinking. And we've been supportive of work-life balance long before it became a trend. The result is a focused but playful place where everyone's ideas are welcome."

Mann said that over the years his work has become increasingly stripped down to a more minimal, essential aesthetic. "While this means a better understanding and use of basic forms and materials, they are deployed in a more fluid, less prescribed way that is open to serendipity, even surprise," he said, adding that in addition to technical skills and an artful eye, he considers his ability to listen — to the client, land, and environment — critical to his prowess as an architect.

Mann said that whenever he starts a new residential project, he aspires to establish a relationship with the client based on trust and collaboration, ensuring everyone can bring their own ideas and experiences to the table.

"These are big, expensive, often once-in-a-lifetime projects, so I am sure to make the experience joyful," he said. "My ultimate goal is for clients to appreciate the tangible and intangible beauties and conveniences in the project as they live and work in it over time, long after our relationship has ended."

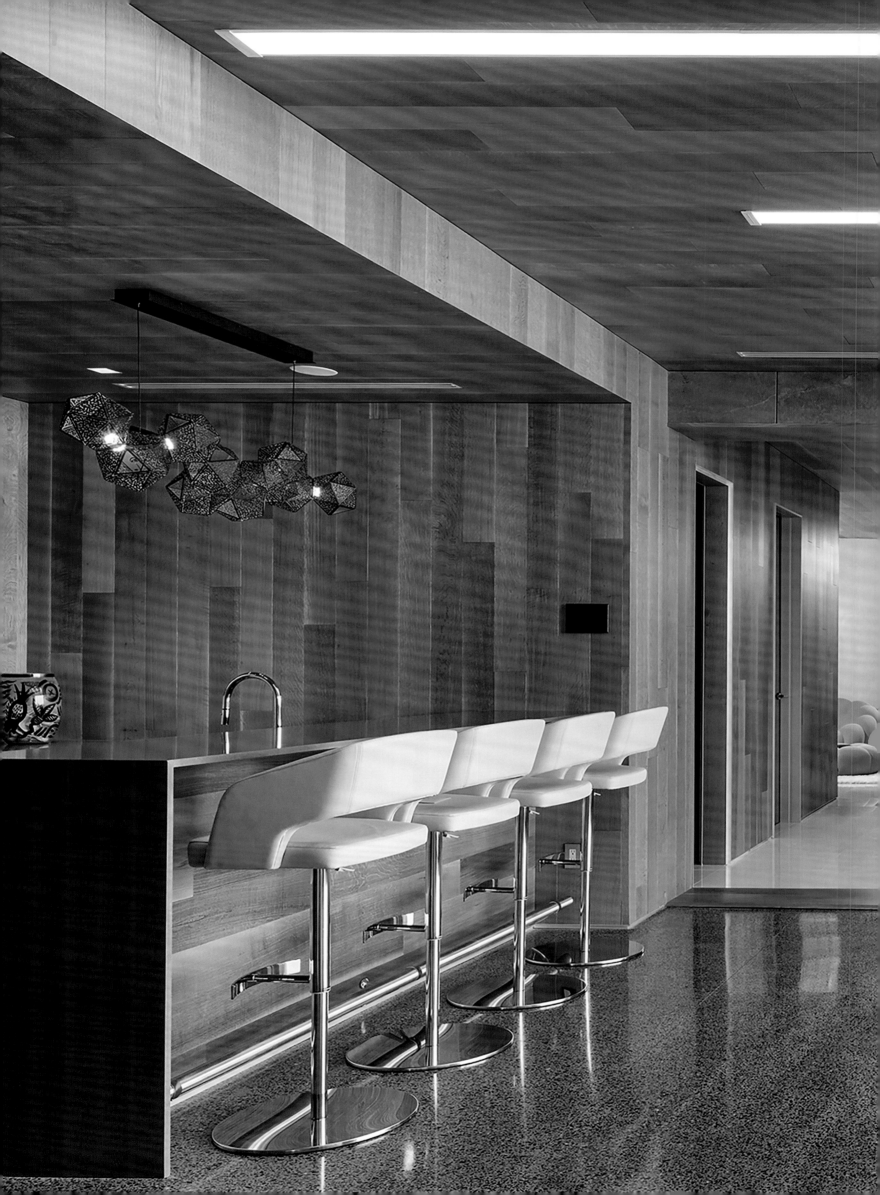

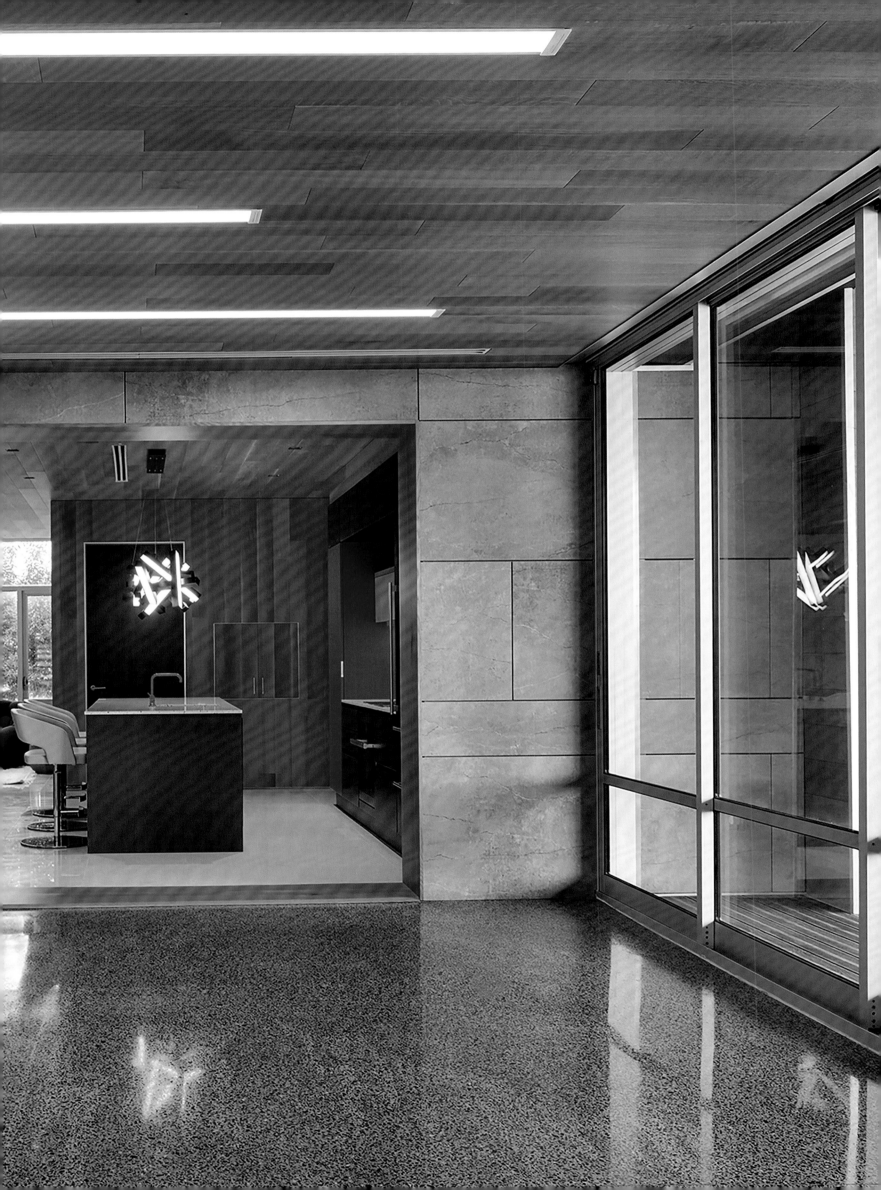

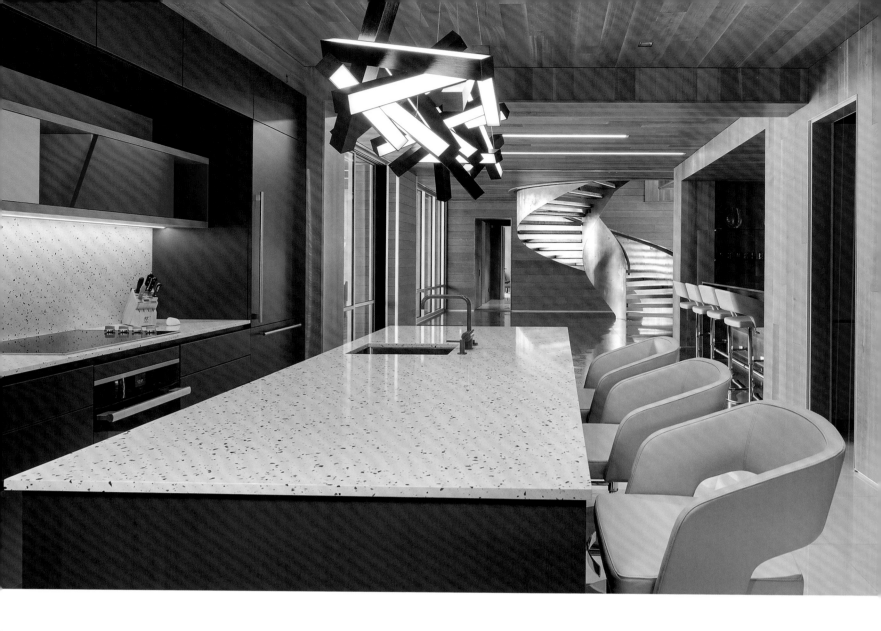

"While I am a quick study, can manage lots of data, and love to solve my project's puzzles, I pride myself on being a calm, studious listener. I also believe strongly in customer service."

— Brian Mann

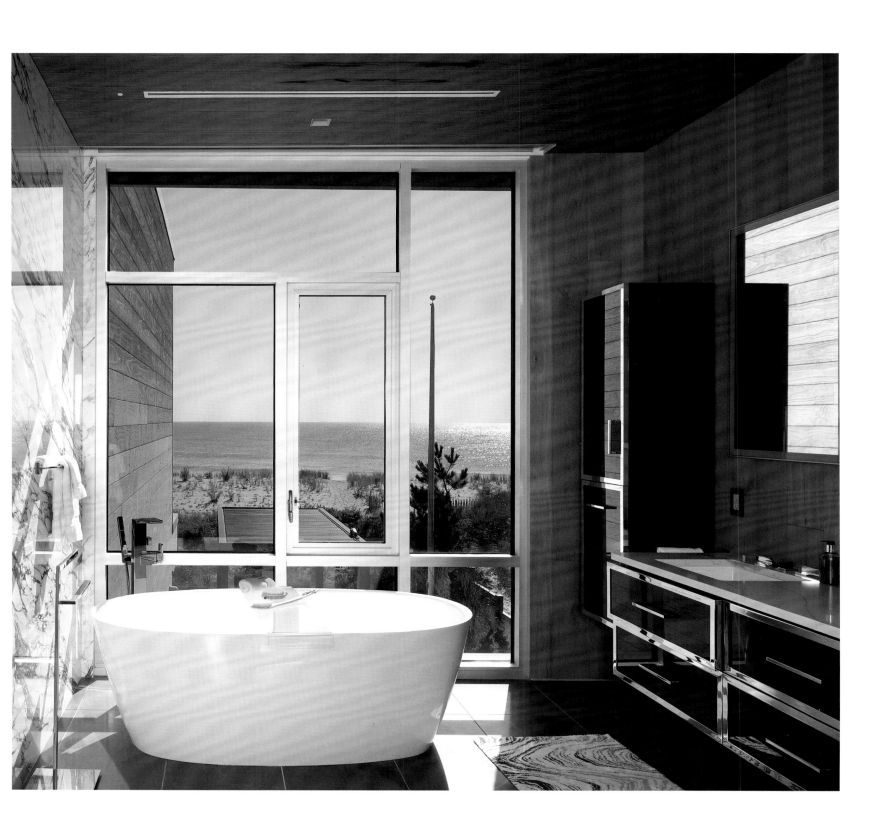

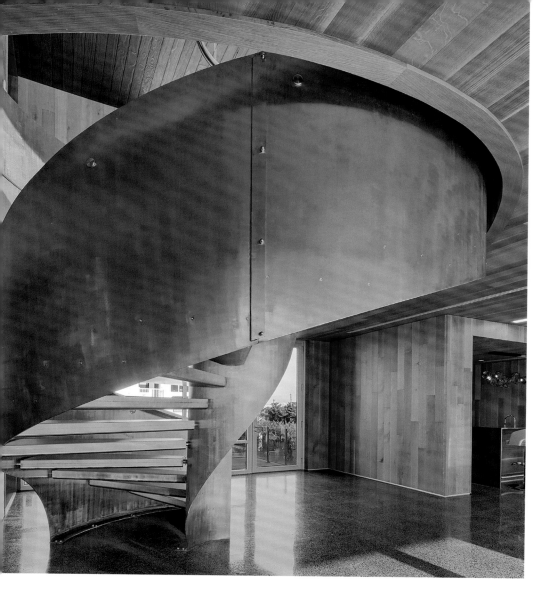

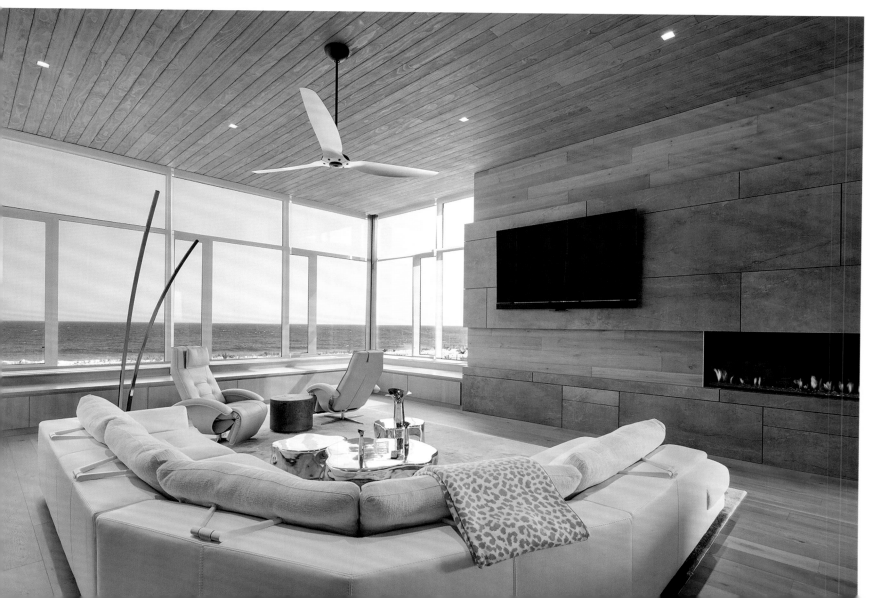

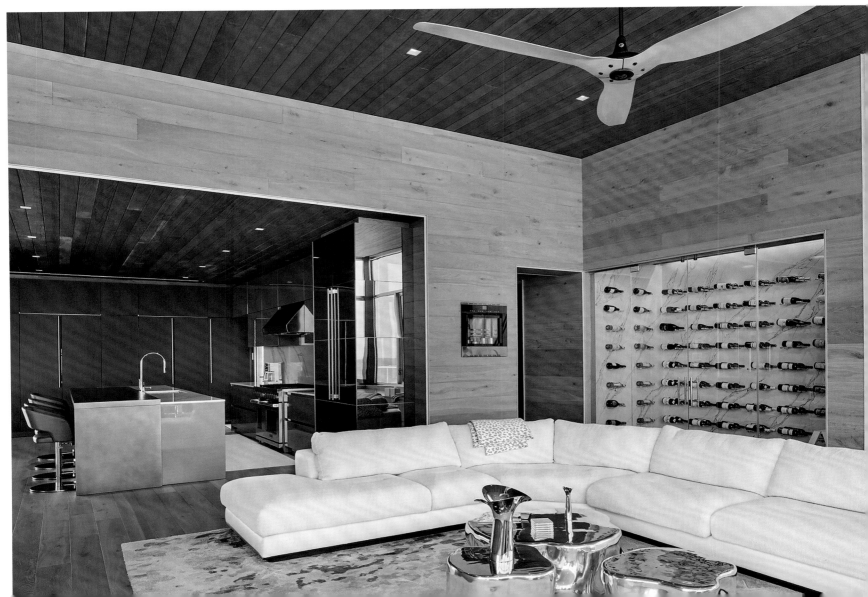

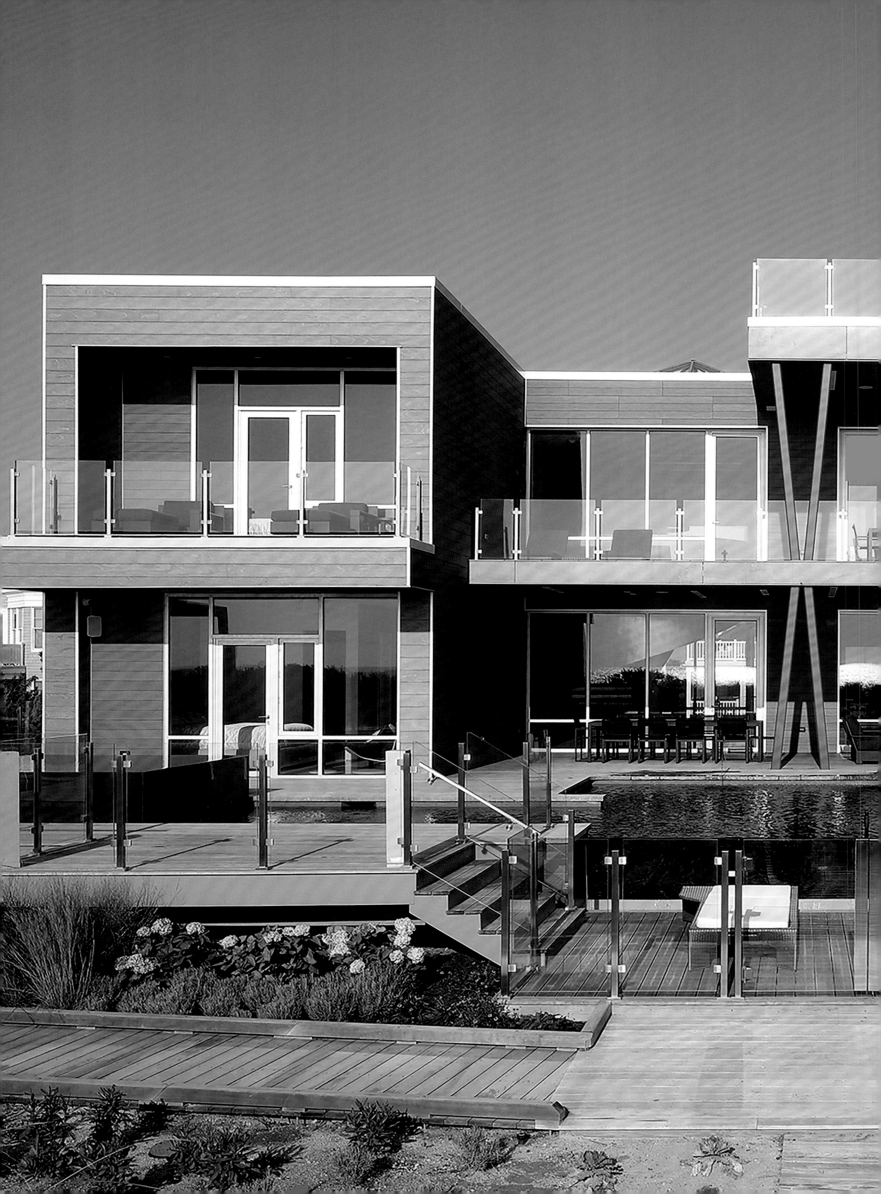

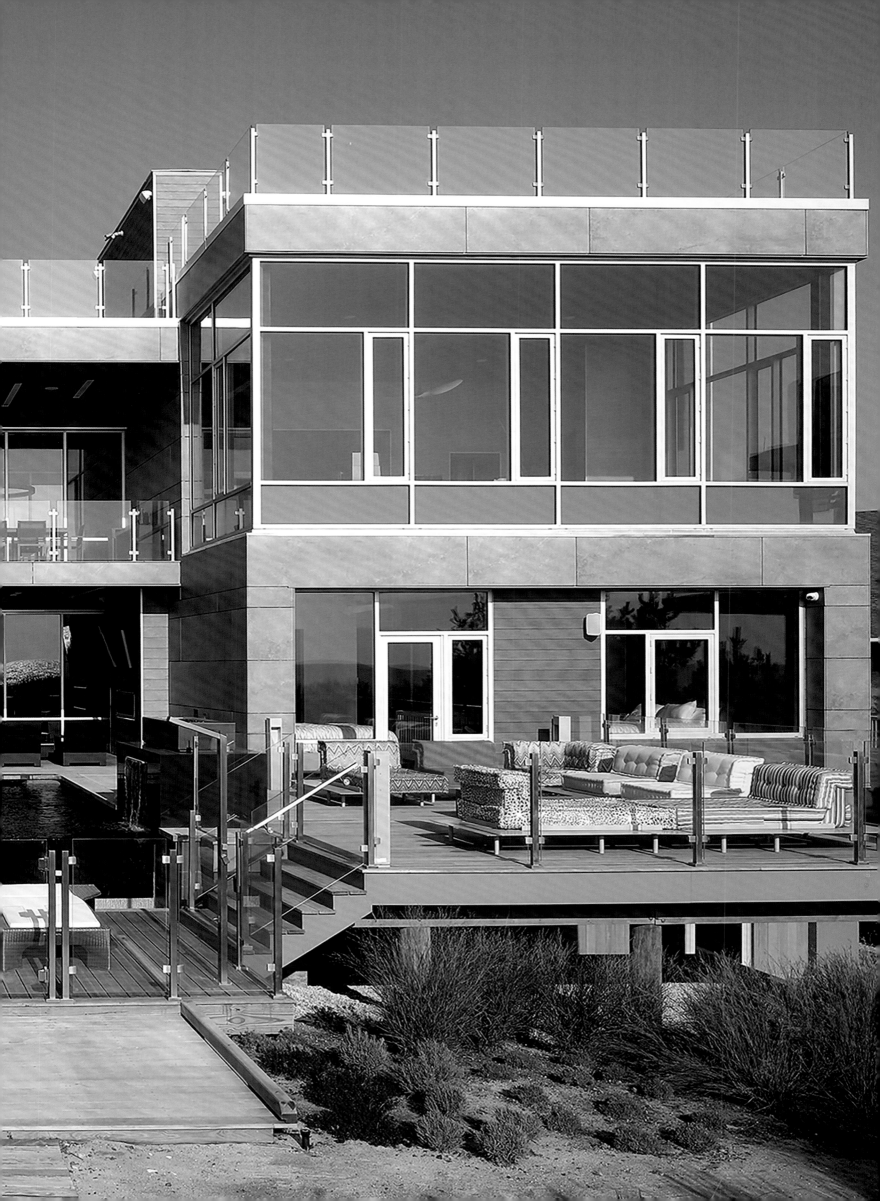

Geography and history also influence each home design, Mann said, which in the Northeast often includes heavy European influences. "This history often underpins our clients' vision and expectations as well as those of planning and development authorities. And there are, of course, environmental factors that affect sustainability and durability and accordingly site selection, orientation, material, and system selection.

But Mann said that rather than be hampered or confined by history or traditional context, his firm works to go beyond those constraints for a more modern aesthetic. This was certainly the case for a beachfront home OMNIA designed recently in Long Island, New Jersey. The clients had spent many summers at the New Jersey shore and were in a position to create a special legacy for themselves and future generations, Mann said. The property occupies a relatively high point, with long ocean frontage and a good degree of privacy, ideal for family gatherings and casual entertaining.

While the site was stunning, it was susceptible to hurricane-force winds and powerful storm surges. Mann and his team designed the 8,000-square-foot house with reinforced concrete and massive steel frames for the piers, walls, floors, and roof.

The structure was designed in an "H" form, with concrete, wood and tempered glass forming multiple bays. The first floor includes dramatic design touches like a sculptural stair of stainless steel and white oak. Also on the first floor are a service kitchen, bar, and six guest suites that flank the gallery, along with 18-foot sliding glass doors open to sundecks, pool, and path to the ocean.

On the top floor, the expansive and private owner's suite offers stunning views, with a balcony, dressing room, and ocean-view tub. Also on the second floor are dining room, balcony, and upper deck, along with a sleek kitchen, which features a 14-foot marble and steel island. The kitchen opens to the great room, which offers expansive ocean views and wraparound window seating.

"I cannot help believing that there are fundamentals underlying great living spaces that are rooted in the few hundred thousand years humans and our nearest ancestors spent living enmeshed in nature," Mann said. "Beauty in architecture too, I think, has some absolute character, albeit mysterious and not a simple surface effect but rather more internal and emotional like music."

---

*Interior Design: The OMNIA Group Architects*
*Wand Bank Street Design*
*Landscape: ThinkGreen, LLC*
*Builder/Contractor: SpectraCon, Inc.*
*Photographer: Matt Wargo*

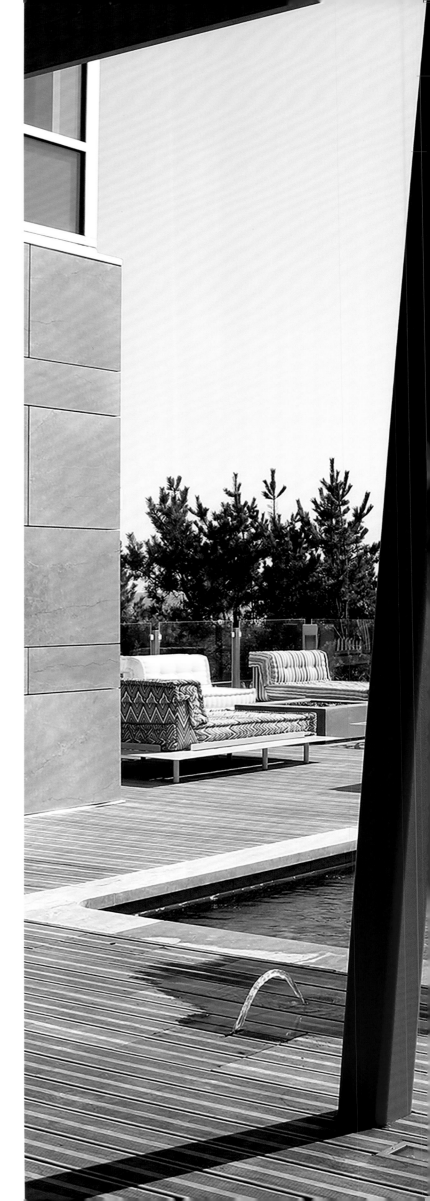

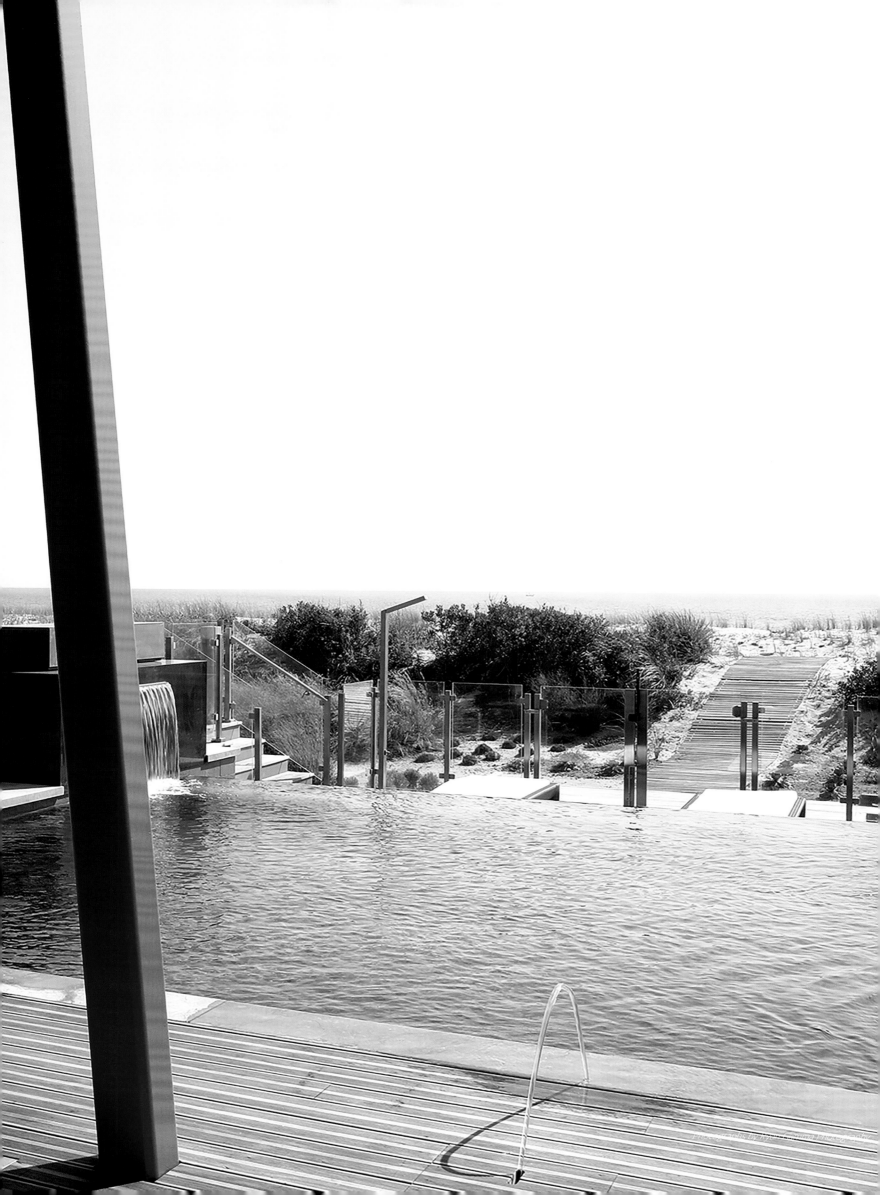

"I find the most inspirational forms in the unique and raw abstractions found in the beauty of nature, music and art."

— Nick Martin

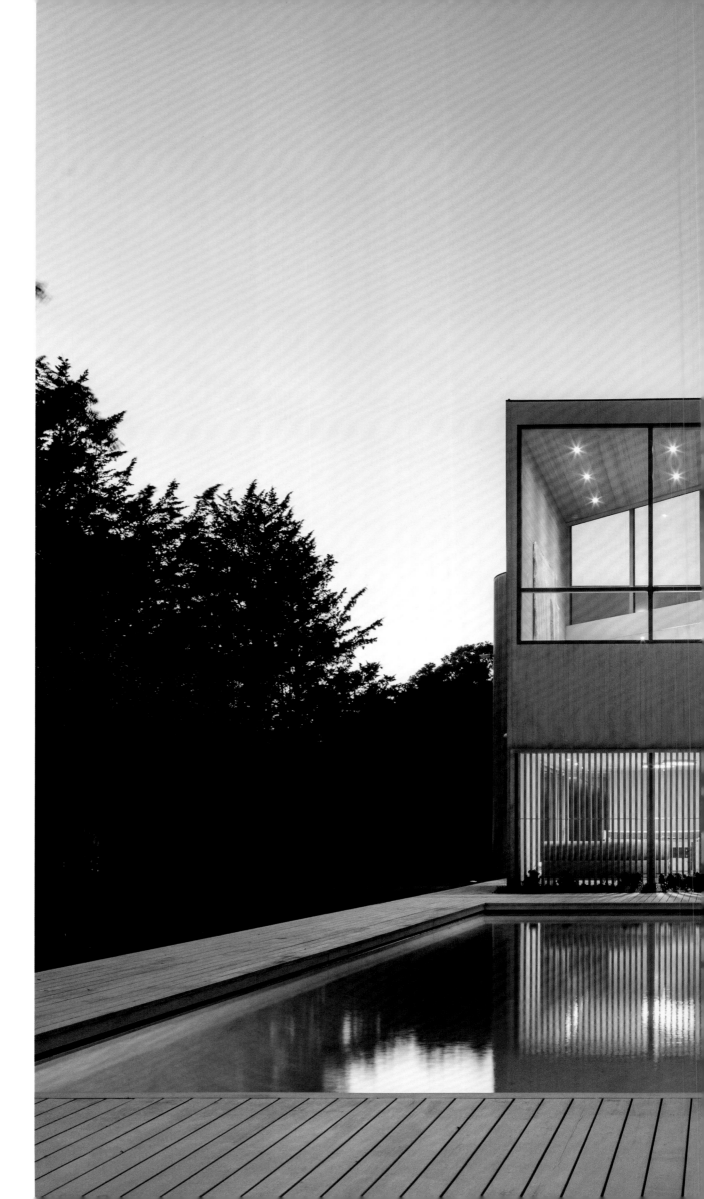

Nick Martin

Martin Architects

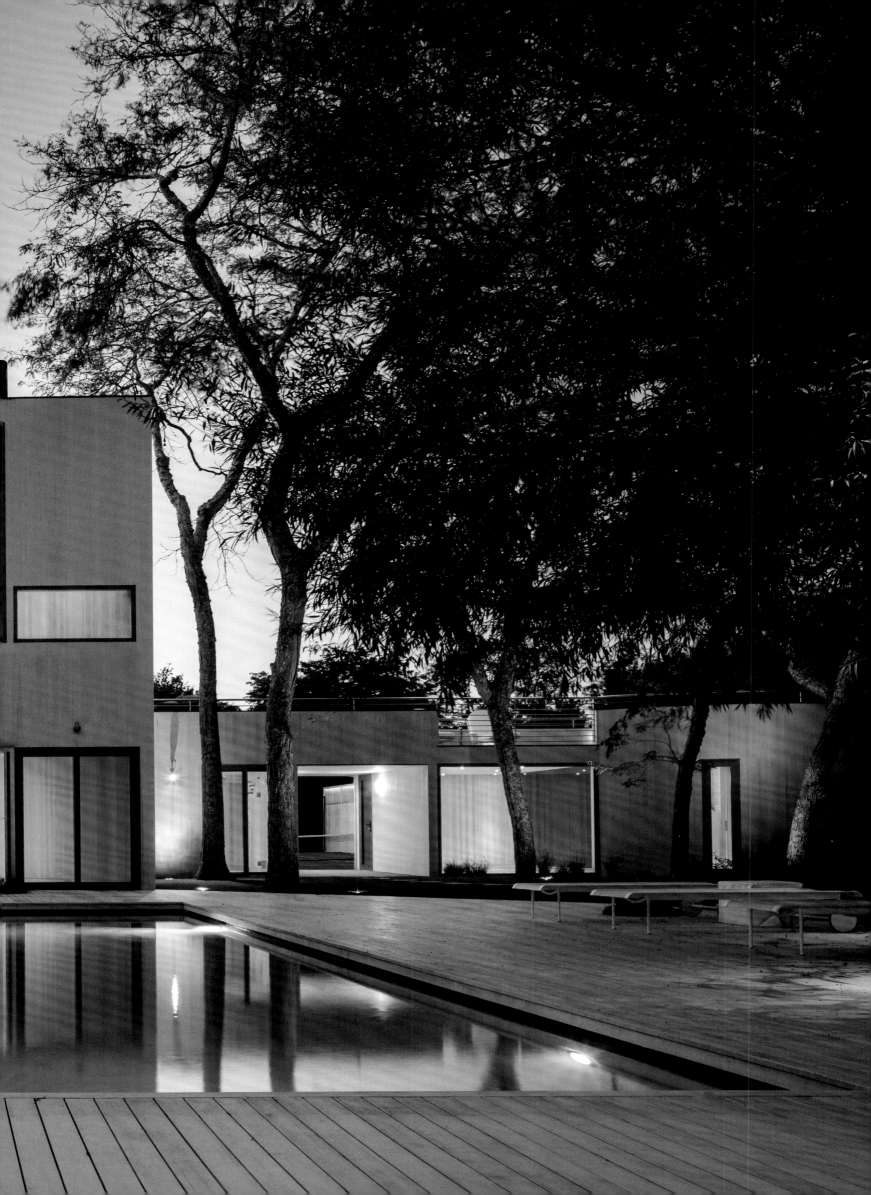

Nick Martin grew up with adventurous, multifaceted parents who "world-schooled" their family. Martin's parents, a banker/writer and archeologist/painter, traveled the globe and relocated a dozen times during his childhood, visiting World Heritage Sites and the great cities of Europe, South America, and beyond. These experiences inspired in Martin a desire to understand cultures, their sense of home space and light, and ultimately the interest to pursue a career in architecture.

His quest for culture continued in college when he participated in the Semester at Sea program, during which he and other students embarked on a multi-country trip aboard a passenger ship, learning about the culture and history of each destination. Later, Martin received several travel fellowships from the Pratt School of Architecture, studying in Cyprus, Athens, and Rome.

After college, he worked at such notable firms as Gwathmey, Siegel & Associates Architects, Gabellini Sheppard Associates, and Wood and Zapata. During these early years, he helped design many high-profile residential projects, including those of Michael Dell, Barbra Streisand, Dakota Jackson, The Guggenheim addition, Nicole Farhi Flagship, MTV's corporate headquarters, and several large multi-use projects in Shanghai and Hong Kong.

He founded the Bridgehampton, New York-based Martin Architects in 1999, which offers a full spectrum of residential and commercial architectural design, interior design, furniture design, landscaping, and investment master planning services. Five years later, he launched 4MA Builders LLC, which specializes in high-end residential and commercial architecture.

"Each member of our team has their own unique skill that adds to the work," Martin said. "We have architects with construction experience, builders with architecture and boat building experience, professors turned administrators, and engineers now dedicated as designers. We work tirelessly to promote a culture of sustainable and exceptionally crafted work that moves quickly through the typical pitfalls of the architecture and building experience."

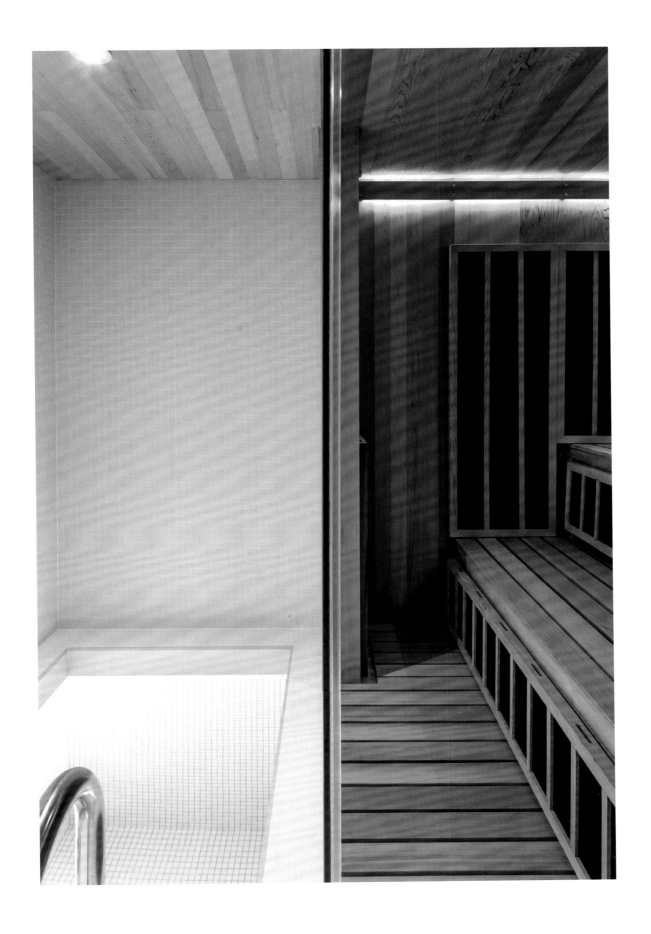

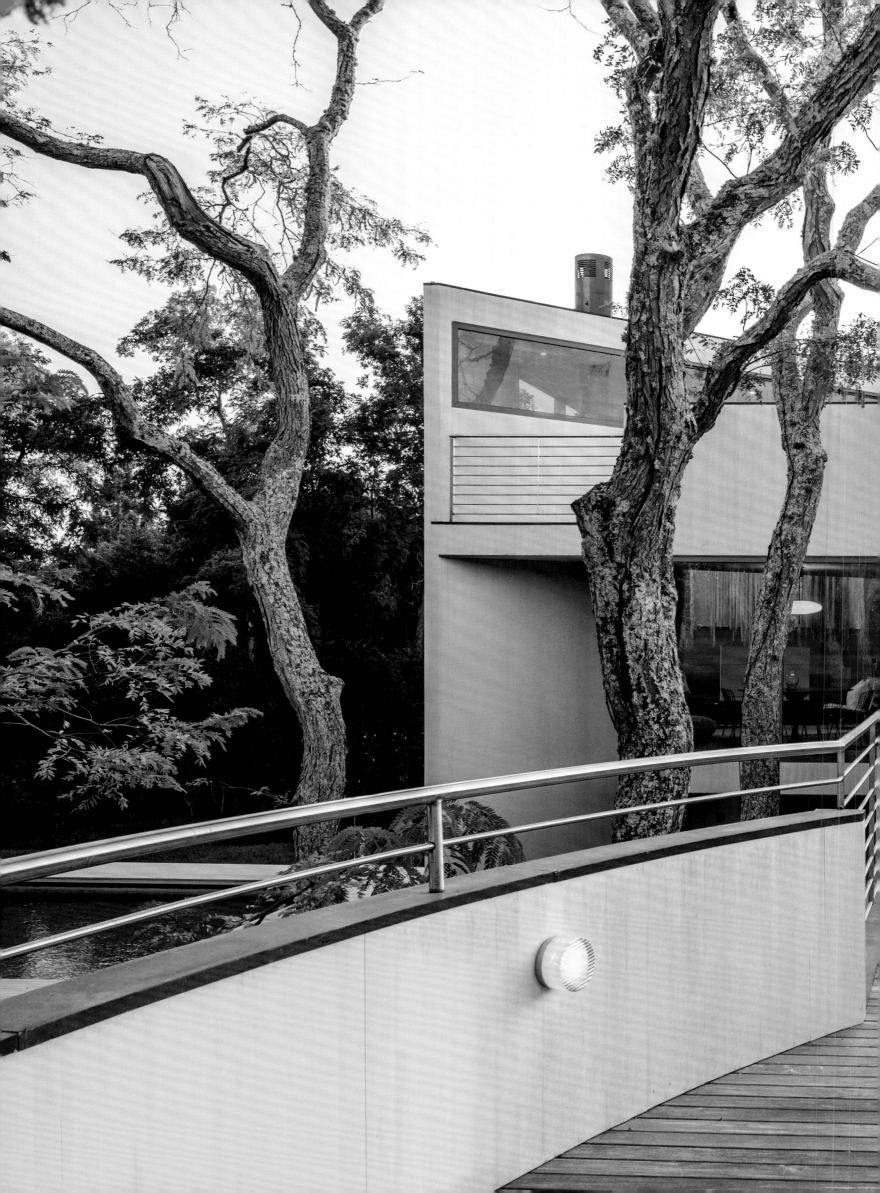

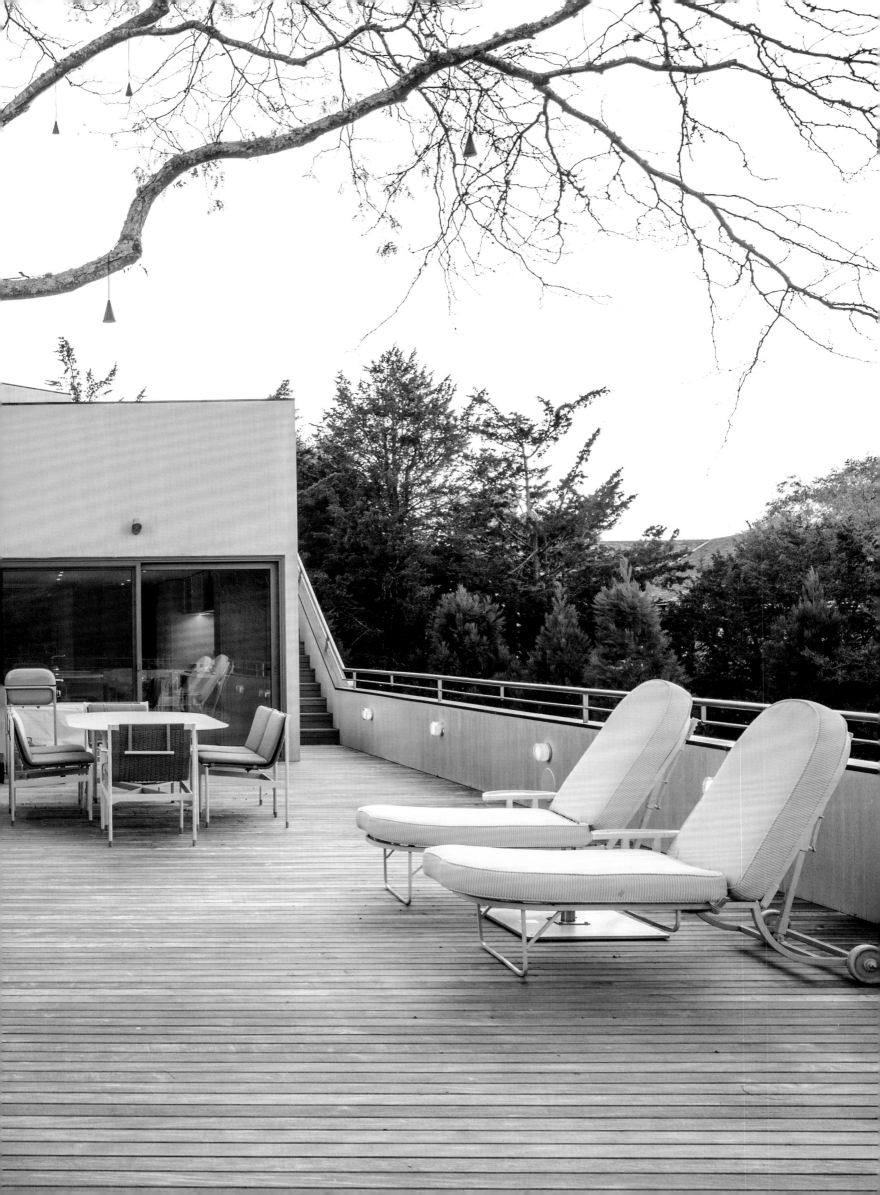

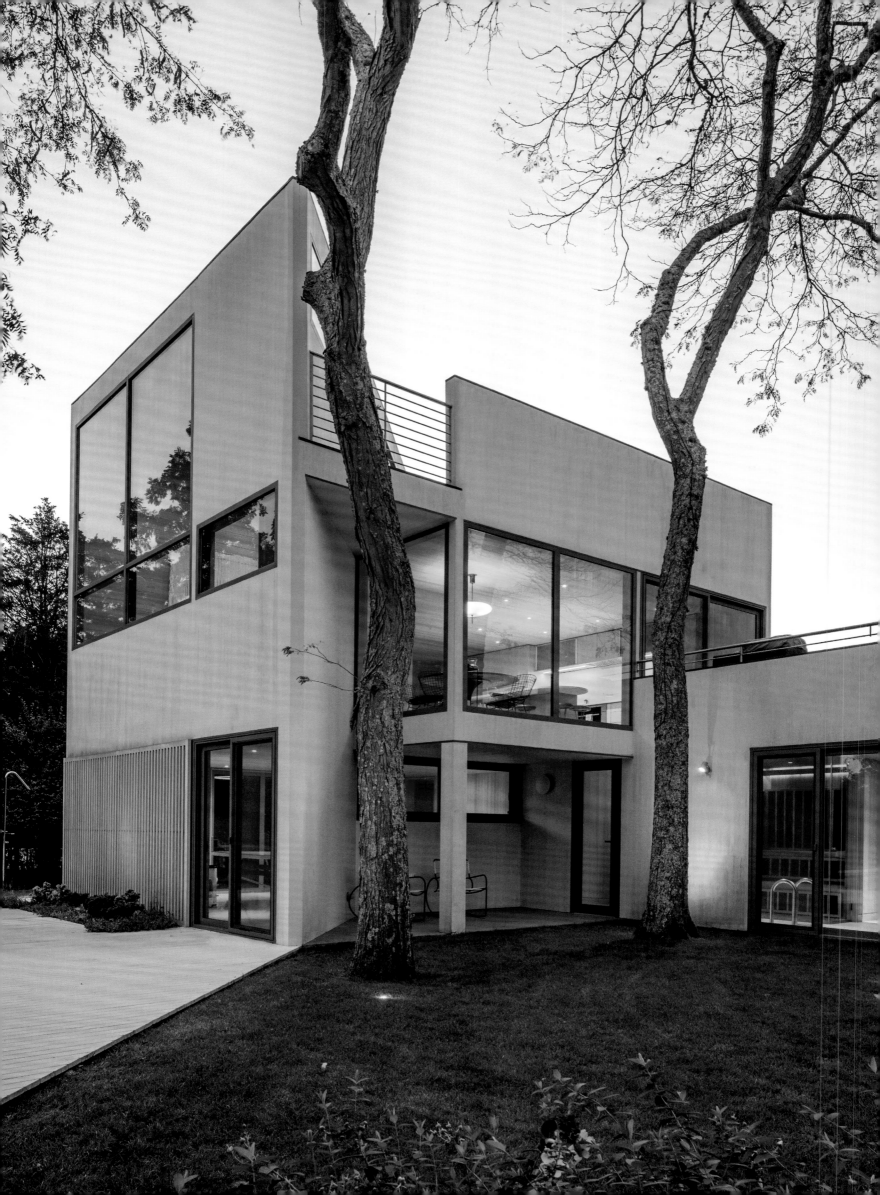

"Each project site contains its own legacy and microclimate, which informs angles and intensity of light. Our team studies the quality of the ecosystem and topography and creates unique and timeless architecture entwined into that natural fabric.""

— Nick Martin

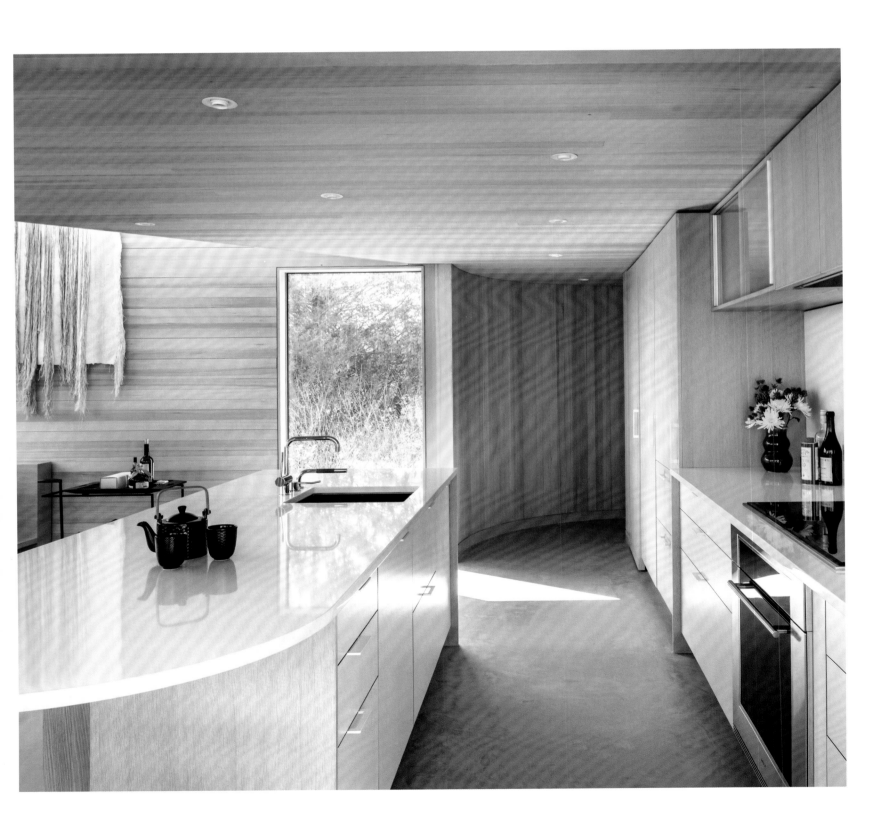

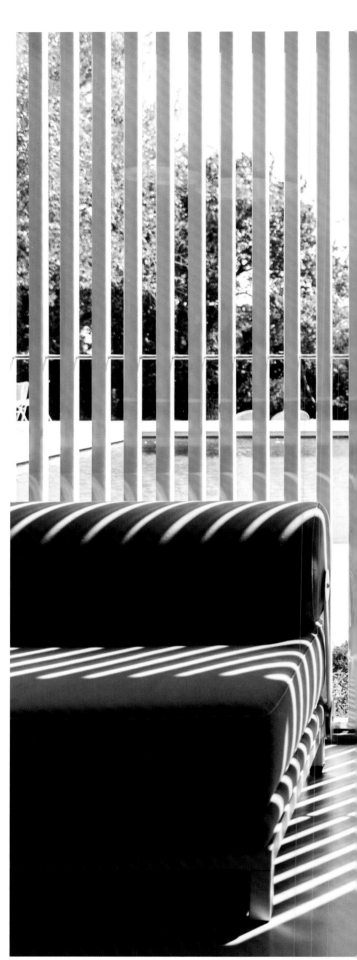

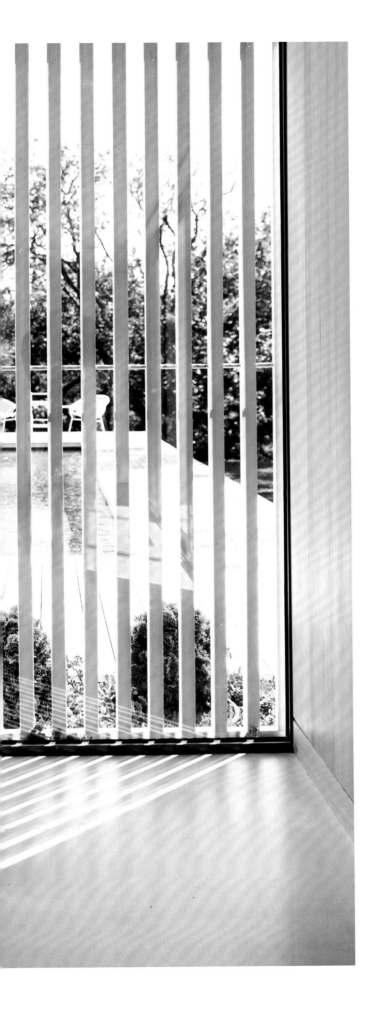
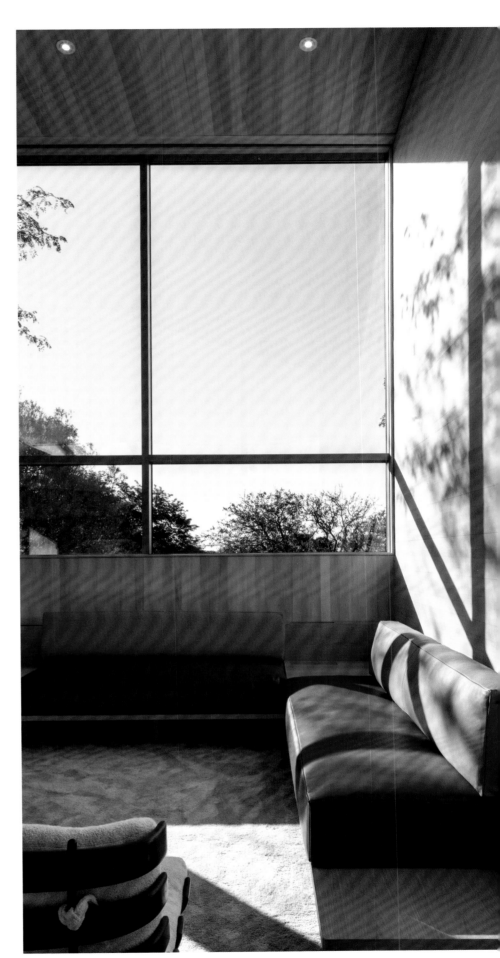

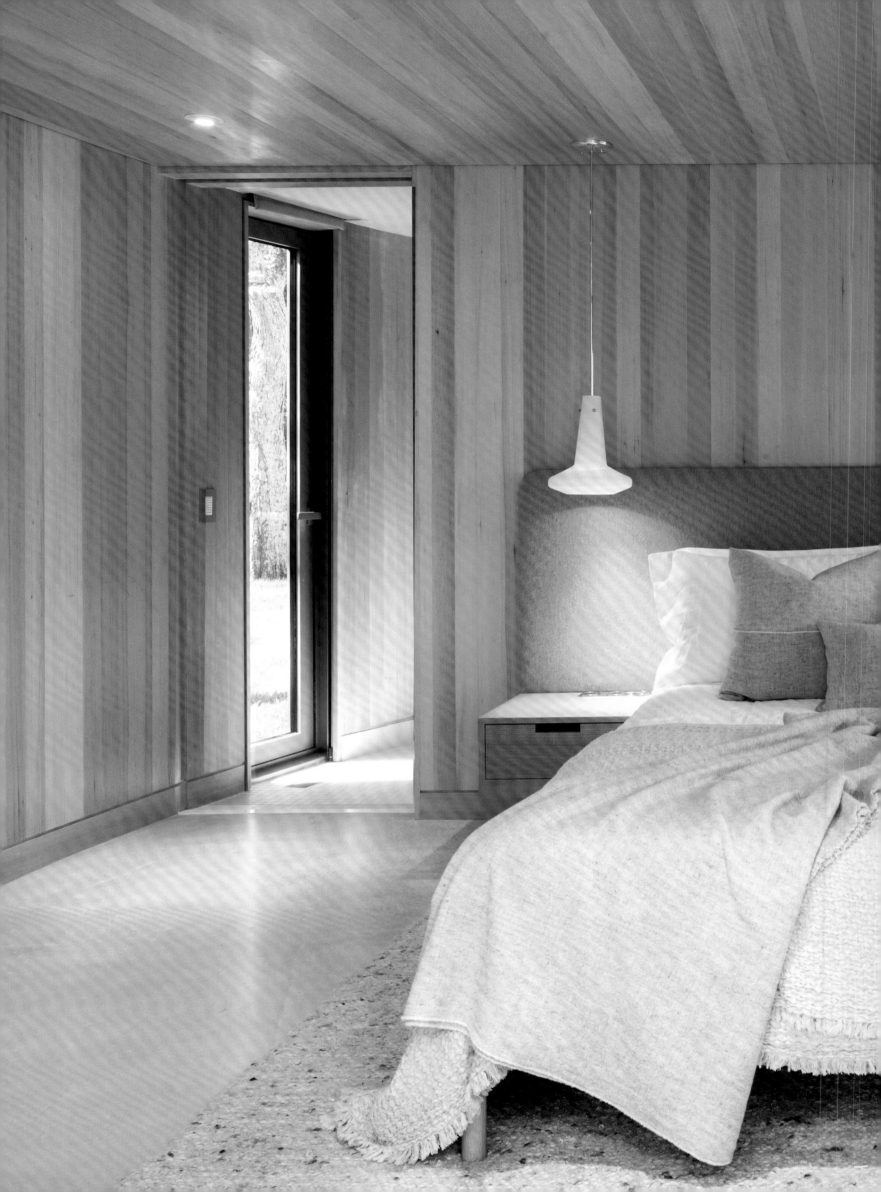

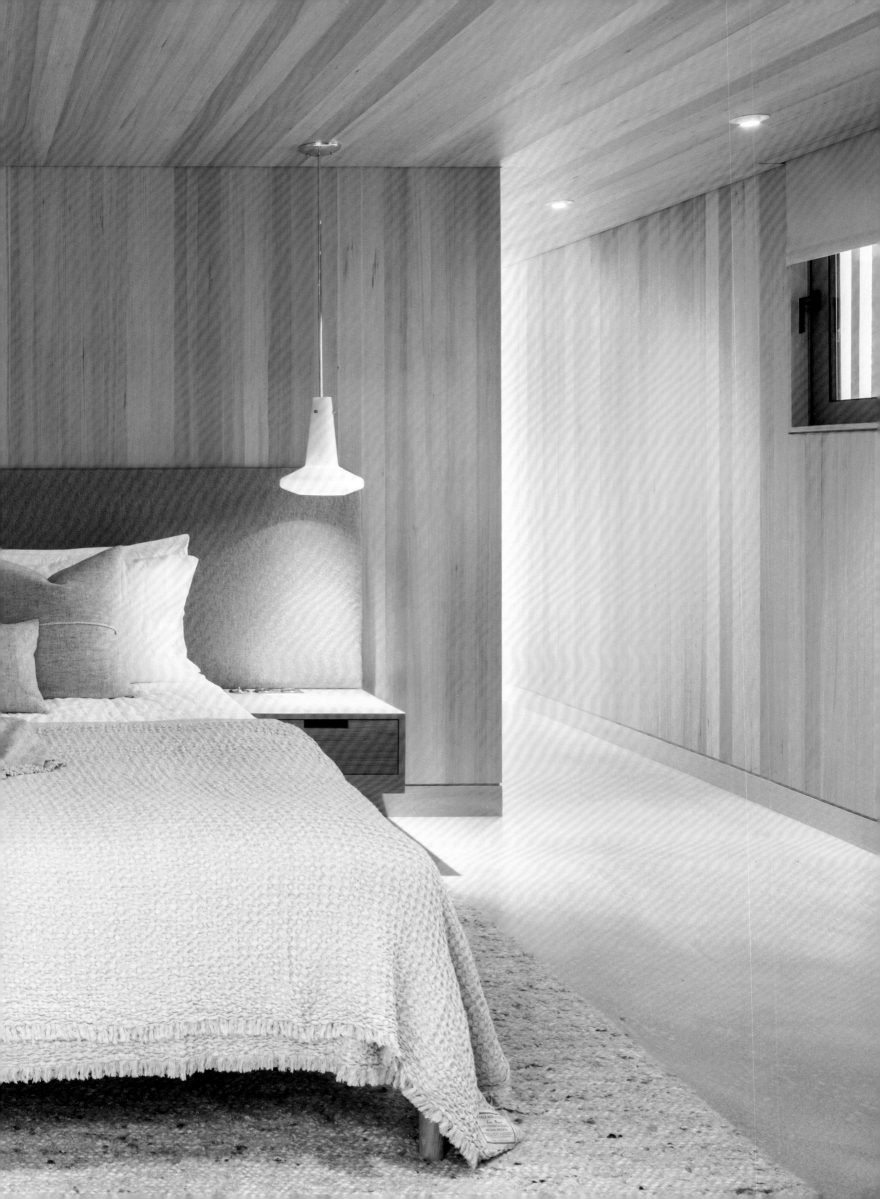

One of Martin's newest completed projects is the renovation of the Tolan House. Charlie Gwathmey, a famed architect and member of the "New York Five," built the house, located in Amagansett, New York, in the 1970s. Martin worked in Gwathmey's office as his first professional experience, and the renowned architect became one of his mentors. Martin, commissioned by an "architecturally inspired" client, was charged with both renovating and making additions to the residence. The mantra was to preserve its critically acclaimed modernist legacy while redesigning with a fresh eye and modernist hand.

"This project was a once-in-a-lifetime opportunity," Martin said.

For the project, Martin incorporated unique current materials that held a purpose similar to the original goals but unavailable at the time of the home's initial design. For example, Martin replaced the 1970's glass block with low-iron Bendheim channel glass. Rather than interior cedar to clad the interior, Martin used hemlock, which has a more consistent and light blond character. Martin also replaced a portion of the home's solid cedar doors and walls with semi-transparent mahogany rainscreens, which allow channeled and focused light into the house.

"In this type of manner, we paid homage to Charlie Gwathmey's inventiveness and sense of creativity," Martin said. "Having worked with Charlie early in my career, I was trained in the modernist discipline and creative approach in using materiality, Corbusier's modular, and nature in the work. Working on the Tolan House was an honor, and the team treated each move as such to stay within the legacy of Charlie's brilliance."

---

*Landscape Architecture: Charlie Marder, Marders*
*Builder/Contractor: 4 MA Builders*
*Photographer: Conor Harrigan*

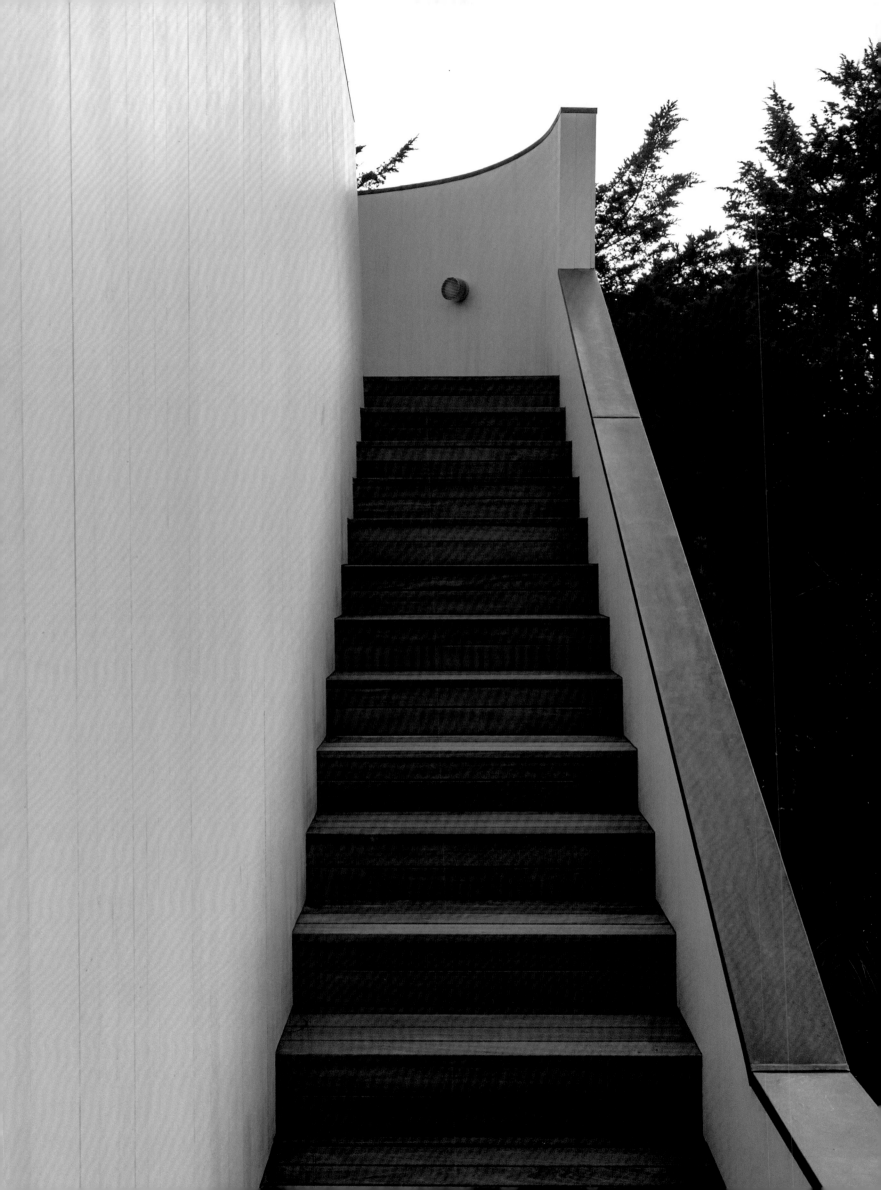

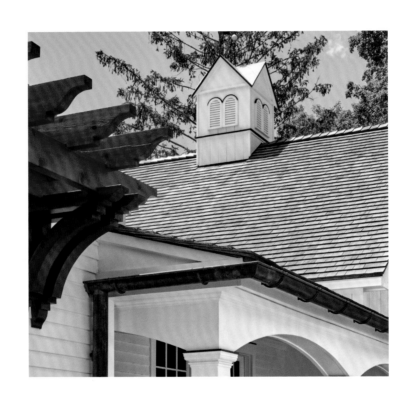

"Every project is a canvas to
artistically demonstrate what I
think the client will desire and
a chance to impress them
not only with quality drawings,
but as design concepts. I
don't want to specialize in any
particular area of architecture.
I want clients to think of me as
'their architect'."

— Peter Paulos

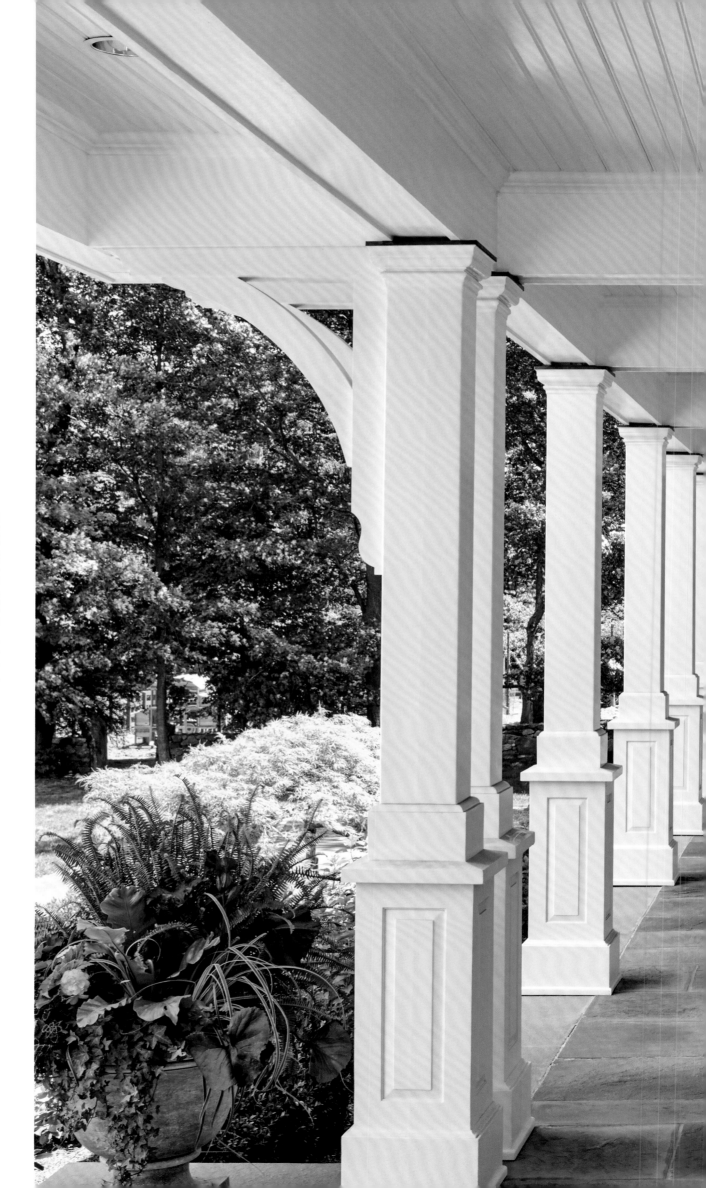

Peter Paulos

PH Architects

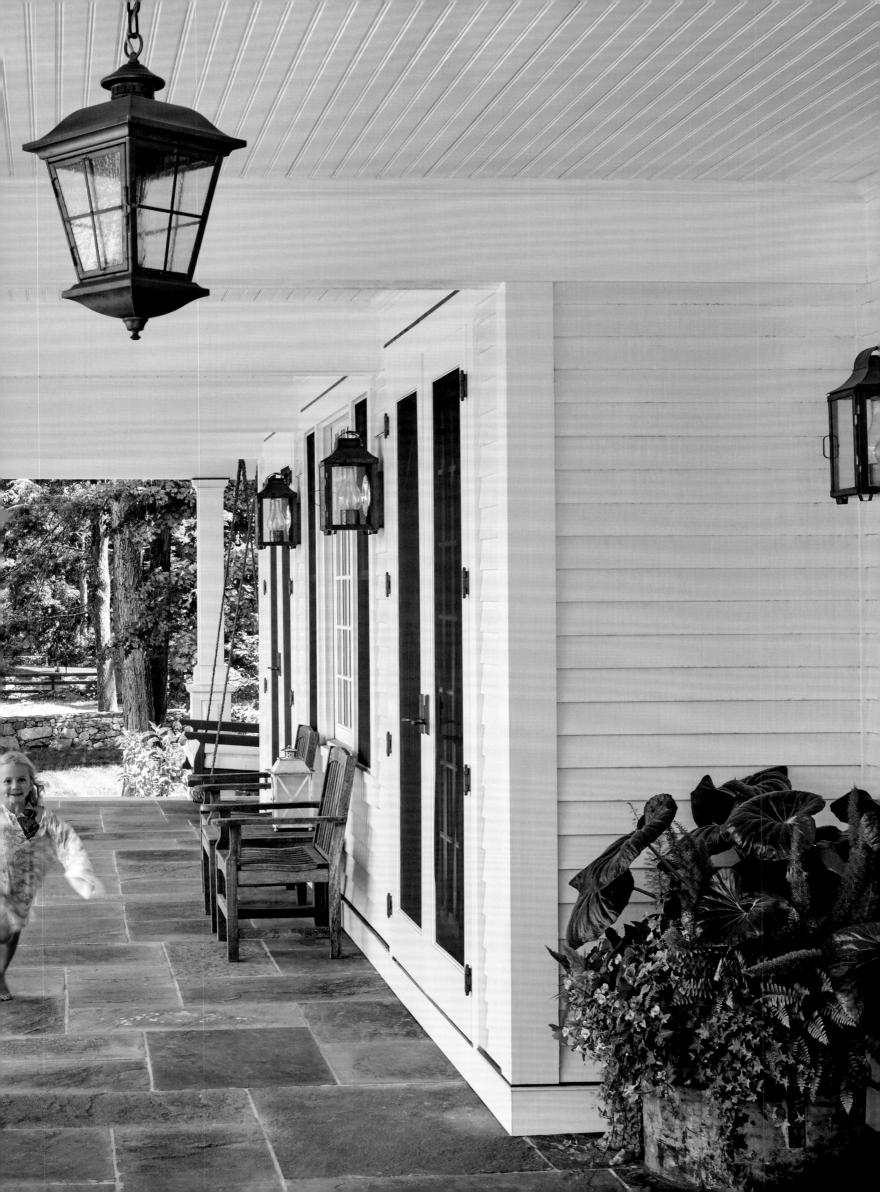

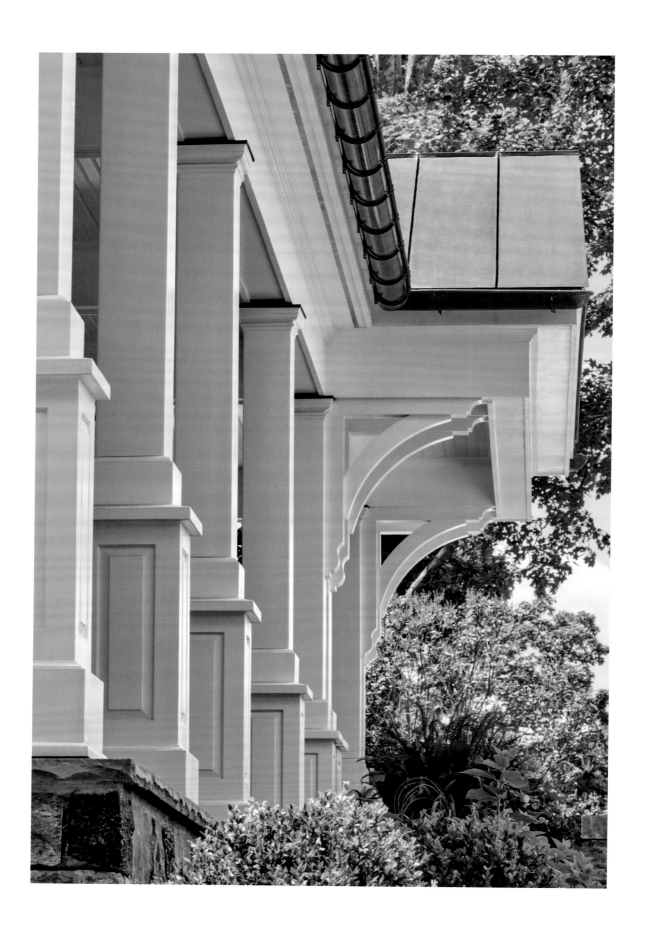

For an architect long inspired by the design concepts of the notoriously single-minded Frank Lloyd Wright, Peter Paulos, AIA, takes a remarkably collaborative approach to his work.

"Every project is a canvas to artistically demonstrate what I think the client will desire and a chance to impress them not only with quality drawings, but as design concepts," said Paulos, principle at Newtown, Connecticut-based PH Architecture. "I don't want to specialize in any particular area of architecture. I want clients to think of me as 'their architect.'"

Paulos's servant-leader approach is illustrative of a practitioner whose entry into the field was more holistic than pre-determined. The Utah native was studying to be an orthodontist at the University of Utah, with visions of taking over his father's Salt Lake City orthodonture practice, and was one semester shy of graduating when he opted to take what he called a "non-stressful" art class that inspired Paulos to re-evaluate his professional path.

One summer and one construction job later, Paulos shelved his previous plans and instead pursued and received his Master of Architecture from the University of Michigan. Since then, Paulos, who moved to Connecticut in 2002 and founded his firm seven years later, has embraced his Greek heritage by studying ancient Greek architecture while delving into the Colonial style that's synonymous with his adopted home state. "I love the history of architecture and love understanding how others before me designed and constructed spaces – not only how they built spaces, but also the details involved," said Paulos. "Architecture found me."

Since starting his eight-person firm, Paulos has worked on approximately 300 projects, about half of which have been residential and the remainder a combination of commercial and mixed-use.

"I have sought out both residential and commercial because I believe doing both makes you better at scale and proportion," said Paulos.

Throughout his work, which he categorizes as "traditional architecture with a twist," Paulos says he's absorbed lessons on the regional architectural specialty of trim design by developing an expertise in detail work, whether it be wainscotting, coffered ceilings, or wall-shingle details.

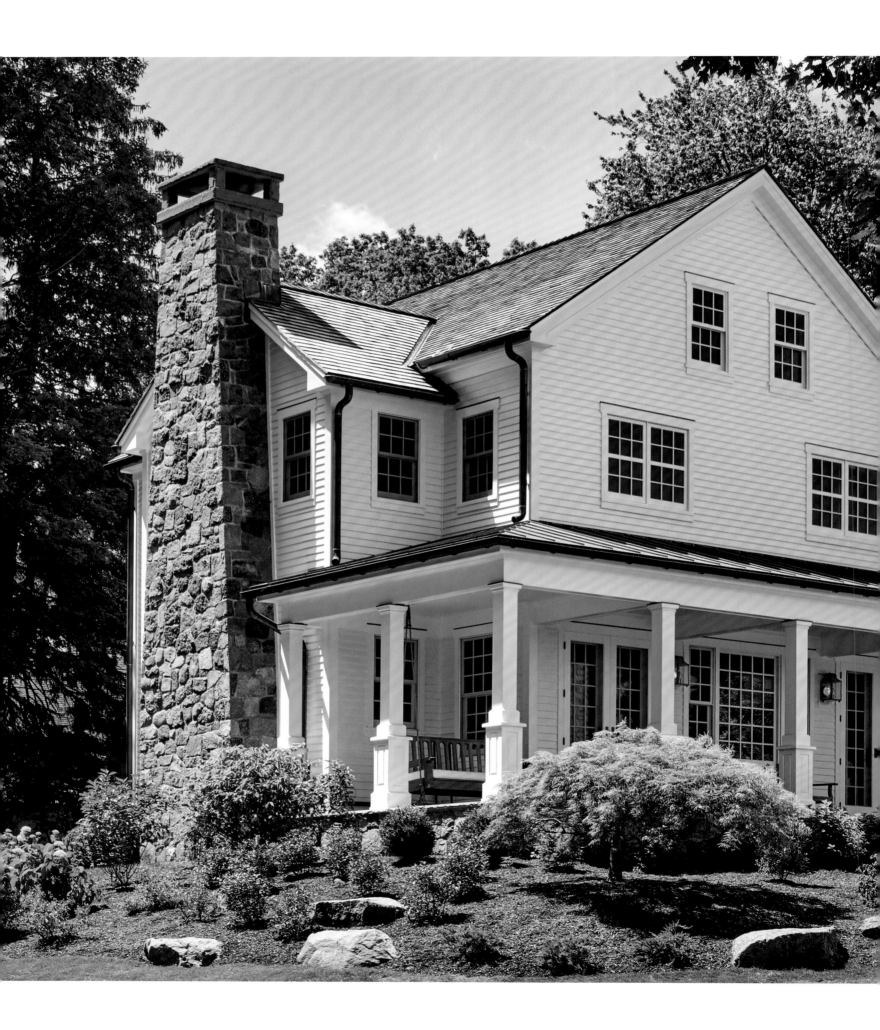

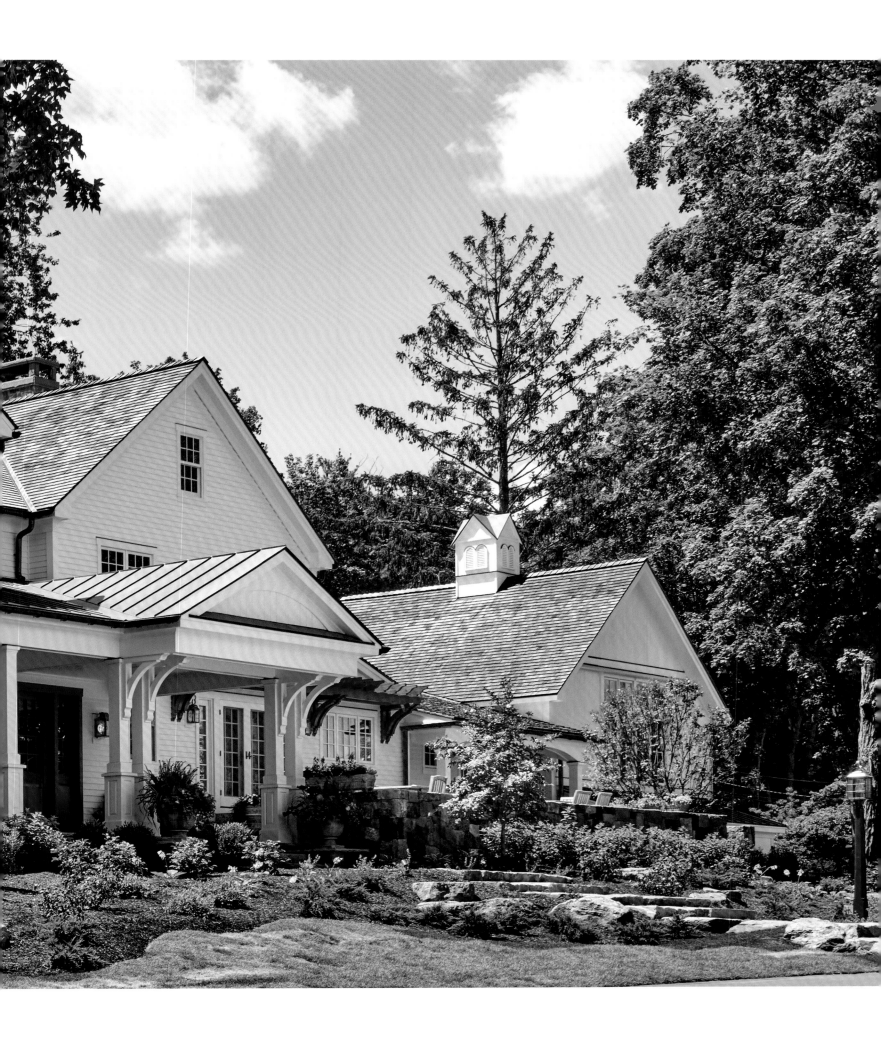

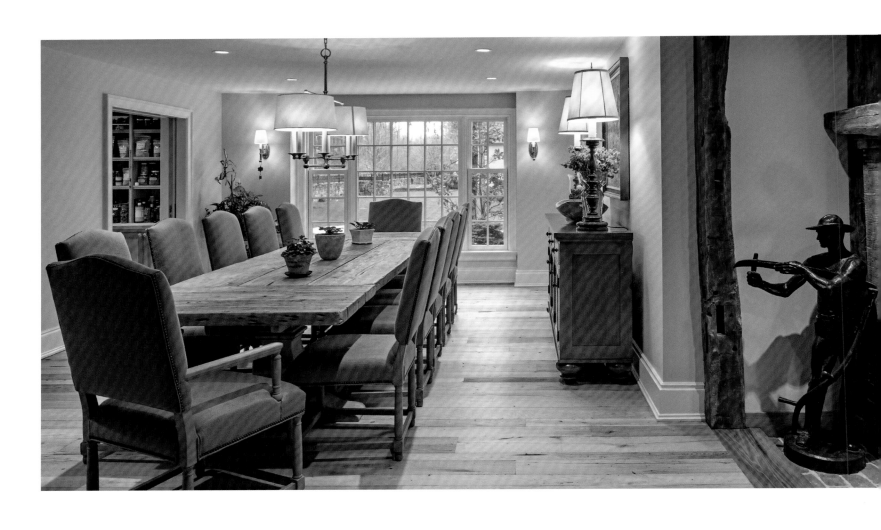

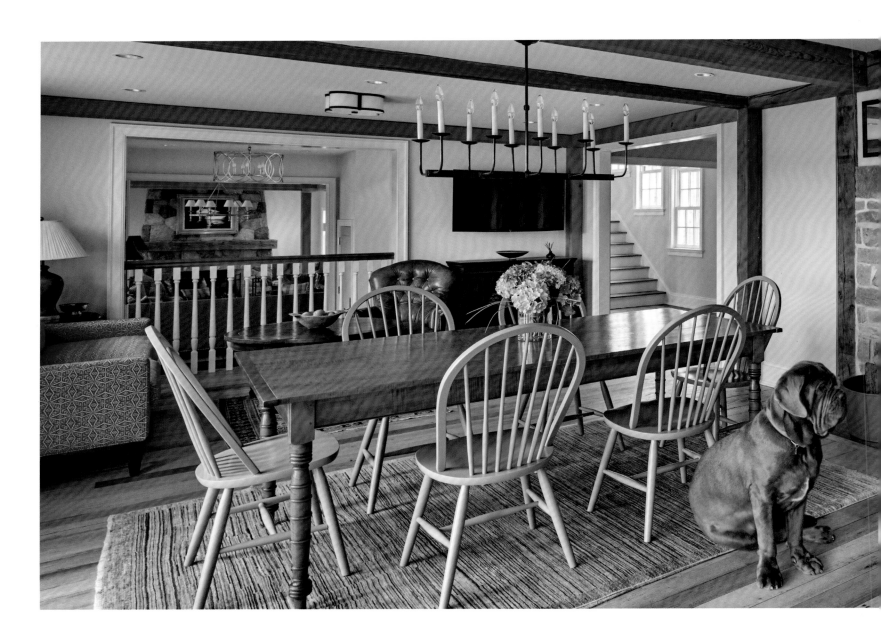

""Being an architect in the Northeast, my aesthetics have most evolved in the details of trim work. Learning how previous architects and builders use ideas to trim a window or door, how they would do a wainscot or coffered ceiling, or how they would bring in wall shingle details into the exterior façade all inspire me. The Northeast is a wonderful example of all of this."

- Peter Paulos

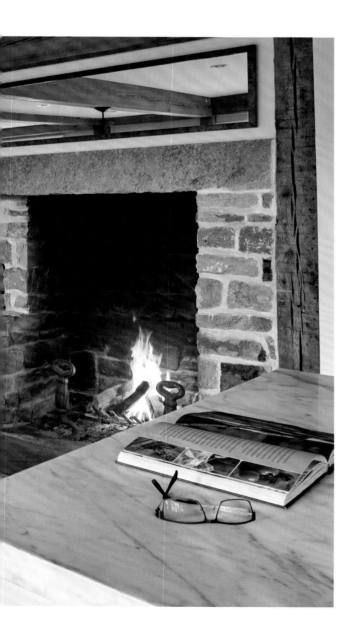

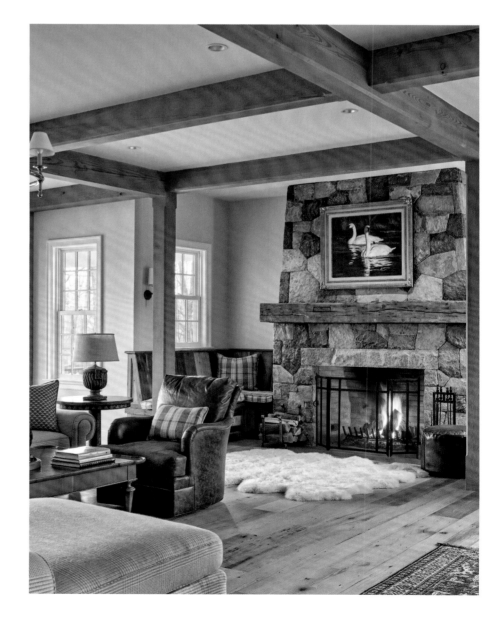

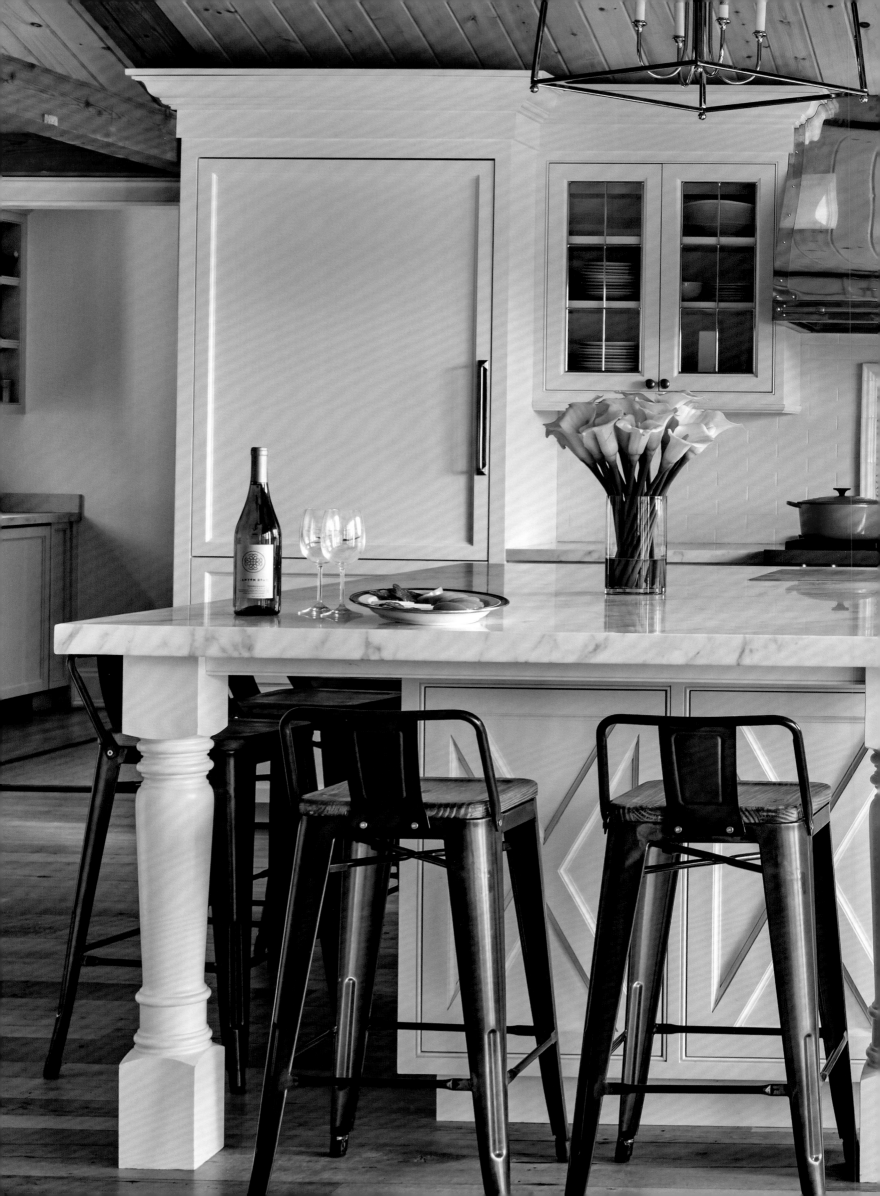

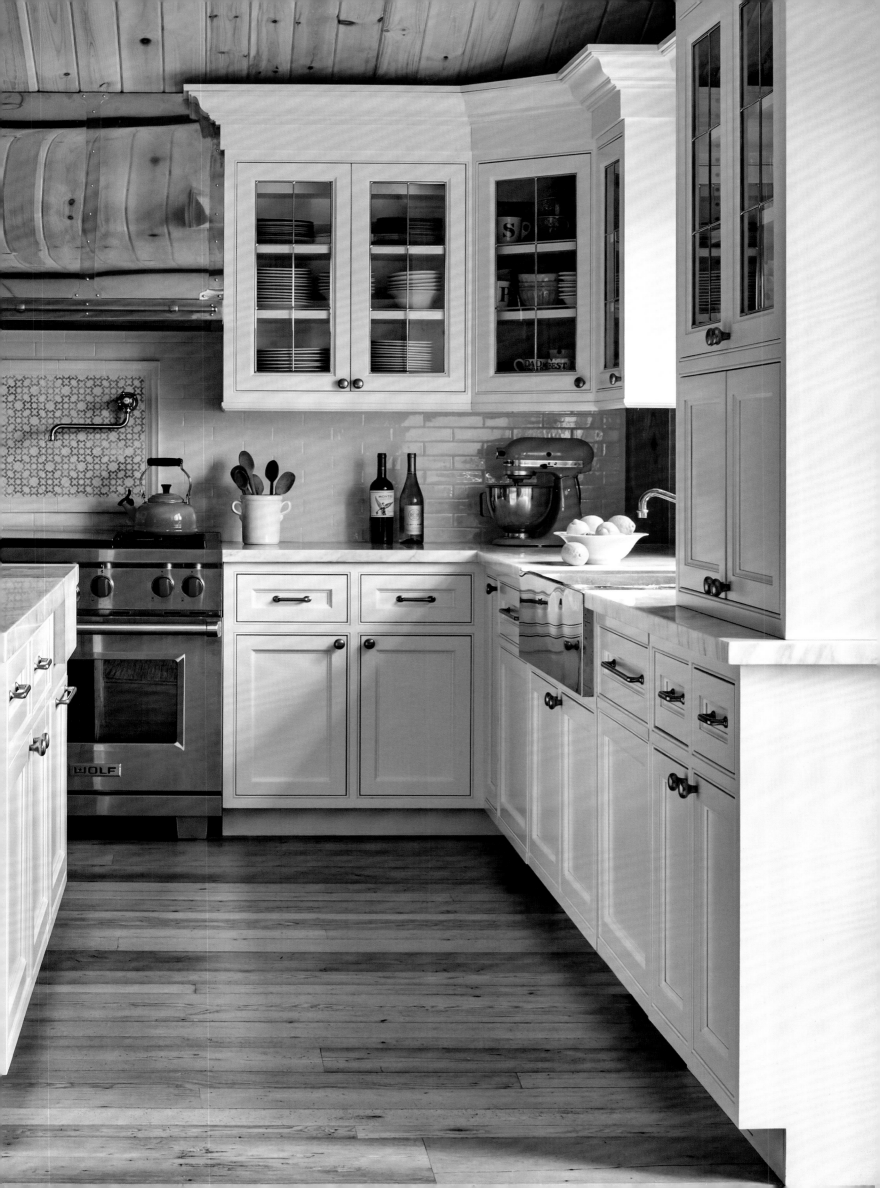

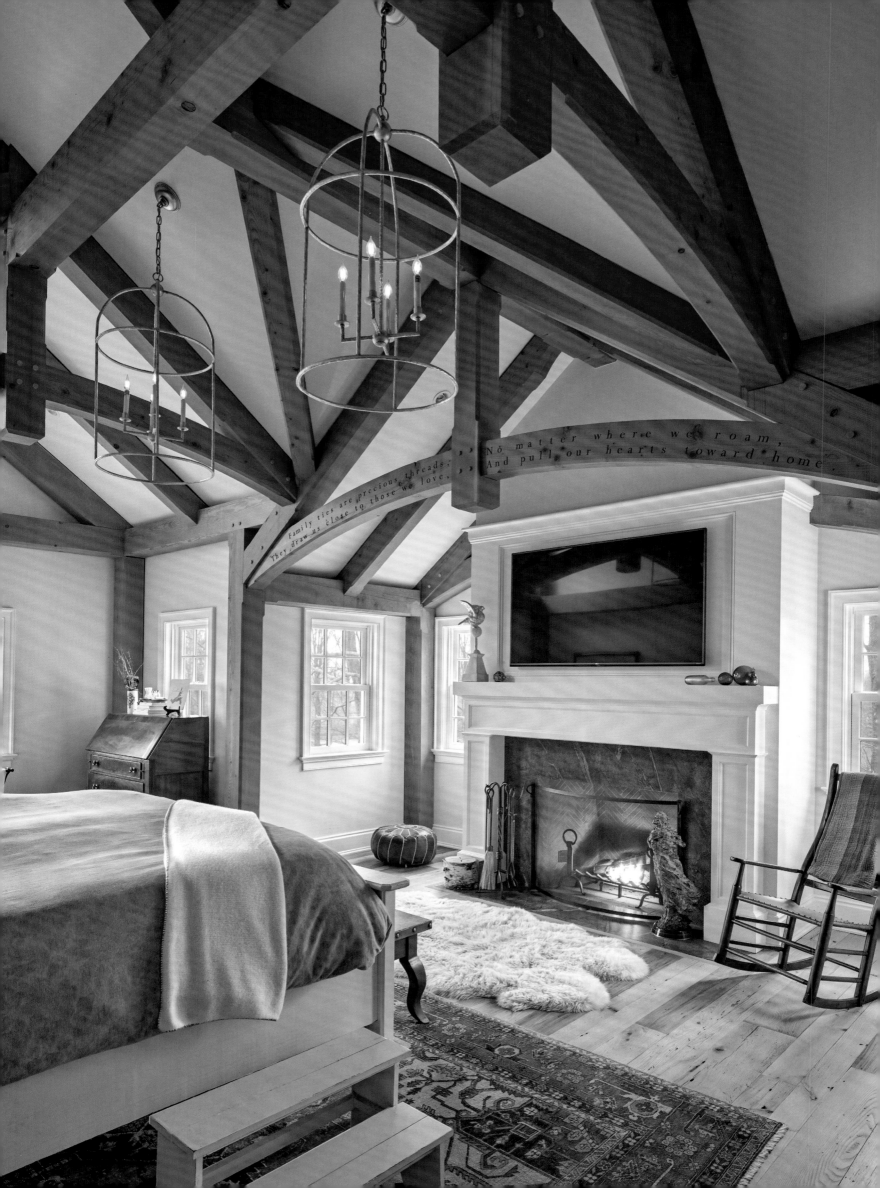

Family ties are precious threads,
They draw us close to those we love,
No matter where we roam,
And pull our hearts toward home.

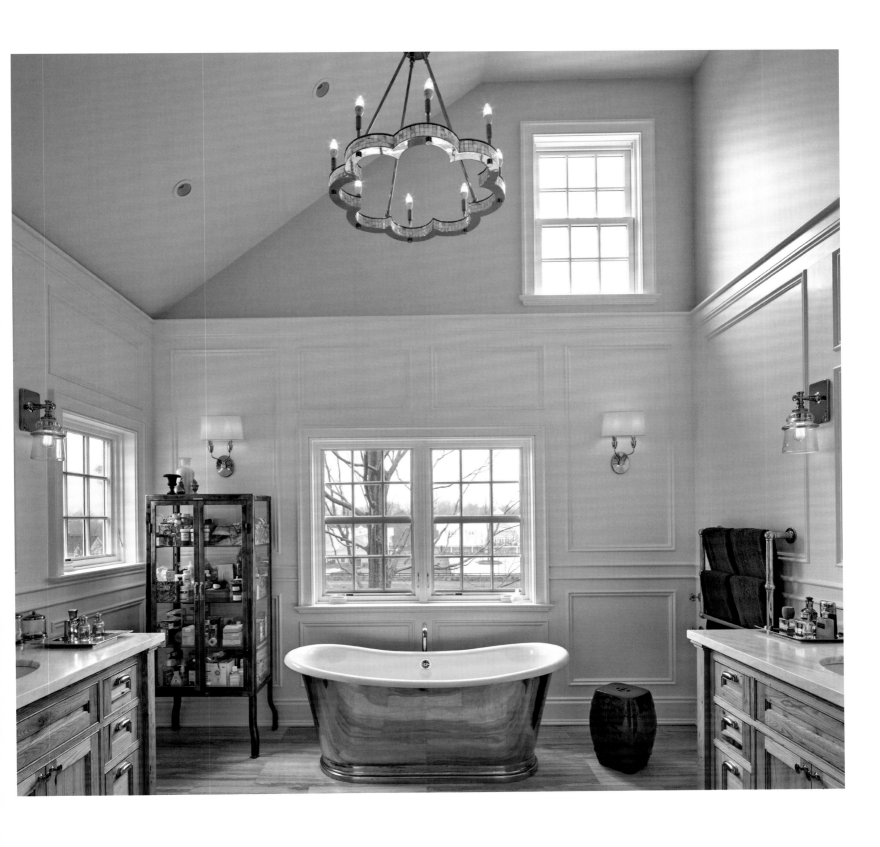

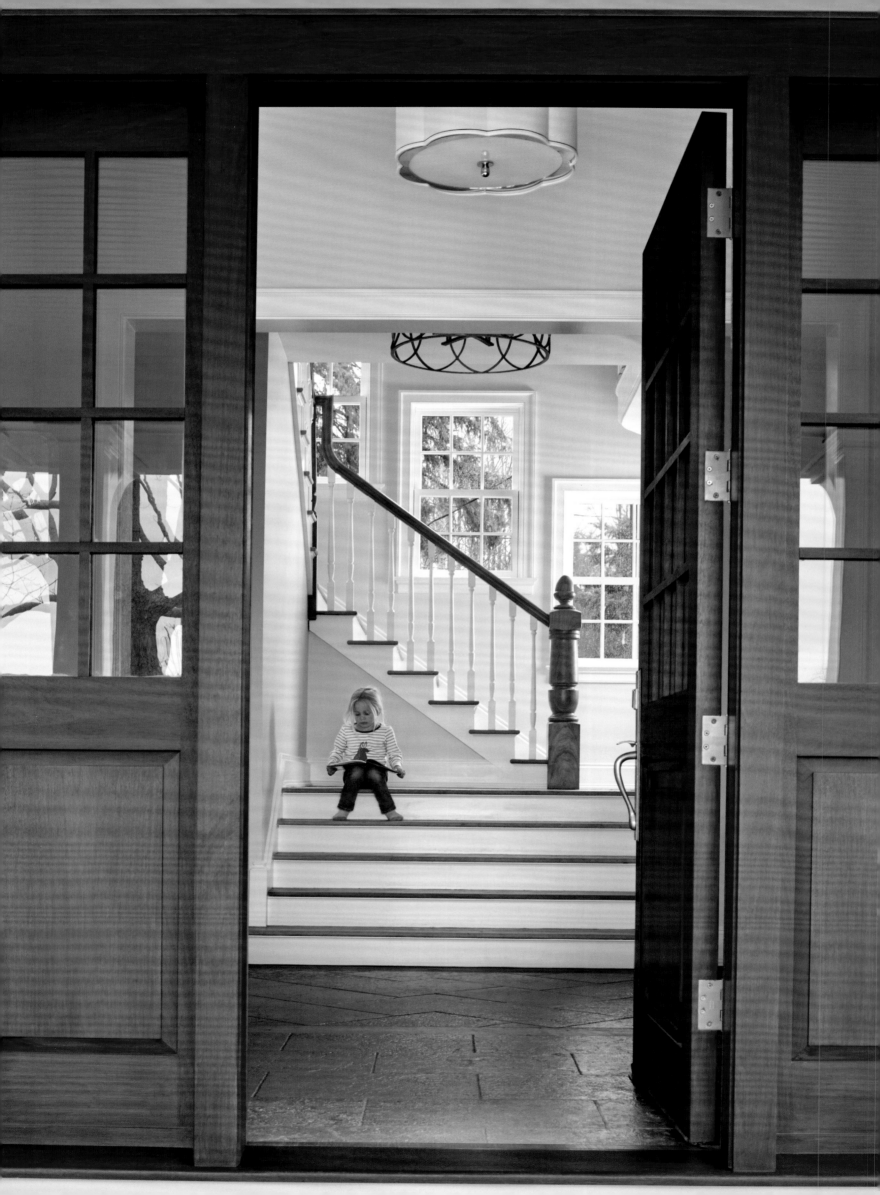

Yet the work of past architectural masters continues to inform Paulos's design approach. For instance, when taking on the renovation and expansion of a 230-year-old Connecticut farmhouse in 2014, Paulos invoked Wright's penchant for building homes with fireplaces that serve as the family's congregation space by redesigning the old home so that its original fireplace would be adjacent to the kitchen.

"When I am in the schematic design phase of a project and I know what style the client wants, I imagine myself in the spaces of the home and often think about what I would want it to feel like or what I would want to see. I usually start off with that in mind, and, most of the time, it sends me down the right path," said Paulos, who also counts UK architectural icon Sir Edwin Lutyens as one of his architectural heroes. "I also bring in elements that I have found are very important to me throughout my studies and travels."

For the future, Paulos, a self-described "perfectionist," is looking forward to boosting the reputation of his boutique firm while preserving the collaborative nature he's tried to foster between himself and his colleagues. With an eye on the environment, Paulos, who says his "dream project" remains to be built, is also looking to better integrate sustainability in his firm's design solutions.

"I would like to still maintain a boutique-type firm that is known for well thought-out design and exceptional service," said Paulos. "My designs coincide with my philosophy of being as diverse as possible, which makes you a better architect.

---

*Interior Design: PH Architects, LLC*
*Landscape Design: Laurel Rock*
*Builder/Contractor: PH Architects, LLC*
*Photographer: Robert Benson Photography*

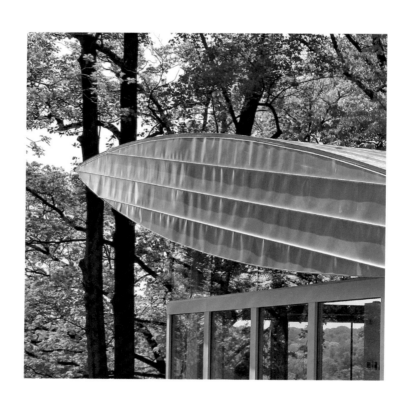

"Three key elements are my guides: Nature, Metaphor, and Modernity. My approach is to find the right south view for winter sun, explore the client's deepest emotions, and form the shape in modern idiom."

— Travis Price

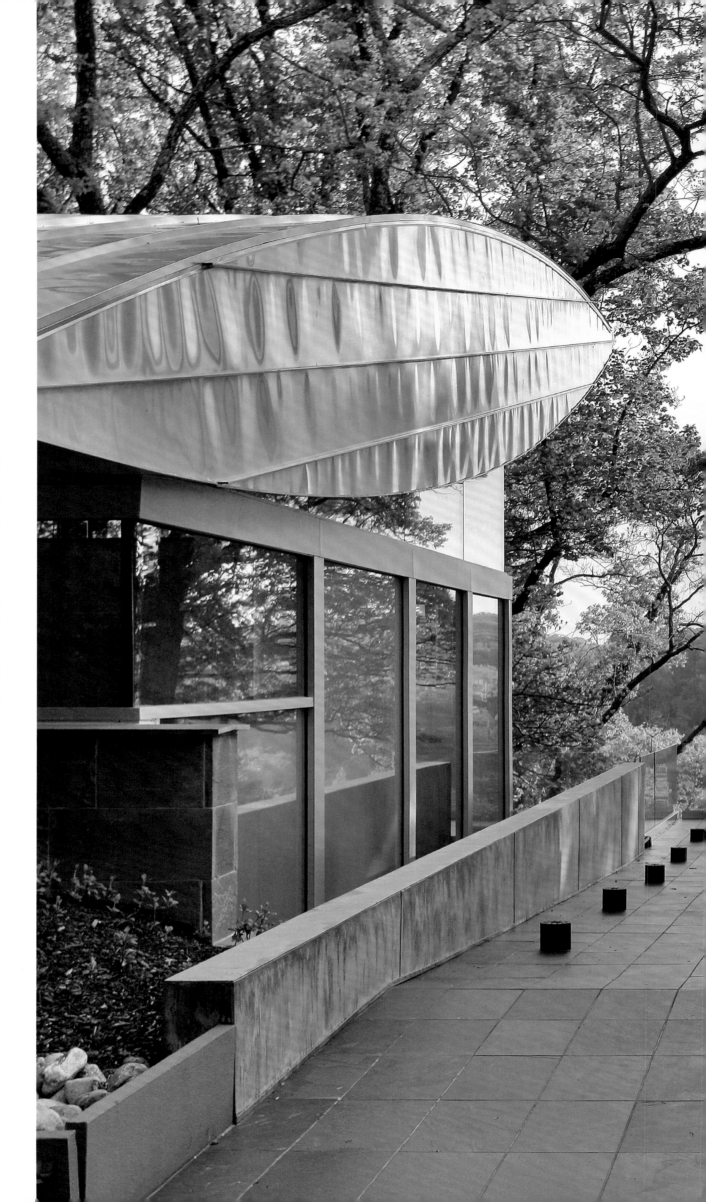

Travis Price

Travis Price Architects

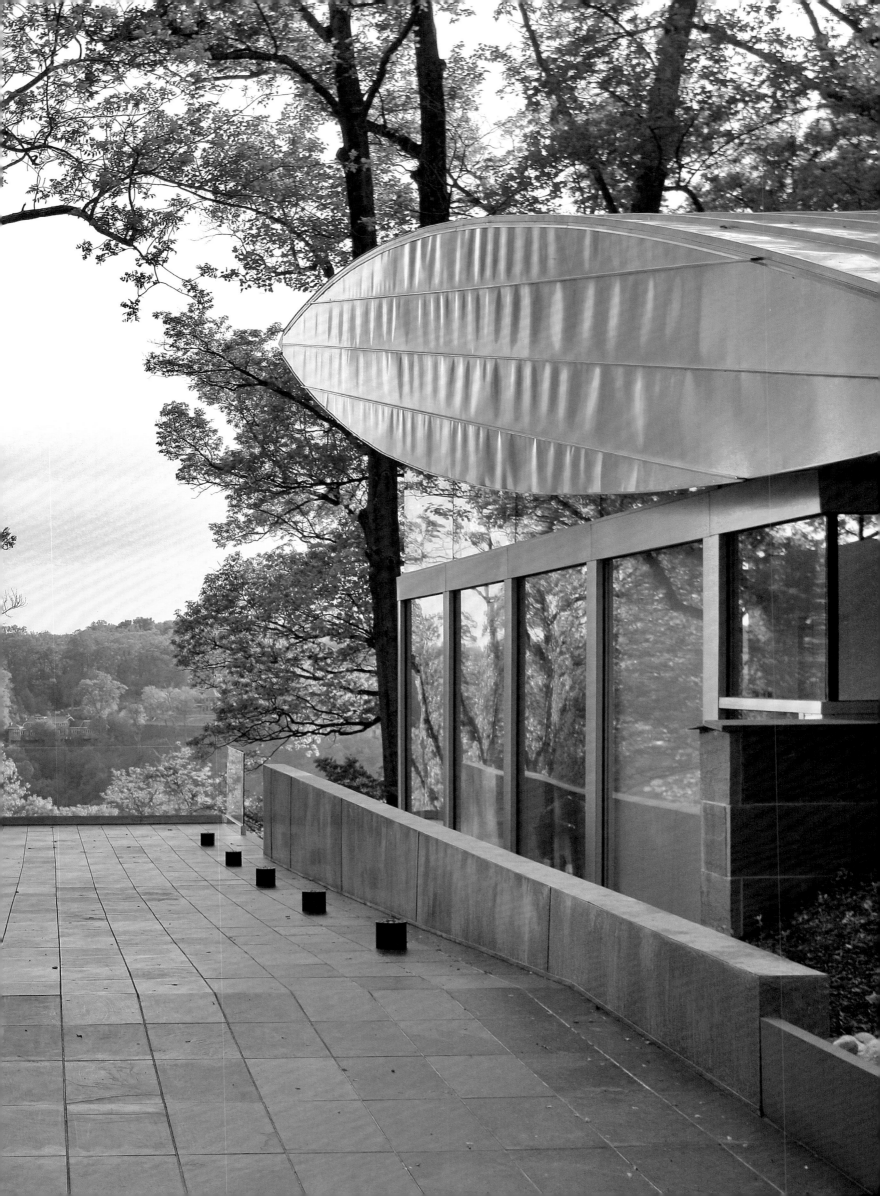

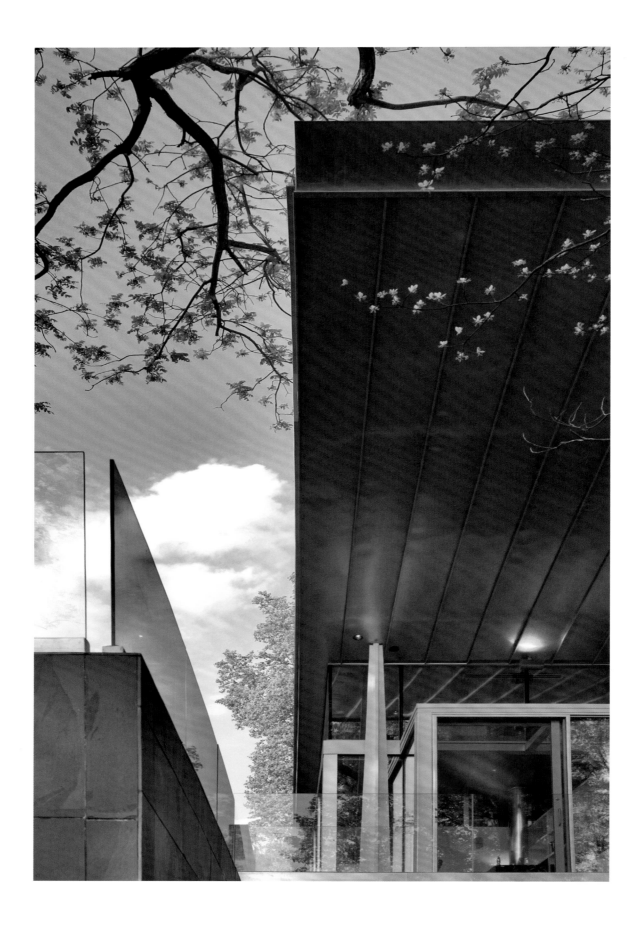

Travis Price's expression of a proposed home's architectural mission statement in haiku may be unconventional, but it's consistent with a philosophical approach that's guided the architect since he first decided, at age 11, that he wanted to build structures for a living.

With an eclectic upbringing that saw him travel from Southern Georgia to Panama to Germany as an adolescent, the Washington, D.C.-based principal of Travis Price Architects, who studied architecture at both Georgia Tech and University of New Mexico, was preaching the melding of environmental sensitivity and aggressive technology long before founding his firm in 1979.

Reflecting his beloved Socratic method of answering questions with responsive questions until some sort of solution is approached, Price's work has run the gamut from an Indianapolis home made out of discarded shipping containers to Manhattan's first wind machine to the world's largest solar-powered building in Chattanooga, Tennessee. Price has also taken pains to spread his gospel of "ecology modernism" at institutions such as the AIA, the National Geographic Society, and the Smithsonian Institution.

"Three key elements are my guides: Nature, Metaphor, and Modernity," said Price. "As to Nature, my approach is to find the right spot on the site – where is the southern view for passive solar heating, shade, breezes, and vistas close and far away. As to Metaphor, I spend a lot of time and some wine to open up the clients' deeply philosophic and emotional stories about themselves. Last and not least, the latest in modern technology directs the material choices. True advances of modern materials is the real ecology."

All of which is conveyed in Price's work on Bethesda, Maryland's Gelman/Salop Residence, whose approach Price distills into the aforementioned haiku: "Hushed Sigh. Silk Water Held. Revealing Rocks. Velvet Sunshine Dappled." Sitting on a ridge overlooking the Potomac River, the four-bedroom, three-bathroom home was designed to minimize its ecologic footprint by complementing technologically advanced materials such as super-insulating window-glazing and brushed aluminum roofing with a layout that maximizes cross-ventilation under a soaring shade roof overhang.

The home achieves such functionality-based goals of providing environmentally conscious shelter while creating a visually arresting structure that maximizes river views while minimizing vista intrusion for adjoining properties.

"While function and aesthetics often are seen as two separate activities, I find it impossible to separate them. Each stands for excellence. Each is a woven cloak of the other. They all must dance together," said Price. "That is the architect's job, to conduct the full orchestra of the owners, engineers, and builders to play the right opera."

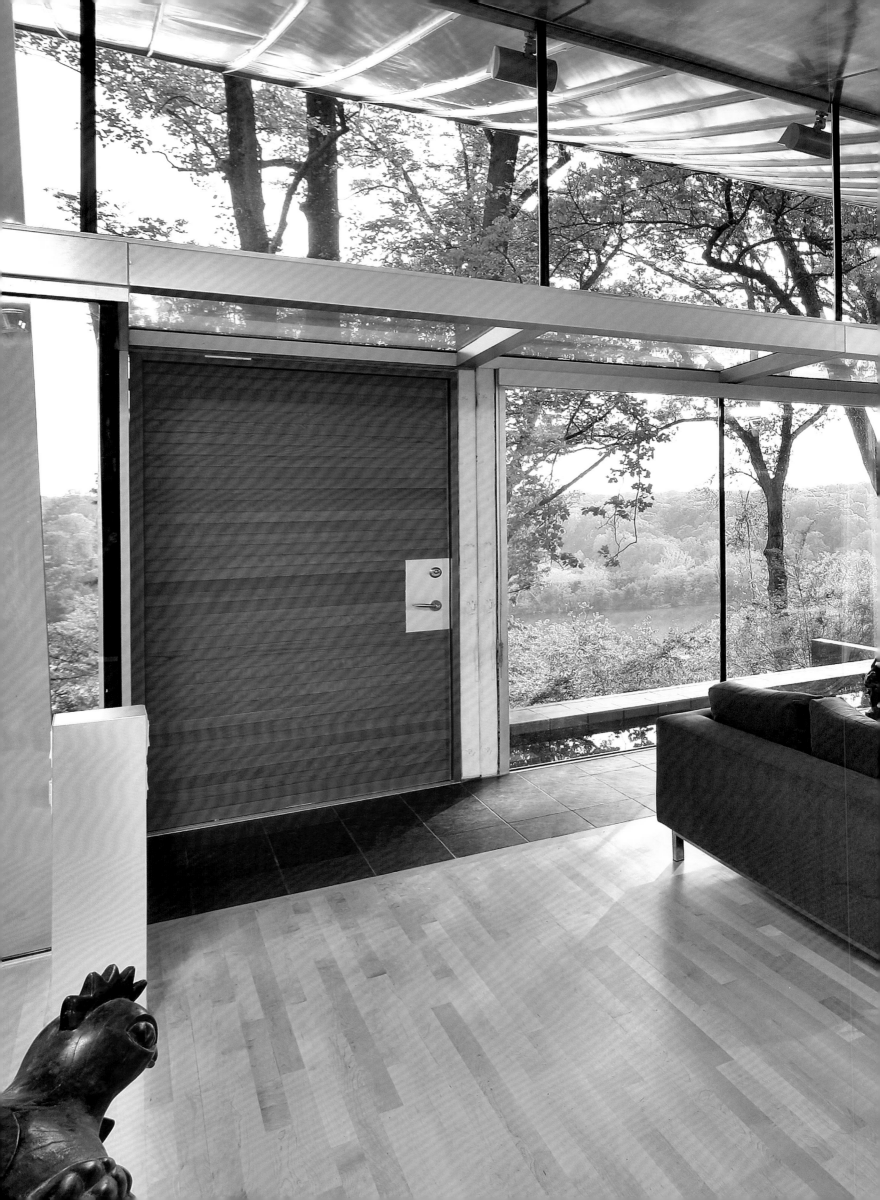

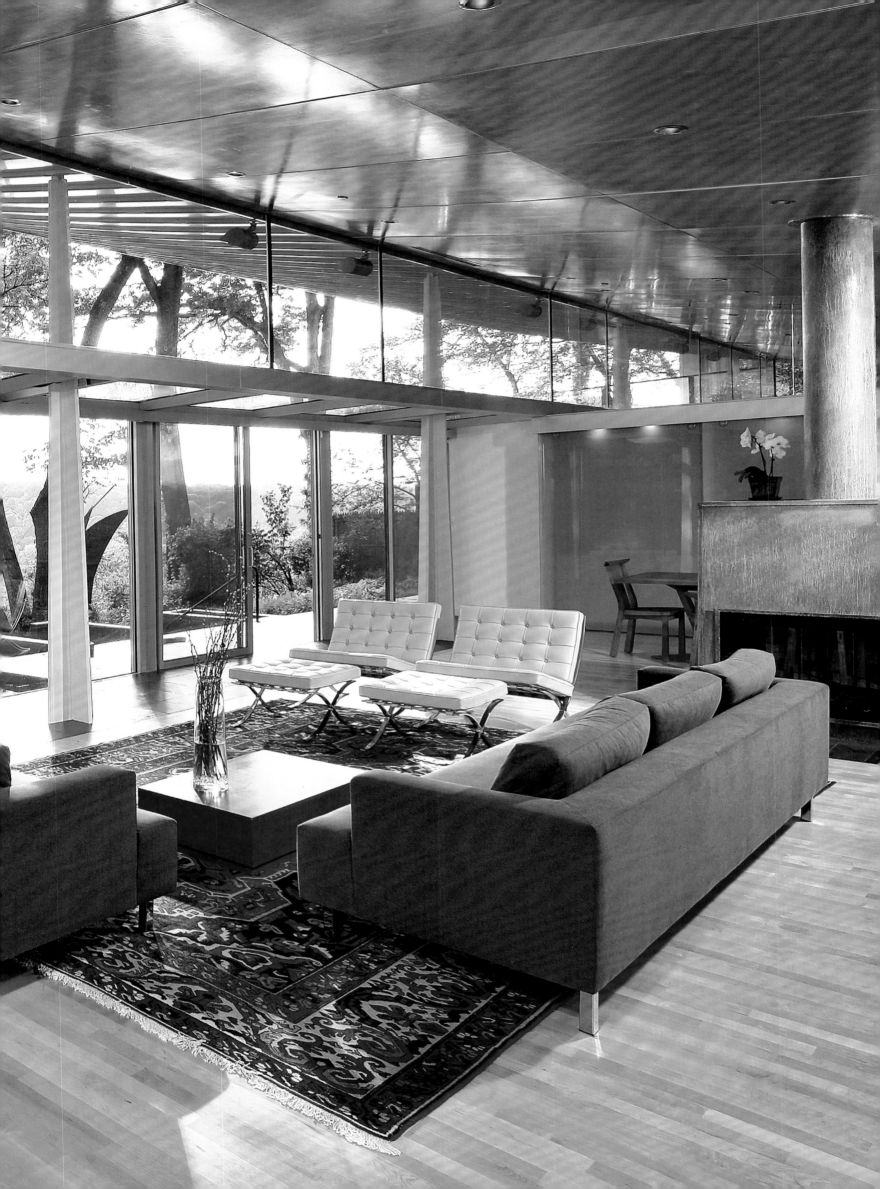

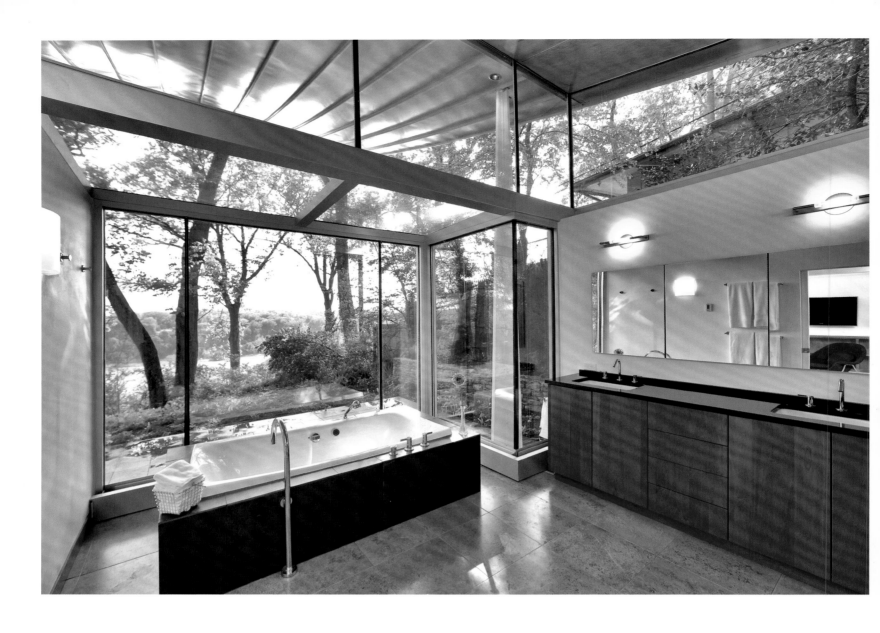
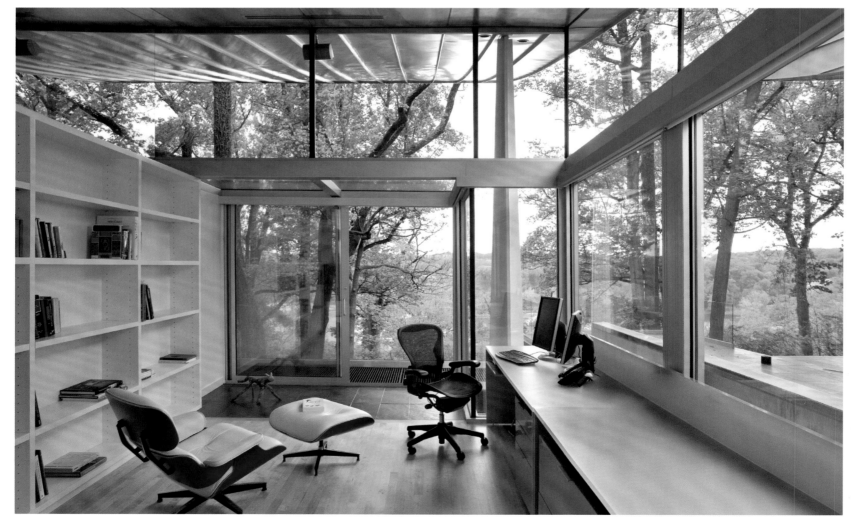

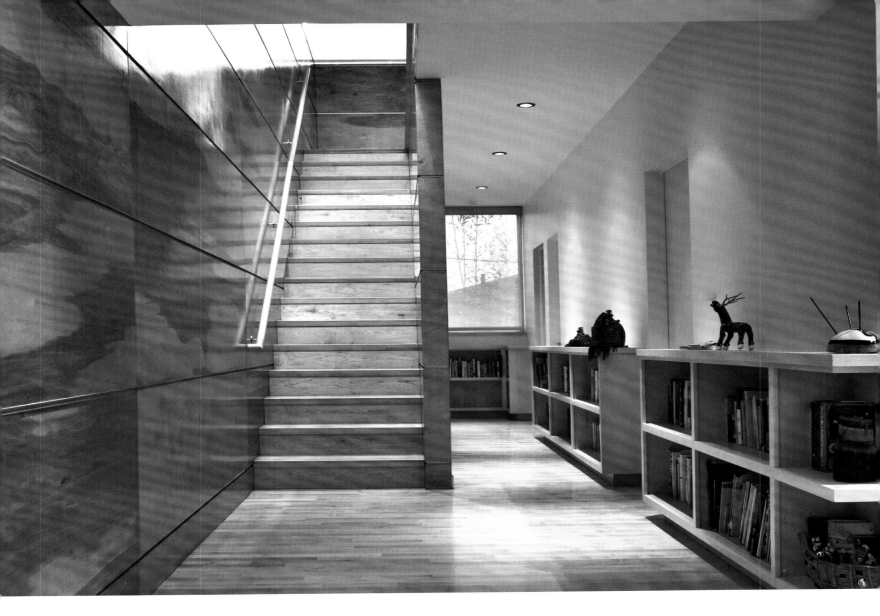

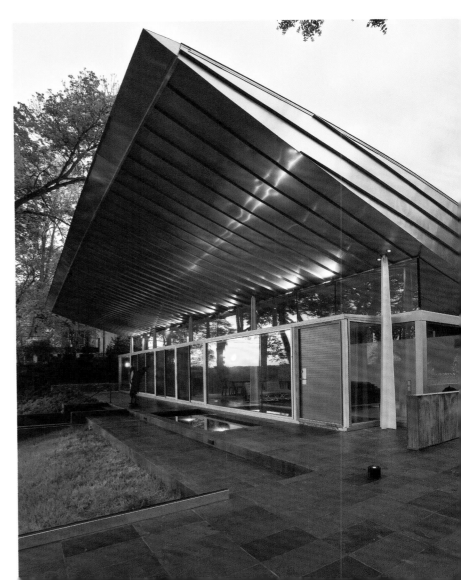

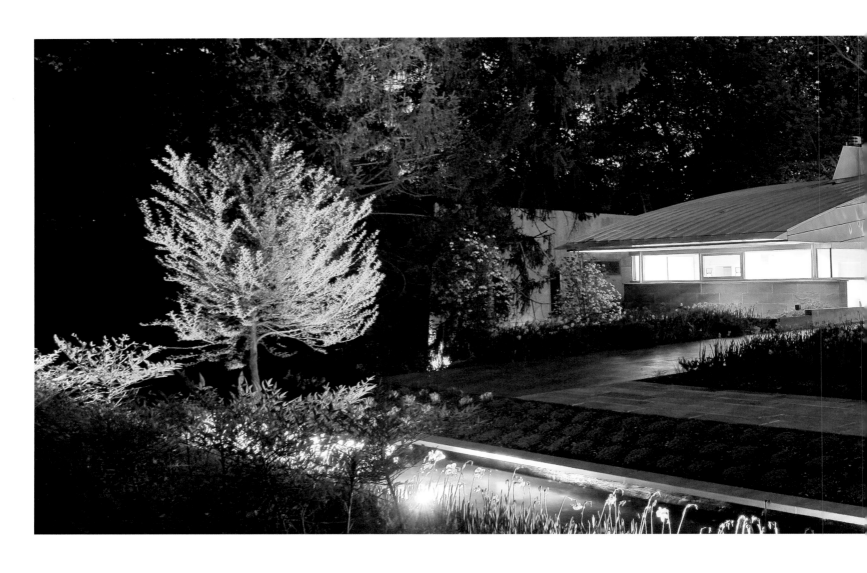

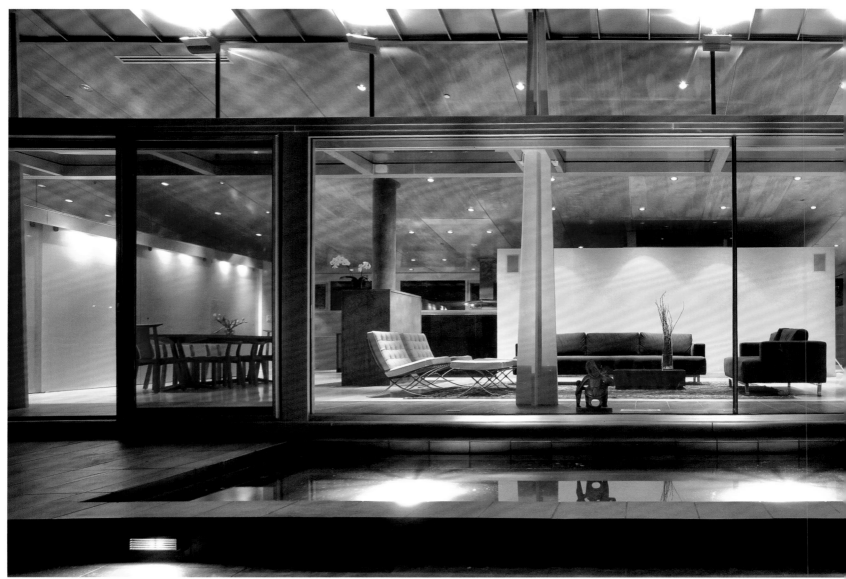

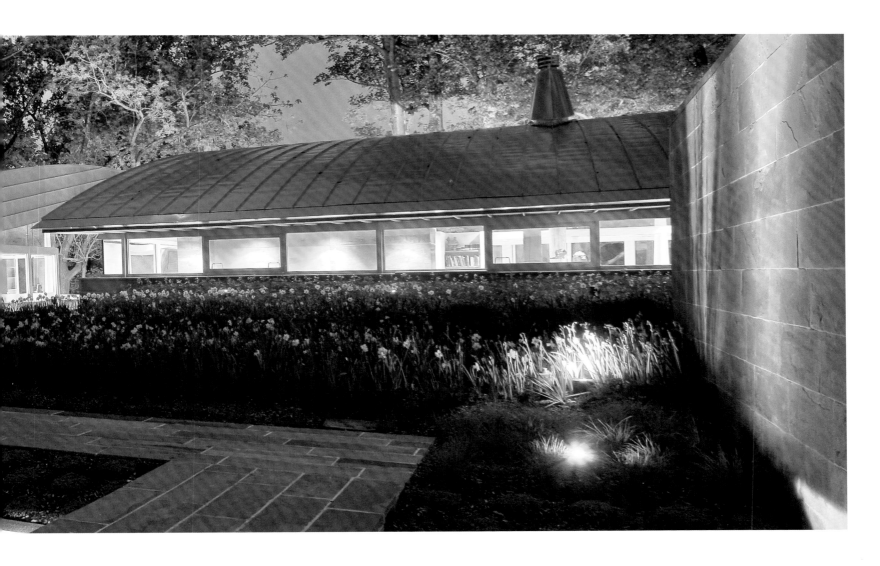

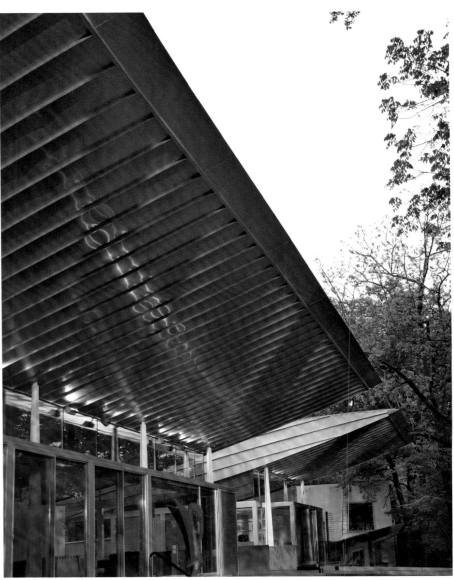

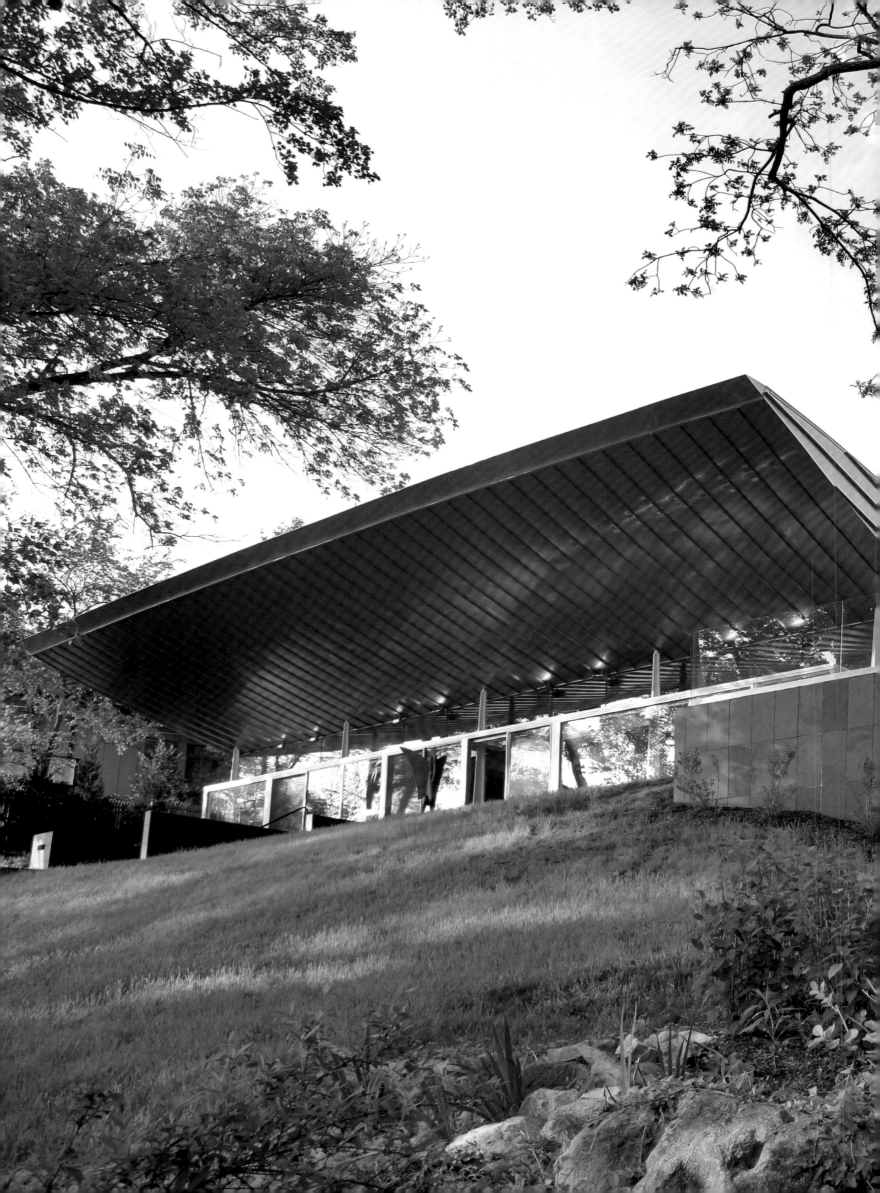

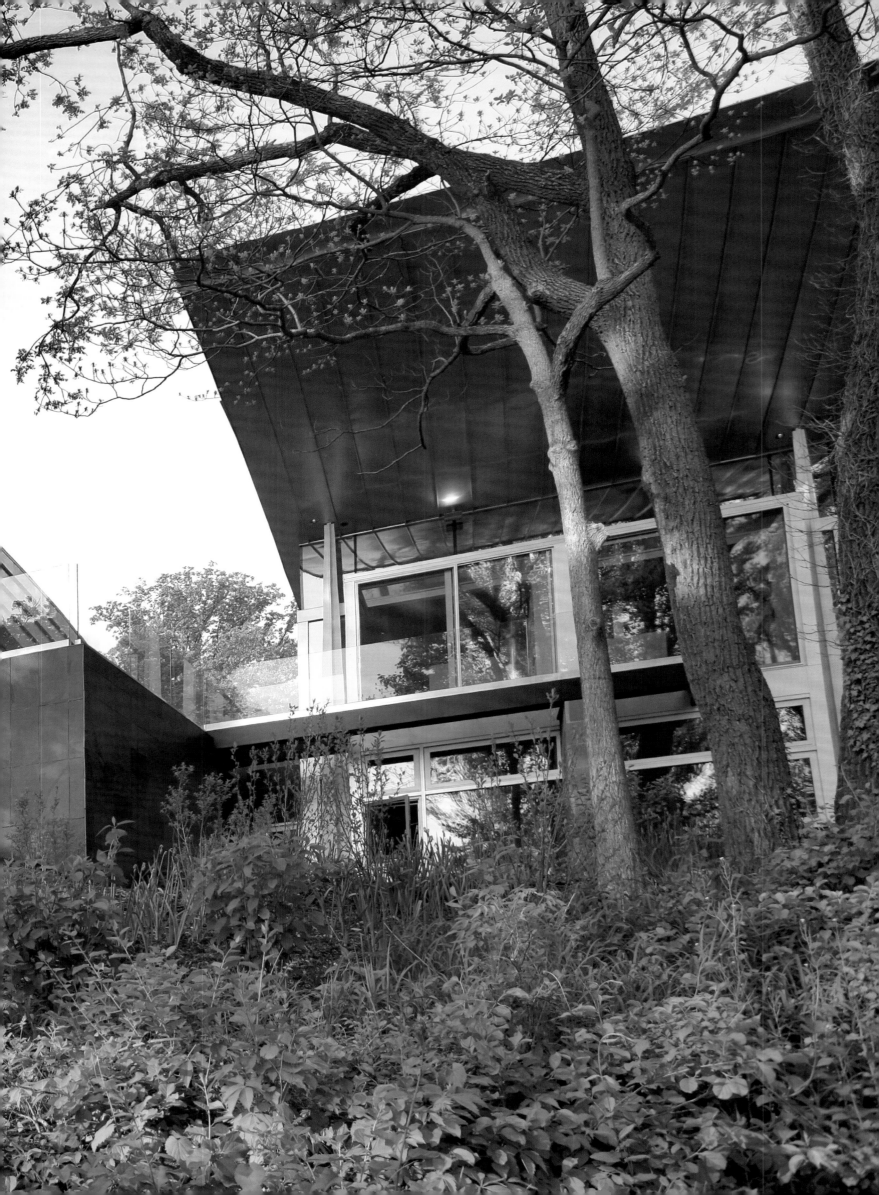

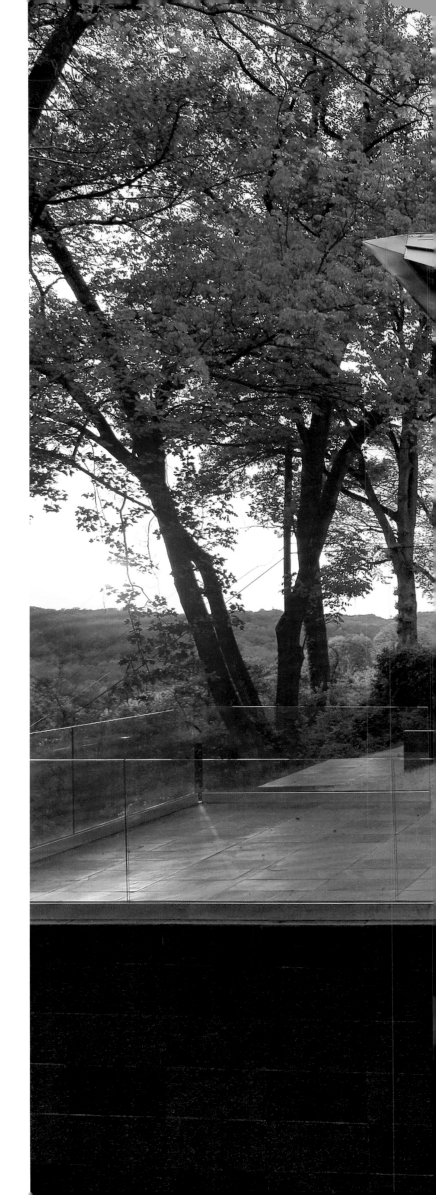

"My dream design projects vary from a house on the Mediterranean rocky coast, to a modern religious building, to an invisible building replete with endless time using nano technology."

— Travis Price

Price, whose own home in Washington's Rock Creek Park made it onto HGTV's "World's Greenest Homes" list, cites past masters such as Frank Lloyd Wright, Mies van der Rohe, Charles and Ray Eames, and even the ancient Greeks as influences and sources of inspiration. Price has expressed such reverence by spearheading the "Spirit of Place" project, in which architectural students under Price's guidance have built more than two dozen modern-design memorials across the world to commemorate ancient civilizations since 1993.

That said, Price, who refers to the current architectural era as "the second wave of modernism," is quick to stress the value of shedding limitations of the past while pushing the limits of technology and imagination.

"My dream design projects vary from a house on the Mediterranean rocky coast, to a modern religious building, to an invisible building replete with endless time using nano technology," says Price. "No metaverse yet, but I'm looking to design a world of modern scaled new eco towns that are self-reliant, humane, and never seen before."

*Interior Design: Travis Price Architects*
*Landscape Architect: Thomas Tait*
*Builder/Contractor: KGPBuild*
*Photographer: Ken Wyner*

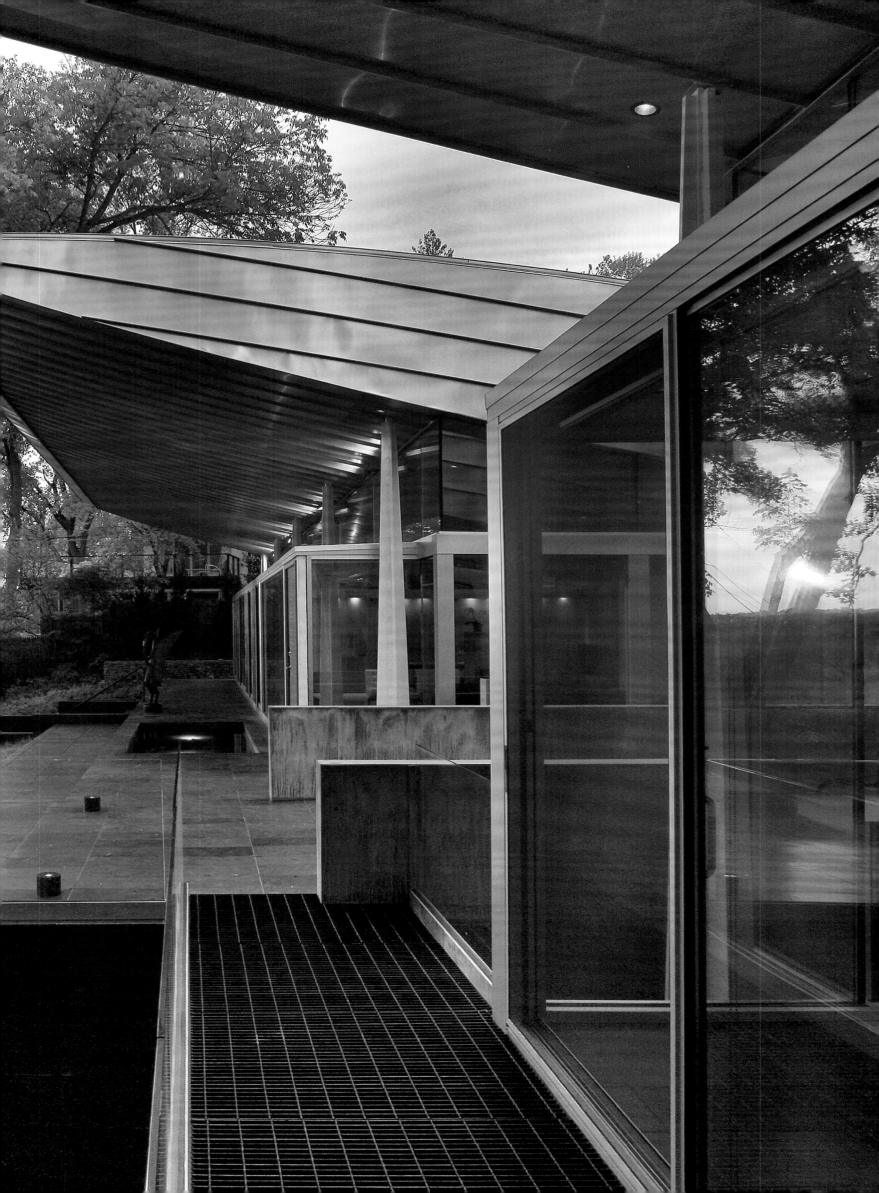

"I love creating something beautiful and giving new life to old buildings. I believe buildings have souls. I love giving new energy to them."

— Joseph Vance

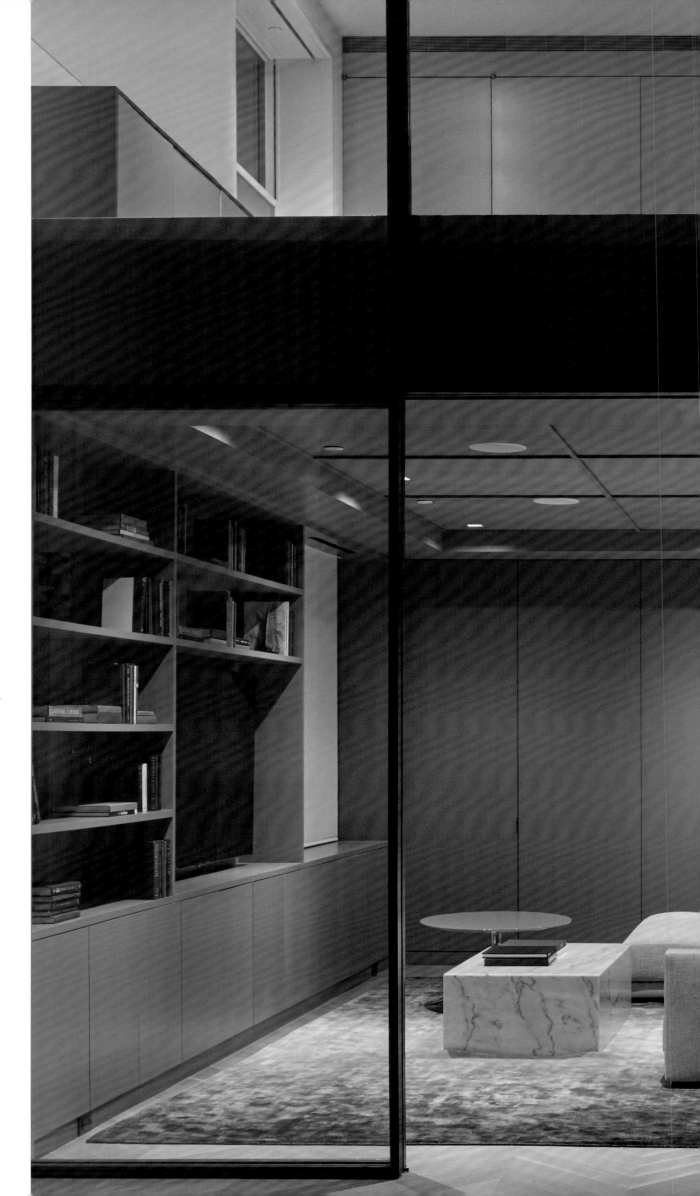

Joseph Vance

Joseph Vance Architects

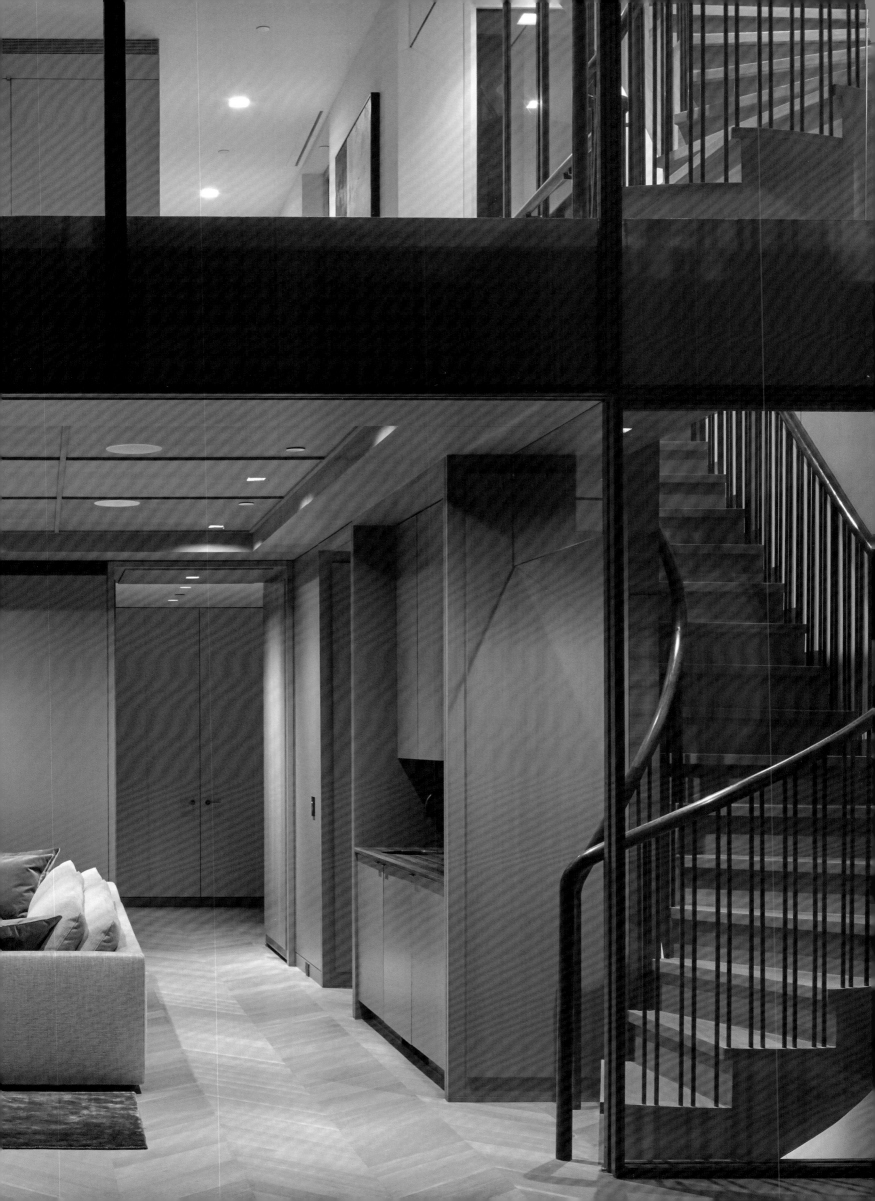

For the past three decades, New York-based architect Joseph Vance has carved out a reputation for inventively repurposing single-family homes and townhouses out of New York City brownstones and brick structures that had previously served as multi-family or commercial buildings. Vance has achieved this while avoiding being pigeonholed for committing to particular styles, materials, or visual cues.

For the often long, narrow, and darkened structural canvases that he's presented with, Joseph Vance Architects (JVA) does, however, abide by one particular ethos: Let There Be Light. "I don't use the material of the moment, or pay attention to what's 'in' now, and I try to avoid cliches," said Vance, whose firm has designed nearly 100 homes since its 1991 founding. "But enhancing natural light has always been integral to every project."

Case in point is a 153-year-old building in Lower Manhattan's SoHo Cast Iron Historic District that started its life as a manufacturing building and was subsequently occupied for more than 50 years by Philip and Kelvin LaVerne, the father-son team of custom-furniture designers and sculpture makers. JVA redesigned it as a six-bedroom, 11-bathroom single-family home, one of only a half-dozen in SoHo.

The townhouse boasts extravagant features such as a dumbwaiter from the kitchen to the penthouse, a cellar-level spa with pool, and a rooftop pool, as well as a restored building façade, complete with a replicated metal roof cornice to duplicate the original.

More importantly, JVA solved the challenges of adding both natural light and a rooftop entertaining space without adding square footage by cutting an interior light shaft between the townhouse and the neighboring building's exterior brick wall. Not only was JVA able to swap the lost square footage from the light shaft for the new rooftop penthouse, but the firm also enabled the addition of two interior bedrooms while flooding much of the rest of the 11,000-square-foot home with natural light.

"The building was 98 feet from front to back, so we did things to bounce the light around. We redesigned the floorplan so that every stairway landing was at that light shaft, and we used opalescent paint on the neighbor's building," said Vance. "So we made this glowing heart out of this dark building."

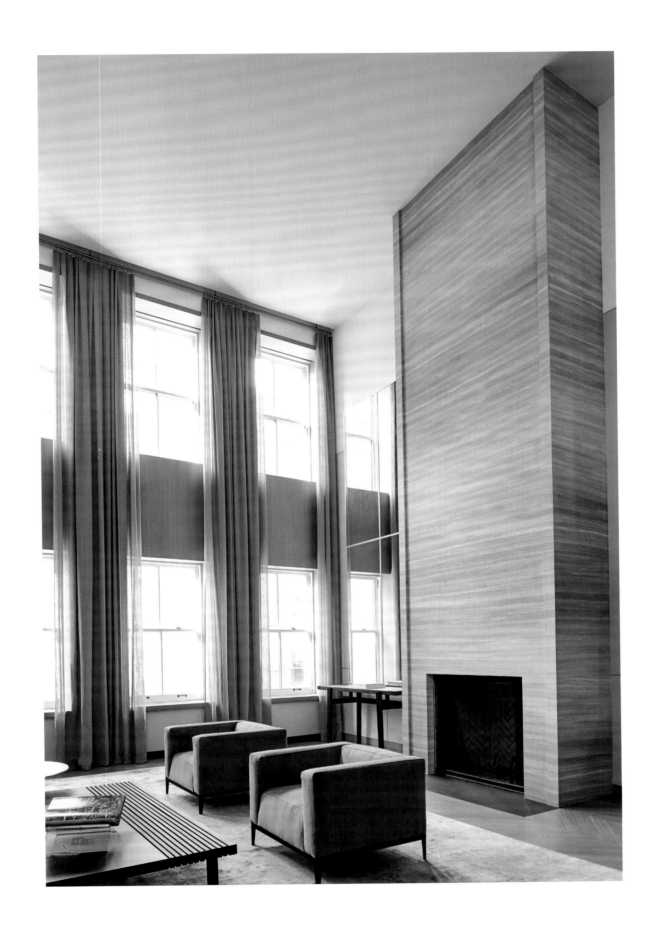

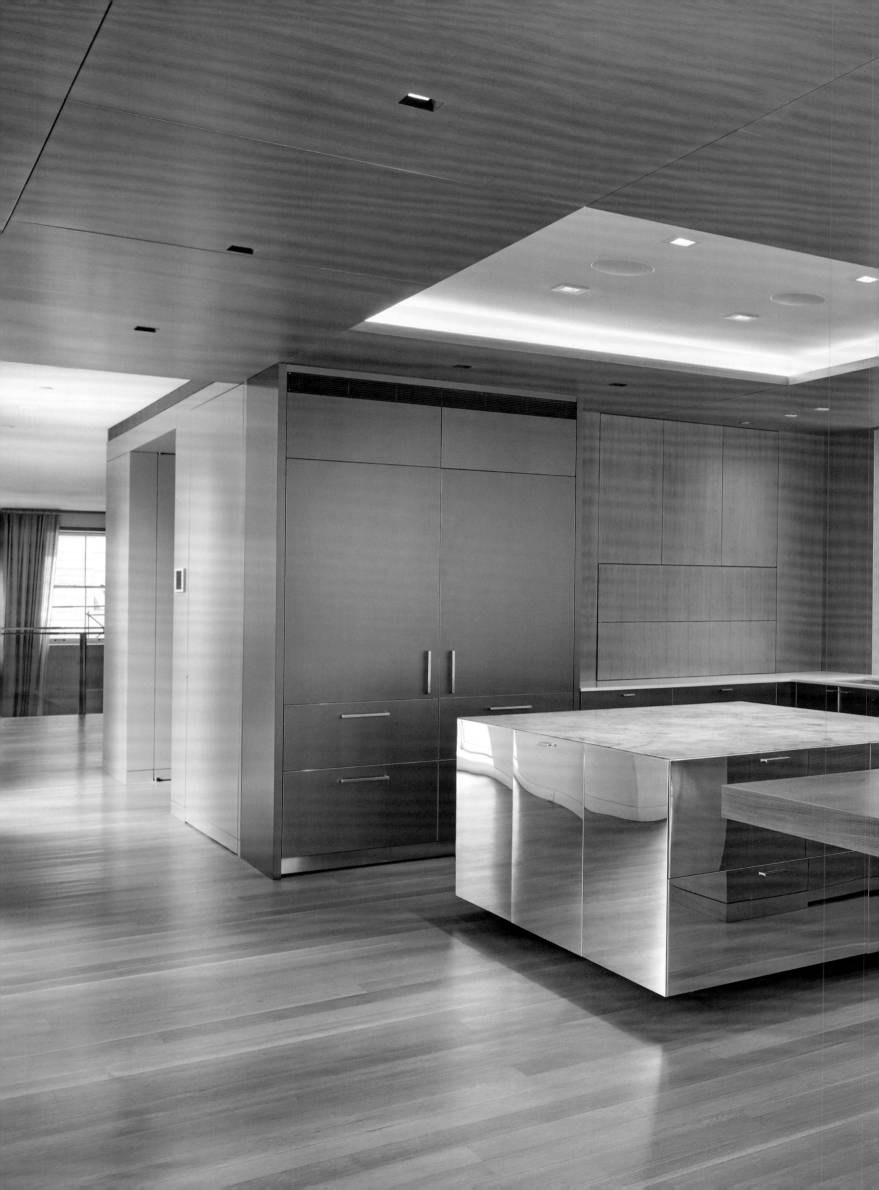

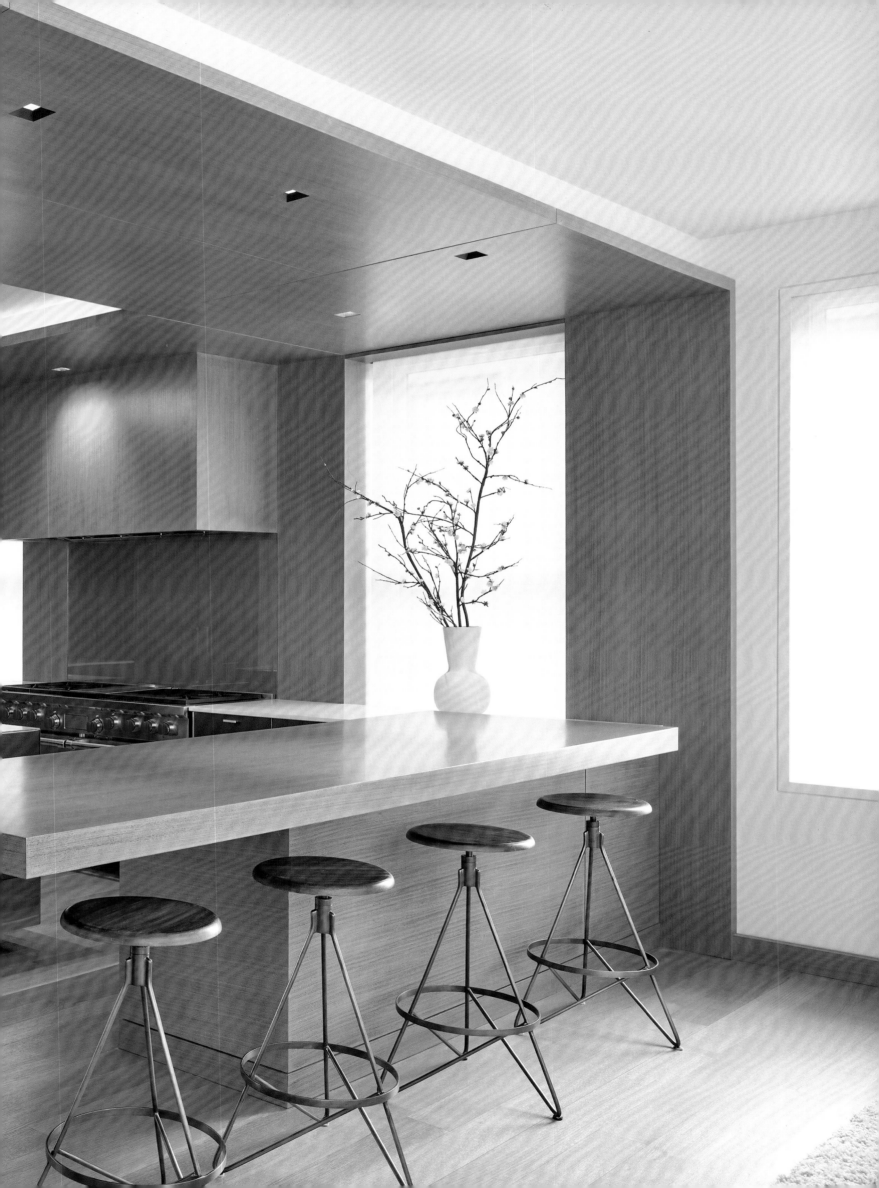

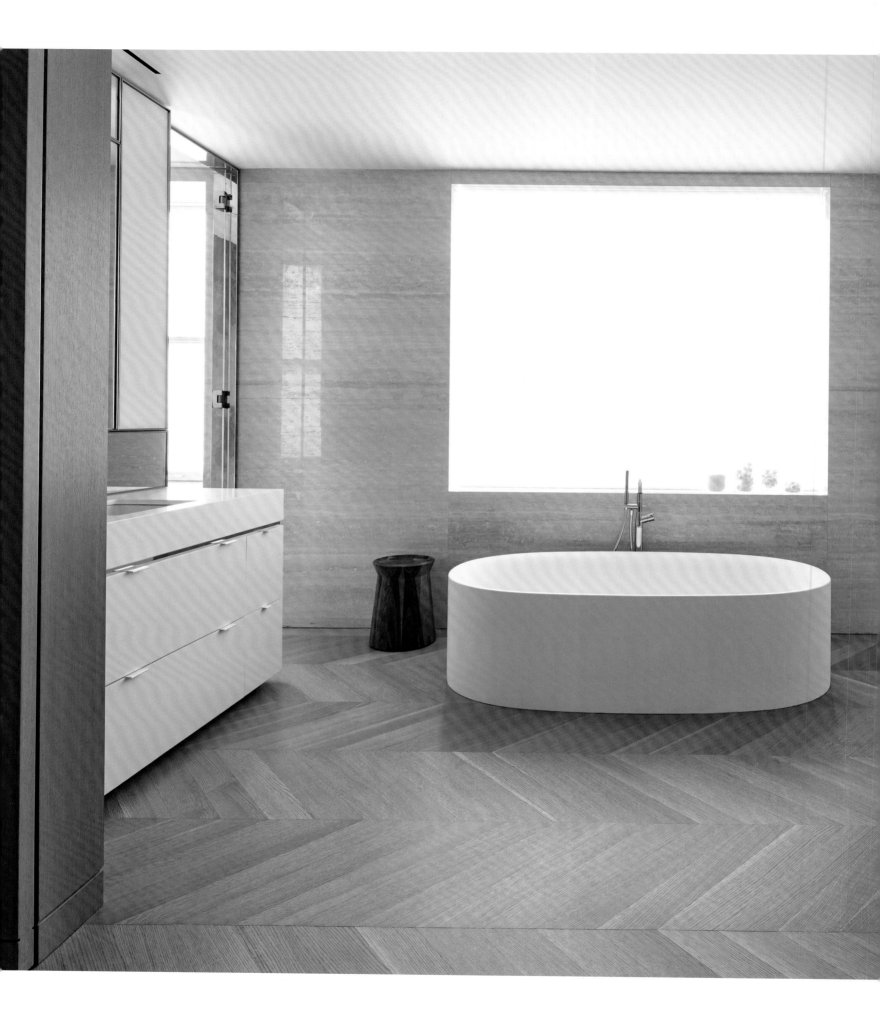

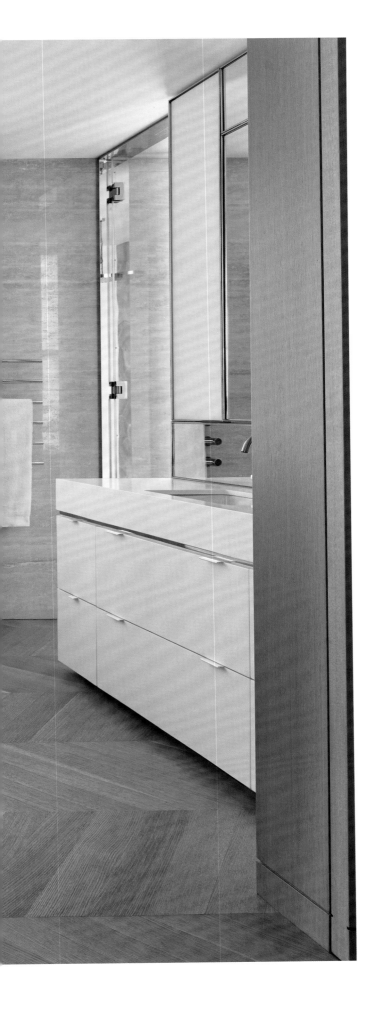
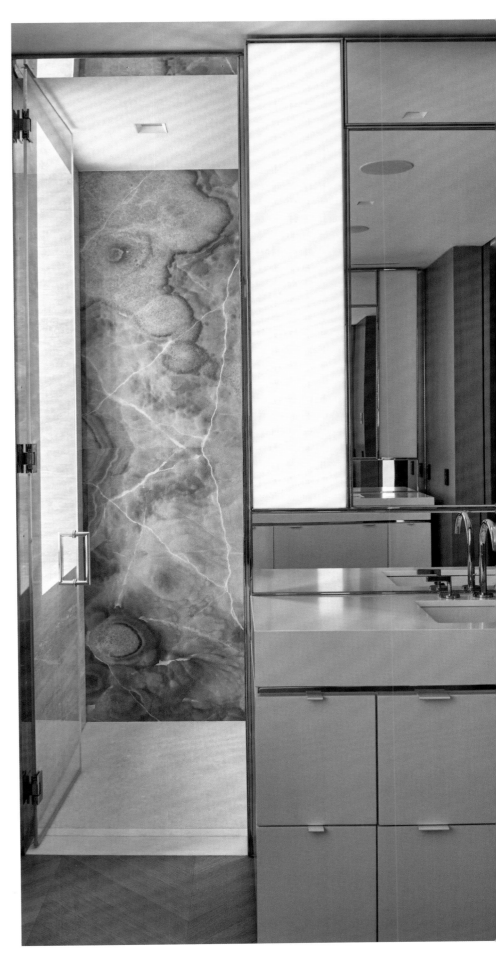

"We do not have a signature style — it is not modern, traditional, or contemporary. Each project is the unique result of a particular client and space."

- Joseph Vance

JVA has relished its role of doing the forensic research required to restore facades to their original grandeur to reflect the roots of structures that often date back to the 19th century. Far from being staunch traditionalists, JVA has embraced technology by employing 3-D software throughout the entire design and build-out process. Not only does this allow the architect to fully integrate building mechanicals and structure with design, but it provides JVA's clients the more immersive experience required for them to envision the end result. They often say it looks just like the model.

"We do not have a signature style – it is not modern, traditional, or contemporary. Each project is the unique result of a particular client and space," said Vance. "That said, all our designs are well-proportioned, focus on bringing in natural light, use warm materials, and are the product of good design. These tenets can result in any style."

Vance's commitment to New York City aesthetics isn't just limited to his practice, however. The longtime Brooklyn resident helped fund the nonprofit North Brooklyn Park Alliance in 2005, which raised funds to rebuild, improve, and expand public parks in North Brooklyn. Vance has also served on the Greenpoint Waterfront Association for Parks and Planning and the Brooklyn Greenway Initiative board.

By limiting his firm's workload to just a handful of projects a year, Vance, a self-described "control freak," ensures his personal involvement in every facet of his clients' buildings.

"Many times you see design that is beautiful, but it isn't practical. When something is not practical, you do not move through it with ease, so it satisfies only the visual, not the functional or the emotional," Vance says. "Good design is a well-proportioned space that's thorough down to the last detail. For us, there is no other way of working."

*Builder/Contractor: ABR Construction Group*
*Photographer: Mikiko Kikuyama*

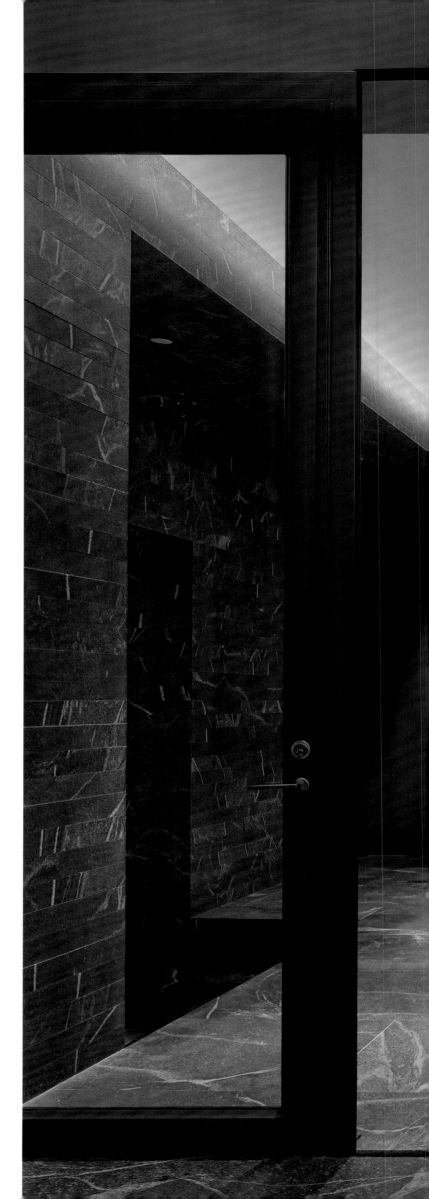

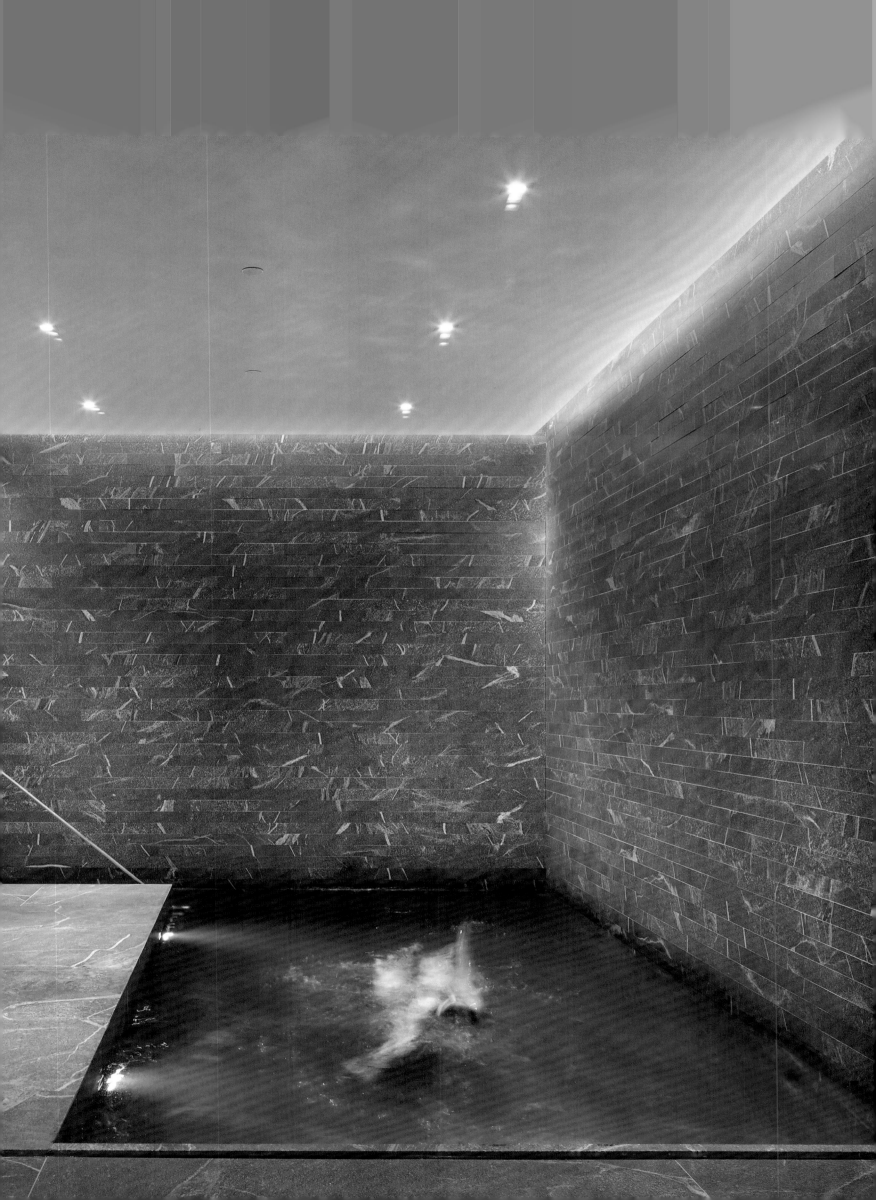

# Acknowledgement

Special thanks to the entire benton buckley books team and all those who contributed to the magic of making this book come to life.

## Creative Team

sheri lazenby — senior executive publisher

Sheri has been in the publishing industry for more than two decades. She loves people, research, and the collaborative process of creating beautiful books. Whatever the project, she deeply immerses herself to become an expert on the subject matter, ensuring that every book is as extraordinary as the one before. Sheri and her husband are long-time residents of Florida.

The Northeast Team, including:
Suzanne Murphy, Sam Boykin, Danny King, Rosalie Wilson, Beth Hisey, Lindsey Wilson, Elle Buckley, Elsie Moore, & Jenny Lynn Ball.

# beth — founder, CEO

Beth Buckley founded boutique publishing house benton buckley books with decades of experience and praise in luxury, exhibitionary publishing, and a life-time of loving all that which is beautiful — and of finding beauty amongst and in all of us. She is devoted to curation, and is steadfast in her pursuit of authentic talent, untempted by the trend of the time. Beth is known for her keen eye and stunning aesthetic, and has collaborated with, and published, the best of the best in architecture, art, interior design, travel, celebrity event design, plastic surgery, food, wine — and has long led the industry in her efforts to sincerely discern, and share, beauty with the world.

Like a museum curator, drawing on her experience in and passion for the art world, Beth brings together the best of a genre and presents it in a timelessly beautiful format. The art always comes first. Beth works intimately with each and every client to ensure their dreams and visions are executed.

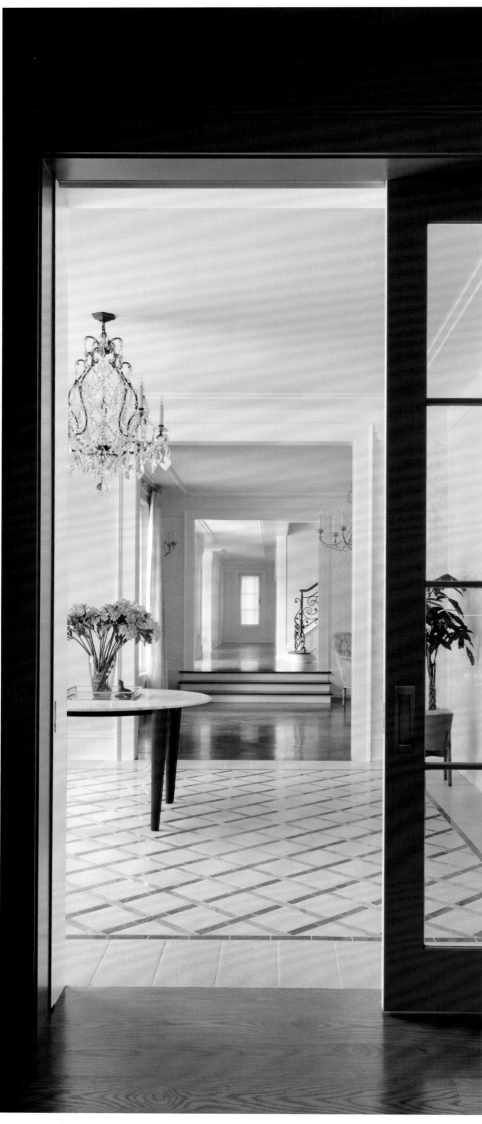

*Sussan Lari |  Photograph by David Mitchell*

# SPECIAL THANKS
We would like to thank all the photographers who contributed to this book.

Andrew Zientek
az-la.com
pages 194-195

Anice Hoachlander
studiohdp.com
pages 176-191

Anthony Crisafulli
anthonycrisafulli.com
pages 96-111
pages 160, top right 169
bottom left 170, top right 171,

Austin Nelson
austinnelson.com
page 197

Bartholomew Studio
bartholomewstudio.com
pages 32-47

Conor Harrigan
conorharrigan.com
pages 272-287

Daniel J. Cardon
danieljcardon.com
page 12

David Mitchell
davidmithcellphoto.com
pages 228-231, bottom left 232,
233, top left 234

Glen Gery
glengery.com
pages 192, top left 200, 202-203

Joshua McHugh
joshuamchugh.com
pages 146-155, top left 156,
158-159

Ken Wyner
kenwynerphotography.com
pages 304-319

Matt Wargo
mattwargo.com
pages 256-271

Meg Matyia
megmatyia.com
page 48-51, 54-55, 59-61

Michael Moran
moranstudio.com
pages 240-243, 246-253

Mikiko Kikuyama
mikikokikuyama.com
pages 320-335

Nicole Franzen
nicolefranzen.com
pages 16-31

Peter Murdock
petermurdockphoto.com
pages 245, 254-255

Peter Rymwid
peterrymwid.com
pages 224-227, top left 232,
bottom left 234, 235-239

Prakash Patel
prakashpatel.com
pages 128-143

Richard Powers
richardpowersphoto.com
pages 112-127

Robert Benson
robertbensonphoto.com
pages 53, 56-58, 62, 288-303

Tom Arban Photography
tomarban.com
pages 80-95

Tom Grimes Photography
tomgrimes.com
pages 198-199, bottom left 200,
top right 201, 204-207

Trent Bell
trentbell.com
pages 64-79, 208-223

Warren Jagger
jaggerfoto.com
pages 162-168, bottom right 169,
bottom right 171, 172-175

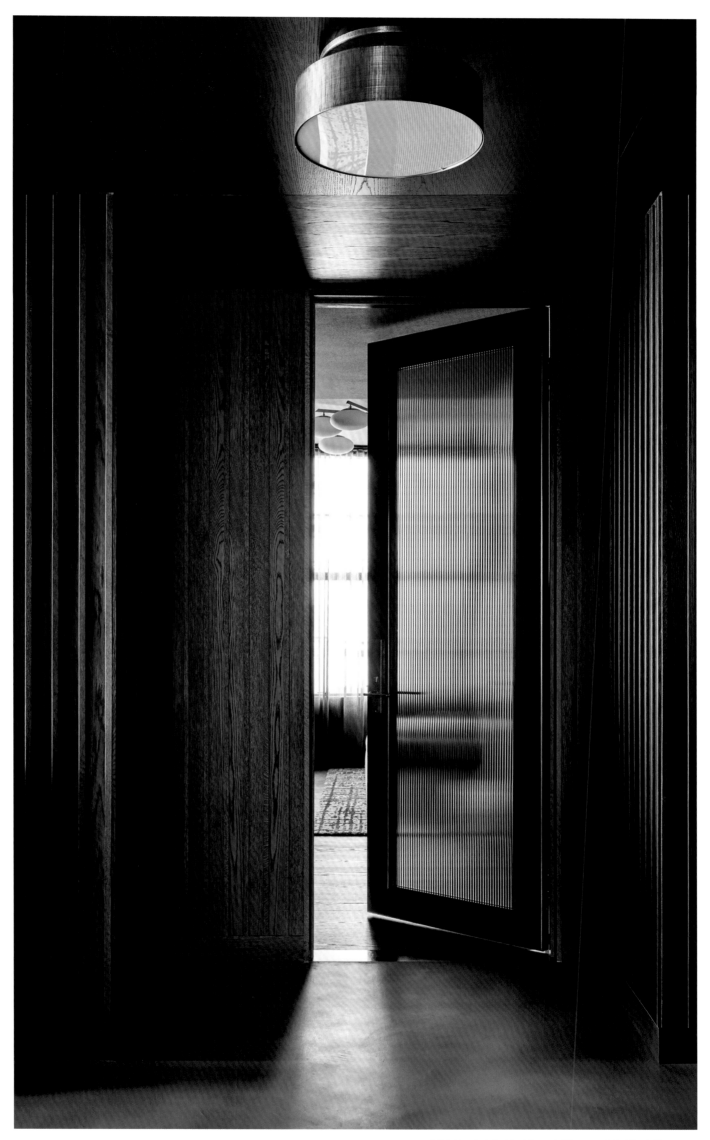

First published in United States of America in 2023

by benton **buckley books**
be **bold.**

www.bentonbuckleybooks.com

Editor-in-Chief: Beth Buckley
Senior Executive Publisher: Sheri Lazenby
Chief Operations Officer: Suzanne Murphy
Co-Writer: Sam Boykin
Co-Writer: Danny King
Editor: Rosalie Wilson

FIRST EDITION

Distributed by Independent Publishers Group
800.888.4741

PUBLISHER'S DATA

New View: A Curated Visual Gallery
Twenty Magnificent Homes by Northeast Architects

Library of Congress Cataloging-in-Publication Data
has been applied for.
ISBN: 978-0-9994818-8-2

New View is a series of regional residential
architectural books.

Visit bentonbuckleybooks.com

For information about custom editions, special
sales, or premium and corporate books, please
contact benton buckley books at
bebold@bentonbuckleybooks.com.

First Printing 2023
10 9 8 7 6 5 4 3 2 1

*Robert Gurney Architect  |  Photograph by Anice Hoachlander*

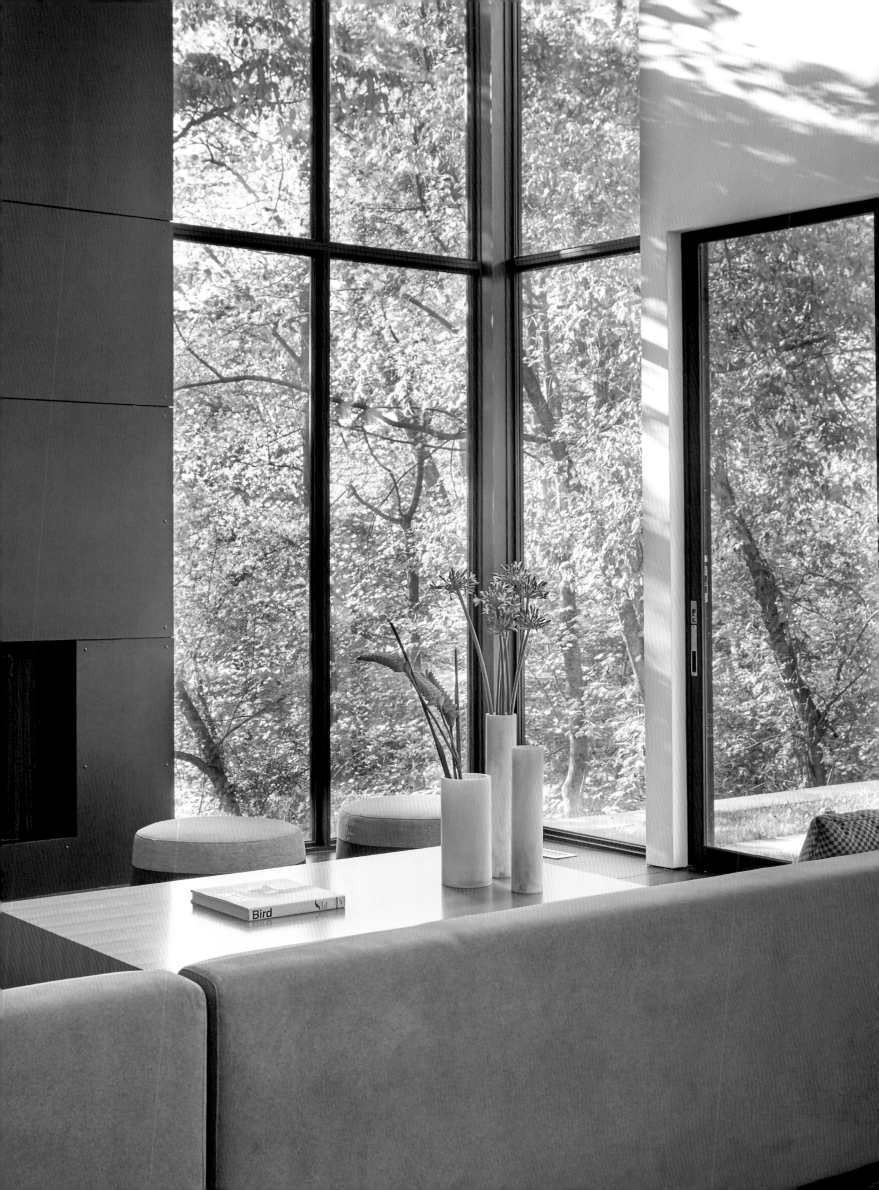

"I don't think that architecture is only about shelter — it should be able to excite you, to calm you, to make you think."

— Zaha Hadid,
Iraqi-British architect
(1950 - 2016)